# HEALERS AND HEALING
# IN EARLY MODERN ITALY

MANCHESTER
UNIVERSITY PRESS

# SOCIAL AND CULTURAL VALUES IN EARLY MODERN EUROPE

*Series editor*
Paolo L. Rossi
Department of Italian Studies
University of Lancaster

In its exploration of the cultural and social upheavals in early modern Europe, this series crosses traditional disciplinary boundaries. It offers a broad-ranging analysis of the forces which shaped structures of belief and practice at all levels of society, providing original insights into the mentality of early modern Europeans.

The volumes assess the manner in which central as well as peripheral values, institutions and disciplines evolved and, through this identification of metamorphoses, seeks to redefine the mechanics of change and to re-evaluate the meanings of a central or hegemonic culture.

Individual titles address many neglected or emerging subject areas, incorporating the history of the less studied countries of Eastern Europe. In so doing, the contributors examine a vast range of source material, including literary, historical, scientific, philosophical and artistic evidence.

Other titles in the series:
*Astrology and the seventeenth-century mind*
Ann Geneva

*Devoted people: belief and religion in early modern Ireland*
Raymond Gillespie

Forthcoming:
*Plague and its spreaders*
William Naphy

*Martino del Rio*
Peter Maxwell-Stuart

# HEALERS AND HEALING
# IN EARLY MODERN ITALY

## David Gentilcore

Manchester University Press
Manchester and New York

*Distributed exclusively in the USA by St. Martin's Press*

*Published by* Manchester University Press
Oxford Road, Manchester M13 9NR, UK
*and* Room 400, 175 Fifth Avenue, New York, NY 10010, USA

*Distributed exclusively in the USA by*
St. Martin's Press, Inc., 175 Fifth Avenue, New York,
NY 10010, USA

*Distributed exclusively in Canada by*
UBC Press, University of British Columbia, 6344 Memorial Road,
Vancouver, BC, Canada V6T 1Z2

*British Library Cataloguing-in-Publication Data*
A catalogue record for this book is available from the British Library

*Library of Congress Cataloging-in-Publication Data applied for*

ISBN 0-7190-4199-6 *hardback.*

First published 1998
05 04 03 02 01 00 99 98      10 9 8 7 6 5 4 3 2 1

Typeset in Bembo
by Servis Filmsetting Ltd, Manchester

Printed in Great Britain
by Bookcraft (Bath) Ltd, Midsomer Norton

# CONTENTS

# FIGURES

# SERIES EDITOR'S FOREWORD

Benvenuto Cellini, the noted Florentine, goldsmith, silversmith, sculptor and murderer, wrote in his autobiography that in 1523: 'The plague had broken out in Rome. While it was raging a very great surgeon called Jacomo da Carpi appeared on the scene. Among his other patients this able man took on some who were in a very bad way from the French pox [...] he claimed that in the use of certain fumigations he had a splendid cure for the disease. He insisted, however, on the payment being settled before he began the cure, and his fees were reckoned not in tens but in hundreds.[...] He was a very learned man, and he could talk marvellously about medical matters. The Pope in fact wanted him to stay in his service, but he said he had no intention of entering anyone's service, and that anyone who wanted him would have to come to him. He was a cunning devil, and he knew what he was doing when he left Rome, because, not many months later, all those he had cured fell so ill that they were a hundred times worse than before. If he had stayed he would have been killed.'[1] Cellini later calls him a *ciurmadore* (charlatan).[2]

This charlatan was probably none other than Jacopo Berengarius, humanist, Practicus of surgery in the University of Bologna, who had written a scholastic commentary on the *Anatomia* of Mondino de'Liuzzi, which he dedicated to Giulio de'Medici in 1521 when he was still a Cardinal. If this is so then there is a chasm between his reputation as a learned theorist and the way his activities as a practitioner were viewed by his patients. Cellini's comments do not stem from personal animosity towards him, indeed quite the contrary, yet he had little love for the professional physicians of his day. When he contracted syphilis he only recovered when he treated himself and ignored their advice. Another illness turns out to be immune to all the medical ministrations as it was a case of demonic possession, and Cellini was only cured when the evil spirit was exorcised, even if unconventionally.[3] He also indicates that the best medical care was not available to all. A friend had to call in a quack to treat his daughter as he did not know how to find a good surgeon. Even when one was found, it was the artist who had to make an appropriate surgical instrument. Cellini's approach to medicine was pragmatic. He took different categories of treatments and sought different kinds of help depending on the circumstances and nature of the illness.

Treatment of the sick was a lucrative trade that led to abuses. Cellini's patron in Rome, Pope Clement VII (Giulio de'Medici) sought to curb the power and independence of the Roman apothecaries with the Bull *In Supernae Dignitatis Culmine* (1531). He put the control of the corporation of apothecaries within the province of the Protomedico (protophysician) in order to regulate and control their activities. The apothecaries were to be the only people authorised to prescribe medicinal compounds, but only under the supervision of the medical Tribunal. A regular meeting was also set up to be attended by representatives from the

apothecaries, the medical Tribunal and the Camera Apostolica, in order to agree on a tariff for their products to avoid fraudulent exploitation.[4]

Clement's cousin Giovanni de'Medici, who had warmed the throne of St Peter for him as Leo X, was preoccupied with another aspect of health and prosperity. He was anxious to re-assert the power, glory and the dynastic ambitions of the family, and at the same time to give himself protection against malign forces. To this end he had the Sala dei Pontefici, the largest room in the Appartamento Borgia, decorated (1520–21) by Giovanni da Udine and Perino del Vaga, with paintings and stucco which present a carefully structured message couched in complex astrological symbols and allusions. It emphasises papal dominion, Leo's destiny, his Medicean ancestry and the return of a Golden Age presided over by himself.[5] The assumption that the heavens influence what happens on earth gave this room another possible purpose apart from overt propaganda. In this case it would function as a protective talisman: a prophylactic, to ward off evil stellar influences and ensure his spiritual and bodily health, and success. Leo was not the first Pope, nor would he be the last, to use such devices.

The link between medicine and astrology (iatromathematics) had a long pedigree, each part of the body was thought to be ruled by a specific zodiacal sign and planet. Marsilio Ficino, philosopher to, and intimate of the Medici, refers to this relationship in a letter of 1474: 'During August [...] I caught a fever and diarrhoea. Perhaps this year Saturn threatened me with this. At the time of my birth, it was in the ascending sign of Aquarius and was then in Cancer, my sixth house.'[6] Ficino wrote a book in defence of astrological magic and medicine *De Vita* (1489), and he was anxious to place the role and efficacy of amulets and talismans within the context of a well-established physical and metaphysical theory. The wearing of such protective devices (semi-precious stones or metals inscribed with words, numbers, zodiacal signs) was widespread. The Florentine, Bartolomeo Masi wrote in his *Ricordanze* that on 5 April 1492 at *tre ore di notte,* the city was overcome with darkness, wind and water and that the lantern of the cupola of Santa Maria del Fiore was badly damaged. This was caused by Lorenzo di Piero di Cosimo de'Medici, (Lorenzo the Magnificent) who, due to a serious illness, had freed and let loose a spirit which he had previously held captive in a ring for many years.[7] This demon-infested ring may have been used to alleviate the pain of the arthritis with which he was afflicted. The dangers of using inscribed talismans and amulets to attract celestial influence had been pointed out by both St Augustine and Thomas Aquinas, but in popular and elite circles it was believed that such illicit traffic could have beneficial curative effects.

It should not be thought that astrology was at the edges of medical practice. It was part of the initial training for the study of medicine, and physicians and astrologers were often one and the same. In the fifteenth and sixteenth centuries the Professor of astrology at Bologna was required to produce every year a *tacuinus,* a body of astronomical data, for the faculty of medicine. This was accompanied by an astrological interpretation (*iudicium*) based on the *tacuinus* and both were to be displayed in the classrooms of the medical teachers.[8]

From these examples we can begin to appreciate that medicine in early modern Europe was a complex affair involving physicians, surgeons, apothecaries, official state bodies, quacks, charlatans, magic, religion and astrology. It is this phenomenon of medical pluralism that is the concern of the present volume. Using sources such as the medical material of the Royal Protomedicato, the Holy Office of the Inquisition and the Congregation of Rites and Ceremonies David Gentilcore eschews the building of general theories in favour of a detailed analysis of a series of case histories for the period 1600–1800 in the Kingdom of Naples. He shows how all types of healers and all explanatory models for illness coexisted, overlapped, competed and contributed to one another and reveals the variety of different perceptions

about what constituted illness, its causation, the methods of treatment, the social divisions in medical provision and the access to care, with conclusions that can be extended, with modifications, to the rest of Europe.

Human nature does not change. In the past, as today, when illness strikes, men and women turn to available provision, both orthodox and unorthodox, in a desperate search for cures. These in turn are subject to control by the authorities to protect both the patients and vested interests. In a sense their recourse to magic, astrology and religion was much more rational than some of our present remedies. The world view that legitimised such beliefs was sanctioned by an illustrious philosophical tradition which saw its roots in the wisdom of Moses. The existence of demons, occult (hidden) properties and the influence of the stars were accepted by the Fathers of the Church such as Aquinas and by the Universities and the theologians. Given the plethora of help available, the sick, in many cases, choose the remedy which best fitted what they thought ailed them. The fact that they chose to consult a wise woman or an exorcist rather than a qualified doctor tells us much about the state of knowledge concerning disease as well as about the organisation of medical care.

## NOTES

1 The *Vita* was written between 1558–66. Benvenuto Cellini, *Vita*, I, xxviii. Quotation from: Benvenuto Cellini, *Autobiography*, trans. G. Bull, (Harmondsworth, 1974) p. 54.

2 Benvenuto Cellini, *Vita*, II, viii.

3 Benvenuto Cellini, *Vita*, I, lxxxv.

4 Ivana Ait, *Tra scienza e mercato. Gli speziali a Roma nel tardo medioevo*, (Rome, 1996, p. 98).

5 For the astrological programme see Janet Cox-Rearick, *Dynasty and Destiny in Medici Art. Pontormo, Leo X, and the Two Cosimos* (Princeton, 1984), pp. 188–98.

6 Letter to Francesco Marescalchi, 6th September 1474. See *The Letters of Marsilio Ficino, vol. 1*, (London, 1975) p. 125.

7 Bartolomeo Masi, *Ricordanze* (Florence 1906), p. 17.

8 The links between astrology and medicine are explored in Angus G. Clark, *Giovanni Antonio Magini (1555–1617) and Late Renaissance Astrology*, Unpublished PhD. Thesis, Warburg Institute, London, 1985.

# PREFACE AND
# ACKNOWLEDGEMENTS

At its heart this book is a study of medical pluralism. It explores the range of healers and forms of healing in the southern half of the Italian peninsula that was the kingdom of Naples. It analyses the features that constituted medical pluralism in this Catholic society, between (approximately) 1600 and 1800. I have not sought to write a conventional medical history, surveying great names and intellectual developments (although these, too, form part of the story). Rather, as much as possible, I have sought to adopt the point of view of the sick people themselves. In this context, religious and popular ideas about disease, its causation and cure, can be considered alongside learned ones. The emphasis is on the interaction and, indeed, competition between these three overlapping 'spheres'. The training, preparation and practice of all healers is discussed, against a backdrop of ongoing attempts by the medical and ecclesiastical elites to limit their activities within bounds considered acceptable.

For a plurality of healing, I have consulted a plurality of sources: medical and demonological treatises, hagiographies, guild statutes, hospital records, government edicts, chronicles, books of 'secrets', local histories, episcopal visitations, canonisation processes, trials for magic, diabolism and simulated sanctity, Jesuit mission accounts, and the records of the kingdom's medical magistracy, the Protomedicato. I have yet to come across either personal diaries or the case books of southern Italian physicians or surgeons, which have proved so useful to social historians of early modern England, France and Germany. Indeed, the sources are never as even as the historian would like, and this is especially so in the case of Naples, whose archives have suffered much over the years. Rather than try to cover every possible aspect of a vast topic, I have chosen a thematic approach. It is also comparative, frequently straying beyond the kingdom's boundaries.

The book begins with a new approach to medical provision. In line with the pluralistic theme, chapter one charts the therapeutic landscape of the kingdom, considering all sources of healing. That is to say, the densities of physicians, barber-surgeons and apothecaries are considered alongside those of midwives and itinerant practitioners, churchmen, cunning folk, saints (living and dead) and healing shrines. These figures are discussed in the context of the different explanatory models for illness which existed in this Catholic society. These are labelled

'medical', 'ecclesiastical' and 'popular', for want of better terms. Throughout, I stress the fact that these three forms coexisted, overlapped, competed and contributed to one another. In their search for understanding and for sources of relief, the sick could make use of one or all of them. In this regard, the mechanisms shaping individual choices are also discussed.

The reason so much can be said about the kingdom's licensed medical practitioners is due to the existence of a medical tribunal, the Royal Protomedicato. Its activities are examined in chapter two. The Protomedicato was headed by the kingdom's 'first physician', the *protomedico* (whom I shall call the protophysician). It was responsible for overseeing the activities of practitioners, making sure they operated within their 'professional' boundaries. Apothecaries were subject to annual visitations or inspections, and barber-surgeons and midwives were examined for their basic competence. Primarily, however, the Protomedicato endeavoured to collect the annual visitation fees from each and every practitioner, this activity being farmed out to tax collectors. That is, with the exception of graduate practitioners – physicians and surgeons – who were outside its jurisdiction until the Napoleonic reforms of the early nineteenth century. As an organ of the state, the Protomedicato was confronted with a range of jurisdictional limitations. The protophysician had an important advisory role, and enjoyed a prestigious place at the top of the kingdom's medical hierarchy, but his actual power was limited. The Protomedicato had only a small role to play in the public health of the kingdom.

In chapter three we turn to the practitioners themselves, their training and education, their practice and the demand for their services. The role of each, in this rigid corporate structure of medical colleges and guilds, is examined in turn. Each type of practitioner had his recognised place in the hierarchy of the medical order. This extended to those who had no corporate representation, but who none the less had a recognised place: the midwives and the itinerants (the latter variously known as charlatans, mountebanks and empirics). While these boundaries were important to both the medical and ecclesiastical elites, the sick were less fussy. As a result, pracititioners often transgressed these boundaries, in a contradiction typical of early modern society.

A particular paradox is that posed by the charlatan. He was at once reviled and recognised by the medical elites. To understand why this was so, and why charlatans were so popular with the public, chapter four examines one charlatan and his remedy: the self-styled 'Orvietan', Girolamo Ferranti, and his anti-poison electuary known as orvietan. We are able to reveal (for the very first time!) the contents of this drug, exploring why a medical 'secret' should capture the imagination of an entire nation, that nation being France. The chapter follows this Neapolitan in his meanderings through the Italian states and France, looking at the role played by the fear of poison, the transformation of snake-charmers into charlatans, medical secrets and recipe collections, theriac and the *commedia dell'arte* along the way. Far from being on the fringes of medicine, charlatans thrived at the intersection of the book's popular, religious and medical spheres.

Existing at another intersection – this time that of the ecclesiastical and medical

– were the kingdom's hospitals, the focus of chapter five. At the beginning of the early modern period the Annunziata in Naples was Europe's largest and richest hospital. It functioned, like all hospitals, as a form of poor relief, caring for foundlings, orphans and paupers as well as the sick. And most of the latter were the poor, unable to afford treatment at home. The chapter traces the role of active piety in the foundation and running of these institutions, within the context of the range of sources of poor relief and health care. These remain little changed throughout the period (dominated, as it was, by the Counter-Reformation), despite the increasing role of the city's other main hospital in university medical instruction.

The final two chapters of the book take us further into religious forms of healing, while bearing in mind their relationship to medical and popular forms. Whereas chapters two and three explored the efforts of the medical elites to impose their idea of order on the medical world, chapters six and seven explore the activities of ecclesiastical elites in related areas. Chapter six focuses on the attempts of episcopal courts throughout the kingdom to curtail devotion to 'living saints'. The latter were people reputed locally to be holy, and hence sources of healing miracles and other wonders, but not recognised by the Church authorities. Indeed, the Church feared that their sanctity might be simulated or be the work of the devil. The episcopal authorities, together with representatives of the Congregation of the Holy Office of the Inquisition, investigated these women (for they were mostly women) and the cults that formed around them. These trials provide the historian with much information about their role as healers in the community.

The investigations of another Roman clerical 'committee', the Congegation of Rites and Ceremonies, form the basis of the book's final chapter. Saints, and the miracle cures they provided, were important elements of the kingdom's therapeutic network. The procedure whereby the Church investigated and recognised its saints, the canonisation processes, recaptured the very words of the sick themselves, the recipients of miracle cures. The processes allow us to study not only the role of miracles but the way the sick viewed their illnesses, their bodies, and their encounters with a whole range of medical practitioners. The latter also figure in the processes, virtually as expert witnesses, distinguishing between natural and supernatural cures. Physicians may have been critical when it came to evaluating healing miracles, but they were seen to occur. And the ecclesiastical elites, rather than seek to diminish the stature of the medical elites by these sacred sources of healing, supported their position by recognising the crucial role of physicians as expert witnesses. This included the physicians' role in investigating the sick, in cases where they might be victims of demonic possession or magical spells; another example of the way the three spheres overlapped during the early modern period.

There are many people and institutions I would like to thank. First of all, the Wellcome Trust, as this book is the outcome of a Wellcome research fellowship held at the Cambridge Unit for the History of Medicine. My thanks to Domenico Bertoloni Meli, Andrew Cunningham, Silvia De Renzi, Ole Grell, and John Henderson at the Unit for putting up with all my talk about saints and miracles.

## PREFACE AND ACKNOWLEDGEMENTS

My thanks to Bob Scribner and Polly O'Hanlon for inviting me to co-organise a seminar series on 'Sickness and health in history' at Clare College, Cambridge. I am indebted to seminar and conference audiences in Barcelona, Cambridge, Gargnano sul Garda, Glasgow, Lancaster, Leicester, London, Messina, Newcastle upon Tyne, Oxford, Pescara, San Miniato, Valencia and Woudschoten.

Portions of this book have previously appeared in print and I would like to thank the following journals and publishers for allowing me to incorporate the material here: *Dynamis* (for parts of chapter two, originally published in Italian), Olschki (parts of chapter three), Routledge (parts of chapters five and six) and *Past and Present* (chapter seven).

Alessandro Pastore and Ottavia Niccoli have provided much kind encouragement over the years. Alvar Martínez Vidal has been a generous guide in all things to do with the Spanish Protomedicato. In Naples, I am very grateful to Giulio Raimondi, acting director of the Naples State Archive, Antonio Borrelli, librarian at Naples University, and to Giovanni Romeo for helping me to look amongst the Holy Office trials at the Diocesan Archive, slowly being catalogued. I would also like to thank the staffs of the various other archives I have visited over the years, in Bologna, Oria, Rome and Siena. Fedele Raguso and Marisa D'Agostino, at the Diocesan Archive in Gravina, were extraordinarily helpful during my short visit there. My thanks also to Stephen Greenberg at the US National Library of Medicine for providing me with photocopies and to the staff of the Biblioteca Giustino Fortunato in Rome for making it such a pleasant place to work. I was guided, in the book's final stages, by the helpful suggestions of an anonymous reader, by the insightful comments of the series editor, Paolo Rossi, and by Vanessa Graham, history editor, who kept everything flowing smoothly throughout.

D.G.

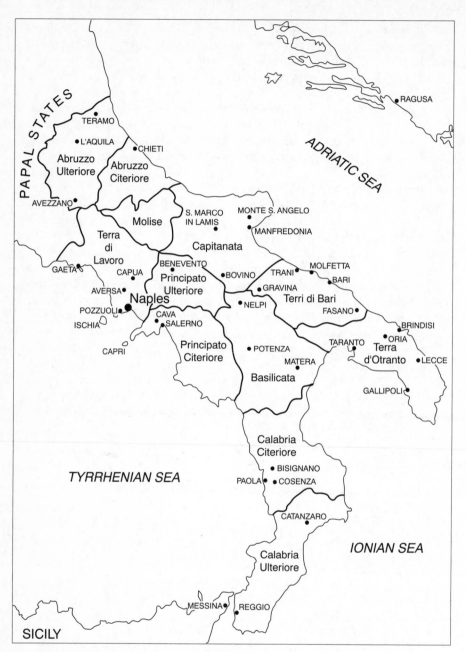

The twelve provinces of the kingdom of Naples

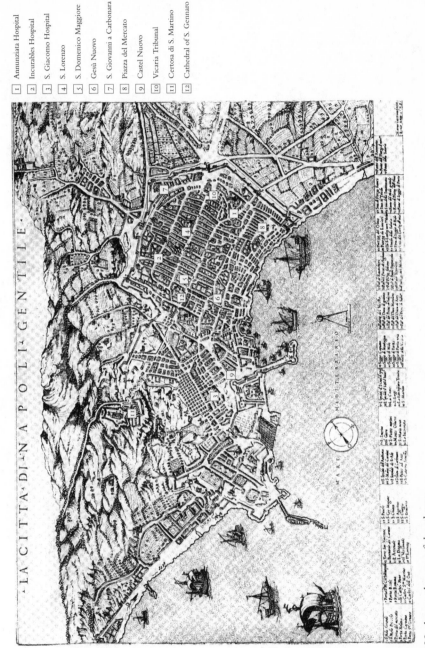

·LA·CITTA·DI·NAPOLI·GENTILE·

Naples on the eve of the plague

FOR FABIANA AND RITA

# CHAPTER ONE

# MEDICAL PLURALISM IN THE KINGDOM OF NAPLES

*Chi vuol conservare l'individuo caro*
*nè sangue, nè medicina, nè magia d'avaro.*[1]

In June 1704, in the town of Oria, Antonia Jurlaro's daughter Domenica became 'seriously ill' with severe pains in her genitalia, accompanied by fever. Antonia fetched the town's community physician, who examined and treated the girl, but without any improvement in her condition. She was also bled three times by a surgeon, Simone Papatodero. Several days later Antonia was washing clothes at one of the town wells, despairing of her daughter's health. A woman named Onofria Bufalo overheard and said it was like an illness she had suffered for a whole year, adding that she might be able to get her the same remedy she had taken. Such was Antonia's anxiety that, she recounted, 'having heard this it seemed to take a thousand years to finish washing the clothes'. She immediately went to Onofria's house and beseeched her to give her the remedy. At this point her account takes an unexpected twist. Onofria, with a local reputation as a healer or 'wise woman', went to examine Domenica. She identified it as the same affliction and said she would go to Papatodero for the remedy, though he did not give it to everyone. She warned Antonia not to tell anyone about it.

The next morning she told Onofria that she had been unable to find Papatodero and so would have to go to the nearby town of Francavilla for the remedy. She asked for seven *carlini* and five *grana* in payment. This was a substantial sum: what a peasant labourer might receive for three or four days' work.[2] Later, Onofria gave Domenica some of the remedy with honey, and prepared an enema of rue and sage which she administered – acting like a physician, surgeon and apothecary combined. Domenica slept the whole night through and seemed better the next day. But at this point some kind of disagreement ensued between Antonia and Onofria. Onofria shouted that Antonia and her daughter should be grateful for what she had done. Unfortunately Domenica's condition began to worsen. Onofria said she required more medicine which Antonia said she could not afford. Onofria offered to take something as a pledge if Antonia could not scrape the money together. But friends of Antonia's were becoming suspicious and advised her to stay away from the 'vile Onofria' and place her daughter's health in God's hands. Domenica's

condition continued to get worse. Such was the stinging pain in her genitals that it was 'as if there were a sea urchin there'.

Mother and daughter became convinced that Onofria had put a spell on Domenica (wise women were reputed to know how to harm as well as heal), especially in view of the fact that Domenica had had a run-in with Onofria the previous May. They were both part of a group of women out gleaning barley when Onofria had the idea of hiding one of the sacks. The other women agreed and did so, despite Domenica's opposition. When the estate factor found the hidden bag, the women blamed Domenica. Later, Domenica recalled Onofria's words to her: 'I'll make you sorry for this and I'll be damned if I won't put a spell on you that will have you chewing your fingernails.' Antonia and Domenica decided to go and see their parish priest to 'heal the spell'. He gave Domenica a blessing and advised them to denounce Onofria to the bishop for 'superstitious acts'. Papatodero suggested the same course of action, 'since we are the doctors and not her'. The resulting deposition before the episcopal court is the only reason the illness episode has come down to us.[3] Yet it introduces many of the aspects of medical pluralism that I wish to explore in this book, outlining as it does Antonia's strategies in searching for a cure for her daughter's illness, the causation of which she diagnosed first as natural and then as supernatural.

When confronted with the inevitable reality of disease, how did the people of early modern Italy react? Of the different forms of healing available, what factors determined which ones they turned to? In this therapeutic calculus, availability was certainly one such factor; but we must also consider others as diverse as the cost of the healer's services and treatment, their reputation, their suitability to the disease and its underlying causation, as well as the past experience of the sick themselves, their family and friends. This can be approached in different ways. In studies of England, the 'medical market-place' model has tended to dominate since it was first used by Harold Cook.[4] It is certainly useful as a way of accounting for the range of services available, especially in the relatively unregulated English situation. Then again, it too closely resembles the health-care developments of the 1980s to be uncritically applied to the past. Laurence Brockliss and Colin Jones have chosen to focus their 'new medical history' on university medical learning and its influences. They write of a 'medical community', consisting of trained practitioners, and a 'medical penumbra', including charlatans and women.[5] The book successfully explores nothing less than the entire 'medical world' of early modern France. The model they use is based around relations of power. Popular forms of healing are considered either entirely derivative of learned ones or impossible to ascertain because of the lack of sources. Matthew Ramsey, exploring a later period of French history, manages to find a place for folk healers in his model, which is admittedly more economic in structure. He divides practitioners into folk healers (part of a traditional economy), physicians (dominated by corporatism) and empirics (part of the market economy). Ramsey's model has the advantage of implying 'a set of social as well as economic relationships': the folk healer being part of popular culture, the physician of urban-bourgeois values and the charlatan as the outsider, trading on

his exoticism.[6] But it does not take account of religious forms of healing or the different categories of disease causation of which the sick made use. The model I propose for the chapters that follow is one of three concentric and permeable rings, labelled 'medical', 'ecclesiastical' and 'popular'. The rings refer not only to the types of healers and sources of healing, but to aetiological categories. It allows us to give due attention, where possible, to the attitudes and actions of both healers and the sick. The model is admittedly anthropological; but it does allow for historical change. Indeed, the circles are continually shifting in relation to one another, as are the places of individual healers and sources of healing. Certain kinds of charlatans, for example, move from being quasi-sacerdotal snake-charmers to secular entrepreneurs selling famed patent remedies.

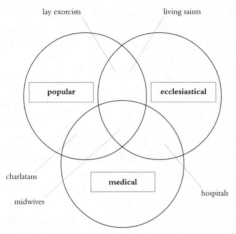

Medical pluralism model: healers and disease categories

In order to explore the implications of this model, the availability of healers is perhaps the logical place to start. It is certainly the most straightforward area to explore, dealing as it does with the supply side of the equation. So, in this chapter, I shall construct a therapeutic landscape of the kingdom of Naples. This is more than just counting the number of physicians and surgeons and calculating their relative densities, as a way of determining medical provision or, as it has been called, medicalisation. To take account of the plurality of therapeutic resources, I shall consider, as much as the data allows, all forms of healing. Thus in the medical sphere this will include apothecaries, midwives and itinerants; in the ecclesiastical sphere it will consider priests, exorcists and healing shrines; and in the folk-medical sphere it will take into account the presence of cunning folk. This will enable us to see how the spheres overlapped in concrete situations.

## Views of the kingdom

Nothing in Antonia's account of her daughter's illness and her response to it is typ-

ically southern Italian. Similar illness episodes could doubtless be traced through-
out early modern Europe. The kingdom's inhabitants suffered from the same range
of diseases as the rest of Europe. Hunger and famine were permanent, 'structural'
threats, as were recurrent epidemics of plague and 'fever' (typhus, cholera, malaria).
Even in the second half of the eighteenth century, when plague was but a horrific
memory, life expectancy in the kingdom was only thirty-two years – low, but little
different from other European rates.[7] We are used to hearing the southern half of
the peninsula referred to as the 'Mezzogiorno'; but the term is not generally used
to refer to a specific geographic and social unit, worthy of further study. Rather it
is used as the negative incarnation of something posing an obscure problem, like
some shameful social disease. The stereotypes of a picturesque peasant folklore and
Mafia become the 'other', or are fitted into improvised journalistic categories such
as 'Mediterranean'.[8] This shorthand view of a backward South offers a dangerous
enough distortion when interpreting present-day realities; it is even more false
when regressively applied to previous centuries. Economic underdevelopment and
exploitation were certainly features of the kingdom of Naples during the 'deca-
dence' of Spanish rule, especially in comparison with the apparent liberty and
merchant capitalism enjoyed by the Florence and Venice generally favoured by
Anglo-American historiography.[9] But these caricatures should not be allowed to
shape our exploration of other aspects of the kingdom, where it shares in the great
themes of early modern European history as a whole. For this reason a history of
medicine and healing within the kingdom, and in particular the characteristics of
medical pluralism, is not meant to highlight something peculiar to the kingdom,
but reveal its typicality within early modern Europe.

In order to explore therapeutic provision as a resource, and how this resource
was used, a few words about population patterns within the kingdom of Naples are
necessary. The kingdom, primarily agricultural, was dominated by its capital.
Cervantes, who spent some time in Italy, has one of his characters refer to Naples
as 'the richest and most delightful city in all the world'.[10] With a population ranging
around four hundred thousand, it was one of Europe's largest cities, and one in ten
of the kingdom's inhabitants resided there. This number was kept up by the con-
stant influx of people from the kingdom's twelve provinces. It helps to explain the
growth of the city in the late sixteenth and early seventeenth centuries. It also
enabled Naples to recover, albeit slowly, from the catastrophic plague epidemic of
1656. Some estimates put the losses at half the city's population, and those for the
kingdom overall at twenty per cent, some nine hundred thousand people.[11]

Throughout, Naples remained the focus of political, economic, religious and
cultural life. It was the place where most of the agricultural production ended up
and the site of aristocratic consumption and display. People came in search of work,
most settling in the crowded southern part of the city, which included the port and
main market. During times of dearth many more came because of the city's food
provisioning. Its grain dealers had first call on all the kingdom's grain and the city
authorities at the Tribunal of San Lorenzo set the price of bread.[12] Of people set-
tling in the city, just under one-third came from the surrounding towns and the

province of Terra di Lavoro, itself very densely populated. Numbers tended to diminish the further one got from the capital, especially in areas offering viable alternatives. The province of Terra d'Otranto, with the lively city of Lecce as its capital, was thus the source of only 1.4 per cent of immigrants. As an important Spanish dominion, Naples attracted large numbers of immigrants from Spain (5.7 per cent) and Sicily, its sister dominion (5.5 per cent).[13] However, all this growth went uncontrolled and no measures were taken to respond to it. Eventually what had been considered an indication of the city's grandeur and pre-eminence came to be regarded as a sign of the kingdom's weakness. In a complaint that echoed around rapidly expanding capital cities, like London, Naples' very size was seen to suck the life-blood of the kingdom. Its unabated growth threatened the kingdom's survival. Gaetano Filangieri adopted a bodily metaphor: 'if the head grows too much, if all the blood rushes there and comes to a stop, the body becomes apoplectic and the entire machine falls apart and expires'.[14] Indeed, after Naples, no town managed more than twenty thousand people, even though places like Lecce and L'Aquila did serve important regional functions. It was only with the French reforms at the beginning of the nineteenth century that the kingdom was decentralised to a degree and certain powers devolved to the provincial capitals. These reforms did bring a relative decline in immigration.

The kingdom was characterised by small and medium-sized towns: close to one-quarter of the population lived in towns of under two thousand inhabitants and one-half in towns with populations of between two thousand and seven thousand. What were conditions like? According to the statistical investigation of the kingdom ordered by Joachim Murat in 1811, town streets were often

> very narrow and unpaved, tortuous, irregular, reduced to mire by water already used for domestic purposes, full of mud, stones, and into which pigsties, stables and sheep pens stick out, with all their filth. The foulest and most stinking butcher's shops and slaughter-houses are found right in the middle of the street. Immense dung-heaps surround the settled areas, where they throw not just the sweepings and excrement from the stables, pigsties and houses, but the corpses of unburied animals as well.[15]

It was a blessing in disguise that these towns tended to be rather distant from one another, separated by difficult terrain. The kingdom was shaped by the Apennines, with three-quarters of the population living in mountainous and hilly areas. Communication was very difficult, especially in those areas outside modern-day Campania and Apulia. Particularly in the case of the two Calabrian provinces, the Abruzzi and Basilicata, the inhabitants were dispersed in a myriad of small mountain towns, cut off from one another, with only slightly larger regional centres. In the mountains of Molise, for example, 'people live in the countryside far from the towns and the assistance of physicians. If you add to this the generally poor nature of the dwellings, the very bad nutrition and personal hygiene, you will understand the great influence poverty has on disease and the slow and difficult recovery.'[16] Only a fifth of the kingdom's population lived along the coast, and most of this was in the capital.[17]

## Natural illness and medical practitioners

Antonia's first response to her daughter's suffering was to diagnose it as falling into that category of causation known as 'natural'. This meant a disease caused by natural factors, such as an imbalance in the four bodily humours (bile, blood, phlegm and black bile). The humours were said to be 'peccant' when balance was lost, corrupting the whole, from the Latin *peccare,* to sin. Conversely, health was linked to holiness (words that are themselves semantically related), wellbeing to salvation, both *salus* in Latin. Lifestyle also played a role: factors like diet, evacuations, exercise, air, sleep and strong emotions. And this was all to be managed according to one's own 'temperament' or constitution. At the beginning of our period, towards the end of the sixteenth century, this university medical knowledge concerning the body and disease was still based almost entirely on Galen. By the end of the period under study, the beginning of the nineteenth century, Galenic medicine had declined, replaced by a range of chemical and mechanical explanations of the body. This was accompanied by an increased stress on 'environmental' or hygiene factors in disease. Over the course of the two centuries the use of chemical remedies became increasingly widespread. However, medical practice and its efficacy in the face of disease – judged from a modern biomedical standpoint – changed very little.

The diffusion of medical knowledge throughout society is something that social historians of medicine have only begun to explore. With everyone responsible for their own health, a certain amount of medical knowledge was regarded as indispensable. This much is obvious. Just what forms this knowledge took is another matter. The wide range and success of popularising medical books, health manuals and recipe collections, both printed and hand-written, suggests a generalised desire to learn about medicine, or at least have access to self-help remedies. Yet, as we shall see in chapter four, the material covered in these collections varied greatly, from the medieval Salernitan tradition through to magical remedies. And we still know very little about how these eclectic texts were used by their owners. The sick not only diagnosed themselves, but expressed their diagnoses to the medical practitioners they called in, who proceeded accordingly. A certain shared language about the body and disease was thus necessary. To a certain extent this revolved around the humoral imbalance theory of pathology and the role of a person's individual temperament.[18] Galenism found its way into all strata of society, where the precepts of the School of Salerno on regimen and the preservation of health were transformed into well-known and oft-repeated proverbs. This is summed up in one proverb from an eighteenth-century Gallipoli collection: 'La deieta sana li lazzari' (roughly, 'diet heals even the lazars/lepers/layabouts).[19] Hospital medicine was another means of channelling elite medical practice throughout society. But to what extent changes in medical theories at university level made their way out into society at large is still a largely unexplored area.

As in Antonia's case, then, it was usual for the sick to make their own diagnoses and, if they were unable to treat the disease themselves with domestic remedies, fetch a healer, according to the nature of the disease. Illness narratives reveal that

such choices were part of the fabric of everyday life. As Mary Lindemann has observed: 'People sought healers where they went to market, solicited advice from those who gave it in other instances, and blended health and illness into the familiar pulse of life.'[20] Most treatment was carried out in the home. Antonia's initial choice of healer was made easier by the fact that the town authorities had hired a community physician, responsible for treating the poor free of charge. The stereotypical view of the presence of university medicine in early modern Europe is that of a high concentration in the cities and a medical desert in the countryside. It persists despite numerous studies to the contrary. Carlo Cipolla has demonstrated that in the Tuscan countryside in the 1630s there was a ratio of around one physician and just over one surgeon to every ten thousand people. Moreover, some small communities actually had higher physician-to-population ratios than the larger towns, due to the small size of their population. Finally, he also noted that that there were almost as many university-trained physicians as there were surgeons, whereas it is often assumed that the latter were much more prevalent because of their apprenticeship-based learning of practical skills.[21]

Just how many physicians were there outside the two universities of Naples and Salerno? Not many, according to one seventeenth-century study on barbering. In the words of its author, Cintio D'Amato, 'the diligent barber is virtually the sole means of treatment, since, in the small walled places and in the villages, where one hardly finds learned physicians, he, with the turn that his art demands, takes care of all problems and treats all kinds of ailments that occur in indisposed bodies.'[22] Cipolla quotes this passage in support of the significantly lower provision in the 'much poorer and less developed' South, in many areas of which 'physicians were rarely encountered'.[23] Yet D'Amato's words may be interpreted as arguing the importance of the 'diligent' barber's role and his acquired knowledge of the body, rather than a reliable indication of medical provision. Of course, a large number of physicians would have been concentrated in the capital, as was true in all the Italian states at this time. But many more would have returned to their native regions, in search of patronage or some sort of engagement. The reasons for this will be explored in chapter three. Neapolitan archives have suffered more than their fair share of damage over the centuries, most notably in the course of the Second World War. So the picture that follows is complete only towards the end of the period covered by this book.

To begin with, an idea can be had by looking at the numbers of physicians who were granted doctorates each year by the Naples College of Doctors. During the first half of the seventeenth century an average of eighteen doctorates were granted each year, a figure that does not include the School of Salerno.[24] By the 1780s, according to Giuseppe Maria Galanti, the number of medical doctorates granted at Naples each year had increased more than threefold, to around seventy, plus an additional fifty issued at Salerno. Based on this, he calculated that there were some 2,400 physicians and physician-surgeons in the kingdom.[25] In fact, the number of Salerno graduates was far higher than Galanti estimated. The annual average went from seventy-seven in 1717 to 152 in 1798, though most of the increase took place in the

final decade of the century.[26] If this increase is taken into account, Galanti was not far off. When the Protomedicato assumed authority over graduate physicians as part of the Napoleonic reforms of Joachim Murat, in 1809–10, they were counted at 3,178 (the two Calabrian provinces are missing). By this time the kingdom's population was just under five million, almost double its seventeenth-century average. It appears therefore that there was a slight increase in the overall density of physicians throughout the kingdom, which probably occurred in the latter half of the eighteenth century. However, there is little to suggest that generalised *patterns* of medical density would have changed much over the early modern period. For, although the content of the medical curriculum had shifted considerably over the years, the need to find sources of patronage or a local clientele had not. Some figures change hardly at all, if compared to anecdotal evidence for earlier periods. Thus Francavilla (Terra d'Otranto) had twelve physicians in 1686; in 1809 it had thirteen.[27] Another continuing feature was the municipal hiring of community physicians and surgeons. Unfortunately it is impossible to estimate what proportion of practitioners they represented and to what extent this may have changed over the period. In any case, we can follow the protophysician – or rather the tax farmer who had successfully bid for the right to collect the dues that each medical practitioner had to pay – as he and his deputies toured the kingdom collecting money, conducting inspections and checking diplomas. The 1786 Protomedicato list (which includes midwives, barber-surgeons and apothecaries) and the 1809–10 list (which also has graduate physicians and surgeons) thus provide the best opportunity we have for mapping the medical landscape.[28] The following discussion is based primarily on the later list, because of its greater precision and thoroughness; but the numbers contained in the two lists, where they can be compared, do not vary widely, even accounting for an ever-increasing population. The source has limitations. It was a tool for collecting revenue: its compilers were not concerned with levels of practice. Thus factors such as invalidity or old age are only rarely mentioned. Nor can it tell us anything about those who sought to evade the annual licence or 'inspection' fee, and whose numbers might be quite considerable, especially amongst itinerant practitioners. But the findings are worth discussing here nevertheless.

In 1809–10 more than ten thousand people practised the 'healing arts', as the list put it, including physicians, surgeons, physician-surgeons, barbers, apothecaries, grocers, herbalists and midwives. The physicians alone numbered just over three thousand, as has been noted, meaning a kingdom-wide ratio of 6.2 physicians for every ten thousand people. This high figure is no longer surprising; what is unexpected is the relatively low density in the capital compared to the rest of the kingdom. While Naples had a respectable 4 physicians for every ten thousand people, medium and small-sized towns could expect more than twice that amount. The town where this chapter began, Oria, with just over five thousand inhabitants, had five physicians. A town of one thousand people could expect to have at least one physician. But it did not end there. This same random town of one thousand people could also expect to have one surgeon or, more likely, barber (also known as bloodletters or phlebotomists), one apothecary and one midwife. As this sug-

Medical densities in
the kingdom of
Naples, 1809–10

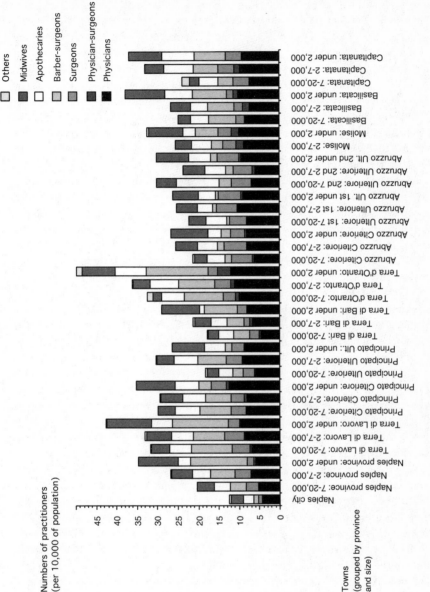

Numbers of practitioners
(per 10,000 of population)

Towns
(grouped by province
and size)

Legend:
- Others
- Midwives
- Apothecaries
- Barber-surgeons
- Surgeons
- Physician-surgeons
- Physicians

Categories (bottom to top):
Naples city
Naples province: 7-20,000
Naples province: 2-7,000
Naples province: under 2,000
Terra di Lavoro: 7-20,000
Terra di Lavoro: 2-7,000
Terra di Lavoro: under 2,000
Principato Citeriore: 7-20,000
Principato Citeriore: 2-7,000
Principato Citeriore: under 2,000
Principato Ulteriore: 7-20,000
Principato Ulteriore: 2-7,000
Principato Ult.: under 2,000
Terra di Bari: 7-20,000
Terra di Bari: 2-7,000
Terra di Bari: under 2,000
Terra d'Otranto: 7-20,000
Terra d'Otranto: 2-7,000
Terra d'Otranto: under 2,000
Abruzzo Citeriore: 7-20,000
Abruzzo Citeriore: 2-7,000
Abruzzo Citeriore: under 2,000
Abruzzo Ulteriore: 1st 7-20,000
Abruzzo Ulteriore: 1st 2-7,000
Abruzzo Ult. 1st under 2,000
Abruzzo Ulteriore: 2nd 7-20,000
Abruzzo Ulteriore: 2nd 2-7,000
Abruzzo Ult. 2nd under 2,000
Molise: 2-7,000
Molise: under 2,000
Basilicata: 7-20,000
Basilicata: 2-7,000
Basilicata: under 2,000
Capitanata: 7-20,000
Capitanata: 2-7,000
Capitanata: under 2,000

Axis values: 0, 5, 10, 15, 20, 25, 30, 35, 40, 45

*Source: A.S.N., Sommaria: Protomedicato, series
II, 34; Arrendamenti: serie registri, no. 250.*

gests, the numbers of physicians, surgeons and barbers, apothecaries and midwives are roughly equal to one another, each of the four 'arts' representing, more or less, a quarter of the total. This finding contrasts notably with France at the same time, where lower-level surgeons predominated over physicians in all areas, especially rural ones, by anything from three-to-one to ten-to-one. In provincial England, too, physicians made up but one-tenth of practitioners, which includes surgeons, apothecaries and druggists.[29]

Another interesting pattern, in this case reflecting Jean-Pierre Goubert's findings for France, is the prevalence of the highest ratios of the kingdom of Naples in the smaller towns. All the peaks on the diagram below are provincial ratios for towns under two thousand people, and the troughs for towns between seven thousand and twenty thousand people. The ratios are fairly consistent from province to province. They do tend to be higher, however, in the wealthier agricultural provinces of Terra di Lavoro and Terra d'Otranto, with their higher population densities overall and better communications. The mountainous areas are the least well served by medical practitioners, though the difference is a relative one.

What can be said about the *demand* for medical services? The provision of community physicians was meant to meet the needs of a town's poor, at least according to the official rhetoric. But those who stood to benefit most were probably those of the same class as these practitioners, both economically and culturally. The very poor would not have been able to afford the remedies prescribed by the physician. Certainly, the physician's complaint that 'the people reduced to abject poverty . . . either call the practitioner at the very last moment of life or never' was a very common, almost timeless one.[30] There is doubtless some degree of exaggeration in this sort of comment, as they (like this one) are often made in time of epidemic. But in such cases the sick may have regarded intervention as futile, even fatal, thinking it best to let the disease run its course. It is possible that, outside of epidemics, consultation with a physician may have been more common than the records suggest. After all, Antonia Jurlaro, with whom this chapter began, had recourse to a community physician for her daughter's illness, despite being quite poor. Where more than anecdotal evidence is available the tendency was for most people to make use of the more practical services of the barber, apothecary and midwife. People also bought medicines from itinerant practitioners, variously known as charlatans, mountebanks or empirics. As a group they are under-represented in the official records, due in part to their travelling nature. While the physician's regular clientele might have consisted only of the town's notables and their families, the others' reached out to the entire community. Here we enter into the realm of public attitudes and shared mentalities, as well as the important consideration of cost. These, like accessibility, all had a part to play in determining contact with medical practitioners.

A further aspect of therapeutic provision in early modern Europe consisted of hospitals. It must be said, however, that these institutions were as much concerned with the health of the soul as with that of the body. They were as much concerned, and in many cases more so, with taking in the poor, wayfarers and pilgrims as they were with the sick. Italian hospitals were more akin to monasteries than the modern

institution, with large numbers of resident clergy and with a chapel at their heart. Nevertheless they did employ physicians and surgeons and often had an apothecary's shop as part of the hospital structure. As such, they represent part of the overlap between learned and ecclesiastical healing.

As befitted its size, Naples had numerous such institutions. During the seventeenth century it had eleven hospitals, plus ten conservatories for women, eleven for girls, five for boys and one for the aged. In all, they were said to assist some six thousand people every year.[31] One of these was the Casa Santa dell'Annunziata, Europe's richest and largest hospital, a source of amazement to travellers from northern Europe. However, hospitals were sparse in the rest of kingdom, though this is consistent with the very much smaller sizes of towns. Only towns like Lecce and L'Aquila had populations large and variegated enough to endow and support more than a single institution. In the two Calabrias, for example, only Cosenza, Castrovillari, Catanzaro, Tropea and Crotone had hospitals with more than a handful of beds.[32] And by the end of the eighteenth century they were all in a perilous state, surviving on ever-decreasing legacies. There was not much change in hospital numbers during the early modern period, although the larger institutions did witness a shift in the latter half of the eighteenth century towards a more medical emphasis. Such services as existed were still intended mainly for the poor, and they made them part of their strategies for dealing with disease and hard times. From the point of view of the sick, hospitals were a resource, which the sick used much as they would any other form of healing. They diagnosed the need themselves, often admitting and discharging themselves as they saw fit. The remedies learned there could also find their way into eclectic popular healing traditions.

## Preternatural illness and ecclesiastical remedies

As 'mixed' institutions, from a modern perspective at least, hospitals are a useful way of introducing ecclesiastical attitudes to illness and forms of healing. The role of the Catholic Church increased substantially during the Counter-Reformation. In 1566, three years after the close of the Council of Trent, a papal bull informed physicians that thenceforth they would have to ensure that the sick had made confession before they began treatment. It was a strict application of long-standing Catholic tradition, that care of the soul had to accompany that of the body. Some physicians warmly embraced the new order, like the early writer on medical ethics Battista Codronchi. Confession, he argued, not only alleviated the fear of mortal sin, but could be considered a 'physical medicament' because of the link between body and soul.[33] The purging of sins would cleanse the body, preparing it for the application of physic – analogous to the purgatives and vomitories preceding treatment and considered to make it all the more effective. However, the impact of such advice on private practice may have been minimal. Physicians may have found it difficult to regard confession as their responsibility. It was said of the physician-surgeon Marco Aurelio Severino in Naples that 'when he goes to visit some sick person, even if they are seriously ill, I have never heard him say that they should

make confession, as physicians are obliged to do'.[34] Whether or not the accusation was true, it was the kind of thing that was plausible enough to be used to incriminate someone. A practitioner's reluctance to insist on confession seems to apply even to hospitals – where 'dual provision' was written into hospital statutes.[35] On the plus side as far as physicians were concerned, if they were expected to be defenders of religious orthodoxy, the Church repaid them by recognising their heightened legitimacy and status. It made their expert opinion decisive in various spiritual fields. They were consulted in cases of witchcraft, to determine whether demoniacal spells were involved, and in the almost infinite number of healing miracles, to evaluate their authenticity.

With regard to illness itself, in addition to natural causation there was the preternatural. God and the saints could send disease as a punishment for sin, a reminder that death was fast approaching and opportunity for repentance limited. If disease brought suffering, it also provided an opportunity to turn to a more pious life. The confrères of the religious brotherhood of the Santissima Annunziata in Lecce, when visiting and serving in the local hospitals, were encouraged to console the sick with the following message: 'They will speak of the fruits which are received from sickness and tribulations, which can serve as a beating to separate the wheat from the chaff, or the dust from our clothes, when they are patiently borne.'[36] An early history of the activities of the Society of Jesus in the kingdom revealed God's use of disease to punish and bring individuals to repentance, in this case a victim of the 'French disease' (the name given to syphilis and similar illnesses):

> There was a person oppressed by a rash suffering for a trying disgrace, when it is only proper to be ashamed both of the shamelessness in committing it and the repugnance in making the sin public. He also suffered from the falling sickness. I know not whether [this was] a disease of nature or punishment for his sin, for which he was doing penance during his life rather than after death. He overcame this shame during the course of a mission and, having vomited all the poison of his soul at the confessor's feet, seemed thenceforth to be healed of every bodily ill as well. Whether it was the work of nature or of grace, he was never more wasted by his usual epilepsy, at least for the next three years about which we have knowledge. This gave occasion fully to believe that, with the favour of his bodily health, the Lord God wanted to establish more completely in him the cure of his spiritual health.[37]

Just as God could punish and then heal individuals, he could deal with entire communities. God's wrath was frequently judged the cause of plague epidemics, as it was of any natural calamity. For the Jesuit Antonio Possevino, 'the more principal causes of plague' were different types of sin. Of much lesser importance was secondary causation – for which God was also responsible – such as 'from the bad quality of the humours, from corruption of the air or from contagion'.[38] And the remedies? 'On hearing of the approach of this visitation sent by the hand of God [Possevino advised], you should at once put your mind on his Divine Majesty, retire to some place apart, and place yourself completely and with great hope in His compassionate hands.' He urged people to pray, perform acts of charity, make

confession, take communion, fast, hear masses and sermons, and perform the 'spir-
itual exercises' (he was a Jesuit, after all). Dubious financial affairs should be ended
and any licentious books, playing-cards and dice destroyed. Possevino proposed that
what he called primary remedies, like processions with saints' relics, could have an
effect on both the primary causes of plague, by placating God's wrath, and the sec-
ondary causes, by purifying corrupt air.[39]

But Possevino's view of the unique role of the divine was an extreme one. Even
his fellow-Jesuits shared the prevailing belief in both primary causes (divine provi-
dence) and a range of secondary or natural ones. It followed, too, that remedies
should take two forms, religious and secular, both of which were generally believed
necessary to deal with plague. For instance, the 1562 directives of Jerónimo Nadal
on how Jesuit colleges should respond to an epidemic began by recommending
prayers and masses. But they proceeded to practical advice on the fumigation of
rooms, the buying of medicines, the consultation of physicians and the segregation
of the sick, as well as the apparently uncharitable recourse to flight in order to avoid
infection.[40]

Physicians could concentrate their efforts on natural secondary causes, while
allowing that these ultimately derived from divine primary ones. Contemporaries,
in fact, performed an ongoing balancing act between religious and secular options.
The Naples plague of 1656 was one such occasion. At its height hundreds of people
were dying every day, 'causing a fear so great in the hearts of the citizens that, nat-
urally inclined towards piety, they turned to God', in the words of the actor, writer
and publisher Domenico Parrino, who chronicled the events. 'In processions of
men, women and dishevelled young girls they came together by the thousands to
implore divine mercy in various of the city's churches. . . . Many miraculous images
were taken out, amongst which the most holy crucifix of Santa Maria a Piazza.'
Before her death in 1618, the nun Orsola Benincasa had prophesied a great calam-
ity for the city because of God's mounting ire, which only the construction of a
hermitage could counter. The viceroy himself was the first to go to the site, digging
twelve baskets of earth. The contradictions, or at least ambiguities, inherent in dis-
tinguishing between natural and supernatural causation are revealed in Parrino's
interpretation of the effects of this very public piety. The short-term effects were
harmful. As a result of the 'just judgements of divine providence they miscarried
into an increase of the disease which, with the union and coming together of so
many people, continued to spread and gradually communicate itself from quarter
to quarter.' But the longer-term effects were positive, prompting the Virgin's inter-
cession to end the plague. Parrino had no doubts about this, since the plague began
to subside in mid-August, on the vigil of the Assumption.[41] Others were not so
sure. The Jesuits gave the credit to their own St Francis Xavier, the Theatines to St
Gaetano da Thiene and the Cistercians to St Bruno.

Antonia Jurlaro made use of two ecclesiastical remedies in combating her daugh-
ter's illness, having exhausted the other forms available: a priest's benediction and
recourse to the episcopal court. The first was part of a whole battery of sacramental
rites administered by the clergy, a spiritual pharmacopoeia which ranged from

making the sign of the cross and reading a passage from the Bible over the sufferer to exorcisms designed to counter the powers of the devil in causing illness. Denouncing the wise woman Onofria Bufalo before the episcopal court was another bargaining tool in her war of words with the suspected culprit. This avenue was opened up by the Counter-Reformation Church's ongoing campaign against 'magic and superstition': a category of rituals believed to gain their efficacy – and their very efficacy was rarely questioned – through the intervention of the devil. If a spell caused illness, it was the devil which gave it its power and God who allowed it to happen as a way of testing the sinner. And only the Church's remedies, the ecclesiastical authorities argued, could safely combat it.

Every ecclesiastic in the kingdom was a possible healer because of the remedies at his disposal. And their total number easily reached into the tens of thousands. Naples was, of course, the focus of the kingdom's religious life. At the end of the seventeenth century there were 140 monasteries and convents, housing some five thousand male religious and six thousand nuns. The Franciscans alone had twenty-five monasteries in the city, the Dominicans seventeen, whilst newer arrivals like the Jesuits and the Theatines had seven religious houses each.[42] And there was certainly no lack of parish clergy with the city's thirty-nine parishes at the end of the 1600s. The kingdom was divided into 148 dioceses, twenty-one of which were archbishoprics and 127 bishoprics.

Clerics responsible for the conducting of parish missions seem to have been a class apart, with sacred powers that far exceeded the average parish priest. This might have been partly due to the climate of tension and anxiety created during the course of a mission, with its emphasis on the pains of hell and the temptations of the devil. In the minds of the laity, the missioners must have constituted the only way out. The Jesuits, as one such order responsible for missions, did nothing to discourage a widespread belief in the sacred presence they represented. Indeed, they were only to happy to record it for posterity in their mission accounts. Their parish missions were accompanied by good omens, visions and miracles. Lay people were recorded cutting off pieces of the Jesuits' habits which they kept 'not just out of reverence for the merits of others, but [to use] as a remedy for their own illnesses.'[43] Miracle cures that occurred were the result of devotions introduced and were not carried out by the Jesuits directly. Thus, during a 1657 mission to the town of Casarano, a man was cured of his sores as he kneeled down to kiss those of Christ during a procession.[44] In another an inhabitant of Lecce was cured of articular pains which the local physicians had been unable to ease. When the sufferer approached the altar of St Francis Xavier the devil was forced to reveal a magical charm in the man's stomach, which he eventually vomited up, and was cured. Such episodes reinforced the knowledge that charms could cause disease and that only the Church had the power to counteract them.[45] Ecclesiastical remedies had powers that the physicians lacked. They could overturn the natural order of things, go against nature, which was not an avenue open to physicians. The Jesuits proudly recorded the case of a convent that, during a mission, went without the physician's regular visit, secure that the Jesuits' presence provided some sort of divinely sanctioned protection.[46]

In 1734 two missioners from the Jesuit College in Lecce carried out thirty missions in the towns of Terra d'Otranto, the central feature of which was an image of St Francis Xavier borne aloft by one of the missioners. The Jesuits missed no opportunity to encourage devotion to their missionary saint: in some areas water blessed in the saint's name was proving to be a popular and effective remedy.[47] In this case they recorded a series of healing miracles that occurred. What is interesting is that they went to the trouble of having them all notarised, sure of their place in history.[48] The missioners thus introduced a source of healing that was not there before.

Because of the sacramentals at their disposal ecclesiastics often branched out into other more secular forms of healing. Physic and surgery were off limits to them, as far as Church teaching was concerned, because of contact with human blood, but they were permitted to run apothecary's shops inside monasteries. In Naples, in addition to the city's eighty-seven apothecaries, there were eighteen monasteries dispensing drugs.[49] The monastic apothecary's shops were partly under the control of the protophysician (a relatively recent 'conquest' on the part of the secular authorities), partly under the control of the respective religious orders and partly under the control of the bishop. However, with a multiplicity of overlapping jurisdictions and with so many ecclesiastics present in the kingdom, from fully ordained clerics to tertiary friars, it was impossible to keep track of them all. One third-order Franciscan from Calafata (Terra di Bari), Fra Carlo Geremia, told the Protomedicato authorities in Bologna that he was there to confer with the cardinal legate to try and get an audience with the pope to discuss some Church business.[50] In the meantime he was going around treating 'cankers, fistulas, scrofulas, *mal di formica* [syphilitic ulcers], and other ailments', based on his thirty years' experience all over Italy. Previously he had been in Brescia, having been awarded a licence there by the medical authorities. He affirmed that he only treated the sick externally, and not internally, according to what was allowed any lower-level surgeon. He remarked: 'I have many secrets for incurable diseases with me, in particular a very marvellous one for consumptives [called] Polignano Powder', which he taught to a local apothecary. The Bolognese Protomedicato allowed him to continue treating people, as long as he did nothing illegal or against their edicts, his habit offering him some degree of protection. What the Church authorities made of his activities is impossible to say since, as a tertiary friar, he maintained certain liberties.

Otherwise the Church was very strict when it came to prosecuting clerics involved in healing, especially if magic was involved. Many such cases appeared before the kingdom's episcopal tribunals, since there was no separate Inquisition as such. Laymen accused of performing improvised exorcisms were also examined by these courts, for exorcisms could only be undertaken by trained and licensed clergy. Given the licensing involved it should be possible to determine the number of exorcists in the kingdom and calculate ratios per head of population, as we have done for the medical practitioners. Alas, the licences themselves, if they were ever more than verbal permissions, have not survived, and so the number of exorcists must remain unknown. Occasionally, several exorcists are named in the course of eccle-

siastical trials, which can give us some idea of provision. In 1675 a desperate Neapolitan man named three alternative exorcists living in his immediate vicinity, after accusing a Dominican exorcist of an excess of zeal in performing eight exorcisms on his five-year-old son.[51] But this is no more than a sample. What we do know is that it was increasingly becoming a clerical sub-discipline 'restricted to a few select priests and very rare exorcists, of whom many qualities are required.'[52] Due to the fact that it was a clerical specialism, and given the occasional references in ecclesiastical trials to exorcists having to be called in from larger neighbouring towns, the supply never seems to have met the demand. Group exorcisms became commonplace. And from the late sixteenth century the demand was ever increasing, as the Church pressed home its message that only its operations could combat the devil, whether his involvement was through a spell cast by a wise woman or a full-fledged possession. One authority on exorcisms, the friar Girolamo Menghi, concluded that most cases were caused by spells, on the basis of the maleficent charms that came to light during the exorcisms. Menghi's identification with possession and magical spells and his close to forty years' experience 'healing' the possessed led him to propose a kind of 'community exorcist' in each diocese, salaried by the local church.[53]

Especially during the seventeenth century, when fear of the devil was at its peak, the exorcist's conjurations may have been as well known as the physician's purgatives. And with exorcists commonly making use of strong medicines to purge the victim's body of the possession-causing charm, as an accompaniment to their rites, the two worlds were quite close together – so close that Menghi warned exorcists not to venture into the physician's realm, by giving oral medicines without a physician's orders.

> Instead of the exorcists that they should be, they turn themselves into herbalists, physicians or charlatans. This they do by searching for this or that herb against demons. And they give syrups and medicines, powders, pills and other similar things to the possessed and the bewitched, without the advice of physicians and against the commandments, rules and orders given them in books, presumptuously usurping the role of the physicians. With these things they occasionally chase the very souls out of the bodies along with the [evil] spirits.[54]

It was *presumption* that allowed these exorcists to act as they did. This was the same accusation made against surgeons, apothecaries and, especially, charlatans who trespassed over professional boundaries by practising physic. That is to say, they made use of oral medicines without knowing how they worked, what amounts were required and whether or not they were appropriate for the sick person's particular constitution and temperament. In addition to the presumption of the charlatan, some exorcists shared with them their itinerant ways. A Sardinian exorcist, resident in Naples at the end of the sixteenth century, admitted performing exorcisms in people's homes on request, going 'around the houses of Naples . . . wherever I was fetched.' Francesco Salinas recounted how he practised exorcisms on victims of spells, following Menghi's treatises. He would identify the presence of spells 'by

seeing if any [possessed person] had a pain in the neck, stomach, kidneys' and claimed to have 'healed many [spells] by the grace of God.'[55]

While the medical authorities sought to keep separate the various branches of the medical arts, the ecclesiastical courts worked to separate clerical and lay. Lay or improvised exorcists were charged with taking on the status of the trained and licensed ecclesiastic, in addition to imitating his specialist knowledge. It was presumption of another sort. In the 1580 case against the Neapolitan fisherman-turned-exorcist Giangiacomo Marsicano this element of his activities on behalf of the bewitched figured prominently. For instance, where a witness recounted how Marsicano proceeded to identify the number of demons possessing a person's body, ordering that person to lick the ground, an ecclesiastical hand has written 'impertinens' in the margin.[56] Only authorised specialists were entitled to make such assertions.

Theologians stressed that God put the remedies for illness at man's disposal, both natural and supernatural. Devotion to the saints and the expectation of miracles was a fundamental part of Counter-Reformation religiosity, shared by all elements of society. Saints, dead and living, ecclesiastically recognised or unofficially sanctioned, were an unfailing source of miracle cures. Once again, Naples was the focus for the kingdom's saints, as it was for the religious life in general. It attracted those drawn to the religious life just as it was a magnet for the country's aristocracy and the thousands of immigrants who flocked there every year in search of work and food. Of the kingdom's 105 canonised saints born during the years 1540–1750, two-thirds died in Naples, though less than one-quarter were born there. Only the centres of Lecce and L'Aquila were able to withstand this attraction because of the strong religious traditions and institutions of their own.[57]

In addition to those saints officially recognised by the Church authorities through the processes of beatification and canonisation, there was also a category of people which historians have referred to as 'living saints.' As we shall see in chapter six, these were women and men (primarily the former) known and venerated locally for their piety, mystical experiences and wondrous deeds. The ambiguity lies in the fact that canonised saints began this way and eventually achieved official recognition; but many more were never so recognised. Indeed, they were often examined by the ecclesiastical courts under suspicion of 'simulated sanctity', their powers believed to have come from the devil, risking perdition for both themselves and their followers. Whether their experiences and accomplishments were labelled divine or diabolical depended on the interpretation of the Church authorities. But for the devotees of these living saints what counted more than orthodox behaviour was the ability to work wonders, first and foremost miracle cures. Naples had its fair share, but most large towns could boast of at least one living saint during the early modern period. It would be premature to suggest a statistical profile, as new cases are continually emerging from the local ecclesiastical archives. However, findings so far suggest that there may have been a periodisation of cases against living saints, with a concentration in the first fifty years or so after the Council of Trent. In any case, trials against living saints tell us more about Counter-

Reformation concerns with enforcing orthodoxy than the reality of the phenom-
enon itself (which continued well beyond the chronological bounds of this book).

The healing powers of saints were available in other forms, such as relics, images
and shrines. Saints' relics tended to be concentrated in towns: in churches, religious
institutions and private collections. No local history published during the period
was complete without a self-congratulatory list of the relics possessed by the town's
churches. The 1634 work *Lecce sacra,* following in the footsteps of similar book
about Naples, set out to describe all the city's religious institutions.[58] The city saw
itself as a second Naples, and books like *Lecce sacra,* though more painstakingly
detailed than propagandistic in tone, helped to bolster this image. Some relics, such
as the corpses of local saints, were on display in churches, where they were available
to all worshippers. Such was the case of the cadaver of St Irene, one of Lecce's
patron saints and the pride of the city's Theatine church. Other smaller relics,
housed in reliquaries, were carried by the clergy in procession on relevant feast days.
One such was a relic of St Vitus, contained in a wooden statue and carried in pro-
cession on the saint's feast day by the confraternity named after him. Some devel-
oped specifically healing functions, such as 'a piece of the altar where St Peter the
Celestine celebrated [mass], the powder of which, [when] drunk by the sick, [who
are] suffering from chills caused by tertian or quartan fever, ordinarily receive
health.'[59] The powder was limited in quantity and the Celestine monks of Santa
Croce must have kept a close guard on its use, determining to whom it should be
dispensed. But most of the numerous relics were probably too small, mounted with
too many other tiny fragments and kept in areas off limits to the laity to attract much
in the way of devotion.

Religious images were another matter, especially where they came to form the
basis of healing shrines. Saints' shrines and their relative success in attracting pil-
grims were a direct response to popular demand, largely unmediated by the clergy
(try as they might). Shrine narratives relate how most images came to be found
outside towns, often in open countryside, in woods or a cave, by a peasant or herds-
man. This has been seen as an attempt by the average Catholic to provide sources
to the sacred over which they had some control, independent of the bishop or the
cathedral clergy.[60] By the same token, shrines were never very far from towns, for
they needed to be readily accessible. In the kingdom, few peasants lived in open
countryside but tended to gather together in the towns, commuting to their out-
lying fields. There were some exceptions to this general rule, such as the shrine to
the Archangel Michael, perched high in the mountains of the Gargano peninsula
(Capitanata). Despite its isolated position, or perhaps because of it, the shrine
attracted devotees from throughout the kingdom and beyond. The town of Monte
Sant'Angelo that surrounded it in fact sprang up long after the shrine had come
into being: in this case it was the shrine that gave birth to the town and not vice
versa.

The kingdom had a veritable network of shrines. Even at the time, shrines ded-
icated to the Virgin Mary were presented in such geographical terms, as in Wilhelm
Gumppenberg's *Atlas Marianus* of 1672. The most detailed description of the phe-

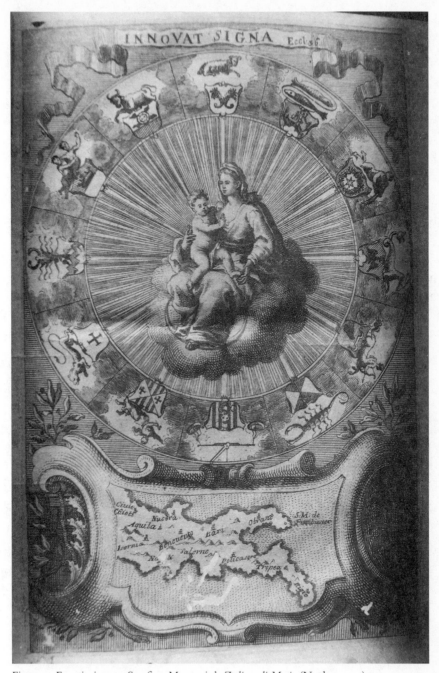

Figure 1  Frontispiece to Serafino Montorio's *Zodiaco di Maria* (Naples, 1715)

nomenon for the kingdom of Naples was made by the Dominican Serafino Montorio, in his *Zodiaco di Maria* of 1715.[61] Montorio organised his discussion along astrological lines, linking each of the kingdom's twelve provinces to a sign of the zodiac, of which the Marian images constituted a galaxy of stars (figure 1). While the existence of shrines was widespread, they were by no means of equal status. Prevailing devotional fashions and the shrines' ability to deliver miracles determined whether they were 'active' or not: whether they attracted pilgrims and devotees, and whether they achieved local, regional or even national status. None the less the degree to which their spread reflects the kingdom's population density is quite striking. Despite their usual location in semi-rural areas, the shrine landscape corresponded to patterns of urban settlement, benefiting from the presence of large towns. The shrines discussed by Montorio were all active and the author was confident that he had reliable and detailed information about their foundation and subsequent development. Of the 120 Marian shrines Montorio discusses, 14 were to be found in Naples, a further 23 in the kingdom's most populous province, Terra di Lavoro, and so on, down to 3 each in the sparsely populated provinces of Molise and Abruzzo Citeriore and 2 in Basilicata. There are numerous limitations to his list, not least of which is the prevalence of miraculous images situated in Dominican monasteries; but it does give us a broad outline.

Although the original impetus for shrine development was lay and semi-rural, they did depend on initial episcopal approval. But unlike the miracle cures investigated during the course of canonisation processes which are the subject of chapter seven, the Church was not concerned here with the miracles themselves. First and foremost the episcopal authorities wanted to ascertain how the money was being raised for the shrine and the related possibilities for fraud, including the publicising of false miracles and the misuse of alms. Episcopal investigations also highlighted the matter of jurisdiction over the shrine and its day-to-day management. Issues such as these may seem of only minor importance, but the sums of money generated by a miracle-working shrine could be enormous. The shrine of Santa Maria dell'Arco, for instance, just outside the gates of Naples, went from having no source of income at all in 1561 to a value of twenty-eight thousand ducats in 1594.[62] The early years of Montorio's own monastery of Santa Maria della Sanità (Our Lady of Health), established to take charge of a shrine of the same name, were more notorious. After the image was unearthed in 1571 and miracle cures followed, archbishop Paolo Burali entrusted the nascent shrine to the Dominican friar Antonino da Camerota. With great entrepreneurial verve he began to publicise the miracles and sell holy souvenirs, including oil from the self-renewing lamp that burned before the image. People and money soon began to flow in from various part of the kingdom and the Dominicans were forced to keep the shrine open day and night. But at the height of its success Fra Antonino was charged with extorting some 6,000 ducats from visitors to the shrine by 'moving' them with his rhetoric. When a miracle cure was reported he made sure that everyone knew about it. As one witness testified: 'When any person brings some votive offering to his church of Santa Maria della Sanità, he takes the ex voto into his own hands in the middle of the church and, shouting

amongst the people, says: See this, see this, sisters! Here, here the Virgin works [miracles]! Come here, recommend yourselves here.'[63] Fra Antonino's links with the city's curia may have afforded him some protection, for two years later he was free. The church was once again attracting large numbers of devotees and was well on its way to becoming one of Naples' foremost healing shrines.

The miracles themselves were not an important aspect of the trial. But when miracle-working images were housed in private chapels, then the episcopal authorities were more wary. In this way the miracles generated by the image of Santa Maria delle Grazie (Our Lady of Graces), in a shrine belonging to the Pagliuca family, were investigated in 1596. Physicians were called in to report on the presumed miracles, which they failed to convalidate. The archbishop's vicar-general ordered the shrine closed except for religious services and that all ex votos and illuminations be removed from around the image. Nevertheless, when miracles continued to be reported, he set up a commission of Dominican theologians to study the events. It was their conclusion that the conditions necessary to describe the cures as miraculous did not exist. They might have reached similar conclusions about the majority of miracles then being reported in shrines throughout the kingdom, had they been requested to investigate them. In any case, the city's vicar-general had not counted on the support for the image of Santa Maria delle Grazie by those who most benefited from it: the people of the neighbourhood. Following a rumour that the archbishop wanted to remove the image and close the shrine, about two hundred of them proceeded to the chapel carrying banners and sounding trumpets and drums. At this point the authorities withdrew and, despite the stabbing of an episcopal guard by the angry crowd, ended their investigations.[64]

Images of saints abounded in Catholic cities and any of these could produce miracles when the saint interceded on behalf of a devotee. From the sick person's point of view, however, miracle cures came at a cost. They were by no means free. The devotee's request for a cure was usually accompanied by some offer of payment, for example, an ex voto or monetary donation to be left at the shrine. There had to be tangible evidence of the saint's positive response. This bargaining was not a question of bribing the saint into action. Rather it was akin to the healing contract often drawn up between a medical practitioner and the patient. According to this arrangement, the agreed payment would be forthcoming when the agreed treatment had been performed and the cure achieved. The practice continued, though by the early sixteenth century doubts had begun to emerge in Neapolitan legal circles as to the validity of such agreements as far as the law was concerned.[65]

## Social causation and popular healing forms

All of the above could come under the rubric of 'popular' healing in the sense that all levels of society participated in it to some extent. Antonia Jurlaro made use of the community physician's services, as well as the surgeon's bleedings, which were most likely part of the former's treatment. But when these failed, in her eyes, to

improve her daughter's condition, she turned to another form of healing. This was based on a changed diagnosis of the cause of her daughter's affliction, from one we might classify as 'natural' to one we could call 'social.' The healer she chose, the wise woman Onofria Bufalo, was the one she believed responsible for the disease. This may seem rather paradoxical, but popular culture had it that such people could both harm and heal. The person responsible for the spell that lay behind an ailment was thus the best able to undo it. Because of increasing attempts by the Church authorities to limit their activities, as part of the ongoing Counter-Reformation, we know quite a bit about cunning folk, how they functioned, and their cliente-les. What we still know very little about is their numbers. Doubtless every town had its compliment of wise women, for in the kingdom of Naples they were primarily women, but establishing the kinds of ratios we can provide for medical practitioners is impossible.

The frequent recourse to cunning folk for the treatment of a whole variety of ailments was one example of the medical pluralism of early modern Italy. This included diseases ascribed to natural as well as supernatural causation. Cunning folk could be specialised to a degree which we might find surprising: one healer might be considered expert in treating fevers, another headaches, still another pains in the joints. Techniques and rituals were quite varied, the prayers (*orazioni)* and conjura-tions (*scongiuri)* accompanied by simple herbal remedies, or even forming the sole means of treatment. An important part of the healing ritual thus consisted in the use of the sign of the cross on the afflicted part, or of holy water or oil taken from a church. The practitioners of these healing rituals were most often women. Healing and health were a natural part of the female domain in southern Italian society, a part of the woman's concern for the wellbeing of the family. Furthermore, poor, often widowed women were frequently driven to the margins of society, and so came to depend on such services for their livelihood and development of a social role. Their power came from the ability to distinguish naturally occurring maladies from those caused by the supernatural. It was only once the causation had been determined that an effective cure could be found.[66]

Cunning folk – or *janare, magare, fattucchiare,* as they were variously called in the kingdom – did share elements of medical knowledge with the medical elites. In addition to this, there were many improvised healers, who practised their cures, learned perhaps by observing medical practitioners or after a time in hospital, in response to a recognised need and following a reputation for success. In terms of efficacy, once again from a modern biomedical perspective, there is little to dis-tinguish their activities from those of the most learned physician of the day. This was recognised on occasion by the sick who made use of their services. In 1569 one Neapolitan dyer commented that children in the city had been treated 'with greater satisfaction by old women and experienced matrons than by physicians.'[67] But to regard their treatments and remedies as merely less sophisticated varieties of learned medicine, as is sometimes done,[68] is to miss the point. In fact, their approach to disease causation, and necessary remedies, could be radically different. While it is true that there was a large herbal component to their operations, tempered perhaps

by practical experience, their theories of disease causation and their healing rituals had an underlying supernatural basis that was quite alien to university medicine.

The reason we know so much about the services of such women is because the Catholic Church claimed jurisdiction over those who used *incanti,* for whatever purpose, from locating buried treasure to treating disease. Even natural magic, with its learned, Renaissance pedigree, was now seen as diabolical, dependent on demonic forces for its success. This Counter-Reformation stance was expressed as early as 1565, according to a Neapolitan church synod celebrated by archbishop Alfonso Carafa, which left forgiveness for such offences in hands of confessors. Two years later the offence was deemed serious enough to become a matter for the archbishop.[69]

It is too often assumed that people sought the services of cunning folk because they came relatively cheap. However, in Antonia's case there was little saving to be made and money did not seem to figure in her initial decision. In fact, a wise woman's services could be quite expensive. There was often much hard-headed bargaining between healer and client, with the additional risk of blackmail if the sick person did not comply. The wise woman could always threaten worse injury and harm if their requests for money and assistance were not met.

I have referred to this causation as social, for instance the use of spells to harm other people, and as such an expression of antagonism and tension within the community. But this is a modern label. People of the time, while recognising the social elements, would have categorised the disease causation as 'magical', that is to say, diabolical. If the charms and spells worked, then it was the devil who gave them their power to do so. The efficacy of such maleficent magic was recognised by all levels of society at the beginning of our period, though to different degrees. If physicians discussed spells, it was to admit to the powerlessness of natural remedies to affect them. The Sicilian protophysician Giovanni Filippo Ingrassia supported the conclusions of Catholic theologians that neither natural remedies or counter-magic would work. Writing in 1570, just seven years after the Council of Trent had drawn to a close, he concluded that victims would have to make reparation with God, making a complete confession of their past sins, giving alms generously, fasting and, if necessary, by means of exorcisms and other 'spiritual remedies.'[70] But the first detailed account of the phenomenon by a Catholic physician came twenty-five years later. Battista Codronchi was prompted to write his *De morbis veneficis et veneficiis* (*On diseases by witchcraft and witches*) when his ten-month-old daughter became seriously ill as the result of a spell.[71] He admits to giving the reality of such spells very little credit before her persistent illness and, indeed, it is his wife who first suspects a supernatural rather than natural cause and searches the baby's bed for evidence of a charm. It is only after these have all been retrieved and destroyed by an 'experienced exorcist' that their daughter recovers. Their response was as the Church taught: to put their faith in ecclesiastical remedies against magic, and not counter-magic nor natural remedies alone. Such was the importance of the event in Codronchi's life that it occasioned not only a book, but a votive painting ('The magical powers of witches and the clergy

and the physician's doubts'), now in the Imola art gallery. Several decades later another Catholic writer on medical ethics, Paolo Zacchia, expressed similar scepticism, quoting the disbelief of most ancients (with the exception of Galen), while at the same time acknowledging the opinion of Catholic authorities as to the efficacy of charms. He adopts a vague compromise position, saying: 'I, who would otherwise have no faith in such matters, would not dare simply to deny incantations.'[72] Zacchia's conclusion is similar to one he adopts regarding miracle cures: an acceptance of the possibility tempered with a suspicious approach to individual cases. It was a scepticism destined to increase over our period, at least amongst the educated elites. It is, however, all but impossible to gauge the opinions of the rest of the population. Accounts of miracle cures and magical charms certainly show no sign of disappearing, and the people involved continue to take the reality of both for granted.

Writing around the same time as Zacchia was another protophysician, Pietro Piperno, in the papal enclave of Benevento. His conclusions about the role of physic in treating what he terms 'diseases of transnatural origin' were radically different.[73] His approach was very much hands-on, proposing medical remedies that could counter magical illnesses, describing in detail how they are to be prepared and administered. His treatise, written in Latin, implies that such matters were, in fact, relevant to the physician just as much as the exorcist (though not, apparently, to the public at large). His ease in dealing with such matters derived from his own experiences as a physician, but he does mention in passing his exorcist brother, the Capuchin Fra Bartolomeo, originator of a mouthwash to treat the loss of voice by magic.[74] Piperno can be said to be the medical version of Menghi, in seeing disease-causing malefice around every corner and in advocating very practical, not to say eclectic, responses to it. As we shall see in chapter six, it takes Piperno forty pages to list and describe the various diseases that could be caused by spells.

Another example of an illness best analysed in its social context is tarantism.[75] Here we have an example of a malady and its treatment which existed entirely outside the realms of university medicine. Tarantism was a culture-bound disorder, in the sense that both the illness and its treatment were unique to local culture, a single system of behaviour. Associated with the bite of the Apulian tarantula spider, tarantism can be defined in modern biomedical terms as a structured and ritualised response to deep psychological malaise, which included the evocation and discharge of the crisis by traditional forms of music and dance. In the early modern period tarantism was a battleground, where popular, ecclesiastical and learned forms of healing competed to define and thus take possession of it. When forces outside its original Apulian habitat sought to appropriate it they marginalised it locally. Neapolitan physicians, such as the protophysician Francesco Serao, eventually dismissed it, when they determined that the local tarantula was not poisonous. The malady therefore had no natural, no 'real' cause. Its victims were fakes.[76] (Paradoxically, where enlightenment medics found poisonous spiders to exist, as in central Spain, tarantism's music ritual was actively encouraged and fostered by them.[77]) In southern Italy, however, the Church also criticised the popular ritual, though for

different reasons. Local churchmen considered it licentious and possibly demonic, and endeavoured to Christianise it and bring it within accepted devotional categories. In the growing separation between elite and popular cultures that occured during the eighteenth century, the conservative local church found itself increasingly siding with the latter.

In broader terms, the Council of Trent brought with it a strengthened episcopacy with the duty to investigate and regulate all aspects of diocesan religious life. This included popular healing rituals, living saints and spates of miracles occasioned by newly discovered saints' images. The intention was not to discourage devotion but to channel it into accepted practices. The same can be said of the Congregation of Rites and Ceremonies, based in Rome, which had ultimate control over the saint-making process. And whilst the kingdom's religious authorities sought to regulate what they defined as coming under their jurisdiction, its medical elites attempted to regulate in their areas of operation. Typically of the Baroque, there were conflicts and ambiguities in jurisdiction which were never ironed out, until the rationalising reforms of the Napoleonic government. A midwife, for example, could find herself before the protophysician's court if she practised without a licence, especially if she treated the sick, but before the bishop's court if that treatment included words defined as 'magical.' More important, however, is the fact that neither tribunal could function without the denunciations of the public. And these only came when there were other factors involved: a personal score to settle or a death following the treatment. The protophysician's court was no more successful in eliminating unlicensed practice than the bishop's court was in wiping out magical healing rituals.

These attempts at regulation are, however, a boon to the historian because of the records they generated (a few of which have survived!). They allow us to say something about therapeutic provision within a country during the early modern period, on the one hand, and how these resources were actually used, on the other. For from being bereft of sources of healing, the kingdom of Naples was awash with them; a pool of remedies which the sick could choose from according to the nature of the illness and reputations of success, however the latter might be defined.

NOTES

1 'Whoever wishes to keep his loved one healthy / not a miser in blood, medicine or magic be.' Carlo Occhilupi, 'Veri motti, buoni consigli, e giusti avvertimenti lasciati da savi, letterati e plebei, e villani huomini', 1774, Biblioteca Provinciale, Lecce, MS 76; published in L. Lazari Congedo, 'Una raccolta settecentesca di proverbi salentini' in M. Paone (ed.), *Studi di storia pugliese in onore di Giuseppe Chiarelli*, v (1980), p. 28. All translations into English are my own, unless stated otherwise.

2 Ruggiero Romano, 'Prezzi, salari e servizi a Napoli nel secolo XVIII', *Studi e ricerche di storia economica italiana nell'età del Risorgimento,* iv (1965), p. 49.

3 A.D.O., *Magia*, 1, 'Antonia Jurlaro denuncia Onofria Bufalo per magia', 6/viii/1704.

4 Harold Cook, *The decline of the old medical regime in Stuart London* (Ithaca, NY, 1986), pp. 28–69.

5 Laurence Brockliss and Colin Jones, *The medical world of early modern France* (Oxford, 1997), pp. 8–20.

6 Matthew Ramsey, *Professional and popular medicine in France, 1770–1830* (Cambridge, 1988), pp. 290–1.

7 High infant mortality – as many as 300 deaths per 1,000 – was the main reason for the low life expectancy. Massimo Livi Bacci, 'Italia e Europa' in L. Del Panta et al., *La popolazione italiana dal Medioevo a oggi* (Rome and Bari, 1996), p. 232.

8 Piero Bevilacqua, *Breve storia dell'Italia meridionale dall'Ottocento a oggi* (Rome, 1993), pp. ix-xi.

9 Antonio Calabria and John A. Marino (eds.), *Good government in Spanish Naples* (New York, 1990), p. 12.

10 Miguel de Cervantes Saavedra, *The adventures of Don Quixote,* trans. J. M. Cohen (London, 1954), pt 1, ch. 51, p. 448.

11 Claudia Petraccone, *Napoli dal Cinquecento all'Ottocento: problemi di storia demografica e sociale* (Naples, 1974), p. 51; Eugenio Sonnino, 'L'età moderna (secoli xvi-xviii)' in Del Panta et al., *Popolazione italiana,* p. 100.

12 Giuseppe Coniglio, 'Annona e calmieri a Napoli durante la dominazione spagnuola', *Archivio storico per le province napoletane,* lxv (1940), pp. 117, 128.

13 Petraccone, *Napoli,* p. 115.

14 Gaetano Filangieri, *La scienza della legislazione* (Naples, 1807), p. 318; in *ibid.,* p. 180.

15 Domenico Demarco (ed.), *La "Statistica" del Regno di Napoli nel 1811* (Rome, 1988), vol. 1, p. 310.

16 *Ibid.,* p. 312.

17 A. Filangieri, *Territorio e popolazione nell'Italia meridionale: evoluzione storica* (Milan, 1980).

18 John Henry, 'Doctors and healers: popular culture and the medical profession' in S. Pumfrey, P. Rossi and M. Slawinski (eds), *Science, culture and popular belief in Renaissance Europe* (Manchester, 1991), p. 200.

19 Occhilupi, 'Veri motti', in Lazari Congedo, 'Proverbi', p. 40.

20 Mary Lindemann, *Health and healing in eighteenth-century Germany* (Baltimore, 1996), p. 353.

21 Carlo Cipolla, 'The medical profession in Galileo's Tuscany' in idem, *Public health and the medical profession in the Renaissance* (Cambridge, 1976), pp. 83–6.

22 Cintio D'Amato, *Nuova et utilissima prattica di tutto quello ch'al diligente barbiero s'appartiene* (Naples, 1671 edn), p. 114.

23 Cipolla, 'Medical profession', p. 85.

24 Ileana Del Bagno, *Legum doctores: la formazione del ceto giuridico a Napoli tra Cinque e Seicento* (Naples, 1993), p. 33.

25 Giuseppe Maria Galanti, *Nuova descrizione storica e geografica delle Sicilie* (Naples, 1786–90), vol. 1, pp. 220, 381. A threefold increase in the number of doctorates over the same period has also been observed for France. Brockliss and Jones, *Medical world,* pp. 199–200, 518–19.

26 According to unpublished work by Antonio Sansone, in Aurelio Musi, 'La professione medica nel Mezzogiorno moderno' in M. L. Betri and A. Pastore (eds), *Avvocati, medici, ingegneri: alle origini delle professioni moderne* (Bologna, 1997), pp. 88–9. The Salernitan doctoral registers are discussed in Modestino Del Gaizo, 'Documenti inediti della Scuola Medica Salernitana', *Resoconto delle adunanze e dei lavori della Reale Accademia Medica-Chirurgica di Napoli,* xli (1887), pp. 191–223.

27 Michele Paone (ed.), *I viaggi pugliesi dell'Abate Pacichelli (1680–7)* (Galatina, 1993), p. 154.

28 A.S.N., *Sommaria: Protomedicato,* series II, 34; *Arrendamenti: serie registri,* no. 250.

29 Jean-Pierre Goubert, 'The extent of medical practice in France around 1780', *Journal of Social History*, x (1977), pp. 410–27; Mary Fissell, *Patients, power, and the poor in eighteenth-century Bristol* (Cambridge, 1991), p. 204.

30 In Annalucia Forti Messina, 'I medici condotti nell'ottocento preunitario: il caso della provincia di Napoli' in G. Politi, M. Rosa and F. Della Peruta (eds), *Timore e carità: i poveri nell'Italia moderna* (Cremona, 1982), p. 468.

31 Enrico Bacco, *Descrittione del Regno di Napoli* (Naples, 1671); *Naples: an early guide,* trans. and ed. E. Gardiner (New York, 1991), p. 55.

32 Umberto Caldora, *Calabria Napoleonica (1806–1815)* (Naples, 1960), pp. 359–61.

33 Battista Codronchi, *De christiana ac tuta medendi ratione libri duo doctrina referti* (Ferrara, 1591), pp. 48–9.

34 'Denuntiatio contra Medicum Marcum Aurelium Severinum', 1640; in appendix to Luigi Amabile, *Il Santo Officio dell Inquisizione: narrazione con molti documenti inediti*, 2 vols (Città di Castello, 1892), vol. 2, pp. 66–8.

35 Adriano Prosperi, *Tribunali della coscienza: inquisitori, confessori, missionari* (Turin, 1996), pp. 471–3.

36 'Regole comuni della Santissima Annonciatione della Beatissima Vergine nel Collegio di Giesù nella magnifica città di Lecce', 1582 in appendix to Pasquale Lopez, 'Le confraternite laicali in Italia e lea riforma cattolica', *Rivista di studi salernitani,* ii (1969), p. 222.

37 Scipione Paolucci, *Missioni de Padri della Compagnia di Giesù nel Regno di Napoli* (Naples, 1651), pp. 88–9.

38 Antonio Possevino, *Cause et rimedii della peste, et d'altre infermità* (Florence, 1571), p. 22.

39 *Ibid.*, pp. 49–59, 63–5.

40 'Ordo per servari poterit tempore pestis', Archivium Romanum Societatis Iesu, *Opera Nostrorum,* b. 159, fols 493–500; quoted and discussed in Lynn Martin, *Plague? Jesuit accounts of epidemic disease in the 16th century* (Kirksville, 1996), pp. 91–2.

41 Domenico Antonio Parrino, *Teatro eroico e politico de' governi de' vicere del regno di Napoli* (Naples, 1692–94), vol. 3, pp. 33, 36–7.

42 Jean-Michel Sallmann, *Naples et ses saints à l'âge baroque (1540–1750)* (Paris, 1994), pp. 150–1.

43 Paolucci, *Missioni,* p. 273.

44 A.R.S.I., *Prov. Neap.,* 75, fol. 144v.

45 *Ibid.*, fol. 263r.

46 *Ibid.*, 76 I, fol. 41v.

47 Trevor Johnson, 'Blood, tears and Xavier-water: Jesuit missionaries and popular religion in the eighteenth-century Upper Palatinate' in B. Scribner and T. Johnson (eds.), *Popular religion in Germany and Central Europe, 1400–1800* (London, 1996), pp. 195–9.

48 A.R.S.I., *Prov. Neap.,* 76 II, fols 553v.-8v.

49 A.S.N., *Sommaria: Protomedicato,* series II, 32: 21, fols 280r.-v.

50 A.S.B., *Studio,* 'Acta Protomedicatus Collegii Medicinae', 320, 4/xi/1683, no foliation.

51 A.S.D.N., *Sant'Ufficio,* 'De operibus prodigiosis Francisci Bartolomaei Belli', 1675, fols 17r-18r. in Pierroberto Scaramella, *I santolilli: culti dell'infanzia e santità infantile a Napoli alla fine del XVII secolo* (Rome, 1997), p. 51.

52 Pietro Piperno, *De magicis affectibus lib. vi* (Naples, 1635), p. 148.

53 Girolamo Menghi, *Parte seconda del Compendio dell'arte essorcistica* (Venice, 1601), p. 590; in Giovanni Romeo, *Inquisitori, esorcisti e streghe nell'Italia della Controriforma* (Florence, 1990), p. 121.

54 Menghi, *Compendio dell'arte essorcistica*, p. 635; in Romeo, *Inquisitori*, p. 138.

55 A.S.N., *Sant'Ufficio*, 305c, fols 43v.-44r.; in Romeo, *Inquisitori*, pp. 147–8.

56 A.S.N., *Sant'Ufficio*, 123a, fols 7v-8r; in Romeo, *Inquisitori*, p. 131. The case is also discussed by Jean-Michel Sallmann, *Chercheurs de trésors et jeteuses de sorts: la quête du surnaturel à Naples au XVIe siècle* (Paris, 1986), pp. 176–8.

57 Sallmann, *Naples et ses saints*, p. 152.

58 Giulio Cesare Infantino, *Lecce sacra* (Lecce, 1634); Cesare d'Engenio Caracciolo, *Napoli sacra* (Naples, 1624).

59 Infantino, *Lecce sacra* p. 233. I cite from a Lecce, 1859 re-edition.

60 William Christian, *Apparitions in late Medieval and Renaissance Spain* (Princeton, 1981), pp. 18–20.

61 Wilhelm Gummpenberg, *Atlante Mariano* (Verona, 1839–47 edn); Serafino Montorio, *Zodiaco di Maria* (Naples, 1715).

62 Pierroberto Scaramella, *Le Madonne del Purgatorio: iconografia e religione in Campania tra rinascimento e controriforma* (Genoa, 1991), p. 175.

63 A.S.N., *Sant'Ufficio*, 98a, fols 12r-14r; in appendix to Romeo, *Inquisitori*, p. 313.

64 A.S.D.N., *Miscellanea*, I; discussed in Scaramella, *Madonne*, pp. 185–90.

65 Gianna Pomata, *La promessa di guarigione: malati e curatori in antico regime* (Rome and Bari, 1994), pp. 310–14.

66 David Gentilcore, *From bishop to witch: the system of the sacred in early modern Terra d'Otranto* (Manchester, 1992), pp. 128–61.

67 A.S.N., *Sant'Ufficio*, uncatalogued trial against Lucrezia De Grosso; in Romeo, *Inquisitori*, p. 204.

68 Henry, 'Doctors and healers', p. 203.

69 *Acta et decreta synodii napolitanae* (Naples, 1568), p. 46 and *Decreta synodi dioces. neapolitanae* (Naples, 1568), pp. 9–10.

70 Giovanni Filippo Ingrassia, *Methodus dandi relationes pro mutilatis, torquendis aut a tortura excusandis*, ed. G. Curcio (Catania, 1938), pp. 431–2.

71 Battista Codronchi, *De morbis veneficis et veneficiis* (Milan, 1618; 1st edn 1595). The passage is discussed by Winfried Schleiner, *Medical ethics in the Renaissance* (Washington, 1995), pp. 99–104.

72 Paolo Zacchia, *Quæstiones medico-legales* (Amsterdam, 1651 edn), lib. 2, tit. 2, quaestio 13, p. 88.

73 Piperno, *De magicis affectibus*, p. 20.

74 *Ibid.*, p. 185.

75 The most detailed study remains Ernesto De Martino's *La terra del rimorso: contributo a una storia religiosa del Sud* (Milan, 1961).

76 Francesco Serao, *Della tarantola o sia falangio di Puglia* (Naples, 1742). On the changing attitudes of the medical elites towards the phenomenon, see Angelo Turchini, *Morso, morbo, morte: la tarantola fra cultura medica e terapia popolare* (Milan, 1987), especially pp. 47–75, and David Gentilcore, 'Ritualised illness and musical therapy: views of tarantism in the kingdom of Naples', in Peregrine Horden (ed.), *Music and medicine: the history of music therapy since Antiquity* (forthcoming).

77 In the second half of the eighteenth century Spanish physicians observed, participated in and described over fifty different cases, almost all in La Mancha. Pilar León, 'Clinical observation and music therapy in eighteenth-century Spain: tarantism' in Horden, *Music and medicine*.

# CHAPTER TWO

# THE ROYAL PROTOMEDICATO
# AND PUBLIC HEALTH

On 23 April 1530 Charles V, two months after being crowned emperor, issued an imperial 'privilege' to the then protophysician (*protomedico*) of the Kingdom of Naples, Narciso Verdugno. Verdugno was having difficulty enforcing his powers and was granted the 'faculty to examine, recognise and castigate all non-graduate physicians, surgeons, apothecaries, grocers, alchemists, barbers, bone-setters, healers, midwives and any other subject and annexed persons.'[1] He was to be in charge of an office and magistracy – the Protomedicato – responsible for supervising the practice of all forms of healing. Like other similar bodies elsewhere, the activities of the Neapolitan Protomedicato were conditioned by the 'political culture and the institutional and legal framework of the larger society'[2] in which it operated. Alas, little in the way of documentation survives to indicate the actual day-to-day activity of the Neapolitan protophysician during the early modern period. What we do know is that in 1609–10 the annual collecting of dues that each practitioner had to pay the protophysician was farmed out to tax collectors. From this date the protophysician was accountable to the Chamber of the Sommaria, the kingdom's highest administrative and fiscal body. This shaped the office's activities for the next two centuries, leading Giuseppe Maria Galanti to remark in 1786 that its object 'seems to consist only of the collection of dues, which for the apothecaries is virtually arbitrary.'[3] Though its impact on public health was therefore minimal, the office of the protophysician can nevertheless tell us quite a lot about healers in early modern Naples, attempts to regulate their activities, and the extent to which public offices were conditioned by the state of which they were a part.

## Origins and nature of the office

Although health legislation and mechanisms for supervising the day-to-day practice of medicine in the Italian states certainly existed during the Middle Ages, they gained force in the sixteenth century, with the establishment of specific structures, like the Protomedicati. These took three basic forms: royal (or Spanish), collegial and municipal.[4] Due to a relatively strong central administration in the kingdoms of Naples, Sicily and Sardinia, royal ordinances regulated the medical profession

from early on. All three kingdoms owe the first appointment of protophysicians to Aragonese kings. Initially, the protophysician's role as 'first among physicians'[5] was an extension of his status as the personal physician of the king. In 1397 King Martin II of Sicily appointed the first protophysician, Ruggero de Camma, with authority over the whole island.[6] The 'Capitula et ordinaciones' of the Sicilian Protomedicato were compiled in 1429 by the protophysician Antonio d'Alessandro and approved by King Alfonso the Magnanimous, according to Giovanni Filippo Ingrassia, who revised them.[7] The same king instituted the office of protophysician in Sardinia in 1455, to be based at Cagliari.[8] It was also Alfonso who appointed the first proto-physician for the kingdom of Naples when he became king there in 1444, though Naples was not lacking medical organisation. In fact, Alfonso's immediate prede-cessor, Queen Giovanna II, had set up a College of Physicians in the city of Naples, naming her personal physician, Salvatore Calenda of Salerno, as its prior.[9] From the start, one of the Neapolitan protophysician's primary concerns was the regulation of apothecaries. King Alfonso granted the guild of apothecaries its statutes in 1455, which were renewed in 1498 by the then protophysician Antonacius de Sanatio.[10] More formal recognition of the office of protophysician in Naples came with the above-mentioned imperial 'privilege' of 1530.

In Naples, from the very start, the office of protophysician was distinct from the College of Physicians, itself part of the College of Doctors (which consisted pri-marily of the much more powerful lawyers).[11] As befitted the person who was chosen from amongst the ranks of the kingdom's most esteemed physicians by the viceroy, the protophysician was occasionally prior of the medical college as well, but this in no way united the two positions. In fact, one has the impression that in Naples the office of protophysician was essentially ceremonial, bringing with it a great deal of prestige, but little real power. Though a great deal was made of the protophysician's jurisdiction over all non-graduate practitioners, the emphasis seems to have been on the collection of licence and inspection fees from them, which was contracted out, as we shall see below. Real medical power was in the hands of the College, responsible for the granting of degrees.

There is no doubting the prestige that went with being protophysician, for it was the highest office to which a Neapolitan physician could usually aspire. He received an annual salary of one thousand ducats from the state, derived from the money rendered by the tax contractor.[12] He had to be a native of the kingdom, a requirement shared with most public offices. The appointment could take the form of recognition of royal service and intellectual achievements, as in the case of the humanist philosopher, writer and physician Antonio de Ferrariis (1444–1517), intimate of both King Ferrante and his son Federigo.[13] At this point the appoint-ment was still for life, though it would eventually consist of a renewable three-year term (and was to revert back to a permanent one by the 1780s). As the most impor-tant position in the state's medical bureaucracy, the appointee was usually at the apex of the kingdom's medical establishment. For example, the protophysician to whom we owe much of our information about the office, Antonio Santorelli, was already the author of various medical treatises,[14] holder of the chair of theoretical

medicine and personal physician to the viceroy, the count of Oñate, when the latter appointed him protophysician in 1651.

The nature of the appointment recognised academic and practical medical achievements as well as the person's ability to form networks of influential people. These networks combined academic and intellectual environments with aristocratic and political ones. This was typical of academic posts in all the universities of early modern Italy. Santorelli, for instance, owed his nomination to the prestigious chair of philosophy to the duke of Osuna, only to be ordered back to the lesser chair of theoretical medicine by Cardinal Zabata when protests were made that it had been awarded without due competition. By this time, no one dared risk his own career by supporting Santorelli, and he lectured at various Italian universities (Pisa, Florence, Padua, Bologna), until the count of Oñate rescued Santorelli by making him his personal physician in 1648. He died in 1653.[15] But the most obvious example is the medical traditionalist Carlo Pignataro. He was characterised as being 'rather more politic than learned', suggesting he knew how to obtain and maintain power.[16] Completely immersed in the Neapolitan medical world, he was born in Nocera dei Pagani, near Salerno, the son of an apothecary, and received his doctorate from the Neapolitan College of Doctors in 1644.[17] A short ten years later, still in his thirties, he was awarded the primary chair in medicine at the university and in 1678 he became vice-chancellor of the College, which meant he was head of that part of the College responsible for physicians. When he published the *Petitorium,* or official pharmacopoeia, in 1684 he was also dean of the university, chamber physician to the viceroy and knight Palatine.[18] He was first appointed protophysician by the viceroy Garcia d'Avelaneda y Haro (count of Castrillo) in 1656, eventually serving five terms in all (1656 to 1665 and 1683 to 1689), the longest of any protophysician under the Spanish viceroys. His death in 1694, and subsequent burial in the Jesuit Casa Professa in Naples, warranted an entry in the chronicle of the notary Domenico Confuorto, a supporter of medical traditionalists like Pignataro and resolute opponent of medical innovators.[19]

Protophysicians owed their appointment to the reigning viceroy: a change in viceroy or a change in medical fashions could prevent their reappointment. This was the case with Pignataro, who was not reappointed as protophysician by the new viceroy Pedro Antonio d'Aragona, after the previous viceroys's death in 1665. The Neapolitan office of protophysician, like the Sicilian and Sardinian, was closely linked to Spanish viceregal administration. Given the links aspiring physicians sought to forge with their often Spanish patrons, it is no accident that many of them followed their patrons to Spain or elsewhere in the Spanish dominions. This often incurred the wrath of local physicians who saw their chances thwarted. Domenico Bottoni, for instance, was appointed Sicilian protophysician by the viceroy, the marquis of Villafranca, an office which he continued to hold under the two succeeding viceroys. In 1688 he was nominated protophysician of Naples by the viceroy there, the count of Santo Stefano. For the next four years he was forced to go under a pseudonym – 'Domenico Cuomo' is recorded as being protophysician

at the time – since statute required that the office be filled by a local physician.[20] Bottoni was not the only Sicilian to be offered the Neapolitan post. Several decades earlier, the then viceroy of Naples, Juan Alonso Enriquez de Cabrera, had offered the post to the Messinese Marco Antonio Alaimo. Before becoming Neapolitan viceroy, de Cabrera had been viceroy in Sicily and no doubt came across Alaimo there, the latter having gained renown during the Palermo plague of 1624–25, publishing a treatise on the subject.[21] But Alaimo refused the appointment, preferring to remain in Sicily, thereby avoiding a dispute with Neapolitan physicians. In 1634 he was appointed consultor protophysician in Palermo.[22] It was not untypical of physicians to follow their patrons throughout the Spanish world. The young Andrea Bastelli, a native of Melfi (Basilicata), gained the esteem of the viceroy, the count of Miranda, while practising medicine in Naples, and followed him to Spain in 1595. He ended up at Philip III's court at Valladolid, was awarded a title of nobility, and in 1602 was preparing to return to Naples as protophysician when he died.[23] And nearly one hundred and fifty years later Francesco Buonocore, a native of Ischia, followed the same iter, accompanying his patron, the duke of Medinaceli, to Spain (with an honorarium of 2,000 *scudi*). Here he was called to the service of the infante, whom he followed back to Naples in 1734 as personal physician and protophysician when the latter became king as Charles III.[24] Occasionally, the viceroy even succeeded in awarding the post to a Spaniard, as in the cases of Andrés Ordoñez (protophysician during the 1620s), Andrés de Gamez (from 1678) and Miguel Marquez (from 1692), who all went on to serve in various official medical capacities back in Spain.

Despite close links with Spanish administration, the Neapolitan office of protophysician never achieved the authority of its Castilian counterpart. The term 'Protomedicato' was only used to describe the fee-collecting aspect; the office did not become a fully-fledged medical bureaucracy or magistracy existing outside the person who was *pro tempore* protophysician. In Castile, meanwhile, much more so than in Naples, the *Tribunal del Protomedicato* developed into a vast and powerful bureaucracy. It appointed medical personnel to hospitals and the armed forces, regulated the publication of books on medical subjects, and directed efforts against plague and contagion.[25] It branched out into the other Spanish kingdoms and overseas possessions, though not without jurisdictional conflicts. It is certainly no coincidence that the Neapolitan office most closely resembled that of another Spanish kingdom: Aragon. This should come as no surprise, since the first protophysicians in Naples owed their appointments to Aragonese kings. When the more powerful Castilian form came into being it was not imposed in Naples, perhaps because of local power structures, prerogatives and traditions. After all, the Spanish authorities tried to impose the Spanish form of the Inquisition in Naples, but failed. So the office of protophysician continued to resemble that prevalent in Spanish kingdoms outside Castile. In Aragon, for instance, the presence of Colleges and guilds in all large towns meant that the protophysician was only effective in rural areas and small towns. His urban role was limited to that of a prestigious physician giving his opinion in medical disputes of the time.[26]

Other Italian Protomedicati which owe their creation to Spanish rule confirm this picture. In Sicily local power structures – the universities amongst them – limited the effective powers of the island's consultor protophysician. This was also true in Milan, characterised by an ongoing tension between royal prerogative and the city's College of Physicians. When the Duchy of Milan became a Spanish possession in 1535 the post of royal protophysician was established as an imperial appointment. He was normally chosen from amongst the ranks of the Milanese medical college, composed entirely of noblemen; such was Milan's most famous protophysician Ludovico Settala, appointed to the office in 1628 by Philip IV.[27] This proximity did not, however, guarantee tranquil relations between the two. Only Sardinia came closer to the Castilian model of the strong, centralised Protomedicato, as outlined in the 'Constituciones Prothomedicales' promulgated by the island's protophysician Joan Antoni Sanna in 1608.[28] Its wide powers may stem from the fact that Sardinia was closer to the Spanish orbit than either Naples, Sicily or Milan, and the fact that it was without a functioning university of its own – and hence a powerful local medical community – until 1632.

In contrast, the Italian Protomedicati of the collegial type seem to have functioned somewhat more harmoniously, in addition to having more extensive powers. The Protomedicati in both Rome and Siena were of this type, having grown out of the Colleges of Physicians of these cities. In Rome the protophysician general gradually took over the authority of the College's prior and was elected annually each December from amongst the ranks of the college to be its head. Likewise in Siena, the first protophysician, to judge by surviving records, held office from 1562, while the post of prior became largely ceremonial.[29] The Protomedicato of Bologna was a similar outgrowth of that city's medical college, which established the tribunal in 1517. Its origins, in fact, lay in the disciplinary norms contained in the original 1378 Statutes of the College of Medicine and Arts, which granted the College jurisdiction over disputes between doctors and patients, over the inspection of apothecary shops and the charging of fines, as well as the licensing of itinerant practitioners.[30]

A third distinct type of Protomedicato existed in Italy, and can be designated the municipal. Here the protophysician was a local physician elected for a short period by the town or city council. In many cases the office was a survival from the days of communal autonomy, as at Gubbio or the papal enclave of Benevento, not far from Naples. The protophysician here was elected by city councillors, and had the authority to inspect apothecary shops, establish fines for malpractice, and issue licences to non-graduate practitioners in the city of Benevento and its immediate vicinity. Although he was independent of the Roman protophysician, serious offences amongst the medical profession had to be referred to the papal legate.[31]

## Visitations and licensing

Despite their differences, the activities and responsibilities of the protophysicians and their deputies were remarkably similar throughout the peninsula. There was

the grinding reality of tours of inspection. These 'visitations', as they were called, were the *raison d'être* of the Protomedicati. In Naples it was even hoped that the protophysician himself would lead the visitations, though the Collateral Council – the kingdom's main politico-administrative organ – noted in 1577 that 'the previous protophysicians only very rarely involved themselves.' Four years later the viceroy, Juan de Zuñiga, insisted that the protophysician, Prospero Bove, should lead the visitations in Naples himself. If unable to do so for some reason, he was to suggest three expert physicians 'of the city's best', from whom one would be selected by the viceroy to fill in for him.[32] Visitations in Naples were to be conducted every October, lasting 'many months', whilst tours of the entire kingdom were to be conducted every two years. All apothecaries were to be visited. Visitations extended to 'all other people subject to the office of the protophysician according to ancient custom' (meaning, presumably, since the 'privilege' of 1530). This meant everyone without a doctorate who practised 'any action whatsoever for the health of human bodies.'[33]

The selection of visitors followed an established ritual. Members of the Guild of Apothecaries were to meet 'in a church of the protophsycian' (usually one of the important churches such as San Lorenzo, San Domenico or San Pietro Martire). They were to elect two visitors, one from the Guild membership and one from the ranks of the eight Guild officials (the Speziali degli Otto). They, together with the protophysician, would conduct the inspections in the city. With regard to the rest of the kingdom, the procedure was slightly different, since the protophysician was not expected to go along. He was to appoint temporary substitutes for the various provinces, 'graduate physicians, learned experienced and good Christians.' Each physician was to be accompanied by 'a licensed and approved apothecary, knowledgeable and experienced in the recognition of simple and compound drugs.' They were to conduct a tour of a specific province within a stated period of time, reporting back to Naples when finished. As befitted his lower social status in the medical hierarchy, it was the apothecary who had the task of keeping records during the visitations, preparing 'a notebook where he records the conditions of the apothecaries' shops, which, having finished his administration, he presents to the Protophysician.' But before they departed for the visitations, the visitors were to deposit a suitable surety (*plageria*) with the Chamber of the Sommaria, promising to perform their task 'accurately and faithfully.' The surety was not cashed, but was to remain intact, in case any practitioner might have a complaint regarding duties paid to the visitors.[34] This suggests that from a very early date the authorities were as concerned about collecting licence fees from practitioners as they were about certifying their actual ability.

The protophysician, visiting Naples and the towns around it, would generally travel by coach, only rarely going by boat or horse. Those who visited the provinces had a much tougher job. Roads could be bad, especially in the mountains, where there might only be mule-tracks, and most lacked bridges. When we consider that mountains covered fully a third of the kingdom's surface area, and hills another half, we can appreciate the difficulty of undertaking inspection tours. The visitors usually

travelled by mule or horse, only in the flat provinces of Bari and Otranto being able to make use of simple wheeled vehicles. Added to this was the fact that, as we saw in chapter one, just under half of the kingdom's population lived in the mountainous areas, often in small isolated communities that had to be inspected nevertheless. Storms or bandits could make travel worse. For this reason members of the inspection team were permitted to bear arms and were accompanied by an armed guard of a handful of soldiers.[35] Banditry was endemic in the kingdom, but the visitors may have had just as much to fear from disgruntled medical practitioners as from outlaws. Surviving financial documents record expenditures for stabling and room (listed as 'beds' rather than 'rooms') and board. They also tell us how long it took to visit each of the provinces, including even the smallest villages, usually an exhausting thirty to forty days.[36]

Upon arrival in a town the visitors were to seek out its governor or captain, syndics and elected officials, to whom they were to show their commissions and explain their wish to inspect the apothecaries' shops, 'for the service of His Majesty and the benefit of the people.' They were to ask the consent of local officials to carry out the inspections, inviting them to participate if they so wished. It was important to make a good impression with the local governors, as they could make life difficult for inspecting protophysicians. And with town after town to visit, it was important that things should go as smoothly as possible. Once they had received their permission, the visitors 'will post an edict in public places' that all those subject to the protophysician's jurisdiction must appear before his substitute.[37] In addition to collecting the visitation fee from all practitioners, the visitors were responsible for examining and licensing all aspiring practitioners. In Naples, the aspiring apothecary was to be examined by a schoolmaster on the Latin text of Mesuë, by the protophysician on how he learned his art and where he served his apprenticeship, and by the deputies of the Guild of Apothecaries on the canons of Mesuë and the preparation of medicines. (The writings of the Arab physician Mesuë continued to be central to pharmacology well into our period.) Outside the city, visitors were to send aspiring apothecaries to appear before the protophysician. But if the distance was too great, or there was some other impediment, then they were to be examined locally as they would be in Naples, with signed and notarised declarations sent to the protophysician, so that a licence could be duly issued. But adequate training and expertise were not enough. According to the 'Instruction' of 1581 the protophysician was required to 'find out about the life and quality of the person, as well as the assets he possesses, and how much of these are liquid', with enough to support himself so that he would not be reduced to fraud in order to carry out his trade. By 1652 aspiring apothecaries were required to possess 500 ducats-worth of goods.[38]

Inspecting apothecary shops was the protophysician's most important activity, to judge by the amount of space devoted to it in both the regulations and surviving registers. The visitation was to take the apothecary by surprise. In the words of the protophysician Santorelli, it was to be like death: 'the apothecary knows it will come, but he does not know the day or time.'[39] This was to prevent him from dis-

posing of deficient or inferior medicines, or borrowing good ones from another apothecary – crimes that nevertheless took place. In fact, Santorelli's description of 1652 suggests that the inspection routine had been made more rigorous, if we consider that back in 1577 the apothecaries had been given twenty-four hours' notice of the impending inspection.[40]

In addition to the inspection's formalistic and somewhat ominous nature, it could turn into a real social event, further adding to the ritual.

> [The visitors] go to the apothecary's shop with all those officials and physicians they can muster and, having entered the shop, the substitute apothecary opens his note-book where he records the date, month and year of the visitation of apothecary so-and-so in town such-and-such, in the presence of the following [named] governors, syndics, elected officials, and physicians, and then he asks the apothecary present in the shop under oath to show whatever simple and compound drugs shall be demanded of him.

The apothecary was to present each medicine from the 'table' as he was asked to. The visiting apothecary (two within the city of Naples) would then 'look at, smell, touch and taste as necessary', before passing it one to the protophysician's substitute to examine. The presence of so many other people at the inspections was meant to guarantee they were carried out properly. Indeed, one feature of the visitation reports that seems to be unique to the Neapolitan Protomedicato was the fact that the inspected apothecary was to undersign the visitors' report, noting 'how they treated him.' And all those present during the inspection – syndics, local physicians – would also sign.[41]

Despite these assurances, apothecaries were often reluctant to have their shops inspected and pay the visitation fee of five *carlini*. According to the 1577 instruc-tions, 'poor apothecaries' were not to be subject to the fee, though it is impossible to determine how often this exemption was applied in practice. On occasion apothecaries did seek to escape the fee by pleading poverty. Petitions for exemp-tion included poverty engendered by 'the high cost of medicines for which the poor cannot afford to pay', as one apothecary complained.[42] In fact, Santorelli noted that apothecaries were not paid immediately, 'as are butchers or bakers', but sometimes after many years, if at all.[43] Hence the need to ensure that apothecaries had other sources of income. In small towns and villages the result could be penury. Another cause for concern on the part of the apothecaries was the fact that they, and other practitioners subject to the protophysician, were to pay for the visitors' expenses whilst they were in town (room, board, stabling). This was the 'ancient custom always followed in the kingdom, in the kingdom of Sicily and all other kingdoms.' To avoid overburdening the local practitioners, visitors were reminded to stick to their proposed itineraries and not visit other towns en route, 'so that they are not inspected twice.' They were not to remain in a town any longer than the time required by the visitations, 'and this is ordinarily one, two or, rarely, three days, according to the number of apothecaries.'[44] The visitors had to ensure that they got what was due them without upsetting the apothecaries. Yet all the good will in the

world did not prevent an unwilling apothecary from locking his shutters, going into hiding or even seeking sanctuary in the parish church when accused of illegal trading. Moreover, apothecaries had their own guild to protect their interests. It was a source of strength they often made use of, bringing them into dispute with Medical Colleges and Protomedicati up and down the peninsula. Hence the Neapolitan requirement to put the surety aside for just such contingencies.

If, upon examination, a medicine was found wanting in any way it was to be destroyed, 'so that it cannot be used.' Bad oils or unguents could at least be recycled: 'they are to be sent to religious institutions for their lamps' (an unexpected example of the religion–medicine link!). Religious institutions were also, originally, the beneficiaries of any fines that might be imposed if an apothecary warranted sterner punishment.[45] This generalised charitable orientation did not last long. By 1585 the proceeds of fines and confiscations were to be divided into three: one part going to the accuser, representing the protophysician, one to the state treasury, and one to Naples' Annunziata Hospital alone.[46] Nevertheless it must be said that the protophysicians were relatively lenient when it came to fines, although their enforcement may seem somewhat arbitrary. Their bark was always worse than their bite, typical of *ancien-régime* law enforcement. This often came down to levels of bargaining, the final punishment being a compromise between the harshness of the official edicts and the assertions and protestations of the accused.

The protophysician's difficulties did not merely concern apothecaries. The Neapolitan instructions of 1577 written for visitors were realistic: they realised that practitioners would not all present themselves at once and that they did not reside close to one another in most towns. Visitors could not therefore afford the luxury of examining them by type, but had to proceed as they appeared. Examining barber-surgeons and midwives, issuing licences, and collecting fees was never a straightforward or popular business. Merely carrying out one's duty was bound to cause resentment. In the kingdom barber-surgeons were separated into two levels of skill and were examined accordingly. On the one hand, non-graduate surgeons were to present their licences to the visiting physician. Then, they were to be examined, 'privately, in the shop where they practise', on how they worked, especially with head wounds, 'nerve punctures' and 'bloody discharges.' On the other hand, barbers were to be asked 'if they know the veins, where they are and how they are bled.' In order to emphasise their subordinate position in the medical hierarchy, barbers were to swear to let blood only under doctor's orders. The visitors were reminded to pay 'particular attention' to recording the administration of the oath, 'so that it can be seen in the next visitation if [the barbers] have transgressed their orders.'[47] In addition to the relevant licence fees, there were very heavy fines for exceeding the limits of one's licence as granted by the protophysician.

Similar restrictions not to exceed the bounds of their 'profession' also applied to midwives. Women were not to be licensed to treat the sick but only to practise midwifery. Though listed in earlier instructions to protophysicians as being subject to the annual visitation fee, the actual examination which midwives were to undergo was first described in an instruction of 1622. This was at the same time that other

Italian Protomedicati were first becoming interested in supervising midwives. However, like the examinations conducted by their counterparts in Spain, those of the Neapolitan protophysicians were not very demanding.[48] Nor did they change at all over at least the next hundred years. The visitors were to ascertain that midwives were able to explain 'how they assist women who are unable to give birth, [what they do] when the baby comes out with the head first, which is a normal birth, or leading with an arm or a leg, or when they cannot discharge the afterbirth or other evident danger.'[49]

Another important aspect of the activity of the protophysicians regarded the licensing of 'charlatans' and other itinerant practitioners. An edict of 1581 put the emphasis on preventing unlicensed practitioners from practising physic or dispensing remedies. It noted that in the previous few years people had died in Naples and various places in the kingdom at the hands of 'uneducated and inexpert people' and threatened a year's imprisonment to anyone, man or woman, who dared or presumed 'to treat medically, order, dispense or counsel remedies or medicines of any sort or type whatsoever to any person without a licence obtained in writing from the Excellent Protophysician.' It was directed at those who claimed to 'be able to treat by means of doctrine or experience, despite not having a degree in physic or surgery.'[50] Two things are of particular interest. First, that women were not specifically admonished to limit themselves to midwifery alone – though this would come in the next few decades. Second, that the protophysicians were not out to eliminate the presence of charlatans in the kingdom, but to regulate their circulation and the goods they peddled. Once again, however, the lack of surviving records means that little can be said about actual licensing activity. Santorelli indicated that empirics must be tolerated and licensed because, in the case of the 'French disease', many victims would go to them who, because of shame, would not dare go to a doctor or surgeon. In the past, those who had practised without being examined and licensed by the protophysician had been deprived of all their personal property. But from Santorelli's time, proceedings against them had to be launched by a plaintiff, who was usually satisfied with getting back from the empiric the money spent on the medicament.[51] This detached attitude was not shared by all protophysicians, primarily since so many charlatans seemed to escape licensing.[52]

## Public health

The fame of certain of the kingdom's protophysicians, as well as their first-hand knowledge of practitioners and medical provision, prompts the question of their involvement in the state's public health organisation. To a limited extent they did participate in issues concerning public health, such as in the Lake Agnano dispute to be discussed in chapter three, where Pignataro took what he regarded as appropriate action to end the fever epidemic. On another occasion, in October 1686, Pignataro and two other physicians were appointed to investigate an epidemic of 'malignant and pestilential fever' in the district of San Giovanni a Carbonara. It had already resulted in many deaths, 'which had caused and causes much fear in the

city', according to the chronicler Domenico Confuorto. The cause was attributed to the monastery's garden, 'which, as it was full of manure, brought there this past summer, and with the autumnal rains having fallen on top of it, had caused the bad air in that district.'[53]

Likewise, their expertise was often sought in times of plague. Pignataro himself furnished advice on remedies and responses during the calamitous plague of 1656.[54] A number of protophysicians elsewhere – Giovanni Filippo Ingrassia in Palermo and Ludovico Settala in Milan, for example[55] – wrote treatises on plague. But their involvement did not usually extend to the health boards set up to deal with plague epidemics, which were generally run by non-medical administrators. The actual administrative and bureaucratic arrangements were left to the boards. The kingdom's public health legislation was woefully piecemeal and ad hoc, dealing with crises as they arose. Unlike several other Italian states, such as Venice, in Naples there was no central health board or magistracy until the arrival of plague in the spring of 1656 forced the government into creating the Magistrato della Sanità. Earlier plagues had been dealt with in a haphazard way, by entrusting port authorities to enforce quarantine and by the granting of special powers to officials like the capital's 'Eletti del Popolo', responsible, in turn, for the appointing of deputies.[56] Perhaps to an even greater extent than elsewhere in Italy, public health continued to be a matter for local communities to deal with as best they could.[57] For the authorities of the small town of Pomarico (Basilicata) this meant setting up guards at the town gates, drawn from the local inhabitants, as well as making a votive offering of thirty pounds of candle wax to St Michael.[58] National measures banning all commerce and travellers from Sicily, the source of the 1575 plague, proved impossible to enforce. Not only did the Jesuits manage to smuggle letters (included in the ban) into Reggio, they also managed to travel by ship from the infected port of Messina to Naples on several occasions, evading the port guards and disembarking.[59]

The unceasing influx of migrants from the provinces, especially in times of famine, resulted in fears of disease epidemics which were thought to originate amongst the poor. During the famine of 1607 an agent reported to the Grand duke of Tuscany:

> The famine is so great throughout the kingdom that whole communities come together into Naples and wander throughout the city shouting: bread, bread. And so many beggars have descended that it is a miracle that the city does not fall victim to plague; because people are dying in the streets, and no measures are taken.[60]

The trio of 'war, famine, plague' seemed to strike together. Naples had not yet recovered from the first two ('war' had come in the guise of the 1647 Masaniello revolt), when plague arrived in April 1656, apparently from Sardinia. At first, the authorities were reluctant to identify the deaths as plague because of the disruption this would bring to trade and the movement of troops. Physicians were, according to the chronicle of Domenico Parrino, 'little experienced in the symptoms of the contagion', but when one physician recognised a case of plague at the Annunziata

Hospital he was immediately locked up by order of the viceroy. The physician died a few days later of plague. For Parrino he is an innocent victim, paying the price of his honesty. Contemporary accounts of plague often assume a kind of dramatic, even mythic tone, and Parrino's is no exception: a mixture of tragedy and morality play. Yet he is unsure how to characterise the unwillingness of the physicians advising the viceroy 'to condemn the pestilential disease': 'whether out of error, fear or evil intent.'[61] In any case, only cosmetic measures were taken. Only when large numbers of people were dying every day did the viceroy give authority to the nobleman Manovel d'Aguilar, regent at the Vicaria tribunal, to organise several physicians, including Pignataro as protophysician, to investigate the matter thoroughly. The physicians demanded that autopsies be performed. These were entrusted to two of the city's esteemed 'anatomicians': Marco Aurelio Severino (who was to die of the plague) and Felice Martorella. When they were certain it was plague, they were entrusted with a response, 'not just to preserve people from it, but also for the treatment of the sick.'[62] The usual steps were now taken: the issuing of passes, the setting-up of guards at all city gates to prevent the entry of suspected goods and people, the taking of the sick to the San Gennaro lazaret, the appointing of physicians and surgeons for each district. But the pontifical nuncio in Naples, Giulio Spinola, was less than impressed by the response of the Neapolitan authorities. Inspected houses were not closed up, 'public commerce' with the victim's families was not prevented, suspect goods were not burned. Even worse, 'if the house of some poor wretch was boarded up, no thought was given as to how to feed him, so that, with even greater scandal, many people died out of simple want.' Money and medicines, Spinola concluded, were only distributed to the poor sick on a sporadic and occasional basis.[63]

Little was done to end the resulting confusion and disorder. Medicines, such as theriac, were found to be in short supply, as was food, since no one could bring it into the city. Exhausted of their supplies, the apothecaries' shops remained closed. According to the Tuscan agent, an 'ordinary man, living near the market', did a brisk trade in holy water, blessed by himself, following a revelation he had received from Our Lady of Constantinople that it would 'preserve from contagion as well as cure it.'[64] For fear of contagion, there were no private confessions, and the Eucharist was administered to the sick by means of a long cane. In the words of Parrino: 'Physicians, surgeons and barbers were dying for treating the body, priests and monks for treating the soul, gravediggers for giving corpses a burial.'[65] Since it was believed that the only effective prevention against plague was to flee, some 60,000 Neapolitans did just that (which no doubt helped to spread it to the provinces).[66] Controlling the movement of people and goods was bound to be extremely difficult, with such an enormous city and, beyond it, so much coastline. Nor did the situation change much during the following century. The famine–epidemic of 1764 caught the city's renamed Supreme Magistracy of Health as off-guard as its predecessor (figure 2). This despite regulations of 1751 that mention the preparation of a 'weekly report on the state of public health' in Naples and its province especially to control epidemics of this kind.[67] Once again, the expert advice of

Figure 2  Naples Health Office, plate 9 in John Howard, *An account of the principal lazzarettos in Europe* (London, 1791)

protophysician and physicians alike was only sought once the epidemic was well advanced. Greater rigour was shown in carrying out their advice, but the death toll was still some thirty thousand people. The inefficient brutality of the state in dealing with the famine–epidemic and the terrible poverty of the masses compared to the privileges of a very few makes 1764 a watershed in the Neapolitan Enlightenment.[68] One is continually struck by the contrast between proposals for the reform of public health and the paucity of measures actually taken, although more work needs to be done on the Supreme Magistracy of Health to verify this hypothesis.[69] Its reputation abroad remained one of general inactivity. John Howard reported that in 1791 that the city's lazaret was 'very small', with 'little attention' paid to 'passengers and shipping, under quarantine'.[70]

The protophysicians could make a more positive contribution to public health when it came to examining medicines. For example, in the late 1670s, the Collateral Council, at the behest of the viceroy, requested the protophysician to appoint a commission to look into the use of chemical medicines in the wake of several suspicious deaths.[71] This would seem to confirm our impression that Neapolitan protophysician's *rasion d'être* revolved around the regulation and activities of apothecaries. In fact, the author of the kingdom's first published pharmacopoeia, the protophysician Quinzio Buongiovanni, insisted that apothecaries be prohibited from preparing 'compositions with simples' without having been inspected first by one of the guild officials and the protophysician. Otherwise, he argued, 'they make the compositions in their own way, without fear of God or justice, and to the detriment of human bodies, which for this reason are daily made to suffer.'[72] For this reason, Buongiovanni was present when the head apothecary of the Dominican

[41]

monastery of Santa Caterina a Formello in Naples, Fra Donato D'Eremita, pre-
pared his famous 'elixir vitae.'[73] But then again, Buongiovanni may have been
invited by D'Eremita, along with the other dignitaries present (Giovan Battista
Della Porta and Nicola Stigliola), to launch his product as part of a publicity stunt.
Was inviting the protophysician a courtesy, a necessity or something that the med-
icine's seller could take advantage of? We could ask the same question of Nicola
Stigliola, who himself had invited an earlier protophysician, Giovan Antonio
Pisano, to attend the preparation of theriac according to renewed classical canons.[74]
Most likely, it was a combination of all three factors, in the same way that a char-
latan could turn mandatory issuing of a licence to sell his medicine into a stamp of
approval to boost sales.

## Jurisdictional limitations

Any impact the Neapolitan Protomedicato might have had was limited by several
factors, such as the extent of its jurisdiction. The various Italian Protomedicati all
competed, or at least overlapped, with trade corporations and other organs of the
state. Although the state apparatus grew in size during the early modern period,
this did not mean that it replaced or even weakened other centres of power. Local
elite groups and traditional institutions maintained their importance in European
states. Even the most powerful Protomedicato, that of Spain, had to share its author-
ity with local medical corporations, especially in cities outside Castile.[75] Moreover,
the Supreme Council of the Inquisition also assumed the right to license charla-
tans, inspect apothecary shops and examine and approve foreign physicians in
certain circumstances.[76]

Let us begin by considering geographical limitations. The protophysician of the
kingdom of Naples had apparent universal authority, reflected in his title 'royal and
universal protophysician.' But there were the notable exceptions of Salerno and
Benevento.[77] Salerno was the only city in the kingdom to have a collegial entity,
the College of Doctors, completely autonomous from its Neapolitan counterpart,
until it was closed in 1810–11 in the reforms of Joachim Murat. Although Salerno's
medical school ceased to be of any real intellectual importance during the early
modern period, its College continued to be an important tool in the city's local
power structure.[78] The Protomedicato tax collectors sought to expand the office's
jurisdiction over Salerno on repeated occasions. Each time the government decided
in favour of the Salernitan College's jurisdiction over local practitioners. In its
claims over Salerno, the Protomedicato was not, in fact, seeking to become some
sort of modern, overarching public medical authority. Rather, the tax collectors
simply wanted to increase their takings. For its part, Benevento was independent
not because of a medical college but as a papal enclave, as we have seen.

The position of the Neapolitan protophysician was not in any way exceptional.
The consultor protophysician of Sicily, appointed by the viceroy, had jurisdiction
over the entire island, but nonetheless had to contend with the presence of munic-
ipal protophysicians in Palermo, Catania, Messina and Modica. And the extent of

the territory under the Roman protophysician general was less that than his title of 'universal protophysician of all the ecclesiastical states' implied. There was the Bolognese Protomedicato: although Bologna had become part of the Papal States in 1506 it jealously sought to retain remnants of local autonomy. The towns of Castro and Ronciglione, Ravenna, Rimini and Urbino were similar exceptions, as were places like Macerata, Fermo and Perugia, with their medical Colleges.

There were also professional exemptions. Unlike the Castilian tribunal, the Italian Protomedicati did not always have jurisdiction over university-educated physicians and surgeons. At the most, newly graduated or foreign physicians would have to undergo an additional examination in front of the protophysician before being able to practise. The protophysician of Naples was typical in having precedence over all other physicians in the kingdom, but he could proceed against them only if they were suspected of preparing medicines.[79] Otherwise, physicians had their own College to deal with whatever criminal and civil disputes might arise involving their practice of medicine.

The protophysicians were generally powerless against apothecary's shops belonging to Religious Orders, since ecclesiastics were exempt from secular jurisdiction. This was the norm throughout Italy, until eighteenth-century reforms limited the autonomy of the religious orders. The Neapolitan protophysician attempted to insist on this right early on, affirming in 1622 that ecclesiastics may have gained exemption to secular jurisdiction as individuals, but because the protophysician was inspecting their shops, and not them personally, they had no right to refuse. This argument was repeated over one hundred years later. In an edict of 1738 the protophysician reaffirmed his right to inspect the apothecary's shops run by members of religious orders, explaining that 'it is not the people who are inspected, but the goods in their shop.'[80] It is impossible to say how effective this argument was; one suspects its impact on ecclesiastical jurisdiction was rather limited. Limitations to clerical power as part of general Enlightenment reforms may be the reason why the 1786 lists include monastic shops in Naples and lay apothecaries serving in monastic shops throughout the kingdom.[81]

Further jurisdictional limitations varied from state to state. In the kingdom of Naples the corporate bodies of each of the three branches of medicine – the physicians' College, and the guilds of the barbers and apothecaries – acted to protect their members' interests. Where these bodies existed, in Naples and Salerno, they circumscribed the protophysician's authority. Everywhere in the kingdom barbers were to be approved and licensed by the protophysicians, as we have seen; but in the capital barbers were subject only to their own guild, the Quattro dell'Arte.[82] For related reasons, the fine line separating apothecaries and grocers was also a source of dispute, as it was throughout Europe. Grocers traded in many of the same goods as apothecaries and frequently supplied them. Santorelli defined grocers as 'those who import medicaments from foreign countries, like agraricum, rhubarb, scammony, lignum vitae, sarsaparilla, saxifrage, cloves, cinnamon, nutmeg and sugar.'[83] The protophysician Prospero Bove assumed control over the grocers in 1581 after a spate of deaths resulted from poisons they sold. Henceforth they were

to keep records and be inspected like the apothecaries.[84] Bove's action may have been taken at the behest of the apothecaries, whose statutes stated that only they could sell poisons, and then only to 'discreet people so as to avoid scandals.'[85] But it also meant that the protophysician would acquire a whole new source of income from inspection fees. It immediately incurred the wrath of the grocers, who successfully appealed to the viceroy and the Collateral Council in 1604. They argued that poisons like arsenic and verdigris were necessary for the work of artisans and, in any case, could be just as easily obtained from other sources. In addition, it was unnecessary to inspect their shops since the goods they sold were inspected upon their manufacture or importation, and what medical goods were bought by apothecaries would undergo further inspection by the protophysician.[86] But the problem did not go away, and by the eighteenth century the protophysician had reacquired inspection rights over them. For the tax farmers awarded the contract to collect the dues of the Protomedicato, the 'right of visitation' of those grocers' shops dealing in compound medicines was an additional source of income which they sought to enforce.[87]

In addition to geographical and professional limitations to their jurisdiction, the Protomedicati also had to contend with political and legal ones. The issuing of licences was not solely in the hands of the protophysician. Other state tribunals gladly did their share, if for no better reason than the extra income it generated. Neapolitan viceroys could not resist intervening, as when, in 1616, Pedro Girón, the duke of Osuna, personally examined two charlatans, both peddling poison antidotes.[88] One wonders what the then protophysician thought of the intrusion. The situation may have resembled that in Sicily, where the viceroy regularly issued patents to non-graduate practitioners. In any case, conflicts of legal jurisdiction were common, as throughout Europe. Each state organism had its own tribunal to investigate cases affecting its interests and employees. This meant that one person could find himself on trial before different tribunals for the same charge.[89] The tribunal of the Neapolitan Protomedicato was of an ad hoc nature, meeting as the need arose and without any permanent bureaucratic structure. The protophysician had at his service a legal consultant, 'by means of whose opinion [the protophysician] administers legal matters', an assistant, a notary and a porter. Cases could involve accusations against practitioners for exceeding the limitations imposed by their licences, or for practising without any licence at all. Lawsuits could also be initiated against practitioners for overcharging or causing harm or death, or against the patients for non-payment. When a dispute was presented before the protophysician the matter would be decided by the consultant. However, if a petition or denunciation was presented then the assistant was to be involved, 'as is the custom in the royal tribunals of Naples.' If the court was required by circumstances to imprison people, then 'they are to be incarcerated in the Silk tribunal or the Vicaria.'[90] The first was the prison belonging to one of the city's most influential guilds, that of wool and silk workers; the Vicaria was the city's central civil and criminal court.

The protophysician was deprived of the authority to try civil cases in 1752 by Charles III, but it was never very important. In a guide to the city and kingdom of

Naples which listed the various royal tribunals, that of the College of Doctors was tenth in order of precedence. The tribunal of the Protomedicato came a mere twenty-first, preceding only the tribunal of the Postmaster General, which had jurisdiction over letter carriers.[91] Moreover, other Neapolitan tribunals also dealt with healing offences, further diminishing the role of the fledgling Protomedicato. The Udienze were the principal organs of judicial administration in the provinces, responsible for public order. A physician and surgeon would usually form part of each provincial Udienza, arbitrating disputes and performing forensic examinations. They were not paid much for their services – the tribunal's porter earned almost twice as much – but they could no doubt continue with regular practice as well.[92]

The other tribunal that frequently intervened in medical matters was the Holy Office of the Inquisition. In Naples the local nobility had opposed the introduction of the Spanish Inquisition, so representatives of the Roman (that is, papal) variety served on episcopal tribunals throughout the kingdom. The episcopal courts were primarily concerned with what they called 'magical and superstitious offences': healing rituals, whatever their content or form, that gained their power through an 'explicit or tacit pact' with the devil. Potentially, this meant most of the rituals used by local cunning folk. According to Santorelli, those who treated wounds with 'meaningless words' were subject to the Protomedicato, 'but those who heal with words and characters must be recognised by ecclesiastics, who are to judge whether to permit such a form of healing or prohibit it as superstitious and containing some tacit pact with the devil.'[93] The danger implicit in 'words and characters' had been outlined by St Thomas Aquinas in the thirteenth century. Aquinas, drawing on St Augustine, held that 'cyphers, words or other vain observances' were not 'conducive to any natural effect'; rather, they worked through the power of the demonic. And man had not been given 'power over the demonic to use it for his own purposes'.[94] Distinguishing the meaningless from the potentially demonic, especially when the words were muttered quietly by the healer, was, however, far from easy. Jurisdiction in such matters was never clear. Women performing healing rituals could find themselves denounced before either of the two tribunals, regardless of the actual nature of their cures (never easy to determine in any case, given the mixture of sacred and profane). It was a case of which court was notified of such healers first, since a woman using magical remedies to treat the sick was also most likely doing so without any sort of licence. Physicians and surgeons tended to be the ones who made such accusations before the Protomedicato, fearing illicit competition, perhaps, and because they were most familiar with the tribunal's functions. Those outside the medical community might denounce the same women before the episcopal courts, made wary – by preachers, confessors, and missioners – of the 'superstitious' or diabolical element present in such cures.

That said, there was some popular knowledge of the existence of the proto-physician's tribunal and its licensing regime, as well as an awareness of potential conflicts of jurisdiction. In 1594 the Neapolitan wise woman Lucrezia Manara sought to boost her respectability before the archbishop's tribunal by declaring: 'I

would obtain a licence to practise if the physicians wanted; but so as not to displease this court I did not try to obtain it.'[95]

## The 'Arrendamento del Protomedicato'

The nature of the Protomedicato as an office closely linked to the state is reflected in still other ways. In pre-bureaucratic Naples the state was a complex network of overlapping and conflicting interests. There was 'no separation of powers, no formal and absolute value of law, no separation of offices nor a hierarchical delegation of responsibilities.'[96] State intervention in the economy was characterised by the consumption of an income derived from the national debt, the contracting-out of taxes and public offices. Whereas in Rome the various fees and fines paid to the Protomedicato funded College salaries and costs, in Naples the income went directly into the coffers of the Chamber of the Sommaria. The picture one gains of it by studying its activities in the early modern period is a far cry from the idealised description made by the Neapolitan physician and historian Salvatore De Renzi in the late 1820s. Instead of being, 'throughout the past, the safeguard of the regular progress of the healing arts',[97] the Protomedicato was in fact but one of many *arrendamenti* or tax farms, a term derived from the Spanish *arrendar*, to contract. This was a system by which the tax farmer or contractor, the *arrendatore*, would offer an anticipated sum of money at public auction based on the annual revenues due to that office. The *arrendatore*, usually by means of a system of sub-contracts, then undertook the collection of the taxes or duties.[98] The *arrendamento* of the Protomedicato was set up in 1610, for which the first contractor bid 8,330 ducats, keeping for himself the emoluments derived from the granting of licences and diplomas, the inspection of apothecary shops, and the payment of fines.[99] Earnings remained relatively low during the seventeenth century, under 5,000 ducats a year. In the eighteenth century, however, it became a lucrative source of income for the crown, rising from around 9,000 during the years of Austrian occupation (1707–34), and to between 15,000 and 19,300 during the late 1780s.[100] Although the kingdom's *arrendatori* stood often made great fortunes, the *Arrendamento del Protomedicato* was of relatively minor importance. To keep things in perspective, even the *gabelle* on playing cards brought in more money, whilst the tobacco *arrendamento* earned the state over ten times as much.[101]

By Santorelli's time, the contractor or his deputy was part of the visitation 'team.'[102] Inevitably, there were pressures on the substitute protophysician and proto-apothecary to earn as much as possible for the accompanying contractor, despite 1622 instructions that 'they must conduct the visitation as judges alone, without any prejudicial interest whatsoever.'[103] By 1743, in a climate of reform which saw Charles III's government attempt to buy back some of the *arrendamenti*, there was a complaint that the farming-out of the protophysician's procedure seriously harmed the practice of medicine. The *arrendatore's* motivation was purely financial, it was alleged, his only object being the collection of dues and the imposition of fines. His rapacity turned him into a 'ruiner of trades', issuing diplomas and

licences without the required examination, which resulted in the mushrooming of practitioners. Inspections of apothecary shops were carried out only after notice had been given, allowing apothecaries to dispose of inferior goods and borrow good quality ones, so that, especially in the provinces, the visitation became a mere formality. When he attempts to intervene and remedy these ills, the protophysician 'finds the way blocked by the pestiferous cause of the *arrendamento.*' The office of protophysician existed to 'promote human health by ensuring the quality and per-fection of medicaments and the necessary requisites the practitioners of pharmacy must possess.' But because it was farmed out to the highest bidder, 'the complete opposite of what the law has resolved is produced, with deplorable disorder.' The system had to be regulated by 'a real policing of commerce', and not by private interest.[104] All the preceding comments were made by the fiscal reformer Carlo Broggia. Admittedly, as a wholesale grocer himself, he did have his own axe to grind. After a run-in with protophysician Buonocore over the matter in 1738,[105] he was at least able to vent his spleen in his treatise on economic reform. In any case, his complaints came to nothing: a shortage of money brought the govern-ment's policy of buying back *arrendamenti* to a halt by mid-century.

Calls for reform became more widespread as the century progressed. Physicians in the provinces advocated the appointment of provincial protophysicians, to be based throughout the kingdom.[106] By 1780 even the president of the Royal Academy of Sciences and Letters, the influential Prince of Francavilla, was advo-cating reform. The Prince recommended that the renters be stripped of 'the authority to dispense licences to treat both in physic as well as in surgery and obstet-rics.' Apothecary shops should be inspected directly by physicians of the crown or the protophysician, 'without the intervention of the contractor, who represents the treasury, leaving to the renter only the authority to demand the visitation fee, which is six *carlini.*'[107] This would have deprived the contractor of most of his earnings. The records of the *arrendamento* – virtually all that survives with reference to the office's activities – contain numerous complaints from apothecaries against the con-tractors.[108] The current system was even said to lie behind the lack of trade in certain provinces, like Capitanata, along with heavy feudal dues and legal fees.[109] However, nothing was done. The protophysician himself, Francesco Serao,[110] was opposed to any change, arguing that the tax collector's participation was required in order to get things done. What he did not state, but what must have been a factor, was that the *arrendamento* was then at its most profitable.

Needless to say, the collection of these emoluments could lead to abuses whether it was carried out directly by tax contractors or not. Moreover, from the point of view of licensees, at least, there was precious little difference between their assidu-ity in collecting fees or merely lining their pockets. In 1639 the protophysician of Benevento, Pietro Piperno, was accused of excessive zeal in exercising his office by the city's barbers. They claimed that his earnestness simply masked his desire for the extra income it brought in. The city council agreed, deciding that the barbers should be inspected only once during the protophysician's three-year term.[111] Elsewhere in Italy, where the office of protophysician was not infrequently sold to

the highest (medical) bidder, office-holders were keen to make the most of their acquired position. In the Papal States the cost of the various provincial offices varied according to the province's importance.[112] In Sicily, when the viceroy decreed that the office of consultor protophysician in Palermo would become a lifetime appointment (1743), it had already been sold for some time. The viceroy hoped that it would be sold to the most senior and experienced candidate, at a price not inferior to that paid in the past.[113] Of course, venality was typical of early modern office-holding and should not be regarded as synonymous with corruption. But protophysicians had to recoup the costs of their office, their appointees the costs of their tours of inspection and the Protomedicati and Colleges the salaries they paid. Nobody admitted to corruption in any case. The guilty would either hide the fact by pleading innocence or falsifying entries on balance-sheets or cite extenuating circumstances for their actions, removing any moral culpability.[114] Moreover, abuses seem to have been a functional part of the system, each element of which sought to protect its individual position. This was akin to the strategy of bargaining and negotiation which was a normal feature of criminal cases. According to a physician in Reggio, apothecaries knew that they could always reach some sort of compromise with the visitors when their stock was found to be faulty or incomplete.[116] Apothecaries also routinely claimed exemptions from the visitation duty (which in many cases were genuine, but sometimes not). Others shut their doors and fled upon the protophysician's approach. Still others petitioned that they had been charged too much. It is the nature of complaints by medical practitioners that they are always plausible, at least as far as the historian is concerned. What are we to make of the legions of midwives who had no idea that licences were required for their profession? Or those who petitioned for exemption, claiming to be, like one Neapolitan midwife, 'unable and foolish'?[116]

## The nineteenth century

As offices so closely linked to the workings of the early modern state, most Protomedicati met their end in the wake of Enlightenment reforms. Thus, in Milan, the reforms of the late eighteenth century sought to replace the autonomous jurisdictions of the Colleges and the Protofisicato with a single centralised, accountable and much more powerful bureaucracy, dependent on the state.[117] These were the years of increasing state direction of public health, based on the idea of 'medical police', as practised in absolutist states like Austria. In Naples, despite a degree of Enlightenment reform during the reigns of Charles III and Ferdinand IV, under the influence of the prime minister Bernardo Tanucci, the Protomedicato was never reformed into a means of organising medicine and public health. Following repeated calls for financial reform, the office was deprived of its authority to try offenders. This was the only significant change to its functions during the course of the whole of the eighteenth century.[118] Later, under the 'French' reforms of Joseph Bonaparte and Joachim Murat in the years 1806–15, the Neapolitan Protomedicato's fee-collecting activities passed from the Ministry of Finance to the

Ministry of the Interior. Rather than decline in importance, its authority actually increased, complemented by the closure of the College of Doctors in 1806.[119] The Protomedicato's registers now become noticeably more detailed, further evidence that we have now entered the kingdom's 'statistical age'[120] (and a temptation luring the intrepid historian beyond the time-honoured chronological boundaries of 'early modern').

The office continued to be filled by the kingdom's most renowned physician. From 1810 the protophysician was Domenico Cotugno, professor of human anatomy (from 1766), founding member (1780) and later president (1809–17) of the Royal Academy of Sciences and Letters, and rector of the University of Naples (from 1811). If protophysician Pignataro represents an important moment in the struggle between medical 'ancients' and 'moderns', protophysician Cotugno encapsulates an important shift in the development of modern medicine in Naples. In fact, the work of Cotugno and people like him during the latter part of the eighteenth century laid the groundwork for all the reforms of the 'French decade.' These included the transfer of degree-conferring powers to the University in 1811, the establishment of the Medico-Surgical College at the Incurables Hospital, as well as the opening of new clinical university rooms there, and the gradual redefinition of disciplines and the founding of new chairs.[121] Rather than face elimination or decline in importance, the office of protophysician seems to find a place in this new order. New statues governing its activities were approved in 1823 and the whole office was reformed in 1844, becoming a fully-fledged bureaucratic commission.[122] Like its counterpart in Sicily, it came to an end with the unification of Italy.

NOTES

1 Antonio Santorelli, *Il protomedico napolitano, ovvero dell'autorità di esso* (Naples, 1652), pp. 25–6.

2 As Matthew Ramsey has noted in the context of late *ancien régime* France, in 'The repression of unauthorized medical practice in eighteenth-century France', *Eighteenth-Century Life*, vii (1982), p. 119.

3 Giuseppe Maria Galanti, *Nuova descrizione storica e geografica delle Sicilie* (Naples, 1786–90), vol. 1, p. 212.

4 David Gentilcore, "All that pertains to medicine': *protomedici* and *protomedicati* in early modern Italy', *Medical History*, xxxviii (1994), p. 123.

5 Santorelli, *Protomedico napolitano*, p. 3.

6 Giuseppe Pitrè, *Medici, chirurgi, barbieri e speziali antichi in Sicilia, secoli XIII-XVIII* (Rome, 1942), p. 162.

7 Giovanni Filippo Ingrassia, *Constitutiones, capitula, iurisdictiones, ac pandectae regii proto-medicatus officii* (Palermo, 1657), introduction.

8 Francesco Monconi, *Castigo de Dios: la grande peste barocca nella Sardegna di Filippo IV* (Rome, 1994), p. 102; Ignazio Lai, 'Farmacopea e farmacoterapia nella Sardegna seicentesca. Spigolature d'archivio', *Studi sardi*, xvii (1987), pp. 315–16.

9 Alan Ryder, *The kingdom of Naples under Alfonso the Magnanimous: the making of a modern state* (Oxford, 1976), p. 79; Miguel Muñoz, *Recopilación de las leyes, pragmáticas reales,*

*decretos y acuerdos del Real Proto-medicato hecha por encargo y dirección del mismo Real Tribunal* (Valencia, 1751; reprint Valencia, 1991), p. 37.

10 'Capitula et ordinatione facte per l'Aromatari Napoletani', *Variarum quistionum et rerum iurisdictionalium*, Biblioteca di Storia Patria, Naples; document no. 4 in Andrea Russo, *L'arte degli speziali in Napoli* (Naples, 1966), pp. 63–6.

11 Ileana Del Bagno, *Legum doctores: la formazione del ceto giuridico a Napoli tra Cinque e Seicento* (Naples, 1993), pp. 167–73; Marisa Gisella Colletta, 'Il Collegio dei Dottori dal 1722 al 1744 attraverso le carte dell'Archivio di stato di Napoli', *Archivio storico per le province napoletane*, xcvii (1979), pp. 217–41.

12 Santorelli, *Protomedico napolitano*, p. 98; Galanti, *Nuova descrizione*, p. 212.

13 He was known as Galateo, after his town of origin, Galatone, in Terra d'Otranto. Gian Giuseppe Origlia, *Istoria dello Studio di Napoli* (Naples, 1753–54), vol. 1, pp. 261–2; Jerry Bentley, *Politics and culture in renaissance Naples* (Princeton, 1987), pp. 268–9.

14 Santorelli was author of: *Ante praxis medica, in quibus, ea omnia, quae praxim medicinae aggressuris, praenoscere et necessarium summa brevitate examinantur* (Naples, 1622); *Post praxis medica, seu de medicando defuncto, liber unus; in quo quaecumque prudens & Christianus medicus debet defuncto praestare, explicantur* (Naples, 1629); *Discorsi della natura, accidenti e pronostici dell'incendio del monte di Somma dell'anno 1631* (Naples, 1632); and *De sanitatis natura lib. xxiv in quibus explicantur quaecumque ad partem phsyiologicam . . . pertinent et sanitate tuenda* (Naples, 1643).

15 Origlia, *Istoria*, vol. 2, p. 81.

16 Giuseppe Mosca, *Vita di Lucantonio Porzio* (Naples, 1755), p. 17; in Max Fisch, 'The Academy of the Investigators' in E. A. Underwood (ed.), *Science and medicine in history: essays on the evolution of scientific thought and medical practice in honour of Charles Singer* (Oxford, 1953), vol. 1, p. 537.

17 Del Bagno, *Legum doctores*, p. 397; Origlia, *Istoria*, vol. 2, p. 414.

18 Carlo Pignataro, *Petitorium in quo continetur ea, quae quilibet pharmacopoeus in sua officina, in hac urbe Neapolis & Regno, in visitationibus faciendi habere & ostendere debat* (Naples, 1684), title page.

19 Domenico Confuorto, *Giornali di Napoli dal MDCLXXIX al MDCIC*, ed. N. Nicolini (Naples, 1930), vol. 2, p. 113.

20 Santorelli does not mention this regulation, though he may take it for granted. Bottoni was Neapolitan protophysician until 1692, when he returned to Messina for health reasons. In 1695 he was made corresponding member to the Royal Society in London, to supply information about the 1693 Messina earthquake. His son, Federico (*c.*1670–*c.*1745), served throughout the Spanish world: in addition to offices in Naples and Sicily, he was court physician first in Madrid and then in Lima. Cf. Alvar Martínez Vidal, *El nuevo sol de la medicina en la Ciudad de los Reyes: Federico Bottoni y la* Evidencia de la circulación de la sangre *(Lima, 1723)* (Saragossa, 1992).

21 Marco Antonio Alaimo, *Discorso . . . intorno alla preservatione del morbo contagioso e mortale che regna al presente in Palermo* (Palermo, 1625).

22 Roberto Zapperi, 'Marco Antonio Alaimo', *Dizionario biografico degli italiani* (Rome, 1960), vol. 1, pp. 561–2.

23 Eustachio D'Afflitto, *Memorie degli scrittori del Regno di Napoli* (Naples, 1789–94), vol. 2, p. 77.

24 Origlia, *Istoria*, vol. 2, pp. 296–7.

25 Juan Riera and Juan Granda-Juesas, introduction to Pascual Iborra, *Historia del Protomedicato en España (1477–1822)* (Valladolid, 1987), p. 10. Luis Granjel, *Historia*

*general de la medicina española*, vol. 2, *Medicina española renacentista* (Salamanca, 1980), pp. 76–7.

26 Asunción Fernandez Doctor, 'El control de las profesiones sanitarias en Aragón: el Protomedicato y los Colegios', *Dynamis*, xvi (1996), pp. 173–85.

27 Settala (1552–1633) served as a *deputato* during the Milan plague of 1576 and wrote a successful treatise on the subject (*De peste et pestiferis affectibus*, 1622). Pietro Capparoni, *Profili bio-bibliografici di medici e naturalisti celebri italiani dal sec. XV al sec. XVIII* (Rome, 1928), vol. 2, pp. 131–2; Silvia Rota Ghibaudi, *Ricerche su Ludovico Settala* (Florence, 1959), pp. 18, 41.

28 Manconi, *Castigo de Dios*, p. 103.

29 A. Garosi, 'I protomedici del collegio di Siena dal 1562 al 1808', *Bullettino senese di storia patria*, ix (1938), pp. 173–81.

30 Edoardo Rosa, 'L'Assunteria di sanità nella difesa della salute pubblica a Bologna durante il XVIII secolo' in *idem*, *Famiglie senatorie e istituzioni cittadine a Bologna nel Settecento* (Bologna, 1980), pp. 182–3.

31 'Statuta civitatis Beneventi' (1588), Museo del Sannio, Benevento, *Fondo civico*, MS. 5362, I, ch. 15, 'De protomedico'; reprinted in appendix to G. Intorcia, *Civitas beneventana: genesi ed evoluzione delle istituzioni cittadine nei secoli XIII-XVI* (Benevento, 1981), pp. 185–6.

32 'Instruction de lo loq. Prospero Bove nuestro Protomedico de Nap. ha da haver en el exercizio de su officio, y los de may que le succederan en el ministerio', document no. 6 in Russo, *Speziali*, pp. 73–5.

33 'Confirmazione del [Consiglio] Collaterale alle relazioni del [Giovanni Antonio] Pisano circa l'offizio del Protomedico. 1577', document no. 5 in Russo, *Speziali*, pp. 67–73, at p. 67.

34 *Ibid.*, p. 69.

35 Lorenzo Giustiniani, *Nuova collezione delle prammatiche del Regno di Napoli* (Naples, 1805), vol. 12, p. 223.

36 'Conto di Pasquale Addiglio amministratore delegato . . . dal primo ottobre 1785 a tutto settembre 1786', A.S.N., *Sommaria: Protomedicato*, series II, 34.

37 'Confirmazione', Russo, *Speziali*, pp. 69–70.

38 'Instruction', Russo, *Speziali*, p. 74; Santorelli, *Protomedico napolitano*, p. 59.

39 Santorelli, *Protomedico napolitano*, p. 69.

40 'Confirmazione', Russo, *Speziali*, p. 67.

41 *Ibid.*, pp. 68–71.

42 A.S.N., *Sommaria: Protomedicato*, series II, 35: 'cautele.'

43 Santorelli, *Protomedico napolitano*, p. 108.

44 'Confirmazione', Russo, *Speziali*, p. 72.

45 *Ibid.*, p. 68.

46 Title cxxii, pragmatic iii, 15.ix.1584, *Pragmaticae, edicta, decreta, regiaque sanctiones Regni Neapolitani . . . collocatis per . . . Blasium Altimarum* (Naples, 1682–95), vol. 3, pp. 1184–5.

47 'Confirmazione', Russo, *Speziali*, p. 70.

48 Teresa Ortiz, 'Protomedicato y matronas: una relación al servicio de la cirugía', *Dynamis*, xvi (1996), pp. 109–20.

49 'Atti di Giulio Cesare Capasso . . . 1622', A.S.N., *Sommaria: Protomedicato*, series II, 33: 1, fol. 11r.; 'Opinioni varie relative all'ufficio del protomedico', 1738, A.S.N., *Sommaria: Protomedicato*, series II, 33: 6; Giustiniani, *Collezione delle prammatiche*, vol. 12, pp. 211–12.

50 Title clii, pragmatic iv, 14.vii.1581, *Pragmaticae,* vol. 3, pp. 1329.

51 Santorelli, *Protomedico napolitano,* p. 48.

52 David Gentilcore, '"Charlatans, mountebanks and other similar people": the regulation and role of itinerant practitioners in early modern Italy', *Social History,* xx (1995), pp. 297–314.

53 Confuorto, *Giornali,* vol. 1, p. 161.

54 In a letter written to Michele Giustiniani in 1656, reprinted in Salvatore De Renzi, *Napoli nell'anno 1656* (Naples, 1867), pp. 372–5.

55 Giovanni Filippo Ingrassia, *Informatione del pestifero et contagioso morbo, il quale affligge et have afflitto questa città di Palermo* (Palermo, 1576); Ludovico Settala, *De peste et pestiferis affectibus* (Milan, 1576) and *Preservatione dalla peste* (Brescia, 1630).

56 Pasquale Lopez, *Napoli e la peste, 1464–1530: politica, istituzioni, problemi sanitari* (Naples, 1989), pp. 34–43, 59–71.

57 George Rosen, *A history of public health* (Baltimore, 1993 edn), pp. 60–2.

58 Maria Pia Digiorgio Viti, 'Peste, terremoti e culto dei santi tra XVII e XIX secolo nella provincia di Matera', *Ricerche di storia sociale e religiosa,* xxxv (1989), p. 135.

59 Lynn Martin, *Plague? Jesuit accounts of epidemic disease in the 16th century* (Kirksville, 1996), p. 144.

60 F. Palermo, 'Documenti sulla storia economica e civile del Regno cavati dal carteggio degli agenti del Granduca di Toscana in Napoli', *Archivio storico italiano,* ix (1846), p. 266.

61 Domenico Antonio Parrino, *Teatro eroico e politico de' governi de' vicere del Regno di Napoli dal tempo del re Ferdinando il Cattolico fino al presente* (Naples, 1692–94),vol. 3, pp. 34–5.

62 *Ibid.,* p. 41.

63 Giulia Calvi, 'L'oro, il fuoco, le forche: la peste napoletana del 1656', *Archivio storico italiano,* cxxxix (1981), pp. 442–3.

64 Calvi, 'Peste napoletana', p. 439.

65 Parrino, *Teatro eroico,* p. 43.

66 Eugenio Sonnino, 'L'età moderna' in L. Del Panta *et al., La popolazione italiana dal medeioevo a oggi* (Rome and Bari, 1996), p. 101. Only the provinces of Terra d'Otranto and Calabria Ulteriore, furthest from the capital, went unscathed.

67 A.S.N., *Supremo Magistrato di Salute,* 'Regolamento del Comitato Centrale di Sanità della Città e Provincia di Napoli', fol. 101; in Gabriella Botti, '"Febbri putride e maligne" nell'anno della fame: l'epidemia napoletana del 1764', in P. Frascani (ed.), *Sanità e società: Abruzzi, Campania, Puglia, Basilicata, Calabria, secoli xvii-xx* (Udine, 1990), pp. 87–91.

68 Franco Venturi, *Italy and the Enlightenment: studies in a cosmopolitan century,* trans. S. Corsi (London, 1972), pp. 202–3.

69 On public health recommendations, see Antonio Borrelli, 'Medicina e società a Napoli nel secondo Settecento', *Archivio storico per le province napoletane,* cxxii (1994), pp. 147–54.

70 John Howard, *An account of the principal lazarettos in Europe* (London, 1791), p. 8. So small was it, he decided, that it did not warrant a plate; he depicted the city's health office instead. The lazaret he refers to is not that of San Gennaro, intended for Neapolitans and located to the north of the city, but the pesthouse at Nisida. Located on the coast near Pozzuoli, this small facility was built in 1626 by the viceroy, Antonio Alvarez de Toledo, to quarantine incoming infected ships and their personnel.

71 One of the commissioners appointed was the 'modern' Leonardo di Capua, who published his findings in 1681: *Parere . . . divisato in otto ragionamenti, ne' quali partitamente*

*narrandosi l'origine e 'l progresso della medicina, chiaramente l'incertezza della medesima si fa manifesta* (Naples, 1681).

72 Russo, *Speziali,* document 7, pp. 75–6. Buongiovanni, a native of Tropea (Calabria Ulteriore), was lecturer of theoretical and then practical medicine at the university of Naples and author of *Peripateticorum disputatio de principiis naturae sectiones tres* (Venice, 1571). Origlia, *Istoria,* vol. 2, p. 34.

73 According to the description in *Dell'elixir vitae di Fra' Donato D'Eremita di Rocca d'Evandro dell'Ord[ine] de Pred[icatori], libri quattro* (Naples, 1624); in Gabriella Belloni Speciale, 'La ricerca botanica dei Lincei a Napoli: corrispondenti e luoghi' in F. Lomonaco and M. Torrini (eds), *Galileo a Napoli* (Naples, 1987), p. 76.

74 Nicola Stigliola, *Theriace et mithridatia Nicolai Stelliolae Nolani libellus* (Naples, 1577); in Paula Findlen, *Possessing nature: museums, collecting and scientific culture in early modern Italy* (Berkeley, 1994), p. 271. Pisano was professor of practical medicine at Naples from 1557 to 1585 and the subject of a work by the canon lawyer Prospero D'Agostino, *De laudibus ac medicinae Jo. Antonii Pisani in neapolitano Regno archiatrae, dignitate et doctrinae praestantia insignis* (Naples, 1580). Fuasto Nicolini, *Saggio d'un repertorio biobibliografico di scrittori nati o vissuti nell'antico Regno di Napoli* (Naples, 1966), p. 577.

75 Granjel, *Historia general,* vol. 2, p. 78; José María López Piñero, 'The medical profession in 16th century Spain', in A. Russell (ed.), *The town and state physician in Europe from the Middle Ages to the Enlightenment* (Wolfenbüttel, 1981), p. 85.

76 J. L. Valverde and F. Sánchez L. Vinuesa, 'Controversias jurisdiccionales del proto-medicato castellano', *Asclepio,* xxx–xxxi (1979), pp. 403–23. The case of a Neapolitan physician in Cádiz, found without licence from the Protomedicato, went before the Inquisition, who exiled him, despite petitions from the Protomedicato. Guadalupe Albi Romero, *El protomedicato en la España ilustrada (Catálogo de documentos del Archivo General de Simancas)* (Valladolid, 1982), items 226–226b, pp. 101–2.

77 Santorelli, *Protomedico napolitano,* pp. 8–11.

78 Salvatore De Renzi, *Storia della medicina italiana* (Naples, 1849), vol. 3, pp. 142–3.

79 Santorelli, *Protomedico napolitano,* p. 34.

80 'Atti', 1622, A.S.N., *Sommaria: Protomedicato,* series II, 33: 1, fol. 17r. 'Opinioni varie', 1738, A.S.N., *Sommaria: Protomedicato,* series II, 33: 6; Giustiniani, *Collezione delle pram-matiche,* vol. 12, p. 222.

81 A.S.N., *Sommaria: Protomedicato,* series II, 34.

82 Santorelli, *Protomedico napolitano,* pp. 51–2.

83 *Ibid.,* p. 13.

84 Giustiniani, *Collezione delle prammatiche,* pp. 202–6.

85 'Capitula et ordinatione facte per l'aromatari napoletani', 1498, Russo, *Speziali,* p. 65.

86 Santorelli, *Protomedico napolitano,* pp. 13–24.

87 Carlo Antonio Broggia, *Trattato de' tributi, delle monete, e del governo politico della sanità* (Naples, 1743), pp. 292–3.

88 Antonio Bulifon, *Giornali di Napoli dal MDXLVII al MDCCVI,* ed. N. Cortese (Naples, 1932), p. 103.

89 Hanns Gross, *Rome in the age of the Enlightenment: the post-Tridentine syndrome and the ancien régime* (Cambridge 1990), pp. 217–21.

90 'Confirmazione', Russo, *Speziali,* pp. 67, 69.

91 Enrico Bacco, *Naples: an early guide* [trans. of *Descrittione del Regno di Napoli,* Naples, 1671], trans. and ed. E. Gardiner (New York, 1991), pp. 122–3. The place of the many tribunals in viceregal administration is discussed in Giovanni Muto, 'Il Regno di Napoli

sotto la dominazione spagnola' in G. Cherubini (ed.), *Storia della società italiana: la Controriforma e il Seicento* (Milan, 1989), pp. 261–2.

92  Aurelio Musi, 'Medicina e sapere medico a Salerno in età moderna' in AA. VV. (various authors) *Salerno e la sua Scuola Medica* (Salerno, 1994), pp. 171–2.

93  Santorelli, *Protomedico napolitano,* p. 33. In Spain, the royal pragmatic of 1477 gave the Protomedicato the authority to make certain no one made use of 'spells, conjurations and incantations', especially when they were 'administered medically', though the Supreme Council of the Inquisition (established 1483) was to be the prime mover in this area. Granjel, *Historia general,* vol. 2, p. 147; Jaime Contreras and Gustav Henningsen, 'Forty-four thousand cases of the Spanish Inquisition (1540–1700): analysis of a historical data bank' in G. Henningsen and J. Tedeschi (eds), *The Inquisition in early modern Europe. Studies on sources and methods* (Dekalb, 1986), pp. 100–29.

94  St Thomas Aquinas, *Summa Theologiæ,* 2a2æ, q. 96, 2: 1–3.

95  A.S.D.N., *Sant'Ufficio,* 247a, fol. 11v.; in Giovanni Romeo, *Inquisitori, esorcisti e streghe nell'Italia della Controriforma* (Florence, 1990), p. 220.

96  Dino Carpanetto and Giuseppe Ricuperati, *Italy in the Age of Reason, 1685–1789,* trans. C. Higgitt (London, 1987), p. 64.

97  Salvatore De Renzi, *Osservazioni sulla topografia medica nel Regno di Napoli (Domini al di qua del Faro)* (Naples, 1845 edn), p. 387.

98  Luigi De Rosa, *Studi sugli arrendamenti del Regno di Napoli: aspetti della distribuzione della ricchezza mobiliare nel Mezzogiorno continentale (1649–1806)* (Naples, 1958).

99  Lidia Castaldo Manfredonia, *Gli arrendamenti: fonti documentarie conservate presso l'Archivio di Stato di Napoli* (Naples, 1986), vol. 1, p. 162.

100  A.S.N., *Sommaria: Protomedicato,* series I, 280 I, 280 II, 281, 282.

101  Antonio Calabria, *The cost of empire: the finances of the Kingdom of Naples in the time of Spanish rule* (Cambridge, 1991), pp. 134–41; Antonio Di Vittorio, *Gli Austriaci e il Regno di Napoli, 1707–1734,* vol. 1, *Le finanze pubbliche* (Naples, 1969), p. 207.

102  Fabio Cava, 'Instruttioni che s'hanno da osservare dal Protomedico, Protospeziale e Affittatore' in Santorelli, *Protomedico napolitano,* pp. 85–95.

103  A.S.N., *Sommaria: Protomedicato,* series II, 33: 1, fol. 10r.

104  Broggia, *Trattato,* pp. 289–91.

105  Contained in A.S.N., *Sommaria: Protomedicato,* series II, 33: 6.

106  Letter from Natale Arcovito to Giuseppe Maria Galanti, in Augusto Placanica (ed.),*Calabria 1792: diarii, relazioni e lettere di un visitatore generale* (Salerno, 1992), p. 471.

107  'Relazione del Principe di Francavilla relativa alle visite di protomedici', A.S.N., *Sommaria: Protomedicato,* series II, 34: 16.

108  In 1789, for example, the apothecary Francesco Dionisio launched a complaint against the *arrendatore* Gian Domenico Montagnese before the Superintendency-General of Health for overcharging and then ordering his shop shut. A.S.N., *Sommaria: Protomedicato,* series II, 34: 22.

109  Francesco Longano, *Viaggio dell'abate Longano per la Capitanata* (Naples, 1790), reprinted in Franco Venturi (ed.), *Illuministi italiani,* vol. 5, *Riformatori napoletani* (Milan and Naples, 1962), p. 397.

110  Serao (Aversa, 1702–Naples, 1783), a disciple of Niccolò Cirillo and advocate of a new clinical basis for medicine, was first professor of medicine at the University of Naples when he was nominated protophysician and personal physician to King Ferdinand IV in 1778.

111  Museo del Sannio, Benevento, *Deliberazioni consiliari,* 1631–40, fol. 380; in Alfredo

Zazo, 'Spigolature sull'autore del *De magicis affectibus*: Pietro Piperno', *Samnium,* xlii (1975), p. 104.

112 Fausto Garofalo, *Quattro secoli di vita del Protomedicato e del Collegio dei Medici di Roma (Regesto dei documenti dal 1471 al 1870)* (Rome, 1950), p. 15.

113 V. Parisi, *Capitoli et ordinazioni della felice e fedelissima città di Palermo* (Palermo, 1768), pp. 96–8; in Pitrè, *Medici,* p. 164.

114 Jean-Claude Waquet, *Corruption: ethics and power in Florence, 1600–1770,* trans. L. McCall (Cambridge, 1991), pp. 107–14 .

115 Arcovito to Galanti, in Placanica, *Calabria 1792,* p. 471.

116 A.S.N., *Sommaria: Protomedicato,* series II, 35: 'cautele.'

117 Anita Malamani, 'L'organizzazione sanitaria nella Lombardia austriaca' in A. De Maddalnea, E. Rotelli and G. Barbarisi (eds.), *Economia, istituzioni, cultura in Lombardia nell'età di Maria Teresa, vol 3: Istituzioni e società* (Bologna, 1982), pp. 993–5, 1001–2.

118 The fate of its stronger Spanish cousin was different. Suppressed in 1799 by royal decree, it was re-established and finally abolished in 1822. Granjel, *Historia general,* vol. 4, p. 92.

119 Gabriella Botti, 'L'organizzazione sanitaria nel Decennio' in A. Lepre (ed.), *Studi sul Regno di Napoli nel Decennio Francese (1806–1815),* (Naples, 1985), pp. 81–98; Vittorio Donato Catapano, *Medicina a Napoli nella prima metà dell'Ottocento* (Naples, 1990), pp. 44–5.

120 The year 1809 marks the beginning of a centralised register of births, marriages and deaths in the kingdom. Claudia Petraccone, *Napoli dal Cinquecento all'Ottocento: problemi di storia demografica e sociale* (Naples, 1974), p. 189.

121 Aurelio Musi, 'Medici e istituzioni a Napoli nell'età moderna', in Frascani, *Sanità e società,* pp. 31–2; Borrelli, 'Medicina e società', 126–8.

122 'Regolamento del Protomedicato del 3 giugno 1823' in P. Petitti, *Repertorio amminis-trativo ossia collezione di leggi, decreti reali prescritti* (Naples, 1851–59), vol. 1; De Renzi, *Topografia,* p. 388.

# CHAPTER THREE

# MEDICAL PRACTITIONERS AND MEDICAL PRACTICE

Why was Amico Gizzi forced to close his apothecary's shop in 1719 by the bishop?[1] Was it because Gizzi, a resident of Ortona, a small town in the mountains of Abruzzi, was a priest? Or was it because he made use of unorthodox medical 'secrets' alongside other more standard prescriptions? His activities might have been tolerated had they not come to the attention of the town's archpriest, who just happened to have been a physician before being called to the priesthood. It was the town's archpriest who brought Gizzi to the attention of the capitular court of the diocese of Avezzano dei Marsi. As a former physician, he knew what functions an apothecary was allowed to perform; and as a cleric, he knew what was expected of a parish priest. Gizzi had crossed the fine line separating licit, regular practice from the illicit and the irregular. What made Gizzi particularly reprehensible in the archpriest's eyes was Gizzi's habit of altering the doses so he could charge higher prices. The sick were being harmed further by these 'exorbitant doses', especially when they were purgatives. It did not help his case that one of the victims was the town's surgeon, Giuseppe d'Ascanio. He later recounted that the purgative 'had such an effect on me that had I not taken a bit of bran that evening I don't know what would have become of me.'[2] The archpriest warned Gizzi, but to no avail. Following this personal rebuff from a social inferior the archpriest was forced to turn to other tactics. He testified that Gizzi was an insult to the clerical habit, especially because he extended credit to customers and then landed them before the secular court. Moreover he was involved in various business dealings, including money-lending and tax collecting, which were in conflict with his status. He had admitted a young woman of low repute into his house, had performed 'immodest acts' during mass and gone on night-time drinking binges. The archpriest wanted action taken against Gizzi 'so that he will reform and live in future as a good priest and act in keeping with his estate.'[3]

At the outset there was little against Gizzi. But the case gathered momentum when his shop, located in his house, was searched. While going through his papers for evidence that he had made up his own prescriptions, without a physician's orders, they came upon a booklet bound in blue paper. In Gizzi's own handwriting they found instructions on how to prepare various basic remedies, such as cinnamon water and rose syrup, as well as chemical remedies like Mercurial unguent and Paracelsian plaster. The instructions were written in a mixture of Latin and Italian.

No doubt many apothecaries kept annotated registers of this kind for their own use. The use of the vernacular, while disappointing in a trained apothecary, was not expressly forbidden. However, Gizzi's booklet also contained numerous medical 'secrets': tried and tested remedies which worked in hidden, unknown ways. Their inclusion suggested a reliance on practical remedies not in keeping with the training and preparation required of an apothecary. To the court's dismay, amongst recipes for curing haemorrhoids, ridding the body of worms and renewing the supply of breast milk in nursing mothers, they found instructions on 'how to bewitch the night guards' and 'how not to be injured.' These were straightforward magical incantations, 'little becoming a priest.'[4]

Later records make no mention of an apothecary's shop in Ortona, so Gizzi's may have been the only one in 1719. This may explain why his activities were largely tolerated by the townsfolk – disgruntled physician and surgeon aside – despite the fact that he never bothered to obtain a licence. When asked if Gizzi handled drugs himself, witnesses replied matter-of-factly that he had. There is no sense of condemnation in their remarks, nor did this fact ever stop them going to him when they needed medicines. When we finally hear from Gizzi himself, a month later, it is something of an anti-climax. Five years earlier, with his own money, Gizzi had bought the contents of an apothecary's shop run by the local Franciscans. He had hired a succession of apothecaries to run the shop and it was only in the preceding six months that he had been unable to find a replacement. For this reason he turned to dispensing the medicines himself. And he did little enough of that, he says, 'since there weren't many illnesses this winter.' The incriminating recipe book is harder to explain away. Gizzi recounts that he had copied it from a *ricettario* kept by his first apothecary, thinking it might be useful to him, given his lack of experience. However, he insists, he has never made use of it. The court is sceptical, referring to Gizzi's comments and underlinings at various entries. These were copied out exactly as they appeared in the original, he says. As for the 'superstitious' entries and their use, Gizzi replies, 'I don't know what to say, I don't know what it is.'[5] The court is more concerned with the other accusations against him. In the end he is absolved, on condition that he not prepare or dispense medicines of any kind, particularly not purgatives, and that his recipe book remain with the trial records (as it has). He is warned to live with all due modesty, not to engage the help of women under forty-five, nor carry out any secular business, or face the penalties of canon law.

Normally, apothecaries caught practising without a licence or exceeding the bounds of their 'profession' by dispensing medicines without a physician's order came under the protophysician's jurisdiction. As a cleric, however, Gizzi could only be tried by an ecclesiastical court. The denunciation made against him by the physician-cum-archpriest is unusual in the variety of accusations made against him. The case against Gizzi can be seen within the context of the ongoing reform of clerical behaviour that followed the Council of Trent. In a wider sense, it also concerns the bounds put on the way in which one earned one's living. These codes of practice were more than social niceties; they were enshrined in law. It took a physician's knowledge of the proper medical hierarchy, combined with a sense of professional

and personal outrage, to initiate the case against him. It was then bolstered with the more customary accusations (against wayward clerics) of drunkenness and debauchery, as well as evidence of tax collecting.

During the seventeenth and eighteenth centuries the medical authorities made unceasing attempts to keep the various branches of the healing arts separate. The ecclesiastical authorities also played their part, whether it was licensing midwives, prosecuting cunning folk or disciplining errant clerics. Both sought to enforce what they saw as a divinely ordained hierarchy and order. The previous chapter explored this from the point of view of the protophysicians responsible for licensing and supervising practitioners. But what about the practitioners themselves? What was it about their activities and the demands of the sick that made licensing necessary? This chapter will explore the practitioners: how they trained, practised and fit into the pluralistic therapeutic network. And it will emphasise that what the medical authorities sought to separate, actual practice and behaviour frequently confused and transgressed.

## Physicians and the medical hierarchy

The seventeenth century witnessed a tightening-up of the limits of authority into which the art had divided itself. The intention was to prevent the chaotic number of conflicts between physicians, surgeons and apothecaries. Medical authority defended and developed the specific place of each, whilst respecting a sacrosanct professional hierarchy. Technical capacity was linked to a corresponding politico-moral responsibility.[6] The writers of medical treatises stressed the hierarchical divisions, the boundaries, which separated medicine. The occupational limits and the provinces of each part were regarded as part of a divine order which regulated the Christian community. Medicine was a noble art, because its practice was compatible with nobility, as enshrined in the doctorate. But it depended on two mechanical arts in order to function. At the bedside of the patient, in consultations and prescriptions, physicians wrote in Latin and gave orders, which were carried out by their lesser colleagues, the surgeons and apothecaries. Physicians were specialists of internal medicine, but avoided all manual activities. There was a tendency for physicians to define themselves in terms of what they were *not* and what they did *not* do. They were not apothecaries or surgeons, whose art was mechanical and whose knowledge was acquired by apprenticeship or, in the case of some surgeons, training at hospitals. Their titles reinforced this distinction. In Naples, Latin documents referred to physicians, along with lawyers and small landowners, by the honorific *magnificus dominus*, while surgeons and apothecaries, along with architects, engineers and notaries, were given that of *egregius* or *nobilis* (though the latter was by no means an indication of nobility).[7] In Tuscan documents a physician's name was always preceded by the title *ser* or *messer*, whereas surgeons were simply designated as *maestri*.[8] And physicians were most certainly not empirics, though the public may not always have been aware of the distinction. For the Neapolitan protophysician and professor of practical medicine Antonio Santorelli, the difference was between those who possessed *scientia* – knowledge acquired at university and recognised in

the doctorate – and those who did not. At the same time Santorelli recognised that physicians did not always comport themselves with the necessary decorum. He singled out one who occupied a 'good place' in the profession despite gambling in public, with all the good graces of 'a thug or blustering soldier.'[9]

The itinerant practitioner, apothecary or barber-surgeon who suggested treatments for internal diseases, despite knowing little or nothing about the body's composition, its humours and temperaments, was seen not only to violate the technical confines of the medical corporation, but to threaten the order of the whole. As Scipione Mercurio wrote in 1603: 'therefore, by treating people, they are presumptuous and arrogant, as they are not ashamed to practise so important an art and disregard and do not care that they are losing their souls, since every time they do it they commit a mortal sin.' Alas, he remarked, 'every measly surgeon [*cirugichetto*], every little barber [*barberuzzo*], every old woman wants to play the doctor.' His denunciation even included exorcists, who administered powerful purgatives to the possessed.[10] It was an offence even to appear to be a physician, by dressing in the robes which identified his status in society and separated him from the mass of healers. Each occupation had its recognised apparel. The physician's gown was lined with dark fur, he wore a velvet cap, black gloves and a large gold ring, and his horse had gilded stirrups and was draped with a blanket known as a *valdrappa* (figure 3).

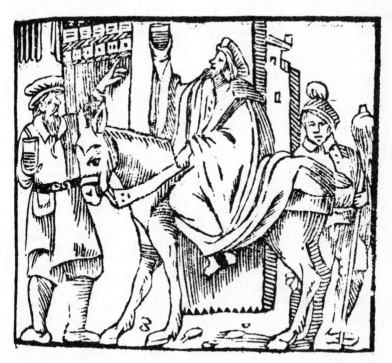

Figure 3 Physician on horseback and apothecary, frontispiece to Giulio Cesare Croce's *Secreti di medicina* (Bologna, 1635)

Never mind that the stirrups, *valdrappa* and similar pomp were generally limited only to great princes and high prelates in the Church.[11] Never mind that, as the Tuscan grand duke's physician Francesco Redi complained in 1682, 'professors of medicine at Padua must have a large retinue of servants and horse attendants and must wear long, majestic robes renewing them daily, and he who does not keep up this pompous affectation is considered worthless even if he is the most learned person of this world.'[12] Never mind that, as Tommaso Garzoni complained in 1585, 'it is enough for the gown to give them honour, rings on their fingers, even though they could not wrap up three pills in a paper bag.'[13] What was worse was that barber-surgeons dared to imitate the physicians' apparel. The right to wear a gown, and related accoutrements, was of symbolic importance. It attested not only to the fact that its wearer had imbibed a certain amount of technical and theoretical knowledge, but that, as a doctor, he had professional status, the *condizione civile* of doctors of law and medicine. So that there was no confusion, the protophysician of Palermo prohibited licensed barber-surgeons from using a *valdrappa*, because they were not graduates.[14] And in 1594 the Bolognese Protomedicato threatened of a fine of twenty-five gold *scudi* and three lashes of the whip against those 'non-doctors who dare to appear in public in the habit and dress of a doctor . . . to the dishonour and derision of true doctors.'[15] For Mercurio the temptation to 'play the doctor' was partially the fault of the 'rabble', who persisted in calling every licensed barber-surgeon 'Signor Dottore'; and the barber-surgeons, 'lulled by this continuous sing-song, easily come to believe it.'[16] As for the charlatans, rather than imitate the physician's apparel, they chose to sport exotic and flamboyant clothes, linking them with the world of street theatre.

## The age of the Colleges

The kingdom's medical community was organised into a corporative structure, with the College of Physicians at its head.[17] The period from the middle of the sixteenth century to the early eighteenth century might be termed the 'age of the Colleges.'[18] There were fourteen Colleges in Italy by the early seventeenth century. During the late Middle Ages some specialist practitioners like barber-surgeons and apothecaries had organised themselves into trade guilds. In principle these were subordinate to the medical faculties, but in practice they had a good deal of autonomy.[19] However, this situation changed during the early modern period. Beginning with an interest in regulating the illicit practice of medicine by means of licensing, the Medical Colleges and Protomedicati sought to extend their authority to the examination and approval of barber-surgeons and apothecaries. Allow me to reiterate briefly. In Naples the protophysician inspected apothecaries' shops alongside officers of the apothecaries' guild, the so-called Speziali degli Otto, from at least 1530. But as of 1573 the protophysician was given the power to ensure that these officers were inspected like any other apothecaries (previously their shops had been exempted), and in 1581 that they were not be given notice of forthcoming inspections. In 1652 the then protophysician Santorelli published a treatise on the office,

outlining its activities and jurisdictions. Much space was devoted to how apothe-caries were to be inspected by him, followed by the 'Petitorio Napolitano', an official pharmacopoeia which listed the drugs to be stocked by apothecaries.[20] In 1668 he ordered how 'the Eight' were to be chosen and the selection of those who were to carry out inspections alongside him was to be carried out.[21] A similar centralisation of power in the hands of the protophysician took place in Palermo.[22]

In Bologna the development was even more pronounced. Here the Protomedicato was a part of the city's Medical College, itself one-half of the Collegio degli Artisti (the other half being the lawyers). In the 1560 the Medical College was awarded powers of inspection, and by the end of the century the apothecaries' guild had lost its authority to license apothecaries to the College. Furthermore, as noted in chapter two, the Protomedicati of Naples, Rome and Bologna were given the authority over civil cases, that is, disputes between healers and practitioners.[23] Previously this power had belonged to ordinary magistrates. In practice, however, such cases continued to be heard in ordinary courts as well, such as the provincial Udienze of the kingdom of Naples and the governor's tribunal in Rome.

Indicative of the rise of the Medical Colleges in general was the foundation of the Florentine College in 1560 by the Tuscan grand-duke. It supplemented the old Guild of Physicians and Apothecaries, considered outdated because it united occupations which were considered separate and subject to hierarchical distinc-tions. The new College consisted of twelve physicians, membership being renewed by co-optation. Membership was the crowning achievement in a physician's career, bestowing both power and prestige. The College examined new physicians and sur-geons, licensing them to practise, and eventually extended its activities to all aspects of the medical profession. Its jurisdiction included the territories of the Fiorentino and the Pisano, even though Pisa had its own College of Physicians, associated with the university there. So the university's graduates now had to be examined and licensed by the Florentine College, even if they intended to practise in Pisa.[24]

The creation of the Florentine College was in fact reflective of profound social change, as Carlo Cipolla has pointed out. Physicians were assimilated into the upper class, for theirs was a noble, learned calling. Surgeons managed to tag along, where they had a medical doctorate – something possible at Italian universities. Barbers and apothecaries, however, were ranked with the lower orders, for their occupa-tion was mechanical in nature. The latter groups retained their guilds, and some-times even limited degrees of power over their members. This was true, for instance, of the barber-surgeons' and apothecaries' guilds within the limits of the city of Naples. Guilds had the power to fine their members for misdemeanours resulting from 'weakness, carelessness or negligence.'[25] Most importantly, they saw to the welfare of their members and their families, which included the funding of beds in local hospitals on the members' behalf. The guilds had an open *matricula* – whoever had the necessary skills was eligible for guild membership – the intention being to eliminate competition from outside. In the case of apothecaries, this extended even to those who were not Neapolitan citizens, the determining factors being residence

and active practice in the city rather than citizenship *per se*. Even though there was an internal hierarchy of positions, all members could become masters, and all masters could be elected to the higher positions (consuls or priors), according to the general rules of promotion. The system was competitive, encouraging emulation and promoting members on the basis of merit.[26]

The Medical Colleges, on the other hand, had a *numerus clausus* of ordinary and supernumerary positions, and membership depended on criteria of birth and social status. There were essentially two types of Medical College: those associated with the universities, which had a monopoly over the granting of doctorates, and, less powerful, those associated with certain cities, which had jurisdiction over who practised in the city and its immediate territory (*contado*). In theory, degrees conferred by the university Medical Colleges were valid without territorial limitations, following medieval tradition. However, both types of College seem to have fought against this, claiming at least the authority to license physicians with doctorates from other states. The city or territorial Colleges were the most rigorous in this regard. Some sought to exclude foreign doctors from practising in the area under their jurisdiction. This included doctors from other states and cities, or even from different provinces of the same state, and natives of the surrounding countryside.

However, in large cities the few privileged members of a College could not and did not pretend to achieve a monopoly over the profession. In Milan, for example, where the College was open only to the local patriciate, College members were far outnumbered by the bourgeois physicians they had recognised. What resulted was something of a balancing act. On the one hand, opening up the membership requirements too much, to the point of resembling an open matriculation guild, represented a loss of prestige. On the other hand, keeping the requirements too strict, *vis-à-vis* the average social status of aspiring practitioners, meant that members were overwhelmed by non-members, with a resulting loss of superiority. By the middle of the seventeenth century the noble physicians of Milan were forced to establish a new College rank of non-nobles attached to the College and allowed to practise alongside them.[27] The Bolognese College, for its part, was open only to Bolognese citizens, but the College reserved the right to make honorary exceptions. The number of College members fluctuated (as high as twenty-three), but did not keep pace with the rapidly expanding number of physicians in the city. Whereas at the beginning of the seventeenth century College members represented thirty per cent of physicians, by the century's end they represented only seventeen per cent.[28] This inevitably meant a high representation for members of certain families within the College and the creation of family dynasties of physicians, a feature of College life that became even more pronounced during the eighteenth century. The Bologna College is nevertheless striking for its relative openness. Of the eighty-four physicians admitted between 1593 and 1692, sixteen had artisan fathers (including a handful of apothecaries and barber-surgeons), twelve were the sons of *gentiluomini*, twelve the sons of merchants, ten the sons of physicians who were College members and four the sons of physicians who were not College members.[29]

The Naples College, rather than close its ranks to non-Neapolitans, granted Neapolitan citizenship to its members. More open still was the College in Salerno. Like its counterparts elsewhere in Italy it was typical in its defence of professional privilege, its adoption of the mechanism of co-optation, the disputes with the city and in the localistic criterion employed in the awarding of positions. But it was exceptional on two counts. First, it accepted all local graduate physicians as eventual members, as the limited places (ten in all) became available. Second, the positions within the College hierarchy were distributed on the basis of seniority, making it a gerontocracy.[30] Despite the decline of the School of Salerno during the early modern period and the claims of the Neapolitan Protomedicato, the Salernitan College of Doctors maintained the right to license local apothecaries, as well as authority over its medical degrees, until its closure in 1810–11. Even towards the end of its existence the College was still issuing large numbers of medical degrees every year, to students from all over the kingdom. Doctoral registers for the eighteenth century suggest that close to a third of students came from the two Principato provinces – no surprise, given their proximity. The rest came from other provinces throughout the kingdom, more or less in keeping with their respective populations. A few even came from Sicily.[31] The fact that Salerno did not require matriculation no doubt helps account for its continued numerical success. It had long been common practice for students to take their degree at Salerno after having initiated their studies at Naples, saving themselves a few years in the process. One who did so was Marco Aurelio Severino.[32]

The power of the Colleges in early modern Italy had a number of important effects on the practice of medicine. The territorial Colleges of smaller cities, like Pavia, sought to deny the right to practise to any but its own members. These limitations eventually extended to those lacking the noble or 'civil' requisites introduced into the College statutes. The Colleges sought to enforce the perceived nobility of the medical profession. Several denied access to physicians from merchant and artisan families. The Milanese College, for example, was open only to the local patriciate, as we have seen. The Pavia College went so far as to obtain a privilege from the emperor in 1667, by which all College physicians became 'Counts Palatine' upon their co-optation.[33] In effect, the Colleges codified social inequality. They reserved for their own members control over examinations and licensing, as well as positions of prestige in the state bureaucracies. Most College members did not even practise medicine, in keeping with their patriciate status; they left that to those physicians ineligible for College membership. The dominance of the Colleges affected the nature of examinations and the awarding of degrees, which shifted from being a check of merit to proceedings aimed at ascertaining the requisites of birth. For those ineligible for College membership, the degree declined in value because it could not pave the way to collegial access.[34] And because the Colleges often shared their hierarchies with those of university medical faculties, this effectively disqualified many physicians from university careers. The closed nature of the Colleges and their degree-granting authority often led to medical dynasties, as mentioned above. In Naples the very successful might look to

an even more prestigious profession for their sons: the law. Occasionally, they bought their way into the nobility.[35]

## 'Ancients' and 'moderns'

The power of the Colleges also affected the way new ideas and theories were received. Most notably, the Colleges were the focus of battles between the medical 'ancients' (dedicated to upholding the classical medical corpus) and the 'moderns.' As physicians, the latter group wanted to be defined, not by birth or seniority, but by their studies, knowledge and publications. Symptomatic of this hidebound system was the reliance of professors of medicine on substitutes for the menial task of giving lectures.

Throughout Italy academic salaries declined during the seventeenth century and were often paid in arrears. As a result, many of the best lecturers accepted well-paying positions outside the university or offered private lessons to paying students, entrusting their university lectures to substitutes.[36] Moreover, the dominance of Medical Colleges meant that students would choose to study under a College member in order to increase their chances of eventually gaining access. In Naples this also meant serving as an assistant, or *pratico,* for a number of years. The clear separation between the Colleges, with their degree-granting and licensing author-ity, and the university, meant that students could obtain their doctorates by merely matriculating, without attending lectures at the university. Indeed the Neapolitan College only lost its degree-granting power to the university in 1811. The publicly granted doctorate, based on mnemonic formulas of medieval origin, became a mere preparation or prerequisite for enrolment and further training within a Medical College, for those who were eligible, or with a recognised professor for those who were not.[37]

In Naples, the university had been founded by royal will and lecturers were still appointed by the sovereign. The head of the university, the chaplain major, was not a scholar, but a state functionary, and university affairs were controlled by the government.[38] The chaplain major, in fact, set the curriculum for the teaching of medicine, traditional in nature. The Spanish authorities had sought to turn the *Studio* into the true academy of the kingdom, by means of legislation and by increasing the number of chairs. But private instruction continued to expand despite this, in addition to the ever-present alternative of the School at Salerno, which did not require attendance. The 1616 pragmatic resulting from the viceregal university reforms defined 'substitutes' as those who filled in for lecturers when the latter were ill or otherwise unable to come; they were not to be used as replace-ments. Except during vacations, no lecturers were to give lectures 'in their own private houses, nor in any other place . . . so that all [students] attend the university, where, in public, they will hear sound and healthy learning.' A fine of one hundred ducats was imposed for a first offence; for a second offence, the lecturer was to be fined two hundred ducats 'and relegated for three years to the Island of Capri.'[39] Such was the widespread nature of the custom that private houses were no longer

spacious enough. In 1621 the government ordered that private lectures were not to be given in churches, chapels or other religious institutions, or in the cloisters of these buildings.[40] In 1663 strict orders against both teachers and students were posted by the chaplain major. Some arrests resulted, occasionally involving lecturers and their students sitting at regular rows of desks, taking notes. Thus in 1669 Giovan Battista Coraggio, lecturing on medicine, while caught *in flagrante* jumped from a window and hid in a nearby church, while the guards arrested the students and sequestered the desks.[41] But the few arrests could not stem the practice. In 1680 the chaplain major complained that more than half the university attended private lectures, some of which had as many as two hundred students, with the lecturers earning as much as three hundred ducats a month.[42] If this was true, the highest paid lecturer could earn as much in two months as he could earn in one year from his university chair.[43]

The plague of private lessons continued well into the nineteenth century, when it was denounced by Domenico Pignataro.[44] It was a symptom of the precarious state of the university, moved from its own edifice (the Palazzo degli Studi) to the monastery of San Domenico Maggiore in the seventeenth century, and back again in 1736, and thence to the Jesuit mother house in 1777, following the expulsion of the Society of Jesus from the kingdom. By this time the reformed medical faculty was kept separate, housed at the Incurables Hospital. Meanwhile, the Palazzo degli Studi was used for the newly founded Royal Academy of Sciences and Letters. The Academy itself was merely the latest in a long line of such institutions which sought to fill the gaps left by an impoverished university structure. Its immediate predecessor had been Celestino Galiani's Academy of Sciences, set up in 1732. Galiani was chaplain major at the time, and rather than directing his energies to reforming the university, he nominated two famous university physicians to important posts: Niccolò Cirillo as president and Francesco Serao as secretary of the Academy.

In the mid-seventeenth century the new academies had offered a challenge to the stagnant university-college system, offering scope for scientific and experimental investigation. Then the medical ancients had the advantage: they occupied all the important chairs and could make use of mechanisms like censorship and the Inquisition to defend their cause. The moderns were dependent on private means or the chance support of a liberal patron. Organising themselves into academies was one solution, but this required even more powerful patronage in order to withstand attack.[45] In Naples the moderns Tommaso Cornelio and Leonardo di Capua founded the Accademia degli Investiganti in 1663. It was under the patronage of Andrea Concublet, the Marquis of Arena, at whose palace they met. They advocated the teaching of chemistry, which was not then part of the university medical curriculum, and so they gave private lectures. The old plague of private lectures now assumed a new urgency, and Carlo Pignataro forbade them. As royal protophysician and holder of the primary chair in medicine, he was already a force to be reckoned with. And he was a traditionalist. He had copies of Sebastiano Bartoli's *Astronomiae microcosmicae systema novum* destroyed, after one of the city's ecclesiastical authorities had declared Bartoli's medical system blasphemous – despite the fact

that the book had received the Neapolitan civil and ecclesiastical imprimaturs.[46] That same year, 1663, an epidemic of 'malign' fevers, accompanied by skin eruptions and high mortality, had broken out around Lake Agnano, near Naples. Following the protophysician's lead, the ancients had ascribed the epidemic to heavy rains, which had prevented the removal of the hemp and flax retted in the lake. The resulting corruption of the air had caused the epidemic. The moderns wanted further studies made, but Pignataro simply forbade the retting of flax in the lake for one year.

It may be, however, that this hasty decision and Pignataro's subsequent tenacity were motivated more by a desire to inconvenience the Jesuits, who owned the land surrounding the lake, collecting a thousand ducats every year from it. The Jesuits of Naples had been wont to call for Pignataro whenever they needed treatment. But after the death of the previous viceroy's younger son under Pignataro's care, and the viceroy's request to have worthy physicians sent in from the provinces, the Jesuits now called in the physician who had been sent up from Calabria, Diego Ragusa. To make matters worse, Ragusa sided with the moderns in the Lake Agnano dispute. In the pamphlet war that ensued, Pignataro's party identified the Investiganti as a stronghold of opposition and a source of satire against the protophysician, who was nicknamed 'Jew-beard', referring to the beards, old-fashioned costumes and affected dignity of the orthodox physicians.[47] The beard seemed to symbolise all that the moderns disliked about the ancients. In one passage Bartoli remarked that the Galenic physicians, 'with long beards and religious hypocrisy ingratiate themselves with princes, gentlewomen, masters of ceremonies, prelates and similar important people, to whom they give medical service gratis, with the hope of later multiplying their gain.'[48]

The moderns did manage some successes before their ultimate 'defeat' of the ancients by the mid-eighteenth century. In 1665, two years after the suppression of his *Systema novum*, Sebastiano Bartoli became physician to the new viceroy, Pedro Antonio d'Aragona. Bartoli had just saved the life of the head of one of the kingdom's most powerful aristocratic clans, Domenico Caracciolo, the Marquis of Brienza, after orthodox treatment had failed. Three years later Bartoli was appointed to the chair of anatomy and surgery at the university, one of the first moderns to gain a university position. He may also have contributed to an interruption in Pignataro's career as royal protophysician. In 1665, in fact, d'Aragona appointed Pignataro's rival Diego Ragusa to the post, which he held until 1673.

However, though Pignataro was no longer protophysician, he retained enough influence to have Bartoli's second version of his book – an 'examination of the commonly received dogmas of the art of medicine'[49] – put on the Index and burned. Pignataro also set up the Accademia dei Discordanti to rival that of the Investiganti. Luca Tozzi was its head. Tozzi became a respected champion of the ancients, dying in 1717, after having been appointed to the chair of medical theory in 1695, and protophysician for three years in 1696. He was a thorn in the side of university reformers because he had his lectures read by an unpaid substitute whilst he went 'daily about the city, doing his rounds and other business.'[50] The sessions

of the Discordanti were devoted to confrontations of Galenic and modern medical doctrines, with the latter getting the worst of it. Following a series of charges and counter-charges between the two, the Marquis of Arena issued a public rebuke to Pignataro for speaking badly of the Investiganti. As a result, the viceroy and the kingdom's Collateral Council advised the disbanding of both academies.[51]

The dispute between ancients and moderns was more than just intellectual in nature, a debate over theory. It involved crucial issues for physicians, like prestige, power and clienteles. In fact, the ancients only contested the ideas of the moderns in a weak, half-hearted way. What they really objected to were the attempts by the moderns to go beyond the confines of their philosophical societies, threatening not so much the cultural hegemony of the ancients, but their 'monopoly on relationships with the public, with clients, power and teaching.'[52] For physicians, individual practices and incomes were at stake; while for students, the choice between ancients and moderns could affect their future careers. For much of the seventeenth century the moderns were 'a small group of physicians unable to guarantee its followers professional success.'[53] A traditionalist protophysician could instigate an investigation into (the newer and still suspect) chemical medicines used by opposing physicians. Moreover, the ten years from 1688 saw increased activity by the Roman Inquisition in Naples, which was seeking to eliminate atomism and other related doctrines allegedly spread by Tommaso Cornelio and Leonardo di Capua.[54] The ancients were still able to command the heights of medicine in Naples, exemplified by Tozzi's appointment as protophysician in 1696, two years after Pignataro's death. As a result, the modern Lucantonio Porzio, despite fame and a chair at Rome's 'La Sapienza', was only just able to obtain the chair of anatomy and surgery at Naples, and this amid much local opposition. Not that the success of Porzio and other moderns was enough to change the university system. Porzio himself was reported to prefer going on his own medical rounds in the city to lecturing, which was done by a substitute.[55]

## Physicians and medical practice

The protracted disputes were seen by contemporaries to lower the physician's professional repute, but this did not seem to affect the numbers of people who opted for medicine as a career. Whatever its standing with regard to the legal profession, physicians still claimed a noble status derived from the doctorate: that is, that their profession was compatible with nobility. We have discussed College physicians, many of whom did not actually practise, and university physicians, many of whom did not actually teach. What about the great mass of physicians? Even within these ranks there were variations, according to their clienteles or the areas where they practised. Clearly there was a great difference between a city physician with patients drawn from the nobility and the *condotto* or community physician of a small town or village. But in either case there was a widespread dependency of practitioners on clients of one form or another, which outweighed collegial bonds between practitioners.[56]

A large number of physicians would have been concentrated in the capital, as was true in all the Italian states at this time. The presence of power structures, from the university to the court, meant that state capitals attracted disproportionate numbers of physicians. The fame of Bologna as a centre of learning meant that there were sixty-three licensed physicians in 1659, for a population of just over sixty thousand.[57] And Rome, as both a religious and secular capital, had 140 physicians for its one hundred and twenty thousand inhabitants in 1656.[58] Exact numbers for Naples are lacking, since the Protomedicato there had no authority over graduate practitioners until the Napoleonic reforms. But during the plague of 1656 the city's health officials, the Deputati della Salute, rounded up fifty-three physicians to serve the city's twenty-nine districts (*ottine*), a figure that probably represents only a small fraction of the physicians then resident in the city. It also appointed one physician-surgeon, fifty-four surgeons and sixty-seven barbers.[59] Appointed practitioners were assigned to a particular area in their *ottina*. They were not to refuse treatment to any sick person, especially when requested by the deputies of the *ottine*, and they were to wear a cross of red cloth of at least a palm's length pinned to their chests so they could be recognised. In the same year, by way of comparison, the Roman Congregazione della Sanità appointed sixteen physicians – out of the 140 theoretically available – for its fourteen *rioni*.[60] In the years following the plague Camillo Tutini's unpublished 'anatomical description' of Naples numbered the practitioners at only sixty-six. And this figure included physicians, surgeons and apothecaries. In addition to this there were 261 barbers and 106 grocers (many of the latter sold medicinal ingredients).[61] Physicians were fairly evenly spread throughout the city, though new arrivals tended to settle in northern areas, where the noble palaces and religious institutions were concentrated. Barbers, on the other hand, in accordance with their status as tradesmen, tended to gravitate southwards to the commercial heart of the city, which included the port and the main market.[62]

As for the kingdom as a whole, there were between two thousand and three thousand physicians, spread more or less according to relative population densities, as we saw in chapter one. The vast majority of graduate doctors would have returned to their places of origin, with the exception of those who sought to make a life for themselves in the capital. We may take with a pinch of salt the polemical comments of Domenico Pignataro, for whom the best of the kingdom's physicians remained in the capital ('where they are able to pursue with greater convenience a glorious career in the natural sciences'), while the worst ('the layabouts, the sluggards, the medical charlatans') returned to the provinces.[63] After all, the kingdom's typical physician was not the College doctor in Naples, but the practitioner based in a small provincial town. He would have obtained his doctorate at either Salerno or Naples. Physic would have made up only a portion of his overall income – perhaps just as well, since a provincial practice would have provided a meagre income. Other sources included land ownership, financial investments and commerce. He would have considered himself a member of the town's elite and might have harboured a desire to join the local aristocracy (or at least enable his children to do so). We are a long way from the modern full-time professional.

Whatever Pignataro might say about competence (impossible to ascertain in any case), there was certainly no lack of physicians outside the capital – whether this is based on anecdotal references, culled from a variety of accounts, for earlier centuries, or based on the Protomedicato lists for later ones. Indeed, if the Protomedicato numbers hold any surprises, it is the relatively small number of physicians who chose to remain in the capital, despite its undoubted attractions, professional and otherwise. While Naples could claim ten per cent of the kingdom's population, it could only attract 5.7 per cent of its physicians. Put another way, Naples had four physicians for every ten thousand people. Although this was higher than ratios for either Paris or London,[64] cities of comparable size, the rest of the kingdom fared much better. Towns one-hundredth Naples' size could expect a ratio of at least eight for every ten thousand. In fact towns of under two thousand inhabitants were, proportionately, the best served, averaging in the region of ten physicians for every ten thousand people.

By way of comparison, in the part of the Tuscan Grand Duchy studied by Cipolla, twenty-three physicians – out of the fifty-two whose birthplaces could be determined – practised in the small centres where they were born. Another fourteen practised in communities within thirty kilometres of their birthplace. Of those practising in the larger towns of Pisa, Pistoia and Arezzo, nineteen of the twenty physicians whose birthplaces can be determined practised in their native city.[65] Given the forms of clientelism then available upon which a physician might build a career, this model probably holds throughout the peninsula. Where possible, graduate physicians took up some sort of permanent engagement (*obbligo fermo*) as a basis for private practice. This consisted of a contract to serve a person or community of people – a household, hospital or religious community – in return for steady remuneration. Many served the last group: it was not unusual for one-third to one-half of physicians to be retained by convents and monasteries.[66] Salaries varied according to experience, reputation and, occasionally, time spent serving the institution. The sums involved were not large, but then practitioners could pursue private practice at the same time (just as individual friars might elect to be treated by outside practitioners). In what seems to have been a typical case, the salary of physician Domenico Pisciotta was raised from twelve ducats to fifteen in 1735 by the friars of San Domenico Maggiore in Naples. In 1743 he received a bonus of three ducats 'for his extraordinary efforts' and in 1746 his salary was increased to twenty ducats. At Easter, Christmas and on the feast of St Dominic physicians and surgeons at the monastery would be offered gifts. Those with long service might even receive a small pension when they retired.[67] The example is Neapolitan, but similar possibilities existed throughout the kingdom.

Aspiring physicians could also seek to develop links with local noble families as a way of ensuring future employment on their return. Whether they chose the law or medicine often depended on circumstance. Patricians with a medical doctorate might, however, view actual practice with distaste, especially if that meant depending on the income derived from it. All of these aspects are reflected in the words of Nicola Gallo, a patrician physician in Bisignano (Calabria Citeriore), about his own

experiences. He began by studying law, before turning to medicine, obtaining his doctorate in 1708 from the School of Salerno.

> I have practised this profession since then, more to assist in the illnesses of their lord-
> ships the prince and princess [Sanseverino of Bisignano] and their children when nec-
> essary, than to derive income from the profession, given that I have only gone to [treat]
> other sick people for the sake of convenience or charity.[68]

In addition to being the household's physician – Gallo made clear – he was also the prince's private secretary, lieutenant-general, vicar-general and procurator-general, as well as vice-prince. Many other graduate doctors from well-off families returned from university to a life of relative ease in the provinces, with no intention of prac-tising. Some came from the professional ranks of the *civili,* families which tended to invest in land. When the last medical graduate of the School of Salerno, Onorato Croce, returned to the small Abruzzese town of Montenerodomo, he turned his hand to administering the family's lands, and later became the town's mayor.[69] Whether they followed outside interests in order to boost their status or because of financial need, it left them open to the criticism that they were putting the sick in jeopardy through lack of experience. In 1811 Giuseppe Ossorio wrote in response to the kingdom's statistical survey that 'the meagreness of their fees and the need to involve themselves in other business in order to survive, the responsibilities they take on, especially that of mayor, and other similar reasons, mean that they neglect their studies.'[70]

Rather than too few provincial physicians, there were too many. There were not enough well-heeled patients to go around. Some, especially young physicians, turned to the public sector for a steady income, small though it undoubtedly was. They served as a community physician (*medico condotto*). The arrangement whereby a community hired a doctor to look after its medical needs had its roots in ancient Rome and was revived during the thirteenth century.[71] Towns and villages took the decision to hire a community physician very seriously. Though it represented an expensive undertaking for the town budget, it was deemed necessary in order to ensure medical provision. Mercurio remarked that smaller communities (*castelli e terre*) were so rigorous in ensuring their selection of a proper and upstanding physi-cian as their *condotto* that it was 'as if he was being promoted to an episcopate.'[72] Nevertheless this arrangement ensured a high medical provision throughout Italy, rural areas included. The model for this has been Cipolla's study of parts of Tuscany, where just over half of the physicians in rural areas were found to be on the public payroll as *condotti* in 1630.[73] But it was as true for the Sicilian countryside, where small towns hoped that physicians would build up a sufficient clientele to be able to remain after their contracts expired, as it was for the Pisan countryside, where eleven community physicians practised in an area with a population of forty thou-sand.[74]

In the kingdom of Naples towns were free to offer special conditions, such as tax exemption, to attract physicians and surgeons. In 1602 the town of Bari offered a 'most worthy' Milanese physician-surgeon twenty ducats towards his rent, raised

by another twelve the following year.[75] Furthermore, the Bari situation suggests that for some towns at least the salarying of public physicians was a matter of administrative routine. Bari had a physician on the public payroll from at least the early sixteenth century, and four or five serving concurrently throughout the seventeenth century. But it remained a contentious issue. The Bari town council narrowly approved the salarying of five public physicians in 1603. Salaries were to range from 300 to 120 ducats a year, based on the physician's age and experience. This amounted to a total annual expenditure of 1,170 ducats. The decision was rushed through, the matter having been deemed most urgent, 'since the city is large and needs not only the said medics, but others too.'[76] The town authorities also encouraged physicians to remain on the public payroll by giving them occasional raises, one-off payments in recognition of extra labours and a small pension when they retired from service. Occasionally, physicians were able to negotiate a pay-rise by threatening to quit unless they were paid more. But the town's annual expenditure remained more or less the same, in the 900–1,200 range. This meant that when one physician retired during the course of the year his salary would be divided up amongst the remaining physicians. Besides making for straightforward accounts, it may have been a recognition that there would be more work for the remaining physicians to do.

Much research remains to be done for Naples before a even a tentative picture can emerge, since the Protomedicati lists for the 1780s and 1809–10 do not distinguish *condotti*. During the seventeenth and eighteenth centuries there was no national policy in this regard and the decision, as well as the cost, was left up to the individual towns. Only in 1816 was an attempt made to ensure more systematic provision. In that year a law was passed requiring every town in the kingdom to have both a community physician and surgeon, who would have the status of civil servants.[77] This is not to say that towns had not been doing their best to attract and employ such people; but information is patchy. For example, we know that small, hilltop towns like Atena and Brienza (Principato Citeriore) were, according to baronial assessments of the time, able to attract physicians to serve their communities.[78] And in the 1590s the municipal officials of the town of Trani (Terra di Bari), despite a deficit, salaried two community physicians and one community surgeon.[79]

The 1811 statistical survey of the kingdom does offer some precise, though selective, information about the presence of town physicians and surgeons. Of the eighty-one communities listed in the Basilicata report, twenty-four are listed as having a town physician or surgeon. In Molise, 28 communities out of 140 hired a medical practitioner, while in Capitanata and Abruzzo Ulteriore we are only told that 'most communities' did so. Finally, in Calabria Citeriore, out of 272 physicians, 38 were *condotti*.[80] The figures are only partial and are presented in a variety of ways, which only seems to reinforce the haphazard nature of the service. Towns could have several *condotti* one year and none the next. On the plus side, many towns are recorded in the survey as paying doctors' fees on behalf of the poor on a case-by-case basis, without going to the trouble of offering a physician a regular contract. The impression the reader derives from these provincial reports is of an institution

on the wane. The compiler for Calabria Ulteriore, the physician Giuseppe Grio, remarked that 'very few towns have maintained the longstanding custom of keeping community physicians', despite recent attempts made to revive the arrangement. Instead, individual families resorted to the practice of agreeing a price with a local physician for a year's treatment, when they could afford to.[81]

Even with the best will in the world small, isolated communities found it difficult to attract outsiders, when there were no locals to meet the demand. They could not afford to be too fussy. The lack of surviving Protomedicati trial records for the kingdom of Naples necessitates a brief trip north, to the Papal States (although the practitioner involved is Calabrian). Disputes between communities and their physician brought before the Rome Protomedicato show that the local elites could be unsatisfied. The pretence for the disputes is often the fact that the physician was unmatriculated or lacked similar recognition from the collegiate authorities. Many *condotti* were taken on without the requisite collegial recognition and documentation, for it meant a trip to Rome and the payment of a fee. It was only if and when things started to go wrong that this lack of College matriculation became a useful tool for redress. The complaint was generally made in the name or on behalf of 'the poor of the community.' An unsigned petition from the town of Castel Bellino (near Jesi in the Marches of the Papal States) noted that its physician 'makes use of secrets in treating people, and not prescriptions, since he cannot speak Latin.' In this way 'the poor of the town' discovered that he had no matriculation. They wanted him removed, since 'it is better to live without any physician at all, then under one who knows not how to read or write.' The accused physician, Giuseppe Umili of Paola (Calabria Citeriore), wrote to the Roman protophysician in his defence that he had a doctoral 'privilege' from Duke Sforza, so that he did not think he needed to matriculate. He added that 'this sort of rigour is not applied in the kingdom of Naples.' Was this true, or simply an attempt at self-justification? In any case, the town's governor came to Umili's defence. He advised the proto-physician, the anatomist Giovanni Maria Lancisi, that he felt unable to suspend Umili, 'so as not to give the poor man this humiliation, and even more so as not to deprive him of his income, of which he has great need; moreover, regarding him and his way of treating people, I have had no complaint, but, rather, I have heard some praise given.' The protophysician ordered Umili to come to Rome to be examined and matriculated. Umili made various excuses, citing the foul air in the town which was causing many people to fall sick. The protophysician then ordered the governor to suspend Umili and fine him twenty-five ducats, only to be informed by the governor that Umili had fled and no one knew anything of his whereabouts.[82]

The hiring of community physicians was not restricted to small towns, as we have seen with regard to Bari. In Naples the urban territory was divided into twenty-nine districts, or *ottine,* each of which had a physician salaried by the city. Their duties were to treat the poor and distribute medicines free of charge. In order to qualify, paupers were issued with a certificate by the Maestri della Carità. The authority for such decisions belonged ultimately to the Tribunal of San Lorenzo,

the city government. The Tribunal was run by six elected officials (*Eletti)* from each of the five noble assemblies (*Seggi nobili)* and from the popular assembly (*Seggio del Popolo)*. It was also responsible for the city's public health board.

Even if there was a golden age when a majority of the kingdom's communities had their own salaried practitioners, we must ask whom the *condotti* served. Contracts varied from place to place and through time, but they usually stipulated that the physician (or surgeon) was to reside in the community and treat the poor gratis. In the case of Bari, physicians had to obtain permission from the syndics before absenting themselves from town. The community's size and wealth would also affect the conditions and salary. In Basilicata some contracts bound the town physicians 'to treat every class of person', others referred only to 'the poor', still others 'the indigent.' In Sicily, by way of comparison, *condotti* might receive 150 *scudi* a year for their services, and were sometimes permitted to charge well-off patients additional fees by the day.[83] In the Pisan countryside, the larger centres might offer the physician a higher, all-inclusive salary, obliging him to treat everyone gratis, while the smaller centres might offer a lower salary, which the physician could then top up by charging the rich for his services.[84]

The decision to salary a community physician was justified with reference to necessary charity for the community's needy poor. Yet it is unlikely that the *condotti* had much to do with the poor. First of all, in cultural terms, the physician was attached to the local well-to-do. They would have been the ones to request his services most often. They shared the same general outlook regarding medical practice, based around the divine ordering of society. A conservative, corporate solidarity was at work.[85] As for the rest of society, there were cultural barriers, however permeable, which favoured the choice of a traditional, popular, easily available form of treatment over a barely accessible learned one. If the elites might have recourse to irregular or improvised practitioners only out of dire necessity or as a last resort, the rest of the population had no such qualms. As late as 1811 it was said that 'the people in [the province of] Molise, as elsewhere, are more prone to believe and obey the herbalist than the physician; they throw themselves into the arms of the charlatan, the cunning man and the astrologer-shepherd for diseases that they believe incurable, and which then become so in fact'.[86] And there was another factor at work. Most people would have been unable to afford the remedies the physician prescribed, even if the visit itself came free of charge and even if suitably 'inferior' remedies were recommended for the more rustic constitutions of the poor.[87] A constant refrain of the 1811 survey was that the poor may have had the 'assistance' of a physician but they were on their own when it came to medicines. Testimony to this, and one possible solution, comes from an unexpected source: the canonisation processes. To counter the problem of expensive remedies, the bishop of Bovino (Capitanata), Antonio Lucci, set up a *monte* for the sick poor of the town in the 1730s. According to devotees, the bishop gave a sum of money in trust to a local merchant. This was made available to the sick on the basis of chits signed by the town's physicians, corresponding to the cost of the medicines required. Such was the exceptional nature of this charity that the bishop,

amongst other factors, was regarded as saintly. Many forms of treatment advocated and practised at the time were simply beyond the reach of the vast majority of the population. One of the treatments of which Bishop Lucci willingly bore the expense was that judged necessary for a peasant 'tormented by acute fever with inflammation of the viscera.' The disease was 'very dangerous and almost incurable', in the words of one of the town's physicians. The treatment was a luxury: it consisted of slaughtering a series of goats, the steaming entrails of which were to be applied to the sufferer's stomach. As the entrails of the first goat cooled, they were to be replaced by the entrails of a freshly slaughtered goat, and so on. 'Ten or twelve goats were killed', according to the physician, and 'within the space of three days the sick man got better.'[88]

## Surgical divisions

Towns that could not afford both a community physician and a community barber-surgeon might request that the physician practise surgery too, offering him a slightly higher salary. But physicians were rarely willing to lower themselves. It was generally easier to hire a community barber-surgeon. They were paid substantially less than their physician counterparts, as befitted their inferior status. The community physician's salary could be as much as four to five times higher than that of the barber-surgeon's.[89] His contractual arrangement was similar to that of the physician, though there are cases of the role being passed from father to son, with the town's approval (something that does not seem to have happened with community physicians).[90] The barber, bloodletter or phlebotomist was the most common sort of medical practitioner. He really came into his own in towns of fewer than 1,000 inhabitants. Towns of 1,000 people or more would usually have at least one of each type of medical practitioner, from physician to midwife, as outlined in chapter one. But the kingdom's very numerous smaller communities would often have only their barber to turn to. He played an important role in the everyday management of health, such as seasonal bloodletting (figure 4). Moreover, his administrations accompanied all forms of physic. Finally, the barber's services were much more accessible, financially and culturally, than those of the physician. The role of the barber in treating the mass of sick people thus represented something of a link between learned and popular medical practice.

For this reason there were pressures on barber-surgeons to practise physic on occasion. In this way he was like the parish priest, who, as a mediator with the sacred, was often cajoled into performing illicit exorcisms by his parishioners. The exorcisms, used as a remedy to 'liberate' the sick from disease, were illicit because the parish priest was neither trained or licensed to carry out what was a specialised activity. To practise their profession canonically, barber-surgeons could only intervene on a physician's orders, not at the sick person's behest. Much of their daily practice, however, would have been based on interventions requested directly by the sick themselves, on the basis of self-diagnosis. Indeed, a not infrequent statement made against a barber-surgeon when incriminated for

Figure 4 Barber-surgeon letting blood from a nun's foot. From Cintio d'Amato's *Nuova et utilissima prattica di tutto quello ch'al diligente barbiero s'appartiene* (Naples, 1671)

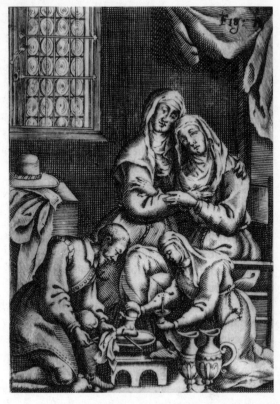

a variety of reasons is that 'he goes about treating all those who call him.'[91] Worse than practising surgery without the physician's instructions was the actual practice of physic, primarily the administering of 'oral' or internal remedies. The barber-surgeon was placed between two stools: on the one hand, he had to respond to his clientele, upon whom his livelihood depended, and, on the other hand, there was pressure from the medical elite to follow the rules and respect the boundaries of his profession.[92] This reality is summed up in Cintio d'Amato's twice-reprinted treatise on barbering. Of course, the barber was the physician's servant: 'that which the learned physician with judgement proposes, the diligent barber with his hands carries out.' Elsewhere, however, for example in France, there were barbers who practised physic. Besides, the 'diligent barber' was often forced by local realities to practise without a physician present, going beyond the bounds of his licence, whether obtained from the protophysician or the College of Salerno. In such cases, d'Amato concludes, he was equal in importance to the physician.[93]

The sick themselves did not make the clear distinctions between the different ranks of the healing arts that the Medical Colleges were seeking to impose. We have already mentioned Mercurio's assertion that licensed barber-surgeons were called 'Signor Dottore' by the populace. Apparently, this was especially the case

with community barber-surgeons. The problem, and the resulting temptation for surgeons, was exacerbated by the fact that, in Padua for example, 'a few doctors of medicine treat surgical cases', as well as practising physic. These were the *medici chirurghi,* or graduate surgeons. Because of them, according to Mercurio, 'the barber-surgeon assumes that he too may practise both arts.'[94] Tiberio Malfi, a native of Montesarchio (Principato Ulteriore) and counsel of the barbers' guild in Naples, noted in his 1626 treatise on barbering the increasing number of physicians who also practised surgery. Though this was not as prevalent in the kingdom as in 'foreign parts (I mean amongst the Spanish, French and others)', there were some noteworthy Neapolitan exemplars.[95] Yet one has the feeling that this point is being made to justify the barbers' practice of physic when the situation required it. Barbers should know more about physic and internal remedies, Malfi asserted.

> I am not saying at all, however, that the barber must become a physician, since if that were the case he would be a physician and not a barber. But since he is a barber and will have to treat people medically, he should have a knowledge of and familiarity with the remedies he would have to use.[96]

This knowledge would protect him from charges of 'inexperience' if he applied a remedy and was later charged with damages by a disgruntled patient. The 1656 plague epidemic exacerbated these tendencies by increasing the demand for medical practitioners and simultaneously decreasing the supply. As the chronicler Parrino wrote: 'The vilest barber passed himself off as a distinguished surgeon, an excellent physician, and one had to beg him and pay him very well in order for him to come.'[97] Indeed, the plague brought with it a generalised sense that the natural order of society had been overturned, given the opportunities available to those surviving in a depopulated city. Giambattista Valentino, a clerk, expressed the sentiments thus in his 1665 poem, written in Neapolitan:

> Lassano affatto l'antico mestiero
> ognuno vole fa mutazione
> è fatto gentelommo lo staffiero
> no pedecchiuso è fatto mercantone[98]

The barber illicitly practising physic became a real concern of the Medical Colleges during the seventeenth century and the early part of the eighteenth. Of the twenty-four denunciations concerning illicit medical practice made to the Roman protophysician-general Giovanni Maria Lancisi in just one year (1711), four were against barber-surgeons for practising physic. Denunciations (*ricorsi*) were made either directly by disgruntled physicians of the town concerned or anonymously by 'the people of the town.'[99] These interprofessional conflicts crop up only sporadically in Bologna during the seventeenth century, but increase during the eighteenth century. This is due in part to the increased frequency of practitioners going beyond the limits of their own professions.[100] But an ever-increasing vigilance on the part of the medical authorities throughout Italy to

affirm the hierarchical and professional divisions of the healing arts is also a crucial element of the story.

Once again, there was no question of the subordination of surgery to physic:

> Every doctor of medicine is also a doctor of surgery, and no simple surgeon can be a doctor. And if one sees, as if very often the case, that, of physicians, not all practise surgery, this is due either to respect for the Colleges or to the fact that not everyone has the stomach to practise it. And for this reason a few manual labourers [*manuali*], called licensed surgeons, are permitted to treat sores and abscesses, clean pus, take the pulse and put on plasters, all however with the permission of physicians. Nor must they persuade themselves that, because of this office, they are doctors, but simple labourers, which is precisely what the name surgeon [*chirurgo*] means, derived from the Greek word (*chiros*) for hand.[101]

To confuse matters still further, the Colleges divided the surgical profession into two, even three categories. Each was permitted only certain surgical operations. In Naples, the Protomedicato distinguished between non-graduate surgeons, who were to be examined on 'head wounds, nerve punctures and other things necessary for the setting of bones', and barber-surgeons, who were to be examined on the location of veins and the techniques of blood-letting. They paid different licence fees as well: the surgeon paid three ducats for his approval by the protophysician, almost three times more than the barber-surgeon's twelve *carlini* for his licence.[102] In Bologna, however, surgeons were subdivided into three categories of competence. These varied from those licensed only to let blood, those who could let blood and treat simple wounds, and those who practised all surgical acts. In both cases, licensing combined restriction and recognition. It sought to limit practice to a corresponding level of skill and experience, while at the same time granting a specific, officially sanctioned status to the practitioner. This was important in a world where individuals without identity were suspect.[103]

In order to be licensed, barber-surgeons were to undergo examinations, according to their category of expertise. Some trials resulted when barbers practised with just the recognition of their guild, without the now (as of the seventeenth century) necessary supplementary licensing by the Medical College or Protomedicato. In some cases the guilty barbers pleaded ignorance of the need for a dual licence.[104] Many more refused to undergo this trial, either because they sought to evade the licence fee, or because they lacked the training or experience necessary to be approved. And for those lacking even guild recognition it meant swelling the ranks of illicit itinerant practitioners. Many of those classed as charlatans and mountebanks by the medical authorities were in fact practitioners of rudimentary forms of surgery, in addition to those who peddled various medicinal remedies.

As far as the elites were concerned, there was a world of difference between the barber-surgeon grudgingly licensed to perform the simplest surgical acts and the hospital-trained, sometimes even university-educated, surgeon. Of barber-surgeons Garzoni wrote: 'they generally prattle like magpies . . . [T]o tell a barber a secret is like telling it to a Levantine Jew, because the example of King Midas' barber, who

revealed that the king had ears like an ass, tells us everything.'[105] Garzoni makes no such remarks at the surgeons' expense. Indeed, their office was of great importance: 'to separate what, in bodies, is united, to unite what is divided, to draw out the superfluous, to preserve without pain and to prevent putrefaction.'[106] While the lowest barber-surgeon overlapped with the charlatan in terms of preparation, practice and status, the graduate surgeon, or *medico chirurgo,* overlapped with the physician. There were chairs in anatomy and surgery at most Italian universities. At Naples it was quite prestigious: one of those who held it, Marco Aurelio Severino, surgeon at the city's Incurables Hospital, numbered the founders of the Accademia degli Investiganti amongst his disciples.[107] As noted in the previous chapter, he was a victim of the very 1656 plague he was assigned to study, as head of a group of physicians appointed to the task.[108] Venice even had its own College of Surgeons, distinct from the barbers' guild (and from the College of Physicians, it must be said). In 1547 the Surgeons' College was made up of fifteen doctors of surgery, three doctors of medicine and seven without doctorates who had been specially examined. One surgeon was even appointed *medico per la terra,* concerned with identifying cases of plague in the city.[109] During the eighteenth century surgeons throughout the peninsula would press for their guilds to be awarded the status of colleges.

There is no doubt that the status of the surgeon changed over the early modern period, though not to the same extent as elsewhere in Europe. This was due in part to the conservative nature of the medical authorities – university, College, protophysician – and their attempts to maintain the separateness of the 'professions' making up the art of medicine. But surgeons did eventually increase their presence at the kingdom's larger hospitals. What seventeenth-century treatise-writers had encouraged as a useful, if somewhat informal, part of a surgeon's training now became increasingly structured. Hospital experience was linked to formal instruction, as university courses were moved to the Incurables Hospital, with its two chairs in surgery and one in anatomy. However, Neapolitan surgeons were far away from usurping the role of physicians or becoming general practitioners. For their part the barbers, increasingly known as phlebotomists or merely bloodletters (*sagnatori*), continued to occupy the lowest rung, though they did have the consolation of knowing that their services would still be the most accessible to the sick.

## The 'good apothecary'

The same can be said of apothecaries. A rare apothecary-surgeon, in the small Abruzzese town of Montenerodomo was, the town's physician grudgingly admitted, 'if not very able, at least of great use to the people.'[110] Despite the usefulness and accessibility of apothecaries the transformation into general practitioners that took place in England never occurred in Naples. Towards the end of the period a handful of practitioners are identified in the Protomedicato registers as 'surgeon-apothecaries', but they are clearly exceptional. Apothecaries practising in the capital, whose numbers fluctuated around a hundred throughout the period, were

kept in check by both the protophysician and their own guild. The various branches of the healing arts were to be kept separate:

> When you find an apothecary practising physic with our licence [the protophysician ordered], you will take it away, because if this had been clear to us we should not have granted it, given that it is not appropriate to be both an apothecary and a physician at the same time. And if the apothecary be a doctor in physic, you will order him to choose one or the other of the said practices, prohibiting the apothecary to meddle in physic in the future, if he should elect to be an apothecary.[111]

This is not to say that apothecaries did not practise physic or surgery on occasion. If the temptation for barber-surgeons to practise physic was great, especially in extenuating circumstances, it was only slightly less so for apothecaries. Given the first-hand knowledge of drugs they acquired both through apprenticeship and the filling-out of prescriptions for physicians, it is no wonder they dispensed drugs themselves on occasion, without a doctor's intervention. As far as the sick were concerned, this form of illicit practice was unlikely to present a problem. Indeed, apothecaries were probably responding to the requests of the sick when they turned to physic, just as barber-surgeons did. The Neapolitan Dominican and apothecary Fra Donato D'Eremita was perhaps writing from personal experience acquired at his shop in the monastery of Santa Caterina a Formello when he remarked: 'It seems to us that the common people hold an apothecary in higher regard than a physician. And we see that a sick person, not believing in the ten most important physicians, will not mistrust in the least the work of a single apothecary, be he poor, vile, corrupt and ignorant.'[112] Not that Fra Donato was advising apothecaries to exceed the limits of their profession; far from it. He reminded apothecaries not to dispense any medicine not prescribed by a physician, nor substitute or otherwise alter their ingredients.[113] But these were widespread practices nevertheless, as the Gizzi case reminds us. However, if a death resulted and criminal accusations were made against the apothecary, it was the sort of evidence that would be brought out to incriminate the accused still further. In any case, it was usually the physician of the town who made any accusation before the medical authorities. If the moral order was threatened by the apothecary's actions, it was only the physician who seemed really concerned, to the extent of making false accusations to bolster the case against his rival. As has been found elsewhere, the Protomedicati do not seem to favour their own in cases involving physicians in some way.[114]

For the eminent French physician and writer Laurent Joubert, the 'ruin of physicians' and 'calamity for patients' lives' was the apothecary, who, with but a little knowledge of medicines, presumed to treat people. But the grass was always greener on the other side of the hill (or the mountains, in this case):

> In Italy and Spain (as I understand it), patients are much better off, for the apothecary does not visit the patient except out of courtesy and friendship, not as an apothecary. And the physicians do not write at the bottom of their prescriptions what the medicine is for, so that the apothecary knows as little about the physician's intent as if he

had seen nothing at all. In this way he is unable to abuse the physician's prescriptions or does so far less than our own apothecaries, to whom everything is too plainly divulged.[115]

Far from stressing their relative ignorance, however, several Italian writers praised the apothecaries' knowledge. Garzoni praised the apothecaries for their medicinal expertise. They 'sometimes amaze the physicians themselves, even though [physicians] are generally contrary and opposed to this type of practitioner.'[116] Their knowledge of the pharmacopeia, and their role in introducing new drugs, often gained them positions of prestige, far beyond the status of tradesman. To say nothing of money: some apothecaries, like some surgeons, could earn far more than physicians. In the mid-sixteenth century Ferrante Imperato achieved great renown in Naples as a botanist and keeper of a private natural history museum. Two centuries later Nicola Meola boasted of similar successes, causing amazement amongst the city's College physicians with his preparation of antimony (though we have only his words to go by).[117] Meola – who lived and worked in the small town of Greci (Principato Ulteriore), after having trained and served his apprenticeship in Naples – is interesting because of a lengthy and rather personalised collection of remedies he compiled. In it he suggests, amongst other things, that he was *prescribing* remedies, trying them out on patients, as well as dispensing.[118] Moreover, he had the daring to advise physicians on what drugs they should use, advice that came with more than a hint of bitterness. With regard to theriac, he comments, in his typically discursive prose:

> Here I am at last under the pressure of truth for the sole [purpose of the] unmasking of malice, oh graduate professors of the medical art, Galenics, Hippocratics and Spargyrics. It rests on you, oh practitioner, for both the decorum of such a proud profession and for the true recognition of simple medicaments, to put into use (without, however, revealing it to the state) a so celebrated antidote, so prodigious, so universal, without falsities, without caprices, without danger. Put it under your eyes, for it is in this especially that consists its power and human benefit.[119]

An experienced and well-informed apothecary like Meola was no doubt quite welcome in a small town (aside from the unwitting victims of his drug trials, perhaps). This was especially so where there were no physicians or surgeons, as in Greci. Scipione Mercurio, a physician like the above-quoted Joubert, remarked in his book devoted to 'popular errors' that a 'good apothecary' was more important for a community than a 'good physician.' 'This is the case', he wrote, 'because the experienced apothecary can often correct the error of the ignorant physician, due to the great experience he has both of the nature of the medicines and their doses.' But there is an important qualification to Mercurio's praise. A bad apothecary, 'miserly and negligent', may ruin the medicines ordered by a learned physician. In the cities the good apothecaries will make up for the one bad one; but in a small town one is in the hands of the only apothecary. From this follows Mercurio's fervent support of the Protomedicati, especially that of Bologna, because they inspect the apothecaries on an annual basis. While community physician in the

town of Lonato, near Brescia, Mercurio instituted a similar procedure. 'Although it cost me much effort and made me hateful to the apothecaries', he remarked, 'nevertheless I wanted to do it to ease my conscience and because I saw how useful and necessary it was for my patients.'[120]

Apothecaries, however much they were appreciated and needed, were reminded to keep their place. Francesco Sirena, in his 1678 guide to the profession, pointed out that treatises like his should be written in the vernacular. This was because 'speaking in a polished and elegant way is necessary in a virtuous academician, but not in an apothecary, for whom speaking poorly is of little importance as long as he practises well.' Humility, simplicity and piety were the crucial traits. The apothecary did not need to know how to measure time into minutes or half- and quarter-minutes for the preparation of medicines; more reliable and better known to him would be the different times required to say an Ave Maria, Credo or Gloria.[121] The Neapolitan protophysician Santorelli, however, seemed to assume a slightly higher standing for the apothecary, though the professional boundaries remained equally fixed. In addition to being of honourable reputation, the 'good apothecary' was to have the means adequate to practise his profession. This meant possessing at least five hundred ducats' worth of goods – an attempt to avoid the temptation facing apothecaries of fraudulent cost-cutting measures. He should know enough Latin to understand the canons of Mesuë, but even this was not absolutely crucial, since most of what an apothecary should know had been published in Italian, and much could be gained with experience.[122] Guild statutes also specified that an apothecary had to have been resident in the city for a given period, such as ten years, and have trained with a recognised apothecary, before he could examined and admitted to the guild and allowed to practise. In order to rent or buy a shop he had first had to obtain written permission from the guild consuls, so that apothecaries' shops 'do not fall into the hands of unsuitable people.'[123] But, as we have seen, guild acceptance was only one level of recognition. The Medical College or Protomedicato had the final say.

Their main business, in fact, was apothecaries. Financial interests coincided with the desire to uphold the moral order. The inspections of apothecaries' shops – to ensure they had the drugs listed in the official pharmacopoeias, in the proper condition and at the proper price – were important sources of income for the medical authorities. Penalties for fraud could even extend to confiscation of the entire shop, one-third of the proceeds going to the accuser, representing the Protomedicato, as was the case in Naples (another third went to the state treasury and a final third to the city's Annunziata Hospital).[124] Yet the somewhat artificial divisions of pharmacy, like those for surgery, made life difficult for the Medical Colleges. The activities of grocers overlapped with that of apothecaries and much legislation was needed in the effort to keep them apart, a dispute witnessed in chapter two.

## Midwives and the continuity of community sanction

Arguably the greatest threat to the moral order of medicine came from those who were outside it, at least according to the official rhetoric. It should have been

straightforward for the Protomedicati and Medical Colleges to exercise authority over both midwives and itinerant 'charlatans', since they had no other bodies to represent them. Actual practice proved otherwise.

Midwives were not a real concern of the medical authorities until the latter half of the seventeenth century. This was left up to community sanction and the parish priest. Midwives were generally illiterate, without any formal training. They usually assumed their role late in life, after having children themselves and gaining experience accompanying an already recognised midwife. Their recognition came as the result of community consensus and some form of episcopal licensing. The Counter-Reformation Church sought to ensure that midwives were pious and of honourable behaviour because they had the responsibility to baptise infants in danger of death and were the only women permitted at the baptism. At first, any concern the protophysician may have had was cursory: the bare minimum needed to justify payment of the licence or visitation fee to the Protomedicato. The Neapolitan protophysician Santorelli, writing in 1652, commented that a midwife need not be examined on what the pregnant woman should do before and after birth; she need only know what to do during birth.[125] This attitude changed little over the next 150 years. When rudimentary training was introduced by the medical elites it was not energetically enforced. Licensing continued to reflect the traditional means of choosing a midwife – community sanction – rather than challenge it. Figures for licensed midwives may seem low in comparison to, say, barbers: around nine per ten thousand of population in smaller towns and four per ten thousand in larger towns. But then a large proportion never bothered to obtain a licence, as we shall see below.

The midwife existed in the overlap between learned, ecclesiastical and popular forms of healing, as suggested in chapter one. However, this did not mean that midwives were of irregular or unrecognised status. On the contrary, the state granted them a degree of official recognition by calling on them to act as expert witnesses in cases of rape and infanticide. In Naples, however, they do not seem to have achieved the status of salaried municipal midwife as it existed in some areas of Europe. But, as with the *condotti,* more research needs to be done at the local level to ascertain the practices of the municipal authorities. In everyday reality midwives frequently found themselves between two different levels of society, two different notions of what was expected of them. On the one hand, there was the link between the midwife and popular culture, where she was associated with the wise woman, because of her ability to treat disease, and where her childbirth experience was complemented by a knowledge of spells and ritual healing techniques. On the other hand, she was connected with power structures, ecclesiastical and medical, on a par with society's artisan classes. A 1615 case involving the Neapolitan midwife Fiorella Testa illustrates this tension.[126] Testa was accused by Antonio Vinaccia, a carpenter, of having caused the deaths of his two children by magic. While on his way to the apothecary's to get a syrup for his ailing baby daughter, he met Testa, who had delivered and baptised both of his children. He mentioned his daughter's illness and Testa returned with him to have a look. She concluded that the infant

had been 'touched' by witches (*janare*) at night. According to Vinaccia she took the infant in her arms and 'secretly said words into her ears and then licked her forehead and spit on the ground.' But the real shock came when Testa remarked to an unsuspecting Vinaccia what a shame it was that his son was also ill.

As a first precaution she ordered bunches of herbs hung by the window and door. The only real solution, however, was a magical rite, and there was no time to lose. Testa ordered Vinaccia to bring her a certain coin, go to the crossroads as the Ave Maria bell was tolling and pick up a handful of earth. He was to divide this into two pouches, one for each child, which they were to wear. Despite this, the infant girl died, followed by his son, three days later.

Was Vinaccia's denunciation of the midwife Testa motivated by the search for vengeance at the untimely death of both his children? Did she really make use of the magical remedies described? Midwives were frequently suspected of including such rituals in their repertoire; but they were just as likely to turn to more orthodox religious responses if their store of natural remedies proved insufficient. The episcopal court asked Testa if she did any healing, in addition to delivering babies. She admitted to treating babies 'who were crying because they had a stomach ache or because of other illness.' But the treatment she admitted to practising was totally acceptable, consisting as it did of placing her hand on the child's forehead, making the sign of the cross and saying 'slowly and softly' three Paternosters and three Ave Marias 'for a devotion I have to Saints Cosmas and Damian'. This was appropriate, since they are the patron saints of medical practitioners. As for the signing ritual, it was one of the most common remedies, used throughout Italy, to the point that in some areas the verb 'to sign' was the equivalent of 'to treat.' Testa can only conclude that Vinaccia must have mistaken her prayers for magical utterances. She never said the girl was 'touched.' Certainly, this was a very real form of disease causation as far as most people were concerned. It was a possibility that worried parents, since young children were considered especially vulnerable. However, Testa denied knowing 'how to recognise babies touched by witches, and I don't know any remedies for it.' Nor was any magic involved in identifying his son's illness. It was clear he was suffering from a hernia. She instructed the parents to prepare a rosewater infusion for the boy. It was Vinaccia who insisted on the magic, though she warned against it. Later, when Testa noticed the two pouches, she asked him what they were for. Vinaccia told her what they contained and said 'they served to keep the witches away from this house.' The coin she asked for was in payment for her services, nothing more. Testa ended her defence by remarking that Vinaccia blamed her for the death of his two children, especially that of his son, that he had threatened her and called her daughters whores.

The Vinaccia house was searched by court officials, where they found the two pouches and various bunches of herbs. At this point there was no obvious way of reconciling the two contrasting versions of events. A month later the court received a petition signed by six men describing her honourable and pious behaviour as a midwife. In form and content it is strikingly similar to testimonials written on behalf of young apothecaries wishing to open their own shops and sent to the

authorities.[127] In this case the signatories identify themselves as from the neighbour-hood and would appear to be of the same social status as Testa (they sign their names, but aside from one tradesman, there are no titles). They declare that she has performed as midwife in all of their houses, 'without ever practising or uttering any superstitious or evil thing', but using 'only the words of the Roman Catholic Church.' The petition seems to have been decisive, for Testa was released the same day. But there was some lingering suspicion: she was assigned a confessor, warned against uttering any secret words or reciting anything other than prayers in her activities, and told she must confess and hear mass regularly.

The trial, before the episcopal court, is an example of how the Counter-Reformation church was seeking to Catholicise the midwife's activities: a move-ment that received full support from the political and medical elites of the day. It was only towards the middle of the following century that the kingdom's secular authorities began to be concerned about midwives – their activities, their training, their licensing. For some time there had been concern that that midwives were evading the visitation fee, though this had little to do with maintaining standards, and much to do with raising revenue for the tax collectors. The first reference to the fining of midwives for practising without a licence came only in 1738, when the fine was set at 150 ducats.[128] This was rather later than elsewhere in Italy. In Bologna, for example, the local Protomedicato had first set about counting mid-wives in 1682, in order to ensure that only licensed midwives practised.[129] Until the eighteenth century learned medical attention to childbirth remained largely theo-retical; the actual practice was left to women. The medical community regarded midwifery as degrading, vaginal blood the most impure.

They did interfere, however, if a midwife was suspected of practising physic or surgery: in other words, treating the sick. Officially, women were prohibited from treating the sick in any way. Whatever women might have been allowed in the past – records exist of women practising physic and surgery during the Middle Ages[130] – only midwifery was now legally open to them. Even midwives were prohibited from administering internal medicines, letting blood or using surgical instruments of any sort, however useful these might have been.[131] This flew in the face of ancient (and continuing) practice, whereby midwives cared for various aspects related to female sexuality and children's diseases. Indeed, along with barbers, 'theirs were the hands that most often touched the sick body, in the most humble and common tasks and aspects of treatment.'[132] The real concern of the elites was to keep them away from physic and surgery. As far as Mercurio was concerned, most of the medical 'errors' were made by women, 'who presume too much in medi-cine.' The problem was that of forcing them to abandon such pretence, so that 'they learn to practise that [profession] which is commanded by expert physicians, and do not seek to meddle in a profession so unbecoming their own estate.' [133]

Actual conditions, however, meant that there was some leeway, at least for the woman healer licensed as a midwife. A clear distinction – that historians do not always recognise – was made between unlicensed women healers and wise women, on the one hand, and officially recognised midwives on the other. Despite the

openly illicit nature of her activities, the Protomedicati could be lenient if certain conditions were met: (i) if she was a licensed midwife, or prepared to undergo licensing; (ii) if she treated the sick gratis, in good faith and at their behest; (iii) if there were no other licensed practitioners in the vicinity; and (iv) she had caused no one any harm.

Medical attention to the standards of midwifery practice began in the eighteenth century. A school of midwifery was first set up in Turin, following the French lead, in 1732. Such schools, generally linked to hospitals, university courses or the rising medico-surgical Colleges, were soon founded elsewhere: 1757 in Bologna, 1767 in Milan, 1774 in Padua.[134] In Naples this happened in 1777, when Domenico Ferrari was awarded the newly established chair in obstetrics at the university and taught 'the art of delivering births' at the Incurables Hospital. Salerno followed in 1791. As far as actual practice was concerned, the Incurables was the only Neapolitan institution to take in women in labour. It admitted 167 in 1759.[135] By 1787 the Hospital had its own maternity ward, under the direction of the Frenchwoman Thérèse Ployant, author of a treatise on midwifery.

With Ployant we are clearly entering into a new phase in the history of midwifery, though one that was not without obstacles. Her role as 'chief obstetrician' at the hospital presented some difficulties, as both an outsider and a woman, in a new academic discipline dominated by men. In her book Ployant relates that on one occasion, while she was removing the placenta from a woman 'in a gentle way, as is required', a young hospital doctor pushed her aside, and took it out 'in a frenzy.' The woman survived the ordeal, but the conflict between Ployant and the doctor wound up before the protophysician, with the doctor attempting to discredit her and have her dismissed. Though the attempt failed, it does remind us of the tensions that existed.[136]

In Italy – as in Spain – the rise of obstetrics did not see the replacement of midwives by men-midwives or accoucheurs. The schools aimed to increase standards of childbirth through the education of women, rather than seeking to edge them out.[137] Moreover, the Catholic Church felt that only women were appropriate to the task, except in emergencies. If formal training did not mean the end of the midwife in the Italian peninsula, it did spell the beginning of the end for the traditional midwife. Nowhere did this take place overnight, of course. Courses may have been offered, but traditional midwives were reluctant to take them, often for very practical reasons. As late as 1816, of an estimated 600 midwives practising in Naples, only six turned up for the course at the Incurables, though it was obligatory for all midwives under fifty.[138] One wonders at the success rate of the impromptu courses that physicians were supposed to hold for aspiring midwives outside the capital. If the comments made as a result of the 1811 government survey are anything to go by, the situation changed little. Most provincial midwives continued 'to learn through practice.'[139] Only the expectations seem to have changed. By now it was becoming a conflict between two different levels of society: between the taught courses, examination and licensing that the central medical authorities were increasingly insisting on and the traditional local way of choosing local midwives,

based on acquired experience, skills frequently passed from mother to daughter. But, even then, there persisted a tacit acknowledgement that, in the absence of taught courses, the only way a woman could gain the knowledge of midwifery necessary in order to be approved and licensed was through previous, unlicensed, experience. The protophysician was also fairly lenient when it came to payment of inspection fees, given that many midwives were poor and requested exemptions. Local administrators judged the fee too high. The intendent of Abruzzo Ulteriore wrote to the Interior Minister requesting a reduction in the fee for the 'wretched midwives who, in the small towns of this province practise out of humanity, helping each other, without any payment.'[140] Finally, in 1824 the intendant of Naples complained to the protophysician that so many practitioners, especially midwives, were evading licence fees and proposed harsh police measures against them. The protophysician took a more realistic, mediating position, asking how unlicensed midwives could be prevented from practising 'if they are the totality'? It would be unwise, not to say harmful, to leave 'the populations without any assistance.' Moreover, the protophysician acknowledged, even if many midwives were unlicensed, they were invariably 'women experienced in the occupation and grown old in their practice.'[141] Community sanction continued to be the most important factor behind a midwife's local practice well into the nineteenth century.

## Itinerant practitioners

One group that makes only the briefest of appearances in the 1786 and 1809–10 Protomedicato lists – but is frequently referred to in the 1811 survey – are the itinerant practitioners. Known by the terms *ciarlatano* or *montimbanco* at the beginning of our period, by the end of it the terms *empirico* and *segretista* have taken over. In practice, charlatans tended to be evasive by their very nature, and often escaped licensing. If itinerant practitioners stuck to the licensed selling of drugs or minor surgery, then they were tolerated by the authorities, despite the harsh and satirical medical rhetoric of the time. The Medical Colleges and Protomedicati took a realistic stance regarding charlatanry: they never sought to eliminate it, merely to contain it within what they considered proper limits. And as we have seen with regard to barber-surgeons, licensing should not be seen merely as a restrictive phenomenon. It also bestowed a form of official recognition of the charlatan which he could use to his advantage.

Charlatanry was simply a response to a demand for accessible medicines, presented in a theatrical and entertaining manner. Some of Europe's most famous empirics were Neapolitan, like the self-styled Orvietan, the focus of chapter four. Yet we know very little about charlatans within the kingdom. An edict issued in 1581 prohibited unlicensed practitioners from practising medicine or dispensing medicaments. In 1652 the protophysician Antonio Santorelli noted that previously those people who practised without undergoing an examination and without being licensed by the protophysician were 'deprived of all their moveable goods.' Whereas by his time the prosecution of a charlatan was dependent on a disgruntled patient's

accusation, which rarely took place since the patient was usually satisfied with his money back. Charlatans ranged from family dynasties organised into theatrical companies, selling their own patented medicines, through to impoverished pedlars making do with a few jars of some herbal remedy bought wholesale. They toured the markets and fairs of the kingdom, concentrating their activities in Naples itself. Here they operated in the Piazza del Mercato, where the 1647 revolt began, or in the nearby Largo del Castello, the ample open space by the harbour in front of the Castel Nuovo. Little can be said about numbers, though there must have been thousands throughout the kingdom. It is impossible to verify the extent to which licensing was a municipal matter because of the destruction of the city archives in 1943. By way of information, the Paris police kept a register of empirics that contained 1,746 names when it was turned over to the Société Royale de Médecine in 1778. If they were all active and present in the city at that time this would mean that charlatans outnumbered physicians and surgeons by three-to-one.[142]

Charlatans were potentially an even greater threat to medicine's moral order than apothecaries or barber-surgeons because of the sheer numbers who boasted of practising physic better than the physicians themselves. The public was easily taken in, Santorelli claimed. Medicine was not like the other professions where 'we are immediately aware if the author is ignorant, whether by the tailor ruining his garment or the shoemaker his leather.' Moreover, the charlatans may have been short on university learning, but they were not short of audacity, and 'because he who knows less prates and raises his voice more, and the populace recognises he who shouts the loudest, so it is that the [person] ignorant in medicine is at times more esteemed than the learned and modest.'[143] For Mercurio it was not simply the remedies they used, but the way they used them. Charlatans wanted 'to heal their patients right away and acquire quick praises from them.' Conversely, physicians awaited 'the motions of nature', attempting to bring about a purgation 'by means of reasonable remedies in a suitable time.'[144] Charlatans met with much revulsion from learned physicians precisely because they straddled the boundaries which separated the medical community. Their use of spectacle and performance to sell their remedies was a sign of their liminality. The medical elites struggled, in vain, to keep the theatrical and commercial side of the selling of drugs separate from the medical aspects of diagnosis and treatment. Charlatans called their remedies 'secrets', because they worked through unknown means, seeking to distinguish them from ordinary simple and compound remedies then available. But, in fact, their 'secrets' did not differ substantially from the drugs listed in the official pharmacopoeias, and the medical authorities knew this.

## The 'professions'

Given the increasing attempts by the medical elites to exert some sort of control over these various sorts of healers, in particular with regard to enforcing the moral structuring of the medical world, can we speak of an ongoing process of professionalisation? To begin with, it would be wrong to regard all the medical arts as

forming one profession. Indeed, in the terminology of the time, each was a 'profession', in the sense of being an occupation. Of course, a clear hierarchical distinction was made between the manual or mechanical and the learned, but this was not implied by the use of the word 'profession', which was not then restricted to prestigious occupations alone.

Professionalism and professional functions were present throughout early modern societies. Healers mediated between a social demand for the prevention and treatment of illness and a more or less esoteric corpus of knowledge. The healer possessed the general knowledge necessary to treat the client's specific case. The healer's social role, derived from his or her social knowledge, is thus a defining characteristic, unaffected by issues of therapeutic efficacy or science-based authority. Practitioners, taken as individuals or groups, may have been of a low or precarious economic status, but their social – and even political – role remained strong.[145] This applies as much to physicians as it does to midwives. What distinguishes the two groups, however, was the existence of formal occupational associations for the physicians, but not for the midwives. It is, in fact, what most distinguishes the medical 'regulars' – physicians, surgeons and apothecaries – from the outside, officially at least, like charlatans and midwives. Like the physicians, barber-surgeons and apothecaries were organised occupational groups, with a broad demand for their services.

It is not difficult to conceive of early modern Italian physicians as a professional group, regardless of the ability to heal the sick in any effective way. They possessed a body of knowledge taught at institutions of higher learning and a means of qualification and official recognition. Through their own exclusive corporations they sought to impose a monopoly on the practice of physic. Their status ensured them of contacts with the wealthy and the powerful, even though most practitioners were not themselves able to attain these attributes. Professionals in early modern Europe need not have been amongst the top levels of the social hierarchy. Physicians, in fact, were considered inferior to the lawyers, to say nothing of the wide variance in status between a protophysician, holder of a university chair and prior of the local Medical College, and physician serving out a contract in some isolated mountain town as its *condotto*. But it has been more difficult for historians to grant professional status to the manual practitioners of early modern Europe: the barber-surgeons and apothecaries. Their professional structure – the guild – was different from that of the physicians, in that it was socially inclusive and comprehensive, rather than elitist and exclusive, but it did provide them with both legal status and group identity. These are two features of a model of the profession that Toby Gelfand has constructed for 'ordinary' early modern European practitioners. Another defining characteristic was substantial numerical strength, with levels of provision approaching one practitioner per thousand inhabitants, and wide geographical distribution, extending into rural areas. Finally, despite nominal subordination to the medical authorities, there is a degree of *de facto* autonomy, as well as independent training structures.[146]

That said, it would be inaccurate to characterise the increasing supervisory role of the Medical Colleges and Protomedicati as professionalisation. The increasing

regulation by the medical elites and attempts to enforce the hierarchical and occupational divisions of the healing arts was not an attempt to control the whole medical field. It was not going to pave the way for the unity of medical practice in its various forms. Nor was it in any way striving to constitute and control the medical market for the expertise of a reorganised and unified profession.[147] As this chapter has attempted to show, it was directed at enforcing boundaries and bolstering the distinction, prestige and power of physicians as reflected in their own professional organisations. It reflected the outlook and of the medical elites more than that of the thousands of lesser practitioners throughout the kingdom, to say nothing of the sick themselves. Local reality often meant a mixing of 'professions.' The 'disorder' so dreaded by the elites was always bubbling away just beneath the surface. As late as 1792 one disgruntled Calabrian physician saw in a renewed Protomedicato the hope that it 'would help put an end to other abuses where some apothecaries take the liberty to practise now as physicians, now as surgeons, especially in syphilitic maladies; surgeons practise as physicians and apothecaries; not to mention several physicians who take advantage [of the situation] to dispense certain of their own remedies.'[148]

His words reflect a breakdown in the corporative divisions that was a feature of late eighteenth-century medicine. But, as we have seen, these transgressions were a fact of life throughout the period. His words would have struck a familiar chord with the elites at any time over the previous two centuries.

## NOTES

1 'Pro Rev. Pro.re Fiscali contra Rev. D. Amicum Giptium', A.D.M., C/23/543.
2 *Ibid.*, fol. 18v.
3 *Ibid.*, fol. 3.
4 *Ibid.*, fol. 7.
5 *Ibid.*, fols 26r., 27v.
6 Guido Panseri, 'La nascita della polizia medica: l'organizzazione sanitaria nei vari Stati italiani' in G. Micheli, (ed.), *Storia d'Italia. Annali 3: Scienza e tecnica nella cultura e nella società dal Rinascimento a oggi* (Turin, 1980), p. 180.
7 Giovanni Cosi, *Il notaio e la pandetta: microstoria salentina attraverso gli atti notarili (secc. XVI-XVII)* (Galatina, 1992), p. 11.
8 Carlo Cipolla, 'The medical profession in Galileo's Tuscany' in idem, *Public health and the medical profession in the Renaissance* (Cambridge, 1976), p. 76.
9 Antonio Santorelli, *Il protomedico napolitano, ovvero dell'autorità di esso* (Naples, 1652), p. 44.
10 Scipione Mercurio, *De gli errori popolari d'Italia* (Verona, 1645), pp. 207, 214.
11 *Ibid.*, p. 114.
12 Francesco Redi to Lorenzo Bellini (1682), in Redi, *Opere* (1741 edn.), vol. 4, p. 89; in Carlo Cipolla, 'The professions: the long view', *Journal of European Economic History*, ii (1973), p. 49.
13 Tommaso Garzoni, *La piazza universale di tutte le professioni del mondo* (Venice, 1616), p. 70v.

14 V. Parisi, *Capitoli ed ordinazioni della felice e fedelissima città di Palermo, sino all'anno corrente 1768* (Palermo, 1768), pt III, section XX, no. 88; in Giuseppe Pitrè, *Medici, chirurgi, barbieri e speziali antichi in Sicilia, secoli XIII-XVIII* (Rome, 1942), p. 133.

15 A.S.B., *Studio*, 214, no. 2.

16 Mercurio, *Errori popolari*, p. 208.

17 Given that the tripartite division was in fact the norm in Italy, it would appear to have more in common with the French system than Laurence Brockliss and Colin Jones allow, in *The medical world of early modern France* (Oxford, 1997), pp. 12–13.

18 Elena Brambilla, 'Il "sistema letterario" di Milano: professioni nobili e professioni borghesi dall'età spagnola alle riforme teresiane' in A. De Maddalena, E. Rotelli and G. Barbarisi (eds), *Economia, istituzioni, cultura in Lombardia nell'età di Maria Teresa*, vol. III, *Istituzioni e società* (Bologna, 1982), p. 80.

19 Toby Gelfand, 'The history of the medical profession' in W. F. Bynum and R. Porter (eds), *Companion encyclopedia of the history of medicine* (London: Routledge, 1993), vol. 2, p. 1122.

20 The 'Petitorio' was revised in 1684, though in a Latin version: Carlo Pignataro, *Petitorium in quo continentur ea quae quilibet pharmacopoeus sua officina, in hac Urbe Neapoli et Regno, in visitaionibus faciendi habere et ostendere debat* (Naples, 1684).

21 Lorenzo Giustiniani (ed.), *Nuova collezione delle prammatiche del Regno di Napoli* (Naples, 1805), vol. 12, pp. 201–9.

22 J. Alarcón and J. L. Valverde, 'El Colegio dei boticarios de Palermo y el Protomedicato', *Boletín de la Sociedad Española de Historia de la Farmacia*, xxxix (1988), p. 41.

23 Gianna Pomata, *La promessa di guarigione: malati e curatori in antico regime* (Rome and Bari, 1994), p. 43.

24 Cipolla, 'Medical profession', pp. 72–3.

25 *Statuti del nobil colleggio delli spetiali dell'alma città di Roma* (Rome, 1607), p. 34.

26 Brambilla, '"Sistema letterario"', p. 84.

27 *Ibid.*, p. 121.

28 A.S.B., *Studio*, 197 and 235 for lists.

29 From a survey of the *civilitates probationes* by Pomata, *Promessa*, p. 36.

30 Aurelio Musi, 'Il Collegio medico salernitano in età moderna' in M. Pasca (ed.), *La scuola medica salernitana* (Naples, 1988), pp. 29–36; Andrea Sinno, 'Vita scolastica dell'almo Collegio salernitano', *Archivio storico della provincia di Salerno*, ii (1922), pp. 39, 46, 55.

31 Modestino Del Gaizo, 'Documenti inediti della Scuola Medica Salernitana', *Resoconto delle adunanze e dei lavori della Reale Accademia Medica-Chirurgica di Napoli*, xli (1887), pp. 191–223.

32 *Ibid.*, p. 201.

33 Cipolla, 'The professions', p. 51.

34 Brambilla, '"Sistema letterario"', p. 86.

35 Aurelio Musi, 'Medici e istituzioni a Napoli nell'età moderna' in P. Frascani, (ed.), *Sanità e società: Abruzzi, Campania, Basilicata, Puglia, Calabria, secoli xvii-xx* (Udine, 1990), p. 54.

36 Richard Kagan, 'Le università in Italia, 1500–1700', *Società e storia*, xxviii (1985), pp. 305–6.

37 E. Brambilla, 'La medicina nel Settecento: dal monopolio dogmatico alla professione scientifica' in F. della Peruta (ed.), *Storia d'Italia: Annali*, vii, *Malattia e medicina* (Turin, 1984), p. 20.

38 N. Cortese, 'Il governo spagnuolo e lo Studio di Napoli' in idem, *Cultura e politica a Napoli dal Cinque al Settecento* (Naples, 1965), p. 40.

39 'De regimine studiorum Neapoli', *Pragmaticae, edicta, decreta, regiaque sanctiones Regni Neapolitani . . . collocatis per . . . Blasium Altimarum* (Naples, 1682–95), vol. 3, pp. 1246–7.

40 Cortese, 'Studio di Napoli', p. 48.

41 A.S.N., *Cappellania Maggiore: Processi antichi*, 1570, fol. 29; in Cortese, 'Studio di Napoli', p. 49.

42 A.S.N., *Cappellania Maggiore: Varietà*, 43; in Cortese, 'Studio di Napoli', p. 50.

43 Salaries varied from 600 ducats a year for the permanent chair in practical medicine, 400 ducats for medical theory, and 300 for anatomy and surgery, to anywhere from 150 to 50 ducats for the quadriennial chairs. Filippo Caravita, 'Relazione' in G. de Blasiis (ed.), 'L'Università di Napoli nel 1714', *Archivio storico per le province napoletane*, i (1876), pp. 151–2.

44 Domenico Pignataro, *Memoria sullo stato attuale della medicina nelle provincie di questo Regno di Napoli* (Naples, 1806), pp. 8–9.

45 Max Fisch, 'The Academy of the Investigators' in E.A. Underwood (ed.), *Science and medicine in history: essays on the evolution of scientific thought and medical practice in honour of Charles Singer* (Oxford, 1953), vol. 1, p. 521.

46 We have only Bartoli's word to go by, as related in the dedication and preface to the second version, *Artis medicae dogmatum communiter receptorum examen in decem exercitationes paradoxicas distinctum* (Venice, 1666); in Fisch, 'Academy', pp. 524–5. The *Systema* was officially banned in 1666.

47 *Ibid.*, pp. 532–3.

48 Sebastiano Bartoli, *Astronomiae microcosmicae systema novum* (Naples, 1663), p. 81; in Giorgio Cosmacini, *Storia della medicina e della sanità in Italia, dalla peste europea all'guerra mondiale: 1348–1918* (Rome and Bari, 1987), p. 181.

49 Bartoli's *Examen* cited above. It was officially banned in 1669.

50 Caravita, 'Relazione', p. 151. Earlier in his career he had substituted for others, such as the protophysician Andrés de Gamez. Tozzi went on to serve as physician to Pope Innocent XII and was on his way to Madrid to serve as physician to Charles II in 1700 when the latter died.

51 The Marquis of Arena, having been appointed secretary to the treasury (*scrivano di ragione*), was assassinated in April 1675. Fisch, 'Academy', p. 537.

52 Maurizio Torrini, 'L'Accademia degli Investiganti: Napoli, 1663–1670', *Quaderni storici*, xlviii (1981), p. 869.

53 Musi, 'Medici e istituzioni', p. 28.

54 Luciano Osbat, *L'Inquisizione a Napoli. Il processo agli ateisti, 1688–97* (Rome, 1974).

55 Caravita, 'Relazione', p. 151.

56 Gelfand, 'Medical profession', p. 1131.

57 'Catalogo de' soggetti, i quali ponno di presente pratticare la Professione di Medicina in Bologna, ordinato l'Anno 1659 nel mese di Giugno', A.S.B., *Studio*, 235.

58 Cipolla, 'Medical profession', p. 82.

59 'Bannum Deputatorum Salutis', 30 May 1656, *Pragmaticae*, 3, pp. 1287–1302.

60 Pietro Savio, 'Ricerche sulla peste di Roma degli anni 1656–57', *Archivio della Società romana di storia patria*, 3rd ser., xxvi (1978), pp. 128–9.

61 Camillo Tutini, 'Discorso anatomico del Regno di Napoli', Biblioteca Nazionale, Naples, MS II A 8; in Claudia Petraccone, *Napoli dal Cinquecento all'Ottocento: problemi di storia demografica e sociale* (Naples, 1974), pp. 64–5.

62 Petraccone, *Napoli*, p. 125.

63 Pignataro, *Memoria*, p. 5.

64 Matthew Ramsey, *Professional and popular medicine in France, 1770–1830* (Cambridge, 1988), p. 60; W. F. Bynum, 'Physicians, hospitals and career structures in XVIII-century London' in Bynum and R. Porter (eds), *William Hunter and the eighteenth-century medical world* (Cambridge, 1985), pp. 106–7.

65 Cipolla, 'Medical profession', pp. 97–9.

66 *Ibid.*, p. 93.

67 A.S.N., *Monasteri soppressi*, 491–510; in Ruggiero Romano, *Napoli: dal viceregno al regno* (Turin, 1976), pp. 183–4.

68 A.S.V., *Riti*, 232, fol. 260r.

69 Benedetto Croce, 'Due paiselli d'Abruzzo'; in appendix to his *Storia del Regno di Napoli*, ed. G. Galasso (Milan, 1992), pp. 404, 414.

70 Domenico Demarco, (ed.), *La 'Statistica' del Regno di Napoli nel 1811* (Rome, 1988), vol. 1, p. 105. Ossorio was the editor for the second province of Abruzzo Ultra. As a fellow of the kingdom's Società di Agricoltura Ossorio may have reflected rising expectations about the role of the provincial physician, reiterating the sentiments of Domenico Pignataro.

71 Vivian Nutton, 'Continuity or rediscovery? The city physician in classical antiquity and mediaeval Italy' in A. Russell (ed.), *The town and state physician in Europe from the Middle Ages to the Enlightenment* (Wolfenbüttel, 1981), pp. 9–46.

72 Mercurio, *Errori popolari*, p. 169.

73 Cipolla, 'Medical profession', p. 92.

74 Maurice Aymard, 'Epidémies et médecines en Sicile à l'époque moderne', *Annales Cisalpines d'Histoire Sociale*, iv (1973), p. 33; Daniela Pesciatini, 'Maestri, medici, cerusici nelle comunità rurali pisane nel XVII secolo' in *Scienze, credenze occulte, livelli di cultura* (Florence, 1982), p. 130.

75 Archivio di Stato, Bari, *Deliberazioni decurionali*, 12/iv/1602, 17/vii/1603; in Vito Antonio Melchiorre, *Il Sacro Monte di Pietà e Ospedale Civile di Bari* (Bari, 1992), pp. 106–7.

76 Archivio di Stato, Bari, *Deliberazioni decurionali*, 12/iv/1602, 13/x/1621, 7/vi/1675; in Melchiorre, *Sacro Monte*, pp. 106–8.

77 Annalucia Forti Messina, 'I medici condotti nell'Ottocento preunitario: il caso della provincia di Napoli' in G. Politi, M. Rosa and F. della Paruta (eds), *Timore e carità: i poveri nell'Italia moderna* (Cremona, 1982), p. 450.

78 Tommaso Astarita, *The continuity of feudal power: the Caracciolo di Brienza in Spanish Naples* (Cambridge, 1992), pp. 141–3.

79 N. J. Faraglia, 'Il censimento della popolazione di Napoli fatto negli anni 1591, 1593, 1595', *Archivio storico per le province napoletane*, xxii (1898), p. 379.

80 Demarco, *Statistica*, vol. 3, pp. 32–205; vol. 1, pp. 314, 410; vol. 2, p. 343.

81 *Ibid.*, vol. 2, p. 551.

82 'Ricorso fatto contro Giuseppe Umili', 20 May 1711, A.S.R., *Università*, 62, fols 265–86.

83 Aymard, 'Epidémies', p. 33.

84 Pesciatini, 'Maestri', p. 125.

85 Brockliss and Jones, *Medical world*, p. 290.

86 Demarco, *Statistica*, p. 312.

87 On the *medicina pauperum*, see Piero Camporesi, *Bread of dreams: food and fantasy in early modern Europe*, trans. D. Gentilcore (Cambridge, 1989), pp. 103–4, 112–14.

88  The Franciscan Antonio Lucci was bishop of Bovino from 1729 until his death in 1752. From the testimony of Dr Tommaso Rossomandi, in A.S.V., *Riti*, 279, fol. 89.

89  Cipolla, 'Medical profession', 91; Pesciatini, 'Maestri', 127.

90  Pesciatini, 'Maestri', 124–5.

91  From a 1722 accusation against the unlicensed surgeon Francesco Antonini, A.S.R., *Università*, 2, XVI bis.

92  Pomata, *Promessa*, pp. 304–5.

93  Cintio d'Amato, *Nuova et utilissima prattica di tutto quello ch'al diligente barbiero s'appartiene* (Naples, 1671 edn), pp. 114–15.

94  Mercurio, *Errori popolari,* pp. 208, 210.

95  Tiberio Malfi, *Il barbiere . . . libri tre* (Naples, 1626), p. 55.

96  *Ibid.*, p. 56.

97  Domenico Antonio Parrino, *Teatro eroico e politico de' governi de' vicere del governo di Napoli* (Naples, 1694), vol. 3, p. 43.

98  'They totally abandon their former trade/everyone wants to change/the footman has become a gentleman/a lousy beggar has become a big merchant.' Giambattista Valentino, *Napole scontraffatto dopo la peste* (Naples, 1775 edn), p. 34. Footmen, in fact, were now earning fifteen ducats a month, three times their pre-plague stipend. Giulia Calvi, 'L'oro, il fuoco, le forche: la peste napoletana del 1656', *Archivio storico italiano,* cxxxix (1981), p. 457.

99  A.S.R., *Università*, 62, e.g. fols 84–9, 901.

100  Pomata, *Promessa*, p. 148.

101  The pun on 'hand' (*manuali* and *chiros*) is lost in translation. Mercurio, *Errori popolari*, p. 209.

102  Ten *carlini* made a ducat. 'Istruzioni al medico . . .', pragmatic VII, Giustiniani, *Nuova collezione*, 12, pp. 211–12, 214.

103  Margaret Pelling, 'Medical practice in early modern England: trade or profession?' in W. Prest (ed.), *The professions in early modern England* (London, 1987), pp. 110–11, 113.

104  Fausto Garofalo, 'I barbieri chirurgi in Roma' in Garofalo, *Collezione C dell'Istituto di storia della medicina di Roma* (Rome, 1949), p. 19.

105  Garzoni, *Piazza universale*, pp. 369v.-370r.

106  *Ibid.*, p. 50v.

107  Fisch, 'Academy', p. 522; Musi, 'Medici e istituzioni', pp. 40–1.

108  Pietro Capparoni, *Profili bio-bibliografici dei medici e naturalisti celebri italiani dal sec. XV al sec. XVIII* (Rome, 1928), vol. 2, p. 66.

109  Richard Palmer, 'Physicians and surgeons in sixteenth-century Venice', *Medical History,* xxiii (1979), pp. 453–5.

110  Croce, 'Due paiselli', p. 405.

111  Lorenzo Giustiniani, *Nuova collezione delle prammatiche del Regno di Napoli* (Naples, 1805), vol. 12, p. 216.

112  Fra Donato D'Eremita, *Antidotario* (Naples, 1639), p. 4.

113  *Ibid.*, p. 6.

114  Pomata, *Promessa*, p. 215.

115  Laurent Joubert, *Popular errors* [*Erreurs populaires au fait de la médecine et régime de santé* (Paris, 1578)], annotated and trans. G. de Rocher (Tuscaloosa, 1989), p. 87.

116  Garzoni, *Piazza universale*, p. 84.

117 'Capaccio. Ad usum mei Nicolai Angeli Meola, oppidi Grecorum', MS, c. 1750, fol. 235; in Cleto Corrain, 'Il prontuario manoscritto di un protomedico irpino del secolo XVIII', *Acta medicae historiae patavina*, v (1958–59), p. 51. The *protomedico* of the article's title misleadingly refers, not to Meola, but to the collection's second owner, 'first physician' in the town of Montesantangelo.

118 Meola, 'Capaccio', fols 204–5; in Corrain, 'Prontuario manoscritto', p. 49.

119 Meola, 'Capaccio', fol. 47; in Corrain, 'Prontuario manoscritto', p. 73.

120 Mercurio, *Errori popolari,* p. 172.

121 Francesco Sirena, *L'arte dello spetiale* (Pavia, 1678), preface; in Panseri, 'Polizia medica', p. 180.

122 Santorelli, *Protomedico napolitano,* pp. 59–61.

123 *Statuti . . . delli spetiali,* pp. 21, 31.

124 *Pragmaticae,* vol. 3, tit. CXXIII, pragmatic III, 16 September 1585, pp. 1184–5.

125 Santorelli, *Protomedico napolitano,* p. 56.

126 A.S.D.N., *Sant'Ufficio,* 'Contra Fiorella Testa obstitricem', 468, no foliation.

127 For a 1668 example sent to the prior of the Salernitan College, see Andrea Sinni, 'Diplomi di laurea dell'almo Collegio salernitano', *Archivio storico della provincia di Salerno,* i (1921), p. 227.

128 'Opinioni varie', 1738, A.S.N., *Sommaria: Protomedicato,* series II, 33: 6; Giustiniani, *Collezione delle prammatiche,* 12, p. 214.

129 Entry of 10 September 1682, 'Acta Protomedicatus Collegii Medicinae ab anno 1662 ad anno 1694', A.S.B., *Studio,* 320. The list itself is in *Studio,* 235.

130 Raffaele Calvanico, *Fonti per la storia della medicina e della chirurgia per il regno di Napoli nel periodo angioino (1273–1410)* (Naples, 1962).

131 Nadia Maria Filippini, 'The Church, the State and childbirth: the midwife in Italy during the eighteenth century' in Hilary Marland (ed.), *The art of midwifery: early modern midwives in Europe* (London, 1993), pp. 163–4.

132 Pomata, *Promessa,* p. 162.

133 Mercurio, *Errori popolari,* pp. 1–2.

134 Claudia Pancino, *Il bambino e l'acqua sporca: storia dell'assistenza al parto dalle mammane alle ostetriche (secoli XVI-XIX)* (Milan, 1984), p. 223.

135 S. Ravacini, *Sulla universalità dell'opera ospedaliera della S. Casa degl'Incurabili in Napoli* (Naples, 1899), pp. 354–5.

136 Teresa Ployant, *Breve compendio dell'arte ostetrica* (Naples, 1787), pp. 49–53; in Laura Guidi, 'Levatrici ed ostetrici a Napoli: storia di un conflitto tra XVIII e XIX secolo' in Frascani, *Sanità e società,* p. 111.

137 Teresa Ortiz, 'From hegemony to subordination: midwives in early modern Spain' in Marland, *Art of midwifery,* pp. 102-3.

138 A.S.N., *Consiglio d'Istruzione Pubblica,* 3102; in Guidi, 'Levatrici', p. 115. The estimate of 600 possible midwives may have been somewhat high, since there 120 *licensed* midwives in the 1809 Protomedicato list.

139 A typical response, from the town of Montemurro (Basilicata). Demarco, *Statistica,* vol. 3, p. 105.

140 A.S.N., *Ministero dell'Interno,* 1st inventory, 909; in Guidi, 'Levatrici', p. 122.

141 A.S.N., *Ministero dell'Interno,* 1st inventory, fasc. 910; in Guidi, 'Levatrici', p. 123.

142 Ramsey, *Professional and popular medicine,* p. 205. He suggests (pp. 211–13) that in most areas the numbers of unlicensed practitioners (empirics, people dabbling in surgery, part-time healers) would most likely be roughly the same as for licensed practitioners (physicians and surgeons).

143 Santorelli, *Protomedico napolitano*, p. 48.

144 Mercurio, *Errori popolari*, p. 206.

145 Paolo Macry, 'I professionisti: note su tipologie e funzioni', *Quaderni storici*, xlviii (1981), pp. 936–8.

146 Toby Gelfand, 'A "monarchical profession" in the old regime: surgeons, ordinary practitioners and medical professionalization in eighteenth-century France' in G. L. Geison (ed.), *Professions and the French State, 1700–1900* (Philadelphia, 1984), p. 151.

147 Ramsey, *Professional and popular medicine*, pp. 4–5.

148 Augusto Placanica (ed.), *Calabria 1792: diarii, relazioni e lettere di un visitatore generale* (Salerno, 1992), p. 473.

# CHARLATANS AND MEDICAL SECRETS

In 1641 Secondo Lancellotti, an abbot of the Olivetan Benedictines of Perugia, published a curious little book in Paris, which he dedicated to Cardinal Richelieu. Entitled *L'Orvietano per gli hoggidiani*,[1] it was intended to combat *hoggidianismo*. From the word *hoggidì*, meaning 'nowadays', *hoggidianismo* was 'the believing, and so always bemoaning, that the world is worse NOWADAYS, and more calamitous than in the past' (according to the title page). The amusing work consists of quotations from a whole range of areas, where authors have expressed this sentiment, with Lancellotti's linking remarks. Despising this negative philosophy, Lancellotti proposed his book as an antidote to the disease, 'an instantaneous and most useful medicament.' It was to be an 'orvietan' for sufferers. In his dedication, the author explains that orvietan was 'an electuary and medicament which has become famous in our time, not only in Italy but also beyond.' What was it about orvietan that made it so successful, to the point of being used as a synonym for 'antidote'? And, more generally, what can remedies like orvietan and the charlatans who peddled them tell us about early modern medicine?

To begin to answer this question we must go back a further fifty years. According to some accounts it was at this time, the end of the sixteenth century, that orvietan was invented, by a certain Lupi of the town of Orvieto, in central Italy.[2] This assertion has proved impossible to document. The earliest records of the remedy concern the Neapolitan charlatan Girolamo Ferranti, who called himself *'l'Orvietano'*, the Orvietan, and bestowed this name on the remedy he sold. He may, in fact, have been orvietan's originator, though the fact that a Neapolitan living in Rome should call himself 'the Orvietan' suggests that he was capitalising on something. The commercialisation of medicine, evident in the profusion of proprietary remedies, was well under way in Italy a century or more before its heyday in England. Although the success of charlatans has often been explored in such commercial terms,[3] this chapter will seek to broaden the analysis. While it does say something about their appeal, a purely economic model does not explain why charlatans were so repeatedly denounced.[4] Nor does it shed much light on the place of charlatans in the period's therapeutic network. This chapter will explore just what this might have been, by looking at these often misunderstood practitioners, the drugs they sold and the way they sold them. The focus remains the kingdom of Naples, but

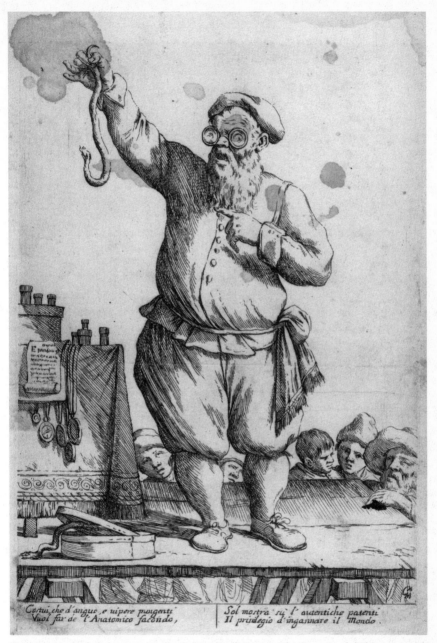

Figure 5 'A charlatan', engraving by G. M. Mitelli (1660). The verses read: 'This man, with biting snakes and vipers,/wishes to become the Fecund Anatomician./He is wont to show, by his genuine patents,/his licence to fool the world'

we shall also range far beyond, such being the nature of charlatanry. Ferranti's earliest documented appearance would seem to be in Florence in 1609, when he petitioned the Otto di Balìa, the chief criminal court, to be permitted to set up a platform and personally sell his antidote throughout the Grand Duchy. The correspondence mentions a similar petition made – successfully – in 1607. The resulting licence of May 1609 granted Ferranti the privilege 'to mount a stage with his company throughout all the states of the aforesaid Most Serene Grand Duke, and particularly in the city and state of Siena, to dispense the said secret.' No one else was to be permitted to make and sell orvietan, with the exception of Jacopo Talavino, 'il Tedeschino' (the Little German).[5] Talavino, from Udine, was well known to the Florentine Medical College. In 1599 he had been granted a licence to sell 'philosophers' oil, hyena and turpentine oil' and, in the same year as Ferranti, was licensed to sell two other oils, 'with his company and women.'[6]

But Ferranti did not limit his activities to Florence. Indeed, his appearance there followed in the wake of a most successful stay in Paris, of several years' duration. The physician Thomas Sonnet, in his *Satyr contre les charlatans,* published in 1610, wrote of having seen 'a notorious and shameless charlatan who was called il signore Hyeronimo' eight years earlier in Paris.[7] The description he gives makes it likely that this was the same Hieronimo, or Girolamo, Ferranti (also Fioranti) who operated around that time in the vicinity of the Pont-Neuf. Back in Italy, in 1611 Ferranti and his son Gregorio were licensed to sell orvietan in Siena.[8] In 1613 Gregorio petitioned the Rome Protomedicato to be allowed to hang a sign outside his house, where he also dispensed the electuary. It was to read: 'Here lives the Orvietan, who sells the electuary against poison and other infirmities; those obtaining it from others under my name will be deceived.'[9] But whilst keeping up the shop, where they manufactured the antidote, members of the family were also on the move in search of other markets. Around this time Gregorio was licensed by the Venetian Medical College to sell orvietan there.[10] In 1616 'the Orvietan' was reported in Florence with his company. According to the city's *Avvisi*, what drew attention most was 'the alluring Vettoria.' The young woman was paid fifteen *scudi* a month 'to sing, dance and skip every day in the square.' Every evening entertainments were performed by the company, varying in length according to how much money had been taken in.

> The amiable Vettoria, cleanly and neatly dressed as a young boy, has large numbers of people running to her, with the somersaults she does, her divine dancing and singing, such a sweet and beautiful sight, that the enchantment touches and lulls everyone, so that, sighing, they cry: alas, alas my heart, what is this? And most of all certain old men, who look at her with mouths agape, because they would like to flirt with her and partake of that tasty morsel.[11]

It may be that around this time Girolamo Ferranti returned to Paris, where he died, leaving his Roman wife, Clarissa. All we know for certain is that Clarissa, widow of Girolamo Ferranti, inherited the French patent for orvietan. She passed it on to her second husband, Jean Verrier.[12] Verrier changed his name to the Italian-sounding Vetrario, taking advantage of the Italian origin of orvietan and of many

of the charlatans operating in Paris. But it was Clarissa's third husband who would have most success with the antidote. He was Cristoforo Contugi, a genuine Italian this time, native of Rome, who was identified as being married to Clarissa when they took out French citizenship together in October of 1646.[13] The next year he was granted royal letters patent to sell and distribute orvietan throughout the kingdom. Try as he might, Contugi was unable to obtain the recognition of the Paris Medical Faculty. It is unlikely that he needed the prestige that their approval would bring to boost his sales, to judge by the number of imitators that sprang up in Paris and throughout France. In fact, it might have been to thwart the competition that Contugi repeatedly sought the Faculty's recognition. Contugi was forced to defend his royal privilege on various occasions within the space of a few years. In May 1656 he obtained a royal injunction against three different charlatans who had been making and selling orvietan in different parts of France over the previous ten years. One claimed to be the son of Jean Vetrario, thus Contugi's stepson, whilst another claimed to be Contugi's brother-in-law. They were charged with having 'attempted to sell their medicaments under the same name of Orvietan and under the sign of the Sun which has always allowed the suppliant to establish the difference between his antidote and the others', 'recognising the great reputation which the suppliant has acquired for the manufacture and distribution of his antidote.'[14]

Orvietan became a real sensation in Paris during the middle years of the century. Its acclaim was such that orvietan also made it into popular medical collections and books of secrets. Its success outlived Contugi himself, who died in 1681. Contugi left his widow – not Clarissa, who had died in 1659, but a second wife – and nine children a small fortune, consisting primarily of property in the villages of Vaugirard and Issy, as well as the secret of orvietan.[15] His descendants continued to do well out of the remedy: the patent for the remedy stayed in the Contugi family until 1764, when it was sold to a charlatan named Nicolas Portier.[16] By this time French orvietan-sellers had more security and legal protetion than ever before, and their numbers soared.[17]

Orvietan also achieved some notoriety in England. The Italian Johannes Puntaeus (Ponzio?), with a licence in surgery from the University of Oxford (1649), achieved renown through his sale of it. To demonstrate its efficacy, Puntaeus had his servant poisoned with a draught of aqua fortis (the solvent nitric acid) before the Oxford physicians. The servant seemed to get the worst of the poison, only to recover the following day.[18] Licensing and patenting was also a lucrative source of income for the Crown.[19] Cornelius à Tilborg (often spelt 'Tilbourne', with other variants) was appointed a physician in ordinary and awarded a gold medal and chain by King Charles II, after he performed a similar trial in the king's presence.[20] But his success brought him into dispute with Pier Maria Mazzantini, who claimed to have cured a groom of the king's bedchamber with the antidote. Mazzantini asserted that he was the first practitioner to bring orvietan into the British Isles in 1660, having obtained the recipe in Orvieto in 1646. He had then passed the recipe on to Tilborg, who had promised to use it only overseas.[21] In various handbills from the 1690s Tilborg claimed that he alone could sell orvietan and gave notice that he would dispense it from accommodation in Covent Garden or Bishopsgate.[22]

Orvietan was by no means the only antidote sold by charlatans. Another Neapolitan, Martino Grimaldi, dispensed his own electuary against poison. It was still being sold by his heirs in 1736.[23] Charlatans were often forced to compete for custom in the same square. It went on to become something of a literary *topos*, of which the square described by Tommaso Garzoni, with charlatans emerging from all corners, is the most elaborate example.[24] A quarrel between the Orvietan and another charlatan selling another antidote in Naples was mediated by the viceroy himself in December 1616. He ordered them to appear before him and test their respective antidotes out on themselves. Only the Orvietan survived the test, and was awarded a collar of gold and privileges.[25]

But the most serious competition for the Orvietan came from other charlatans selling the same remedy. A sign of orvietan's popularity was the number of imitations. One is tempted to call them 'illicit', as they were so often manufactured by those outside the original family. But most of these charlatans were able to obtain a licence or 'privilege' from one body or another, due to the overlapping in jurisdictions which characterised the early modern state. The surest way for a charlatan to gain prestige and a patent was to tout himself as the successor of the remedy's originator. The physician Thomas Riollet wrote in 1665 that over two hundred charlatans claimed to be the 'true possessors' of the orvietan patent.[26] The figure may cause some doubt, but not the real situation behind it. As late as April 1714 the Neapolitan Paolo Toscano petitioned the lieutenant-general of police in Troyes to be licensed to sell his orvietan. Toscano claimed that he was the 'successor of Hierosme Ferrand' and that the authorities of Troyes had licensed him twice before, in 1693 and 1707. No mention was made of the actual French patent-holders, the Contugi family, but Toscano was granted a licence none the less.[27]

A similar situation prevailed in orvietan's country of origin. In Naples and Rome the authorities issued edicts against the illicit selling of the electuary by people calling themselves 'relations' or 'companions' of the Orvietan, but to no avail. Issued by the Roman cardinal chamberlain, no doubt at the behest of the patent-holder, a 1645 edict warned *'mont'in banchi et ciurmatori'* ('mountebanks and charmers') not to dispense electuaries imitating orvietan in 'smell, colour or taste', under penalty of a five hundred-ducat fine.[28] It is hard to believe that these edicts had any effect in discouraging competition. From 1632 to 1652 the Siena Protomedicato licensed half a dozen different Orvietans from places like Pisa, Ravenna and Bergamo, all claiming to be relations or heirs of the originator.[29] The edicts did, however, have the effect of heightening the seller's prestige and offering him a means of recourse should he want to prosecute those infringing on his patent. For this reason Paolo Angelini went to the trouble – and, no doubt, expense – of having himself recognised as the 'true heir' to the secret by the Tuscan grand duke in 1665.[30] Nine years later he petitioned the Rome Protomedicato to be recognised as its 'true fabricator' with the right to pass it on to his descendants, which was duly done in an edict published the following year.[31] This official recognition suggests that the antidote had achieved a certain status in Italy.

The Bologna Protomedicato adopted the most cautious stance. In 1642 it denied Giovanni Cei a licence to sell orvietan on the grounds that the 'public service' did not warrant it. The physicians did not give any reason.[32] In 1650, after appearing on several occasions before the College without success, Francesco Nava was finally issued a licence to sell it. The physicians had had two dogs bitten on the testicles by a viper and administered orvietan both internally and on the wounds. The dogs emerged unharmed and the physicians approved the electuary.[33] Not all Colleges were equally severe, however. In 1665 the above-mentioned Angelini was asked by the Sienese Protomedicato to put his orvietan to a similar test. Armed with a large bundle of attestations and licences from other Colleges, Angelini refused. The College protophysician and counsellors wrote to Grand duke Ferdinand II: 'He is ready to try it out on himself, which makes us worry that he could or might want to protect himself with other drugs before the experiment, which we would have been more satisfied to see [performed] on an animal.' But Angelini so impressed them with his answers on ingredients and doses that they recommended the grand duke to approve his petition anyway.[34] The apparent duplicity of the medical elites in their treatment of charlatans is something to which I shall return below.

Competition did not come just from other charlatans, however. The apothecaries were eager for a share of orvietan's riches. As early as 1624 an apothecary named Giovanni Battista Pasino published a treatise in Latin on orvietan, describing when it could be used and in what doses.[35] This was a sign of things to come. It was not long before it would appear in official pharmacopoeias throughout Europe for the benefit of apothecaries: by 1674 it had appeared in the pharmacopoeias of Lyon and Toulouse. By the eighteenth century the apothecaries of Paris were preparing their own 'superior' version of the antidote, in the presence of magistrates from the Faculty of Medicine.[36] In Italy, Religious Orders such as the Dominicans manufactured and sold it at their own pharmacies,[37] which were exempt from secular jurisdiction until the end of the eighteenth century. Orvietan, like other remedies peddled or marketed by charlatans, was not some sort of alternative medicine. Rather, it was based on traditional medical knowledge, as we shall see. For this reason remedies sold by unlicensed charlatans, when confiscated, were often not destroyed but sent to local hospitals.

In any case, admirers of the orvietan antidote may have felt that all this competition only served to lower its quality. As early as 1665 Thomas Riollet wrote: 'The orvietan that is displayed in public nowadays is not the same: it has many more simples and drugs. But it has more or less the same taste, the same smell and the same consistency.'[38] The 'nowadays' in Riollet's remark brings us back to our point of departure: not even orvietan was spared the negative appraisal of the closet *hoggidiani*.

## The fear of poison

To call orvietan simply an antidote is to do it a grave injustice. Handbills distributed by the various Orvietans testify to its numerous virtues (figure 6). In addition to countering poison, 'both living and dead, cold and hot', it was effective against

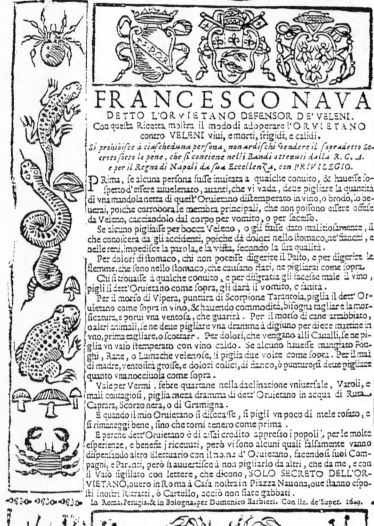

# FRANCESCO NAVA

DETTO L'ORVIETANO DEFENSOR DE' VELENI.

Con questa Ricetta mostra il modo di adoperare l'ORVIETANO
contro VELENI viui, e morti, frigidi, e calidi.

Si prohibisce à ciascheduna persona, non ardischi Vendere il sopradetto Se-
creto sotto le pene, che si contiene nelli Bandi ottenuti dalla R. C. A.
e per il Regno di Napoli da sua Eccellenza, con PRIVILEGIO.

PRima, se alcuna persona fusse inuitata a qualche conuito, & hauesse so-
spetto d'essere auuelenato, auanti, che vi vada, deue pigliare la quantità
di vna mandola netta di quest'Oruietano distemperato in vino, o brodo, lo be-
uerai, poiche corrobora le membra principali, che non possono essere offese
da Veleno, cacciandolo dal corpo per vomito, o per secesso.

Se alcuno pigliasse per bocca Veleno, o gli fusse dato maliciosamente, il
che conoscerai da gli accidenti, poiche dà dolori nello stomaco, ne' fianchi, e
nelle reni, impedisce la parola, e la vista, secondo la sua qualità.

Per dolori di stomaco, chi non potesse digerire il Pasto, e per digerire le
flemme, che sono nello stomaco, che causano flati, ne pigliarai come sopra.

Chi si trouasse à qualche conuito, e per disgratia gli facesse male il vino,
pigli il dett'Oruietano come sopra, gli darà il vomito, e sanità.

Per il morso di Vipera, puntura di Scorpione Tarantola, piglia il dett'Or-
uietano come sopra in vino, & hauendo commodità, bisogna tagliare la mor-
sicatura, e porui vna ventosa, che guarirà. Per il morso di cane arrabbiato,
o altri animali, se ne deue pigliare vna dramma à digiuno per diece mattine in
vino, pria pigliare, e scottare. Per dolori, che vengono alli Caualli, se ne pi-
glia vn vaso stemperato con vino caldo. Se alcuno hauesse mangiato Fon-
ghi, Rane, o Lumache velenose, si piglia due voite come sopra. Per il mal
di madre, ventosità grosse, e dolori colici, di fianco, ò punture, si deue pigliare
quanto vna nocciuola come sopra.

Vale per Vermi, febre quartane nella declinatione vniuersale, Varoli, e
mali contagiosi, piglia meza dramma di dett'Oruietano in acqua di Ruta,
Capraria, Scorzonera, o di Gramigna.

E quando il mio Oruietano si diseccasse, si pigli vn poco di mele rosato, e
si rimaneggi bene, sino che torni tenero come prima.

E perche dett'Oruietano è di assai credito appresso i popoli, per le molte
esperienze, e benefit j riceuuti, però vi sono alcuni quali falsamente vanno
dispensando altro Electuario con il nome d'Oruietano, facendosi suoi Com-
pagni, e Parenti, però si auuertisce à non pigliarlo da altri, che da me, e con
il Vaso sigillato con lettere, che dicono, SOLO SECRETO DELL'OR-
VIETANO, ouero in Roma à Casa nostra in Piazza Nauona, oue stanno espo-
sti inoltri Ritratti, ò Cartello, acciò non siate gabbati.

In Roma, Perugia, & in Bologna, per Domenico Barbieri. Con lic. de' Super. 1649.

Figure 6  Orvietan handbill, outlining its virtues and giving instructions on how it is to be
taken, with a range of venomous animals in the margin and the coats of arms of the Roman
and papal authorities (1649)

the venom of vipers, tarantula spiders and rabid dogs, as well as poisonous mush-
rooms, frogs and snails. It was also proposed for indigestion, *mal di madre* (prolapse
of the uterus), gross flatulence, stitches, cholic pains, worms, quartan fever, poxes
and 'contagious diseases.' The references to poison are particularly interesting,
however. They provide one of the keys to its success. The antidote could work
either before or after ingesting the poison:

> First, [a 1649 handbill advised] if anyone should be invited to a banquet and has a sus-
> picion he might be poisoned there, he must take an almond-sized quantity of this
> orvietan dissolved in wine or broth before he goes, which he will drink so it will
> fortify his principal members, so that they will remain unharmed by the poison, elim-
> inating it from the body by vomiting or defecation. Second, if anyone should take
> poison through the mouth, or it is given him with evil intent: which he will know
> by the effects (*accidenti*), because it causes pains in the stomach, sides and kidneys,
> impedes speech and sight, according to its qualities.[39]

Poison was one of the great fears of the age. Its threat lay in the fact that its mode
of operation was considered similar to that of magical spells and sorcery. For
Leonardo Vairo, bishop of Pozzuoli, near Naples, *veneficia* were the same as *maleficia*:
not poisons so much as bewitchments, the horrible effects of which could be
ascribed to demons. The belief was shared by physicians too. The community
physician at Imola, Battista Codronchi, writing six years after Vairo (in 1595),
expressed similar views, arguing that demons could come to possess the human
body through *veneficium*.[40] The belief in the occult or hidden nature of poisons per-
sisted throughout the following century, despite the beginnings of more experi-
mental notions towards the secret arcana of nature. 'We call poisons', wrote the
Frenchman Jean Baptiste Du Hamel, 'what in some occult way are wont to attack
us or suddenly take away our life.' Antidotes worked because their corpuscles joined
up with the poisonous particles, which were then expelled from the body
together.[41] And poisons had a wide range of effects, according to the Swiss Jean
Prévost, professor at Padua: some madden, some induce sleep, some inflame, others
extinguish the natural heat and suffocate by flatulent humidity, others kill by
dryness, erode and exulcerate, some irritate parts of the body by excessive mordac-
ity and dryness, and some by lethal astriction.[42]

A whole genre of scholarly writing dealt with poisons and how they could be
countered. For the Sicilian protophysician Ingrassia the first defence against poison
was to lead a Christian life, praying and doing good works.[43] This advice was con-
tained in an essay dedicated to the viceroy, Juan de la Cerda, Duke of Medinaceli.
Perhaps it was requested by the viceroy himself; he certainly must have felt the need
for it, given the in-fighting and intrigue at his court.[44] Ingrassia proposed swal-
lowing a decoction of his own invention before meals, describing how this was to
be done. It is worth noting that the advice for taking orvietan, quoted from above,
was laid out in much the same way and made use of the same sort of language.
Ingrassia could not have known of orvietan, but he did recommend analogous elec-
tuaries like theriac and terra lemnia. He also included some practical cautions, such

as eating one's food slowly and carefully, checking its smell, taste and colour. Given the intricacies of baroque culinary concoctions, this would not have been easy to follow. Harder still, for a viceroy, was Ingrassia's advice that the foods themselves should be simple, as poisons could easily be hidden in complex and elaborate dishes.

To combat the fear of being poisoned at table, the elites had official food-tasters. In 1584 Girolamo Mercuriale, physician at Padua, wrote favourably of three means of detecting poison at table: serpent's horn, which was said to sweat in the presence of poison; dishes made of aurichalcum, which would change colour; and emerald worn in a ring, which would lose its green colour.[45] There were other alleged methods, such as the gem aetites, which would actually prevent the intended victim from swallowing poisoned food, and, most remarkably of all, vulture's foot. If this were used as a lamp, the flame would go out in the presence of poison.[46] Not all methods described met with equal favour. Andrea Bacci, who lectured on poisons in Rome – a city with some empirical evidence on the matter – advised anyone who thought himself to be the victim of poison to vomit it, even if this occurred at his own table.[47]

Whilst physicians may have been tending away from a specifically demonic force in poisons, the link between sorcery and poison continued to be widespread. The records of Italian ecclesiastical tribunals bear witness to this in the number of cases that mixed the two: bewitchment and poisoning were both methods by which one person might inflict harm on another. Witnesses themselves did not generally distinguish between the two: known cunning folk who gave people food and drink to harm them might be accused of 'poisoning' them.[48] They were both part of the same magical ritual, worked in the same way against the body and, most importantly, could both result in diabolical possession.

Those in power lived in constant fear of bewitchment and poisoning. In some senses it was the same fear. Magical spells and charms could be used to bring about the prince's death. Magistrates took accusations of such activity very seriously, even when it was undertaken by those in quite inferior social positions.[49] Both could be used to bring about the ruler's death. But a magical spell could be more insidious, since it could surreptitiously result in the ruler's loss of self-control and opened the way to manipulation by others. It was not unusual for confidants or favourites at court to be suspected of having used magical means to gain the prince's ear. It could explain the ruler's attraction to an otherwise unremarkable person. But the accusation could also be employed by opposing factions to incriminate and remove that person from court.[50] Needless to say, it was also a fear that preoccupied, even obsessed, the rulers themselves. The Duke of Osuna, viceroy of Naples, was frequently disturbed by such worries, if contemporary chroniclers are anything to go by. He was the same viceroy who challenged the two rival charlatans, honouring the victor. In autumn 1616 a rumour reached him that he had been bewitched by one of his mistresses, Donna Vittoria Mendoza. The spell had led him to favour Donna Vittoria with some potentially lucrative business information and appoint her son-in-law, Don Antonio Manriquez, to the regency of the Vicaria, the kingdom's central civil and criminal court. She was eventually exiled, and her jewels

sequestered, while her son-in-law was deprived of his office and imprisoned in the castle of Gaeta.[51]

It is also possible that the viceroy only used the charge of sorcery in order to justify his own actions against the pair. Such accusations were all part of the intrigue at court. This penchant for intrigue and conspiracy gave Italians a dubious primacy. The Englishman Fynes Moryson, who had travelled extensively in Italy at the end of the sixteenth century, noted that 'By this nature, or practise growing to a second nature, the Italyans above all other nations, most practise revenge by treasons, and espetially are skillfull in making and giving poisons . . . For poisons the Italyans skill in making them and putting them to use hathe been long since tryed.'[52] Divided into factions as they were, Italians could not trust one another, and were forced to employ Swiss or German guards. It also explained the fact that 'the bakers of bread in most partes of Lombardy, as having meanes to betray men by poyson, are not Italyans, but commonly Germans.'[53]

Poison was regarded as being part and parcel of Italian political life. The behaviour of Italian rulers and elites would seem to bear this out. When Alfonso the Magnanimous of Naples was sent a copy of Livy (once owned by Petrarch) by Cosimo de' Medici, his physicians advised him not to touch it as the pages might have been poisoned.[54] Both the Sforzas of Milan and the Aragonese of Naples were suspected of having recourse to poison in order to achieve power. But more than anything else, it was the Borgias who gave their name to poison as a form of government and crisis management.[55] Their preferred poison, according to contemporaries, was a whitish sugary powder, probably based on arsenic. It could be dissolved in a liquid or mixed with food without its own taste being noticed. The reputation of Pope Alexander IV and his son Cesare was such that their poison was said to work at any distance of space or time. This is not completely surprising, given beliefs about the nature of poison and the way it worked. What is somewhat surprising is that Cesare should have inherited the reputation of an arch-poisoner since, as Duke of Romagna, he usually favoured more direct methods of assassination, like the dagger and the rope.[56]

The prominent reputation of Italians as poisoners did not mean that poison was a tool of government and social relations in Italy alone. As this chapter began with the success of orvietan in France as well as Italy, it might be worth noting that poison was not an unheard-of method of assassination in the former country. But even in France there is no getting away from the unsavoury reputation Italians had at the time. After the Italian Catherine de' Medici married Henri II in 1531 presumed deaths from poisoning in Paris increased so considerably that a scare ensued. Italians were occasionally employed as hired assassins during the wars of religion. In 1568 the Cardinal of Lorraine's plots against Huguenot leaders included paying some fifty Italians one thousand crowns each 'to empoison wine, wells and other victuals.'[57] The prominence of some Italians merely increased suspicions of their general craftiness and 'Machiavellian' tendencies (a term always used in the superficial sense of political perversion).[58] According to the mental logic of the time, it is perhaps no surprise to find that if Italians should be considered master poisoners, then an Italian could market the most successful poison antidote in France. Fear of poison – and

indeed its use – continued throughout the seventeenth century, coinciding with orvietan's greatest success. For instance, a spate of poisonings occurred in the late 1670s amongst Parisian high society, centred around the fashionable Parisian fortune-teller and maker of love philtres Madame Monvoisin. Three presumed sorceresses were condemned to death and an important noblewoman fled the country. When the investigations of the special court set up to deal with the matter led to accusations against King Louis XIV's mistress, Madame de Montespan, it was closed down by the king and his ministers. In 1682 the sale of poison was strictly controlled, private laboratories strictly forbidden, and the practice of sorcery prohibited.[59]

## From snake-charmer to entrepreneur

This fear of poison extended to animal venom, above all that of snakes. Indeed, it would be more accurate to say that the fear of poison began with animal venom, especially that of vipers. The fear of vipers' bites goes back to remote Antiquity. It became synonymous not only with poison but with disease itself. We need only think of the rod of Asclepius, on which a snake is entwined, to remind ourselves of the classical association between snakes, poison and healing.[60] The way local cultures dealt with this threat contributes another strand to the story of orvietan.

As early as the twelfth century the verb *marsare* was used in the Latin of Italy to mean 'to do what the Marsians do.' What did the Marsians do? Based on the ancient Marsians' reputation as snake handlers and charmers, it referred to the ability of certain people to charm snakes using incantations and destroy the fatal effects of their bites by means of their saliva. The Marsians, inhabitants of what is today Umbria and Abruzzi, were synonymous with snake-charming. Even Galen had used their name in this way, although he was describing not actual Marsians, but 'those who are called Marsians.'[61] People went on claiming to be Marsians, or their descendants, through the centuries. And the link between them and the Orvietan was not lost on Riollet: 'what today are our Orvietanists and our Theriac-sellers, was done in ancient times by the Marsians and the Psylli, on whom the people's credulity had bestowed the ability to charm serpents and dispel their poison.'[62]

In the late medieval and early modern periods snake-charmers were particularly prevalent in the Apennines of central and southern Italy, though they extended into the island of Sicily. They were known generically as *serpari* or *ciaralli* (also *ciarauli*), and often formed dynasties of snake-handling families. Dynasties or families of specialised healers seem to originate in the late Middle Ages, perhaps deriving from classical beliefs in the special powers possessed by certain ethnic groups, like the Marsians.[63] According to a description of 1678:

> In this region of ours [Abruzzo Ulteriore], in the town of Bisegna, Father Paolo Ciarallo, then archpriest, and the males of his family, who maintain that they descend from the ancient Marsians, pick up serpents with their hands without harm, heal serpent bites with their saliva and from birth bear the image of a serpent on their right arm.[64]

The archpriest's surname, Ciarallo (given in Latin as Ciarallus), referred to his role in just such a dynasty. The snake-charmers even achieved the kind of official sanction that came with attempts to regulate them. In his 1564 gloss upon the 1429 Constitutions of the Sicilian Protomedicato, Giovanni Filippo Ingrassia listed the snake-charmers as those who would come under the jurisdiction of the medical authorities. In addition to physicians, barber-surgeons and apothecaries, Ingrassia refers to 'the *psylli*, who are called *chirauli* in the vernacular (because they operate without medicaments by the powers of St Paul the Apostle, to whom they are given from birth).'[65] In the kingdom of Naples they are occasionally listed in the records of the Protomedicato, as in the case of the 'ciraule' licensed in the town of Sanarica (Terra d'Otranto) in 1785.[66]

Ingrassia thus introduces another element: the saintly patronage that snake-handlers acquired for themselves. The involvement of St Paul was part of the Christianisation of their ancient ritual. The Acts of the Apostles (28:3–5) recount how St Paul, on the island of Malta, shook off a viper which had fastened on his hand without coming to any harm. Snake-handlers capitalised on this association, referring to themselves as members of the 'house of St Paul.' They thus became known as *pauliani* or *sanpaolari*. The first published description we have of them in this guise is in Ferdinando Ponzetti's 1521 treatise on poison, which devotes a chapter to them. Ponzetti, a former physician and bishop of Molfetta (Terra di Bari), concentrated on the tricks and deceits they employed to carry out their various feats. Later authors would take up this same approach.[67] Ponzetti noted that when they caught snakes, they held them by their tails and spit on their heads, since human saliva was reputed to have a property against snakes. Before ingesting the snakes' venom, they ate plenty of tripe. This retained the venom temporarily. They then swallowed plenty of hot water mixed with oil and butter, causing them to vomit the tripe and poison together. Their cure for a snakebite was to make the sign of the cross over the bite and have the victim drink some water tempered with terra sigillata, whilst they pronounced the following incantation: 'Caro caruzet, reparat sanum et emanuel paraclitum.' The ritual was even supposed to work at a distance, when performed on the messenger who brought news of someone having been bitten.[68]

Terra sigillata owed its existence to the same Pauline incident on Malta. Literally meaning 'sealed earth', these small cakes were originally made from earth of the island of Lemnos, as described by Dioscorides. To certify their authenticity, they were stamped with a seal. Lemnian earth was believed to have absorbent, astringent and sudorific properties, and was used as an antidote and general remedy against infection. By the period under consideration here Maltese earth was in the ascendancy. It was known under a wide variety of names: Terra di Malta, Gratia Pauli, Pietra di San Paolo. Such was its reputation that it was even worn around the neck as an amulet, to protect the wearer from the bites of vipers and poisonous snakes. But not everyone was convinced of its efficacy. In his 1544 commentary on Dioscorides, Pier Andrea Mattioli wrote that although terra sigillata 'has not a few properties against serpents' venom . . . In truth, where someone has been bitten by a deaf asp or a viper, little or nothing will help.'[69]

Terra sigillata's reputation was none the less better than that of the *sanpaolari* who often sold it. Tommaso Garzoni's 1585 description of one such operator is worth quoting at length:

Master Paolo of Arezzo appears in the square with his banner . . . where on one side you see a St Paul, sword in his hand, and on the other a bed of snakes which, hissing, they almost bite everyone who looks at them, painted as they are. Now he starts to recount the false origin of his house, the fictitious descendance that he draws from St Paul; he tells of the story when he was bitten on the island of Malta, he untruthfully declaims how that grace is present in all those of his family, he describes the trials made, the competition experienced, the victories received, the banners conquered, which are unfolded to show to the people. He picks up his boxes, and takes out a charcoal-black serpent, two yards long and thick as a pole, and then a *madrassa,* and then a viper, and he frightens the people with the horrible appearance of these beasts. Here he weaves a tale around how he caught them in the forest, while the harvesters harvested the wheat, and saved the estate from the certain death which threatened everyone because of the danger of those damned serpents. The plebeian curls in fear, the peasant trembles at the news, which is told with such ability that no one feels safe putting a foot out of the city if they have not first drunk a glass of powder given them by Master Paolo.[70]

The reputation of the *sanpaolari* was brought further into disrepute thanks to the rivalry they had with another similar group of snake-charmers, the *sandomenicari.* Originating in the Abruzzi, they took their name from their saintly patron, St Dominic of Sora. The two competing operators fought pitched battles for custom whenever they encountered one another. Or, no less harmful, they would interfere with one another's performances. To thwart their rivals, they were said to substitute secretly wild vipers for the tame ones their competitors were using, with often fatal results.[71] As early as 1451, a snake-charmer (*ciurmatore)* known as Master Ferrante from Lecce was found guilty of using his serpents to cause the death of another snake-charmer, Master Alessandro, in Florence.[72] The *sandomenicari* boasted of an advantage over the *sanpaolari:* they had St Dominic's tooth as a relic. In one miracle narrative dating from the eighteenth century the holy tooth was charitably employed to save the life of a rival *sanpaolaro.* The snake-charmer was performing in the town of Cocullo (Abruzzo Ulteriore) on the vigil of the feast of St Dominic, boasting of being of the house of St Paul and recounting how he feared no poisons. Whilst playing with his vipers, he was bitten by one on the tongue. The *sanpaolaro* would have died had the priest not brought him into the church and signed him with the tooth.[73]

The groups of snake-charmers I have been describing were part of a wide range of itinerants described as swindlers and cheats by the literature of roguery, going back to Teseo Pini's *Speculum cerretanorum* of around 1484–86.[74] They were the first charlatans, and the direct ancestors of the Orvietan and his competitors. The most obvious semantic link between snake-charmers and charlatans is in the Tuscan word used for charlatan, *ciurmatore,* which means 'charmer' or 'bewitcher.' It was

employed with reference to the two 1451 snake-charmers cited above. Vernacular terms used elsewhere in Italy referred to their on-stage performance. Thus *montimbanco*, or mountebank, which refers to their mounting a platform to perform farces and sell their wares. The term charlatan itself derives from *ciarlatano*, a result of the intromission of the verb *ciarlare* (to chatter or prate) into the word *cerretano*. The latter term designated someone from the Umbrian town of Cerreto, whose inhabitants had the ill fame of wandering about dressed as pilgrims, collecting alms under false pretences. In the tradition that begins with Pini, they gave their name to all sorts of false mendicants and traders: pilgrims, indulgence sellers, friars, alms collectors for hospitals, relic bearers, disease sufferers, all fake. And, of course, snake-charmers. As the most successful of the lot, combining healing skills with show, they are a crucial link in the transformation, real and semantic, from *cerretano* to charlatan. The Orvietan, a charlatan *par excellence*, may himself have been a snake-charmer. He certainly capitalised on the tradition: his stage name and alleged place of origin in the central Apennines, his antidote which contained vipers' troches and terra sigillata. The Orvietan was a true entrepreneur, making use of traditional beliefs and rituals, whilst at the same time taking advantage of new economic opportunities. His patented medical 'secret', one of medicine's earliest brand-names, was grafted on to the older world of the sacred healer exemplified by the snake-charmer. At a time when most charlatans were peddling 'distilled waters and divers oyntments for burning aches and stitches and the like, but espetially for the itch and scabbs',[75] charlatans marketing their own exotic electuaries were the first of a new breed.

## Medical secrets

What else did the orvietan antidote contain? This is not merely a pedantic exercise. The contents of the remedy will help explain its popularity and tell us something about seventeenth-century medicine besides. Charlatans stressed the mystery and exotic nature of what they sold. A medical 'secret' would not have been much good to a charlatan if the public at large knew its ingredients. According to proto-physician Santorelli, charlatans

> call the remedies they use secrets, and as such unknown to physicians, to whom they do not want to reveal them, in case learned by [the physicians], they would take their earnings away. [These people] are commonly called empirics, both because they cannot explain what they do and because they have learned that that medicament is effective, either by means of an experiment done on themselves, or on a friend or relation.[76]

The 'secrets' they marketed were justified as having been 'tried' or 'tested.' Some charlatans even published booklets of secrets, containing recipes for the treatment of common ailments, a genre of how-to writing that went back to the Middle Ages. These were collections of supposedly proven medical recipes and other 'how-to' instructions. They were 'secret' because they worked by hidden or artificial (as opposed to natural)

means. During the Middle Ages the best known had been the pseudo-Aristotelian *Secretum secretorum,* an Arabic work translated into Latin in the twelfth century, and the *Liber aggregationis* or *Secreta Alberti,* attributed to Albertus Magnus.

The advent of printing brought with it an expansion of such works, directed at wider readerships. Such was Girolamo Ruscelli's *Secreti nuovi* of 1567.[77] It contains an astonishing 1,245 different recipes: over one thousand were various medical remedies, the rest a miscellany of cosmetic and technical recipes. The book's author had moved to Naples in the early 1540s, where he entered the service of the marquis of Vasto, Alfonso d'Avalos. Ruscelli apparently founded the Accademia Segreta during this time, where the recipes later published in the book were collected and tried out. The Academy was 'secret' in the literal sense of being a secret society and in its investigation of the workings of nature. With the support of a local nobleman, the Academy built a three-storey building, complete with herb garden and laboratory. Its twenty-four members made use of the services of various apothecaries, goldsmiths, perfumers, herbalists and gardeners to assist them in their trials. We only have Ruscelli's word on all this, but its existence is quite plausible. The patron Ruscelli refers to was probably the Prince of Salerno, Ferrante Sanseverino, who was, amongst other things, supporter of the university there.[78]

If the Academy had a direct descendant it was the Neapolitan Giovan Battista Della Porta. While still very young he may have been one of the Academy's privileged observers. He went on to found his own Accademia dei Segreti in the 1560s. Moreover, his *Magia naturalis* of 1558, consisting of recipes and experiments in medicine, crafts, optics and other secrets of nature, is similar to Ruscelli's work in both content and methodology (despite the fact that Della Porta's approach is sometimes quite obviously tongue-in-cheek). Throughout his life Della Porta remained interested in natural magic − calling it 'the science of the extraordinary' − and was acknowledged as Europe's foremost authority. It was something he was not afraid to take advantage of. Towards the end of his life it was even said that he had received more than one hundred thousand ducats from his patrons for his work, ten times the viceroy's annual salary.[79]

Despite the eventual impact of the new science, an esoteric tradition survived in the kingdom, as elsewhere. Nor did printed recipe collections entirely supplant the manuscript tradition. For example, the familiar mixture of medicine, magic and religion is present in an eighteenth-century manuscript recipe-book that has come to light. It is unusual in that we know its author: he was Iacopo Fraiese, from the town of Capaccio, south of Salerno. The title he gave to his collection suggests his reason for compiling it: 'Idleness avoided in prison. A collection of very good secrets and proven [tried out] medicaments.' I cannot say why he was in prison or what his profession might have been. But I can say that his collection consists of nearly three hundred recipes, which follow one another without apparent order. The recipes are a mixture of: (i) Latin verses taken from the ever-popular *Regimen Sanitatis Salernitatem,* with Italian commentary; (ii) remedies in Italian for a whole range of maladies; and (iii) a series of verses from various psalms. The latter, when uttered 'devoutly', had the power 'to find hidden things', spare those in danger of

drowning, provide divine help for the sick, or counter the bites of dogs and serpents, to mention just a few.[80] Certainly there is nothing surprising in using the recitation of psalms to beseech divine intercession. What might surprise, however, is the way each psalm was used to target a specific malady or misfortune, in the same way that popular invocations addressed the particular saint most relevant to that malady. Biblical verses are scattered throughout the collection, such as the remedy for falling sickness (that is, epilepsy). This was to have a priest say the verse 'Memento, Domine creature tue' three times into the sick person's left ear. A remedy for kidney-stone consisted of a powder made from rosemary which had been planted on the feast of the Annunciation (25 March) and picked on the feast of St John (24 June), similar to remedies found in popular healing rituals. Many of the secrets listed by Fraiese are not medical at all: how 'to destroy any malefice', 'to find out whether the husband or the wife dies first', 'to find out if a woman is pregnant', and even laundry advice like how 'to remove any stain' (brandy and starch). It is impossible to say whether the collection was ever consulted, and if so in what way. Was it ever used in a household setting? All we can say is that it managed to find its way into the archive of the Del Mercato family, where it still rests.

Were such collections 'popular'? The answer depends upon our definition. Fraiese certainly drew upon oral herbal traditions, the property of every housewife, and the incantations and conjurations of cunning folk. But he also took his secrets from the published works 'of the finest ancient and modern authors', as he says in his premise. These include Della Porta and a certain Madamma Fochetta. The latter turns out to be the Frenchwoman Madame Fouquet, author of a successful charitable handbook, first published in 1675.[81] But unlike Fouquet, Fraiese was not writing for the uplift of the poor, but for his own delectation and that of his class. The vegetable ingredients like ambergris, saffron, 'dragon's blood' (a resinous substance given off by the Indian palm), myrrh, and the mineral ingredients like rock alum, litharge (protoxide of lead) and minium (red lead), which fill his secrets, were accessible only to the well-off. The same can be said of the recipes found in Ruscelli's *Secreti nuovi,* which reflect upper-class tastes, especially evident in the secrets of a cosmetic, alchemical and technological nature. The Italian manuscript recipe collections I have come across range from the very detailed and technical, compiled and used by apothecaries, to the more approachable, descriptive and practical, for use in upper-class households. The Gizzi *ricettario,* described in the previous chapter, has elements of both. The collections are all very eclectic and varied; and they are clearly intended for an at least semi-educated, literate audience. It is, of course, quite possible that some of these medical secrets would have found their way down to the oral tradition. For this reason it may be helpful to see these collections as mediators between oral and literate cultures, much like the charlatans.

In 1585 Tommaso Garzoni included a description of 'professors of secrets' in his *Piazza universale,* referring to them as tireless searchers into obscure, veiled and occult things. Some of their secrets were 'great' (such as for healing plague), others 'mediocre' (healing quartan fever) and others 'light' (healing scabies). Some were 'perfect', in having the desired effect all the time, others worked most of the time,

the rest rarely.[82] The link between them and charlatans was the increasing commercialisation of the economy as a whole and of drugs in particular. As far as Santorelli was concerned, it was axiomatic that charlatans sold 'secrets.' The Neapolitan Protomedicato continued to label 'secretisti' certain of the charlatans it licensed, eight of whom were included in the 1784–85 list for the capital.[83] Charlatans became synonymous with the secrets they marketed, like orvietan. Referring to orvietan, the Palermitan naturalist Paolo Boccone bemoaned that 'the secret passes from father to son by inheritance and usually these charlatans or mountebanks do not reveal the entire description of orvietan to the authorities for fear of losing their daily income.' Boccone could only repeat the description of it made by Madame Fouquet in her book of remedies, adding the version revealed to him by a Palermitan charlatan operating in Genoa in 1688.[84] Fortunately, we have the records of the Italian Medical Colleges and Protomedicati to help us. As part of their petitions for licences and patents, charlatans had to list the ingredients of their 'secrets' and the quantities used. Whatever Boccone thought of the deceits of char-latans in withholding details from the authorities, by comparing the submissions of various (competing) charlatans for licences over a period of some one hundred and fifty years, we should be able to get at the actual contents of the antidote.

Riollet gives two versions of orvietan. The first, which he states was dictated to him by the charlatan Desiderio Combes,[85] contained eight ingredients. The second contained fifteen ingredients. Although the two versions had only three ingredi-ents in common, their contents were entirely herbal, with the addition of theriac and mithridatum (about which, more below). Other versions circulated, according to Riollet. But, whatever their differences, they all share 'a horrible bitterness, that can only come from the roots I have listed.' Anyone who considered the people selling orvietan, the price at which they sell it and the short time and minimal fuss required to make it, could only come to the conclusion that it was made of plants, without any rare or precious ingredients. Orvietan's low price and the 'prodigious quantity' sold indicates that the simples were abundant and readily obtained.[86]

In fact, there were many more ingredients than those indicated by Riollet – as many as forty-five. The sheer number of simples suggests that orvietan was being offered as an accessible, if not poor man's, theriac. This was the conclusion reached early on by the German physician, resident in Rome, Johannes Faber. Referring to a 1603 case, he noted that orvietan was 'very common amongst the people, much less effective than theriac and therefore much cheaper.'[87] The theriac of Andromachus still came out on top, with sixty-four ingredients, but orvietan was a close second. The most detail comes from two petitions made in the second half of the seventeenth century, when the Protomedicati and Medical Colleges were at the strictest when it came to examining and approving charlatans. Of these two recipes for orvietan, the first has forty-five ingredients and the second forty-two. At first glance they seem quite at odds with one another, since only just over half the ingredients are found in both orvietans. This is especially curious since both recipes come from submissions made by the same charlatan, Paolo Angelini, heir to Gregorio Ferranti. The first is contained in a petition made to the Siena

Protomedicato (1665), the second in a petition made to the Rome Protomedicato (1674).[88] It would seem to bear out the words of Boccone. However, a closer look at the seemingly disparate list of ingredients reveals some noteworthy similarities. Both recipes depend overwhelmingly on traditional herbal simples, with three or four spices (cinnamon, cloves, cassia, pepper) added for good measure. Both share a core group of the same thirteen simples reputed to be effective against poison: angelica, snakeweed, blessed thistle, white dittany, viper's bugloss, gentian, juniper berries, St John's wort, bay berries, tormentil, valerian, vervain, swallow-wort. In addition, they contain a few simples – though not necessarily the same ones – used to treat wounds and sores (such as speedwell, germander, agrimony). Finally, they each contained at least ten simples used to cleanse, purge and open obstructions of certain organs. How could it fail? Orvietan took advantage of accepted wisdom on herbal antidotes, putting them all together for added effect. And it included powerful simples known for their perceptible purgative effects on the body. No poison would dare to remain in the victim's body with all that working against it.

If the simples did fail, then theriac was there to back them up. Riollet was prepared to admit that orvietan did have its 'good effects, sanctioned by long and happy experience.' But it could not fulfil the extravagant claims made for it by swarms of charlatans. Herbs alone could not possibly perform miracles. Though orvietan may have been prepared with 'good things', one had no way of knowing whether the roots were well chosen, gathered when their balsamic virtues were strong and prepared in such a way as to maintain these virtues. 'Orvietan is nothing but a confused and badly compounded mixture of powders and roots', Riollet concluded. Therefore any efficacy it had must be due to the theriac contained in it. Orvietan's success was just a flash in the pan, whereas theriac had been an approved remedy for over eighteen centuries. Moreover, unlike orvietan, it was methodically prepared and dispensed with 'marvellous order.'[89]

## The antidote of antidotes

Theriac, always popular, had been enjoying something of a new vogue when orvietan came on to the scene. In 1572 the physician and professor at Salerno, Bartolomeo Maranta, wrote that theriac had two principle virtues, 'one is that . . . it preserves the healthy, the other that it cures the sick.'[90] Its sixty-four ingredients formed a miniature pharmacopoeia. Indeed it owed its success to its very complexity, for a medicine's therapeutic value was proportional to its compositional intricacy. Theriac was a standard feature of medical practice, especially for the rich, who could afford its costly and exotic ingredients.[91] The poor were stuck with more standard herbal remedies, especially garlic, which was proposed as the 'theriac of the rustic' and considered better suited to their rougher constitutions.[92]

The origins of theriac went back to the ancient world, when a physician of Alexandria prepared a remedy against poisons for King Mithridate VI. To his antidote, called mithridatum, Andromachus the Elder, physician to Emperor Nero, added viper's flesh. It was believed that vipers were resistant to their own as well as

other poisons, because their flesh contained something active against them. Disease itself was thought be a kind of poisoning, through the corruption of vital humours. Therefore, when ingested by humans, viper's flesh would be effective not only against viper's venom, but against disease in general. For this reason Galen recommended theriac for all sorts of ailments, in addition to poison.[93] It gained a reputation as a universal remedy, with an important role in preventative medicine. During the early modern period every Italian city with a university or Medical College prepared its own theriac, in elaborate public ceremonies involving medical, civic and ecclesiastical dignitaries. It was being manufactured in Venice as early as the twelfth century.[94] In fact, Venetian theriac achieved the most renown throughout Europe. This success was 'an expression of Venice's commercial power and the wealth of the great Venetian emporiums, well-stocked in all kinds of spices and drugs.'[95]

For the Bolognese naturalist and protophysician Ulisse Aldrovandi, the theriac of Andromachus was the 'regal antidote of antidotes', 'the most powerful and invincible, and I shall say predestined arm that physicians can use against every lethal, soporific, wasting, incurable, horrendous, pestiferous poison.'[96] During the latter decades of the sixteenth century botanists and apothecaries like Aldrovandi felt they were getting closer to the theriac of Antiquity, locating the precise simples that made up the 'true' theriac of Andromachus. The Neapolitan apothecary, botanist and museum-keeper Ferrante Imperato spent years tracking down the true ingredients, some of which he obtained from contacts in Venice. Between 1557 and 1571 he was able to reduce the number of substitute simples used in its preparation from ten to six, according to Maranta, who collaborated with him.[97] Such was the momentous nature of developments towards perfecting theriac according to classical canons that the Neapolitan physician Nicola Stigliola invited the kingdom's protophysician to attend its preparation.[98]

For his part, Imperato had gone about as far as it was possible for an apothecary to go in the kingdom. His museum of curiosities allowed him to dabble in natural history, the sort of thing that would normally have been off limits to an apothecary. His interests propelled him forward and opened up new worlds. He was a member of the council governing the guild of apothecaries, the Speziali degli Otto, author of a treatise on natural history,[99] had close ties with the Spanish viceroy, and would go on to hold various political positions. He was able to help a fellow apothecary when Aldrovandi, as protophysician, got into difficulty over his attempted reform of Bologna's official theriac. The dispute centred around the quality of the vipers that the Bolognese apothecaries were using and the troches made of them. Imperato wrote in Aldrovandi's defence, as did other prominent physicians, including the Neapolitan protophysician, Giovan Antonio Pisano:

> You will hear from Ferrante Imperato, from whom I received one of your most learned letters, that I have procured the opinions of our College so that it would be more authoritative, confirming the correctness of your judgement of the time to collect vipers and that those troches were badly made. I wrote it myself, showed it to everyone and had it confirmed by the Prior of our College.[100]

Alas, it did not help Aldrovandi's position in Bologna much. The city's apothecaries allied themselves with the Medical College to have him ousted as protophysician, though he was eventually reinstated.

The popularity of theriac in Bologna does not seem to have suffered as a result, appearing in the city's *Antidotari* from 1574 through to 1783. This longevity was in no way remarkable. In the nearby city of Reggio Emilia the last official preparation of theriac was around 1850, while Venice had only abandoned its public ceremony in 1842.[101] Theriac was one of the few compound medicines which went on being recommended during the eighteenth century, including the French writers of the *Encyclopédie*.[102] Its decline in some areas – it was left out of the Edinburgh pharmacopoeia as early as 1756[103] – seems to have had little effect on the kingdom of Naples. At mid-century the experienced apothecary Nicola Meola referred to theriac as 'a miracle continued here on earth for the benefit of man.'[104] He thought it should be more widely used, though this should be kept secret from the state, presumably because of the latter's attempts to enforce a monopoly on its production and sale. King Ferdinand IV was determined to reinforce this monopoly. His pragmatic of 1779 was meant to ensure that all the kingdom's theriac came from the same source and was of the same standard.[105] Previous attempts to control it had been through the inspection of apothecaries' shops. The kingdom's apothecaries were required to stock only jars of theriac bearing the signatures of two of the Speziali degli Otto, responsible for its preparation. Needless to say, apothecaries were occasionally tempted to prepare their own. For instance, in 1697 two Salernitan apothecaries were accused of making twenty litres.[106] Worse still, they had done so in secret, at the villa belonging to one of them – in contrast to the official theriac, prepared very much in public. The penalty for the offence was an amazing 1,000 ducats, an indication of how seriously the authorities regarded their monopoly. Nor could it prevent its clandestine importation from dubious sources, including cheaper theriac manufactured illicitly in Trieste and resold as far afield as Constantinople.[107] The 1779 law stated that all the kingdom's theriac was to be prepared in the chemical laboratory of the newly founded Royal Academy of Sciences and Letters. It obliged all apothecaries to buy a certain amount annually, all from one apothecary's shop in the capital designated to dispense it. Profits from the sale of theriac were to go to finance the activities of the Royal Academy. The Abbé Ferdinando Galiani was prompted to remark sarcastically: 'in order to make an excellent theriac, superior to Venice's, and in order to oblige apothecaries to buy it by force' an Academy was founded, 'much more as an object of finance than for the progress of human knowledge.'[108] Rather than ease difficulties surrounding the distribution and control of the sale of theriac, this policy led only to further irregularities, which persisted until all pretence to the monopoly and the income generated by it was finally abandoned in 1860.[109]

## Charlatans and theatre

Given the official nature of theriac, it is easy to see how orvietan could undercut the market. It was touted as something new. It responded to the attraction for

novelty, according to Riollet, despite the fact its contents were entirely traditional, simples known and sold by apothecaries. What for Riollet was a weakness, a sign of deception, could also be seen as a point in orvietan's favour, helping to account for its success. But there was something new about orvietan. Riollet realised this, when he observed that 'there is also the high-flown display of dancing and pantomime, which strongly attracts the people, and which compels those who see them to give them money, more with the intention of obliging the sellers to put on their farces than with the purpose of buying their remedies for their health.'[110] The Italian charlatans in general, and the Orvietans in particular, brought entertainment with them. And not just any tricks, but theatre, in the form of the *commedia dell'-arte*. The more orvietan they sold, the longer their performance would be. Though not all *commedia dell'arte* troupes sold patented remedies, and not all remedy-sellers performed extemporised comedies, there was a significant overlap between the two groups.

At the end of the sixteenth century these overlapping groups were new on the French scene and soon caught the public's imagination. Italian troupes had been coming to France since the 1570s, and by the early decades of the seventeenth century they were staying longer – as long as ten years – and becoming a familiar part of the French cultural scene.[111] The years when Italian charlatans like Contugi decided to reside permanently in Paris were also the years when Italian actors did the same, eventually leading to the formation of the Comédie Italienne in Paris.[112] The fact that both groups came from Italy helps to explain why French *opérateurs* like Verrier and Descombes should change their names to Vetrario and Combi, respectively. To quote Riollet once again, Frenchmen 'have not missed the opportunity of calling themselves foreigners in order to sell their drugs with as much fuss as the others.'[113]

In Italy the *commedia dell'arte* and charlatanry derived from the same medieval traditions of farce, trickery and clowning.[114] Both began to flourish at the same time. Just when snake-charmers were developing into charlatans, the *commedia dell'arte* players in Naples and elsewhere were drawing up contracts for professional performances.[115] Their histories are in fact intimately interwoven, a fact which has been hidden by the divergent approaches of scholars over the years. Historians of theatre have, naturally enough, been interested in the performance-related elements, whilst historians of medicine have focused on the remedies sold. But the distinction is, often as not, an artificial one. Certainly, in the strict climate following the Council of Trent the religious and secular authorities tarred them all with the same brush. They were all itinerants, lacking a secure legal status. Moreover, any kind of acting was suspect, since their fictions were considered akin to lying and deceit. After having excluded troupes for a time, Naples opened its gates to them again in 1589. By way of penance, however, the income derived from the licence fees for each performance was awarded to the Incurables Hospital.[116] In Milan the governor forbade all 'masters and players of comedies, herb-sellers, charlatans, buffoons, zanies and mountebanks . . . who are wont to mount their platforms and to draw a crowd around them' from performing on Church feast days or

during Lent and from erecting their platforms near the church.[117] Neapolitan archiepiscopal decrees were more concerned with their activities *inside* churches, especially disruptive while mass was being said.[118] Contemporary descriptions also relate how troupes would 'choose a place in the public square, where, having set up a stage, they get up on to it, to be first the charlatan and then the actor.' They would gather the attention of passers-by with tricks and clowning. Once a crowd had formed, the head charlatan would discourse on 'the great and incomparable credit of his marvellous medicament.' It would then be offered for sale. Once the selling had come to an end, 'the platform becomes a stage and every charlatan an actor.' The grand finale was 'a theatrical performance which, in the comic tradition, entertains the people for about two hours with revelry, laughter and amusement.'[119] The overlap between player and charlatan is also reflected in the licensing records. Actors and charlatans were frequently the same people, as their stage-names reveal. The tooth-drawer and seller of a 'refreshing ointment' for burns and sores and an oil to help hair grow, Tommaso Maiorini of Capua (near Naples), went by the name 'Polcinella', one of the characters in the *commedia dell'arte,* and particularly linked to the city of Naples.[120]

The charlatans' use of theatre was one of the aspects that most infuriated the medical elites. The Italian Medical Colleges and Protomedicati were increasingly concerned with trying to impose some kind of order on the wide range of healers. As explored in chapter three, physicians, surgeons, apothecaries and midwives all had their recognised roles. They were not to exceed their professional boundaries. Charlatans, however, broke all the rules. They had pretensions to knowledge and experience which, the elites believed, should have been the monopoly of university-educated physicians and surgeons. By selling medicines, they competed with apothecaries, a fact that was especially insidious because they often insisted on calling them medical 'secrets.' Their use of performance and entertainment was the most apparent indication of their ambiguous status. It was thought to bring medicine into disrepute. Critics like Scipione Mercurio quoted St Thomas Aquinas on the sinful nature of stage-plays, based as they were on dishonesty and deceit. Watching their 'performances acted out by zanies, Gratians, puppets or other sorts of buffoons' was not just sinful; trusting in their ineffectual remedies prevented people 'from employing other remedies, of help to the sick.'[121] In their treatment of charlatans, we see the medical elite's 'fear of crowds, of novelty, of strangers and, perhaps, of laughter itself.'[122]

It was not just the charlatans who were accused of being 'theatrical' during this period. The same criticism was made of Fra Antonino da Camerota, who would announce miracle cures to all and sundry in the church of Santa Maria della Sanità, in search of donations, as we saw in chapter one. Whereas the investigating physicians may have seen cause for reserve and caution, the friar certainly did not. Indeed charlatans frequently had to share the same square with equally histrionic monks and priests. In Naples one well-known preacher shouted to the crowd to ignore the Pulcinella performing opposite. 'The true Pulcinella', he said, pointing to his crucifix, 'the really great Pulcinella, here he is.'[123] Camillo de Lellis, the Abruzzese

founder of the Ministers of the Sick, also made the connection. On one occasion, in his native town of Bucchianico, he climbed on to a platform and told the people gathered outside church on Sunday that he had 'resolved to come into the square to find you and be a spiritual mountebank for your salvation.' After preaching on the abhorrence of sin, he said: 'Just as the other mountebanks always sell something useless to the people at the end of their patter, so at the end of my talk I would like, not to sell, but to give you a pious and blessed thing.' And he took from a bag, not the usual patent medicines, but religious medals, which he handed out to the crowd.[124]

Preachers and charlatans alike – sacred and secular orators – held their audiences spellbound by their emotionally charged performances. While charlatans were being reviled and ridiculed by the medical elites, they were also exceedingly popular with audiences everywhere, as the example of Girolamo Ferranti shows. They mixed care for the body with an understanding of popular culture and sensibilities. The combination of spectacle and treatment became a kind of social ritual, the charlatan – with his patented 'secret' – a 'commercialised shaman.'[125] In a very public space charlatans offered entertainment, escape, laughter, play, fear and surprise, along with medical treatment and the easing of suffering. Of course, not all charlatans managed to reach the heights of dynasties like the Ferrantis. In fact, most charlatans led a rather wretched, wandering existence. They would take advantage of whatever opportunities to buy and sell presented themselves, often selling simple remedies for everyday ailments purchased from apothecary shops. Many itinerant pedlars were not born into the trade, but adopted it as part of a personal strategy of survival. It was often just a stage in a person's life, giving way to other activities according to need and opportunity.

The only reason so much can be said about the Orvietan and other charlatans is because of the medical licensing records. Fortunately for the historian, the medical elites were inconsistent in their revulsion for charlatans. The physicians may have despised them in their learned treatises, but they licensed them to sell their remedies throughout Italy and France. Though so often perceived as the 'other',[126] the charlatan was in fact a crucial part of the medical network of early modern Europe. A remedy like orvietan was within firmly established medical traditions. The assumptions behind it were entirely humoral. Its contents were repeatedly examined and approved by the medical authorities. The petitions made by generations of Orvietans to the authorities were written by literate men. And the handbills they used to sell orvietan were written in Tuscan Italian, the language of a small elite, employed to impress. They had as much faith in their patented antidote as the elites had in theriac. For this reason at least one Orvietan dispensed his 'secret' from his Roman home. That is, he had a permanent address, which, far from keeping hidden from the public, he actually sought to capitalise on.[127] When it came to marketing secrets, regular practitioners soon learned how to play the charlatans' game. The only difference was that they hid their own rare secrets in learned treatises. The physician-surgeon Federico Zerenghi concluded his 1603 work on surgery with a teasing reference to his own sure-fire cure to the French disease. It purported to

cure within a few days, without suffering or inconvenience. Anxious – or merely curious – readers were referred to his next book, soon to appear.[128] (But like the academic monograph announced as 'forthcoming' for years on end, it never did.) More in keeping with this chapter's subject was protophysician Piperno's proposed antidote included in his treatise on magical afflictions. It was proclaimed to be effective against 'all magical and inveterate diseases', poisons and animal bites, acting as both a preservative and a curative. Piperno compared his remedy favourably to orvietan, though his version had a paltry twenty-five ingredients. But, the author boasted, unlike the mass of greedy charlatans, he was motivated to reveal his antidote by charity alone: 'for, in the words of St Augustine, to hide the truth is to tell a lie.'[129] This public-spirited motivation was one way in which physicians attempted to differentiate themselves from charlatans. The charlatans themselves, when caught selling without a licence, or when accused of harming someone, also played the charity card. They insisted that they had been distributing their wares gratis, for the benefit of the poor sick, not for financial gain. It is to the role of charity in health care that we now turn.

## NOTES

1 Secondo Lancellotti, *L'Orvietano per gli hoggidiani* (Paris, 1641).

2 Claude-Stephen Le Paulmier, *L'Orviétan: histoire d'une famille de charlatans du Pont Neuf aux XVIIe et XVIIIe siècles* (Paris, 1893), p. 11.

3 Lucinda Beier, *Sufferers and healers: the experience of illness in seventeenth-century England* (London, 1987), p. 33; Roy Porter, *Health for sale: quackery in England, 1660–1850* (Manchester, 1989), p. 43.

4 The point is made by Mark Jenner in his article 'Quackery and enthusiasm, or why drinking water cured the plague' in O. P. Grell and A. Cunningham (eds), *Religio Medici: medicine and religion in seventeenth-century England* (Aldershot, 1996), p. 327.

5 Archivio di Stato, Florence, *Otto di Balia*, 232, fol. 115; in Andrea Corsini, *Medici ciarlatani e ciarlatani medici* (Bologna, 1922), pp. 37–8.

6 *Ibid.*, p. 40.

7 Thomas Sonnet de Courval, *Satyr contre les charlatans* . . . (Paris, 1610), p. 101; in Le Paulmier, *L'Orviétan*, p. 12

8 A.S.S., *Studio*, 60, fol. 28r.

9 A.S.R., *Università*, 58, xxxi, fol. 175.

10 From a document contained in a petition to the Rome Protomedicato, A.S.R., *Università*, 58, no. xxxi.

11 Archivio di Stato, Florence, *Carteggio di Don Giovanni*, 5140, fols 452, 466; in Alesssandro D'Ancona, *Viaggiatori e avventurieri* (Florence, 1974 edn), p. 107. The *Avvisi* (advices, notices) was a sort of early newspaper, containing items of local news.

12 'Arrêt du Conseil privé rendu à la requête de Christophe Contugi, véritable Orviétan', 25.V.1657, Archives Nationales, Paris, V6, 346; in Le Paulmier, *L'Orviétan*, pp. 139–40.

13 'Lettres de naturalité pour Christophe Contugi, dit l'Orviétan et Clarisse Vetraria, sa femme', 21.X.1646, Archives Nationales, Paris, Z 5997, f. 46v.; in Le Paulmier, *L'Orviétan*, pp. 128–9.

14 'Arrêt du Conseil privé à la requête de Christophe Contugi . . . par Gilles Bary, François Fossa et Christophe Poloni, vendeurs d'orviétan', 19.V.1656; in Le Paulmier, *L'Orviétan*, pp. 130–2.

15 Le Paulmier, *L'Orviétan*, pp. 48–9.

16 *Ibid.*, p. 98.

17 Laurence Brockliss and Colin Jones, *The medical world of early modern France* (Oxford, 1987), pp. 638–41.

18 Anthony à Wood, *Fasti Oxoniensis*, II, 1641–91 (London, 1820), p. 122; in Leslie Matthews, 'Licensed mountebanks in Britain', *Journal of the History of Medicine and Allied Sciences*, xix (1964), pp. 32–3.

19 Porter, *Health for sale*, p. 28.

20 According to a licence petition he made in 1682, Public Record Office, London, *Calendar of State Papers, Domestic*, p. 450; in Matthews, 'Licensed mountebanks', p. 36.

21 *Calendar of State Papers, Domestic*, 1682, pp. 520–1; in Matthews, 'Licensed mounte-banks', pp. 35, 38.

22 British Library, *Quack Medicine Advertisements*, no. 6; in Matthews, 'Licensed mounte-banks', p. 39.

23 A.S.B., *Studio*, 233, edict of 29 December 1736.

24 Tommaso Garzoni, *La piazza universale di tutte le professioni del mondo* (Venice, 1616), p. 324v.

25 Peter Gunn, *Naples: a palimpsest* (London, 1961), p. 106.

26 Thomas Riollet, *Remarques curieuses sur la Thériaque, avec un excellent traité sur l'Orviétan* (Bordeaux, 1665), p. 21.

27 Archives Municipales, Troyes, *Lieutenant général de Police*, 7.IV.1714; in Bernard Jacquet, 'Empiriques et charlatans troyens du XVe au XIX siècle' (Paris, 1960, thèse pour le doc-torat en médecine, Faculté de Médecine de Paris), p. 39.

28 A.S.R., *Università*, 23, xviii, xxxi, 1626,1645, 1675.

29 A.S.S., *Studio*, 60, fols 61v., 64v., 75r., 77r., 79r., 81v.

30 A.S.S., *Studio*, 48, fols 181–3.

31 A.S.R., *Università*, 23, xxxi, 10.viii.1675. Angelini's son Giuseppe inherited it in 1725 (A.S.S., *Studio*, 61, fol. 741.).

32 A.S.B., *Studio*, 319, fols 150r.-v.

33 A.S.B., *Studio*, 214, fol. 56v.; 319, fols 162v.-165r.

34 A.S.S., *Studio*, 48, fols 181–3.

35 Giovanni Battista Pasino, *Modus utendi electuario quod Orvietanum dicitur, contra omnis generis venena* (Padua, 1624); in Le Paulmier, *L'Orviétan*, p. 33.

36 *Ibid.*, p. 36.

37 According to a handbill: 'Virtù dell'elettuario triacale, o sia Orvietano composto e dis-pensato nella spetiaria de MM.RR.PP. di S. Domenico di Borgo Val di Taro' (Parma, 1714); in Piero Camporesi, *La miniera del mondo: artieri, inventori, impostori* (Milan, 1990), p. 268.

38 Riollet, *Remarques*, p. 17.

39 'Francesco Nava, detto l'Orvietano defensor de' veleni . . .', 1649; A.S.B., *Studio*, 214.

40 Leonardo Vairo, *De fascino libri tres* (Venice, 1589); Battista Codronchi, *De morbis veneficis ac veneficiis libri quatuor* (Venice, 1595), in Lynn Thorndike, *A history of magic and experi-mental science* (New York, 1941), vol. 6, p. 544.

41 Jean Baptiste Du Hamel, *De corporum affectionibus cum manifestis tum occultis libri duo* (Paris, 1670), pp. 427–39; in Thorndike, *History of magic*, vol. 8, p. 208.

42 Jean Prévost, *Medicina pauperum ac eiusdem de venenis ac eorundem alexipharmacis opusculum* (Frankfurt, 1641), pp. 335–43; in Thorndike, *History of magic*, vol. 8, pp. 410–11.

43 Giovanni Filippo Ingrassia, 'De veneno post tempus pernecante', in idem, *Methodus dandi relationes pro mutilatis, torquendis aut a tortura excusandis*, ed. G. Curcio (Catania, 1938), pp. 166–73.

44 He was eventually overthrown by members of his own faction. H. G. Koenigsberger, *The government of Sicily under Philip II of Spain* (London, 1951), pp. 179–80.

45 Girolamo Mercuriale, *De venenis et morbis venenosis* (Venice, 1584), pp. 20r.-v. The discussion that follows is based on Thorndike, *History of magic*, vol. 5, p. 477–85.

46 Andrea Bacci, *De venenis et antidotis* (Rome, 1586), p. 51.

47 *Ibid.*, p. 52.

48 David Gentilcore, *From bishop to witch: the system of the sacred in early modern Terra d'Otranto* (Manchester, 1992), p. 221.

49 Sabina Loriga, 'A secret to kill the king: magic and protection in Piedmont in the eighteenth century', trans. M. Gallucci and C. Biazzo Curry, in E. Muir and G. Ruggiero (eds), *History from crime* (Baltimore, 1994), pp. 88–109.

50 For an early eighteenth-century case involving the Duke of Martina and an illiterate tailor, in Gentilcore, *Bishop to witch*, pp. 221–3.

51 Francesco Palermo, 'Narrazioni e documenti sulla storia del Regno di Napoli dall'anno 1522 al 1667', *Archivio storico italiano*, ix (1846), p. 478.

52 F. Moryson, *Fynes Moryson's Itinerary* ed. C. Hughes (London, 1903), pp. 405–6.

53 *Ibid.*, p. 408.

54 Alan Ryder, *Alfonso the Magnanimous, King of Aragon, Naples and Sicily, 13964–1458* (Oxford, 1990), p. 320.

55 J. Lucas-Dubreton, *The Borgias*, trans. P. J. Stead (London, 1954), pp. 211–12.

56 E. R. Chamberlin, *The fall of the house of Borgia* (London, 1974), pp. 267–8.

57 N. M. Sutherland, *The Huguenot struggle for recognition* (New Haven, 1980), p. 170.

58 Jean-François Dubost, *La France italienne, XVIe-XVIIIe siècle* (Paris, 1997), pp. 312–18.

59 Nancy Mitford, *The Sun King: Louis XIV at Versailles* (London, 1966), pp. 83–92.

60 Peter Burke, *The historical anthropology of early modern Italy: essays on perception and communication* (Cambridge, 1987), p. 213.

61 Galen, *De simplicium medicamentorum*, bk xi, ch. 1. See discussion in Angelo Turchini, *Morso, morbo, morte: la tarantola fra cultura medica e terapia popolare* (Milan, 1987), pp. 165–6.

62 Riollet, *Remarques*, p. 11.

63 Giuseppe Pitrè, 'Mirabili facoltà di alcune famiglie di guarire certe malattie', *Archivio per lo studio delle tradizioni popolari*, xiv (1895), p. 218.

64 M. Felonio, *Historiae marsorum* (Naples, 1678), p. 6; in Alfonso di Nola, *Gli aspetti magico-religiosi di una cultura subalterna italiana* (Turin, 1976), p. 95.

65 Giovanni Filippo Ingrassia, *Constitutiones, capitula, iurisdictiones, ac pandectae regii protomedicatus officii* (Palermo, 1657), p. 10. The list also includes midwives, veterinary doctors, grocers and the 'sellers, practitioners and dispensers of medicaments.'

66 'Conto di Giuseppe Bausi', A.S.N., *Sommaria: Protomedicato*, series II, 34.

67 For example, Garzoni, *Piazza universale*, p. 322r.; Scipione Mercurio, *De gli errori popolari d'Italia* (Verona, 1645), p. 278.

68 Ferdinando Ponzetti, *Libellus de venenis* (Rome, 1521), bk ii, tract 1, ch 5.

69 Pier Andrea Mattioli, *Discorsi de' sei libri di Dioscoride* (Venice, 1712), 831; in Di Nola, *Aspetti*, p. 75.

70 Garzoni, *Piazza universale*, p. 324r.

71 Riollet, *Remarques,* 31, citing Mattioli.

72 Archivio di Stato, Florence, *Magistrato degli Otto: Libro delle condannazioni,* 4/vi/1451; in Piero Camporesi (ed.), *Il libro dei vagabondi* (Turin, 1973), introduction, p. cxlix.

73 Anon., *Breve notizia del miracolosissimo dente di S. Domenico dell'Ordine di San Benedetto, che si conserva nella terra di Cocullo, diocesi di Sulmona* (Naples, 1928), p. 18. A second edition of the book was published at Naples in 1770; in di Nola, *Aspetti,* p. 96.

74 Reprinted in Camporesi, *Vagabondi,* pp. 3–77.

75 Moryson's, *Itinerary,* p. 424. His observation is borne out by the detailed records of the Siena Protomedicato. In the period from 1592, when records begin, to 1611, the first appearance of Ferranti in the records, most charlatans sold a variety of unglamorous specific remedies designed to treat common ailments. A.S.S., *Studio,* 60.

76 Antonio Santorelli, *Il protomedico napolitano, ovvero dell'autorità di esso* (Naples, 1652), pp. 45–6.

77 Girolamo Ruscelli, *Segreti nuovi di maravigliosa virtù* (Venice, 1567).

78 William Eamon, *Science and the secrets of nature: books of secrets in medieval and early modern culture* (Princeton, 1994), pp. 147–52.

79 *Ibid.,* p. 222.

80 Iacopo Fraiese, 'L'otio fugato nelle carceri. Raccolta di bellissimi secreti e medicamenti esperimentati', MS, Archivio di Stato, Salerno, *Archivi Privati, Del Mercato,* 30. Reprinted in R. Marino (ed.), *Medicina e magia: segreti e rimedi in due manoscritti salernitani del '700* (Rome, 1991), pp. 107–9.

81 Madame Fouquet, *Recueil de receptes choisis, expermimentés et approuvés* (Villefranche, 1675).

82 Garzoni, *Piazza universale,* pp. 80v-81r.

83 A.S.N., *Sommaria: Protomedicato,* series II, 34.

84 Paolo Boccone, *Museo di fisica e di esperienze* (Venice, 1697); in Alberico Benedicenti, *Malati, medici, farmacisti: storia dei rimedi attraverso i secoli e delle teorie che ne spiegano l'azione sull'organismo* (Milan, 1951 edn), vol. 2, p. 903.

85 Combes, or Descombes, went by the name of Combi, claiming to be an Italian; Le Paulmier, *L'Orviétan,* p. 16.

86 Riollet, *Remarques,* pp. 17–18.

87 Johannes Faber, *Rerum medicarum Novae Hispaniae thesaurus, seu plantarum animalium mineralium mexicanorum historia* (Rome, 1651), p. 778. Faber was physician at the Rome hospital of Santo Spirito at the time. He recounts that a peasant came to him, at death's door following a viper bite and having taken some orvietan. Faber immediately administered some theriac, amongst other things, and cured the man. My thanks to Silvia De Renzi for bringing this to my attention.

88 A.S.S., *Studio,* 48, fols 181–3; A.S.R., *Università,* 58, no. xxxi. A third recipe is contained in Francesco Nava's 1649 petition to the Bologna Protomedicato. It contains thirty-four ingredients, two-thirds of which are shared with the Angelini recipe. A.S.B., *Studio,* 214, fol. 55.

89 Riollet, *Remarques,* pp. 5, 21–3.

90 Bartolomeo Maranta, *Della theriaca et del mithridato libri tre* (Venice, 1572), pp. 8, 163.

91 Nicola Mongelli, 'Diffusione di un medicamento popolare nel Regno di Napoli: la teriaca di Andromaco', *Lares,* xlii (1976), pp. 310–11.

92 Piero Camporesi, *Bread of dreams: food and fantasy in early modern Europe,* trans. D. Gentilcore (Cambridge, 1989), p. 103.

93 Galen, *De theriaca,* xv, xvi.

94 Gilbert Watson, *Theriac and mithridatium: a study in therapeutics* (London, 1966), p. 98.

95 Mongelli, 'Diffusione', p. 314.

96 Biblioteca Universitaria, Bologna, *Aldrovandi, MS* 21, vol. 3, fols 134, 170; Giuseppe Olmi, 'Farmacopea antica e medicina moderna: la disputa sulla teriaca nel Cinquecento bolognese', *Physis,* xix (1977), p. 200.

97 Maranta, *Della theriaca,* pp. 33–5, 82–3, 105; see Richard Palmer, 'Pharmacy in the Republic of Venice in the sixteenth century' in A. Wear, R. French and I. M. Lonie (eds), *The medical renaissance of the sixteenth century* (Cambridge, 1985), p. 109.

98 Paula Findlen, *Possessing nature: museums, collecting and scientific culture in early modern Italy* (Berkeley, 1994), p. 217. Stigliola was a member of the Accademia dei Lincei and author of a treatise on theriac, *Theriace et mithridatia Nicolai Stelliolae Nolani libellus* (Naples, 1577).

99 Ferrante Imperato, *Dell'historia naturale* (Naples, 1599). It was dedicated to the viceroy's son-in-law and governor of Milan, Juan de Velasco. Imperato's son Francesco would follow in his footsteps, both as author and as man of politics, eventually becoming the Marquis of Spineto.

100 Biblioteca Universitaria, Bologna, *Aldrovandi, MS* 21, vol. iv, fol. 348r. (Naples, 10 December 1575); in Findlen, *Possessing nature,* p. 283.

101 Olmi, 'Farmacopea', pp. 213–14; Corsini, *Medici ciarlatani,* p. 36.

102 Lynn Thorndike, '*L'Encyclopédie* and the history of science', *Isis,* vi (1924), p. 385.

103 In a short treatise entitled *Antitheriaca, essay on mithridatium and theriac* (London, 1745), the English physician William Heberden denied theriac had any antidotal virtues at all. None the less, theriac did find its way into the London pharmacopoeia of 1746; it disappeared from the following one, issued in 1788. Watson, *Theriac,* pp. 136–47.

104 'Capaccio. Ad usum mei Nicolai Angeli Meola, oppidi Grecorum', MS, *c.* 1750, fol. 28; in Cleto Corrain, 'Il prontuario manoscritto di un protomedico irpino del secolo XVIII', *Acta medicae historiae patavina,* v (1958–59), p. 67.

105 Lorenzo Giustiniani, *Nuova collezione delle prammatiche del Regno di Napoli* (Naples, 1805), vol. 12, pp. 224–7.

106 'Atti relativi a teriaca', 1698, A.S.N., *Sommaria: Protomedicato,* series II, 33:3.

107 According to a 1777 Venetian trial discussed in Mariano Brugnera, 'Frammenti di un processo per la falsificazione della teriaca veneta', *Atti e memorie dell'Accademia italiana di storia della farmacia,* viii (1991), pp. 87–93.

108 Mongelli, 'Diffusione', p. 327.

109 *Ibid.,* p. 340.

110 Riollet, *Remarques,* pp. 6, 26.

111 Dubost, *France italienne,* p. 101.

112 Allardyce Nicoll, *The world of Harlequin: a critical study of the commedia dell'arte* (Cambridge, 1963), pp. 176–7.

113 Riollet, *Remarques,* 15.

114 Camporesi, *Vagabondi,* introduction, pp. cxxxvii–cxl; Peter Burke, *Popular culture in early modern Europe* (London, 1978), p. 95.

115 Nicoll, *Harlequin,* p. 174. Benedetto Croce, *I teatri di Napoli* (Milan, 1992 edn), p. 42.

116 Archivio degli Incurabili, *Platea* (1589), fol. 349; in Croce, *Teatri,* p. 50.

117 Winifred Smith, *The commedia dell'arte: a study in Italian popular comedy* (New York, 1912), p. 61.

118 *Constitutiones et decreta provincialis synodi neapolitanae* (Naples, 1580), p. 73; *Constitutiones diocesanae synodii neapolitanae* (Rome, 1608), p. 6.

119 Giovani Domenico Ottonelli, *Christiana moderatione del theatro, libro detto l'ammonimento a' recitanti* (Florence, 1652), p. 455; in Camporesi, *Vagabondi,* introduction, p. cliii.

120 According to his petition for a licence from the Sienese Protomedicato in 1663, A.S.S., *Studio*, 48, fols 93–7; 60, fol. 84v. He also wrote a pamphlet on his secret remedies. See Domenico Scafoglio and Luigi Lombardi Satriani, *Pulcinella: il mito e la storia* (Milan, 1992), p. 45; and Carlo Ginzburg and Marco Ferrari, 'The dovecote has opened its eyes', trans. E. Branch, in E. Muir and G. Ruggiero (eds), *Microhistory and the Lost Peoples of Europe* (Baltimore, 1991), p. 18 n. 13.

121 Mercurio, *Errori popolari,* p. 267.

122 Eamon, *Science and secrets,* p. 247.

123 Gunn, *Palimpsest,* p. 103.

124 'Vita di P. Camillo de Lellis Fondatore della Religione de Chierici Ministri dell'Infermi descritta brevemente dal P. Sanzio Cicatelli Sacerdote della stessa Religione', 1608, MS, Archivio Generale dell'Ordine dei Ministri degli Infermi, Rome. Published as R. Corghi and G. Martignoni (eds), *Un uomo venuto per servire: Camillo de Lellis nell'antica cronaca di un testimone oculare* (Milan, 1984), pp. 181–2.

125 Burke, *Historical anthropology,* p. 220.

126 Alison Lingo, 'Empirics and charlatans in early modern France: the genesis of the classification of the "other" in medical practice', *Journal of Social History,* xix (1986), p. 583.

127 A.S.R., *Università*, 58, xxxi, fol. 175.

128 Federico Zerenghi, *Breve compendio di cirurgia* (Naples, 1603), p. 52.

129 Pietro Piperno, *De magicis affectibus lib. vi* (Naples, 1635), p. 115.

# CHAPTER FIVE

# HOSPITALS, POOR RELIEF
# AND HEALTH CARE

As one of Europe's most populous cities throughout the early modern period, Naples had hospitals to match. The Casa Santa dell'Annunziata, for example, was Europe's richest. Built 'like a spatious castle', according to a seventeenth-century guide-book, 'it maintained as their condition, age and health require, two thousand souls.' It took in many hundreds of children, 'between orphane and exposed infants as well as males as females', instructing them 'in letters and art, according to their inclination till they become great.'[1] It treated the sick of all kinds, dividing them up into wards. Each patient had, much to the amazement of an anonymous seventeenth-century English visitor, 'a clean bed, with all necessaries and attendance, as if he were at home in his own house, until he recovers, all gratis.'[2] What was more, 'every bed stood as in an alcove, and had a wall on both sides separating it from beds on both hands, and as much void space on both sides of the bed that the bed it self took up but half the room.'[3]

The Annunziata was but one of the city's many hospitals. Enrico Bacco's guide to the city, first published in 1616, lists eleven hospitals in operation, ten conservatories for women, eleven for girls, five for boys and one for the aged. Together, they assisted some six thousand people every year.[4] The Annunziata and the Incurables hospitals were by far the largest and most endowed. Together, they were referred to as 'the two eyes of Naples, the two columns' supporting the city.[5] However, despite their imposing presence and the impression they made on visitors from abroad, their contributions to poor relief in Naples were but drops in the ocean. Throughout the early modern period the kingdom lacked a co-ordinated programme of poor relief, depending instead on forms of charity that had their roots in the Middle Ages. The study of poor relief and health care in Italy has tended to focus on the development of hospitals for beggars.[6] In Naples, this took place relatively late and was never very effective. This does not mean that poor relief was lacking, but that it was decentralised. The unification of smaller hospitals into one large 'ospedale maggiore' that took place in some other Italian cities during the second half of the fifteenth and first half of the sixteenth centuries did not occur in Naples. As in other Italian states, forms of charity were extremely varied. And although the Counter-Reformation inspired a flowering in works of charity and devotion, most of this was *ad hoc* and sectorial, arising out of particular situations

or in specific places and targeted at special groups. The Catholic Church, in the form of a strengthened episcopacy, did seek to exercise increased control over hospitals, as it did over confraternities and other 'pious works.' Yet this went in the face of ever increasing politicisation of hospitals, more closely linked to civic and state authorities. These are the features of health care and poor relief during this period.

## A Naples hospital for the *mal de Naples*

Some of Naples' charitable structures were in place by the fourteenth century. The earliest hospital was Sant'Eligio, founded in 1270 by the French who came with Charles of Anjou, and followed by the Annunziata in 1336.[7] The hospitals were assisted by confraternities like that of San Cristoforo, already flourishing by the mid-fourteenth century.[8] The same could be said of the kingdom's other cities, for example Lecce's Spirito Santo Hospital, founded in 1392 and still that city's largest hospital in the seventeenth century, or the hospital of the Benedictine monastery at Cava, in the mountains above Salerno, already exercising a specifically medical function in the early twelfth century.[9] But it was the sixteenth century that witnessed the greatest expansion in the kingdom's hospital structure, beginning with the Santa Casa degli Incurabili, the Incurables Hospital, in 1519. Hospitals for 'incurables' were a response to a new plague which had been spreading through Europe since the closing years of the previous century: the 'French disease' (the name given to syphilis and related complaints). It first appeared on the European scene in Naples, explaining why the French preferred to call it the *mal de Naples*. The first hospital to be set up was San Giacomo di Augusta in Rome, which received Pope Leo X's approval in 1515. The response to the disease is best seen in a devotional context, in the religious renewal that was taking place throughout Europe and would lead to both the Protestant and Catholic Reformations. The Incurables Hospital in Naples was founded by the Catalan noblewoman Maria Laurenzia Lonc, through the assistance and inspiration of the Genoese Ettore Vernazza. The latter had set up the pious association known as the Oratory of the Divine Love, first in Genoa and then in Rome. He even attempted to found one in Naples, but it floundered on the rocks of rivalry between the local nobility and the Genoese merchant nobility.[10] The Oratory had a close relationship with hospitals for incurables: in Genoa it would run Santa Maria del Ridotto, and it founded other hospitals elsewhere.

The project to build such a hospital in Naples attracted substantial donations and bequests, and within three years it had moved to new larger quarters at Santa Maria del Popolo. Lonc was indefatigable and chose to live in the hospital. By 1525 it was taking in 'almost innumerable poor people . . . oppressed by the misery of sores and diverse illnesses.' A short ten years later the number of inmates was put at six hundred.[11] It is difficult to say how strict the criteria for entry into the hospital were, and just what conditions were included under the rubric of illnesses ordinarily 'incurable' at home. In fact, like many of its counterparts elsewhere on the peninsula, initial specialisation in the care of syphilitics did not exclude other

illnesses, nor did it mean a shift to an exclusively therapeutic function.[12] By this time the hospital was also the base of the pious brotherhood known as the Compagnia dei Bianchi, taking the place of the Oratory of the Divine Love in Naples. Similar to the Oratory in most respects, the Bianchi had the important distinction in that they provided assistance to people condemned to death. Many early members were important religious figures, like Gaetano da Thiene, founder of the Theatines. Some were followers of the Spanish reformer Juan de Valdés during his stay in the city. One such was Sigismondo Miñoz, who was also one of several Bianchi who served on the hospital's governing body.[13] In 1523, soon after its inception, the Bianchi moved to the Incurables from their original base, at the ancient church of San Pietro ad Aram, in order 'to bring benefit to the said hospital and increase its devotion.'[14] In its charitable activities, the hospital was to be given priority, a weekly alms collection being destined for it. As the brotherhood's 1525 statutes explained: 'given that we are as a limb to it, it is right, indeed natural, that one member feel compassion for the other.'[15]

The Incurables was unusual in being founded and run by a woman. In 1535 Lonc retired to a strict, enclosed Capuchin convent, which she herself had founded. She was succeeded by her assistant and confidante, Maria Ayerbe d'Aragona, the duchess of Termoli. Ayerbe was likewise a pious noblewoman, a source of inspiration to the hospital staff. At the same time, the hospital was acquiring a more regular bureaucratic structure. The viceroy Pedro de Toledo sought some sort of control over the institution. As of 1539 the appointment of governors had to meet with the approval of the civil authorities, according to the hospital's statutes of that year, recognised by the viceroy. The statutes suggest that Ayerbe's role was reduced to the spiritual and hint at possible tensions between her and the governors. They concluded with a reminder to all members of the governing body 'to show all possible reverence and respect, as befits her Ladyship's services, and involve her in all the affairs of the hospital.'[16]

Ayerbe rewarded the hospital by leaving it all her worldly goods. Indeed, bequests of money and land were soon pouring in from all over the kingdom and beyond (principally Spaniards and Sicilians). Most of the wills did not stipulate how the money was to be used. A few testators, however, donated to the hospital on the condition that they be cared for there until they died; others, for the maintenance of a specific number of beds within the hospital.[17] One benefactor even specified that special consideration be given to other natives of his own town of San Marco in Lamis (Capitanata). This included giving them three ducats for their return home after hospitalisation.[18] Two other features of the legacies are worth noting. First, the fact that most concern income derived from the collection of the kingdom's numerous taxes and duties (the *arrendamenti* and *gabelle*): an indication of just how common this form of investment was. Second, benefactors were quite happy to give to the Annunziata Hospital as well, splitting their money evenly between the city's two main charitable institutions.

The hospital belonged not just to the city but to the entire kingdom. Links between the Incurables Hospital and the viceregal administration expanded over

the course of its first century. The formation of its governing body went far beyond purely municipal dynamics. One of its governors had to be designated from amongst the ranks of the kingdom's Collateral Council, another had to be a titled nobleman, another a knight from one of the city's five noble assemblies (*Seggi nobili*), another a Spanish member of the great central tribunals, two were to come from the popular assembly (the *Seggio del popolo*) and one was from the representatives of the foreigners in the kingdom.[19] This did not mean that the hospital was somehow secularised, but it did ensure that serving on its governing body became a mark of prestige for those holding important administrative offices. Moreover, benefactors living throughout the kingdom left substantial sums to the hospital, especially in its first seventy years. In practice, the hospital did not exist for citizens of the capital alone, as has been suggested.[20] The same could be said of the Annunziata. Indeed it was not unusual for well-placed functionaries to serve on the governing bodies of both institutions. One early example was Giovanni Battista Manso, jurist, baron and president of the Chamber of the Sommaria, who was a governor at both hospitals in 1539.[21]

## Hospitals and the Counter-Reformation

If there is no real dividing line separating hospitals founded before Trent and those founded after it, there is no doubting the great impulse that the Counter-Reformation gave to hospital charity. It is worth emphasising in this context that we must resist the temptation to see hospitals as existing in a medical or welfare sphere that is outside the religious. This is especially true after Trent when, with their increased powers, bishops seek to exercise jurisdiction over them. For contemporaries, hospitals were 'pious works', sacred places, in the same category as churches, monasteries, convents and chapels. Communities of religious lived in the hospitals, along with other pious individuals who dedicated themselves to serving them. This is why they are so often the theatre of religious devotions, the nature of which changes as the religious climate at large changes. At the same time, and not always harmoniously, they were also sources of political power, as we have seen. Finally, it is only towards the end of our period that hospitals become the focus, first, of medical learning, usurping the role of the universities, and, later, treatment, competing with home visits by practitioners. It is worth bearing in mind that even in the 1780s the Incurables hospital had more ecclesiastics than medical practitioners and nursing staff combined.[22]

One of the many clerics who lived at the Incurables in the 1580s was the Piacentine Alessandro Borla, assistant to the bishop of Naples. Borla's presence there allowed him to have needy girls and women admitted, who had been refused entry by the Casa dello Spirito Santo. The latter was itself founded in 1564 as a conservatory for vulnerable women or *pericolanti* – the fear being that they had already or might turn to prostitution. In 1583, in response to what was felt to be an obvious need, the princess of Sulmona, Costanza Doria del Carretto, spent twelve thousand ducats to have some ground-floor rooms renovated, to house the poor women. It

was one of the spheres in which women, especially noblewomen, could undertake initiatives. At the same time, del Carretto was continuing in the female tradition of the Incurables Hospital. Two years later, through Borla's ongoing influence, she was able to found the Casa Santa del Rifugio, purchasing the former Orsini palace for the purpose. Like many other Tridentine structures of its type up and down the peninsula, it was intended for the reform of prostitutes, the hope being that they would eventually marry or become nuns. In the meantime, they were to be isolated from the world: living a cloistered life, centred on work and prayer. The fact that the girls processed into the refuge wearing the habits of Capuchin nuns was a sign of what was in store for them. It also points to a paradox typical of the Counter-Reformation: while women were encouraged to undertake important charitable activities, their effect was to exclude groups of women from the public sphere.[23] Despite del Carretto's substantial means, the refuge relied on public support for its continued survival. Amongst the contributions was a fixed donation every year from the bank of the Annunziata Hospital – as incongruous as it may seem to have one hospital contributing to another.[24]

The Annunziata had the ability to adapt to the changing climate. Even before the Council of Trent had ended in 1563 the hospital had become a renewed focus of spirituality and charity. In 1556 its governor, the nobleman Alfonso Piscicelli, downplayed its activities in an attempt to involve the nascent Society of Jesus. He told St Ignatius that the hospital was only working to half its capacity: caring for bodies most splendidly, but ignoring people's souls. This opinion was not shared by other Jesuits in the city. In the same year Cristoforo Mendoza informed Ignatius that 'if there is devotion in Naples, it is all in the Annunziata.'[25]

The hospital's liturgical and spiritual activities came to be performed by a well-prepared clergy, resident at the hospital. The clerical body consisted of sixty priests and thirty deacons. In 1575, after the Jesuits had declined to become directly involved, it established its own seminary, training twenty-five priests. The hospital's superior, the *sagrista*, was usually a bishop, and was an important figure in the life of the city. The hospital's church became a centre for preaching the Tridentine message, including such preachers as the Jesuit Alfonso Salmerón. The splendour of its ceremonies was well known: one thousand ducats a year was spent on music alone. In fact, its wealth was the result of centuries of bequests. Luigi d'Aragona, bishop of Aversa, put it on a firm footing in 1515 when he left it the fief of Montevergine. As of 1587 it had its own bank, or *monte*. By the time Francesco Imperato wrote his treatise on the hospital in 1629, the Annunziata possessed landed estates throughout the kingdom and owned numerous buildings in Naples, as well as earning interest from investments in the collection of various taxes and *arrendamenti*. The latter earned the hospital around two hundred thousand ducats a year.[26] The physicians it employed earned a salary of two hundred ducats a year, fifty more than that of a university professor of medicine and ten times more than the physician serving the city's main Dominican monastery.

But the fame of the Annunziata also rested on the fact that the money was spent, and spent charitably. It maintained some eight thousand foundlings a year, many of

whom were sent out to its 2,500 wet nurses. Whatever the infants' places of origin – and many foundlings were sent in from provincial towns – they were considered Neapolitan-born, acquiring the right to Neapolitan citizenship (assuming they survived).[27] At the age of eight, boys were entered into a trade, via the city guilds, or into a family. Occasionally, they became clerics. Girls could remain in the hospital until the age of eighteen, where they were taught 'feminine activities and skills' by the hospital's several hundred teachers.[28] Each year seventy girls were awarded dowries of ninety ducats.

Although the abandonment of infants was a regular practice, the Tridentine Church did not attempt to eliminate it. Rather it insisted that infants only be abandoned out of dire necessity, and only once they had been properly baptised. Infants were to be left with a note around their neck bearing their name. And they were to be left only at hospitals and other places prepared to take them. The phenomenon seems to become worse during the second half of the seventeenth century with the decline in living standards. In some areas parents temporarily left children at foundlings' homes, as part of an economic strategy to cope with lean times – like admitting oneself to the workhouse during periods of the year when work was slack outside.[29] The effects were particularly acute for those living from day to day on temporary work. It may explain the constant increase in the number of foundlings taken in by the Annunziata. Despite an only gradually increasing population throughout the kingdom, the annual average intake of the hospital climbs from around 600 foundlings in the 1680s to around 1,100 in the 1730s.[30] According to Giuseppe Maria Galanti, writing in the mid-1780s, of the kingdom's twenty-five thousand foundlings, two thousand were sent to the Annunziata from outside Naples every year. This was despite the existence of a network of Annunziata foundlings' homes, linked to the Neapolitan parent home, throughout the kingdom, but especially in the province of Terra di Lavoro. In addition, it received another seven hundred from within the city. Of the total, over half were dead on arrival or died within their first year while out at a wet nurse (numbers that are comparable for other European cities).[31] The situation was worse in the provinces. In most areas there was not a single institution able to take in and care for foundlings, with the result that 'they are exposed at the gates of monasteries far from inhabited areas, or at the doors of [the houses of] parish priests, confessors or public midwives.' Eight out of ten perished.[32] An attempt to reform the situation was only made in 1801 under Ferdinand IV. Each municipality, overseen by a local commission, was to be equipped with a *ruota* to receive foundlings, who were to be visited by community physicians and surgeons. But differences between Naples and the rest of the kingdom remained, as did the low payment awarded to wet nurses.[33]

The Annunziata was also a hospital for the sick, divided into several separate wards: an infirmary, and wards for fever sufferers, those with curable sores and convalescents. The English Catholic priest John Eustace even noted that 'when a patient has recovered his health and strength and is about to return to his usual occupations, he receives from the establishment a sum of money sufficient to compensate for the loss of time and labour unavoidable during his illness.'[34] Can this

have been standard policy? The Annunziata also supported charitable activities outside its walls. Its five *maestri* had a list compiled of deserving or shamefaced poor, to whom was destined a total of 100 ducats a month. This was not a great amount: roughly enough to pay the monthly wage of seventeen labourers. For the more common poor the hospital could spend up to thirty ducats a day, plus one thousand ducats every Saturday. The latter was a substantial amount, enough to buy around a thousand *tomoli* of wheat (forty thousand kilograms), though less than half that amount in times of dearth. In addition to dowries for its own foundlings, the hospital provided 100 poor girls from the city and surrounding countryside with dowries of sixty ducats (equal to what a labourer might earn in ten months) and contributed to the dowries of the less poor to the tune of twelve ducats each. Every year it made two thousand ducats available for priests and religious institutions fallen on hard times, as well as providing some convents and monasteries with medicines. It supported the city's smaller hospitals (as we have seen) and contributed one complete meal to the inmates of each of the city's ten prisons once a week.[35] It even responded to private requests for assistance, providing help to take up a trade or pay the rent.[36] Such was the Annunziata's place in the heart of Neapolitans that when a fire destroyed part of it in 1574 donations poured in from all sides, including two thousand ducats from the Incurables' hospital.

As with the Incurables Hospital, the governing body of the Annunziata was made up of highly placed individuals, though they were more closely connected with city politics than the governors of the Incurables. Of its five top governors, one – the *mastro nobile* – was to be appointed from the noble *Seggio* of Capuana, and four – the *mastri cittadini* – from the *Seggio del Popolo,* so that non-noblemen tended to hold sway. Indeed the hospital was one of the strongholds of the popular assembly, and many of its governors went on to become representatives (*eletti*) of the *Seggio*.[37] In this sense, it was used as a power base or a stepping-stone to greater things. Because of the Annunziata's multiplicity of interests and activities it had to govern itself shrewdly and seek to maintain links with the civil authorities. The demands of influence and integration into local elites explain why its four 'popular' governors are specifically referred to as citizens of the city. But this was the only sense in which the Annunziata privileged city residents over outsiders. Other offices, such as that of physician, often went to practitioners from outside the capital.[38] And, as we have seen, the foundlings and patients themselves came from all over the place. Once again, there does not seem to have been the same discrimination against non-citizens for poor relief as experienced in other Italian capitals, such as Turin.[39]

Although private charity in Naples continued to revolve around the Incurables and the Annunziata, individuals did establish their own, smaller hospitals. This was a continuation of traditional models of charity, where institutions were set up to meet a specific need. Such was the conservatory and hospital of Sant'Onofrio, for the aged, founded by Ottavio Cassano in 1607, the conservatory 'for blind youths', founded by Aniello de Mano the following year, and the hospital 'for poor cripples' founded by the surgeon Tiberio Melfi in 1655.[40] The inspiration behind such

foundations was primarily devotional and charitable, but practical considerations had an important role in governing them, dependent as they were on private funds for their continued survival. The founding charter of the hospital for poor cripples advises caution, and a dose of scepticism, in awarding home relief: 'Do not pay heed to the lamentations that with much show they are well able to demonstrate and exaggerate their needs, giving to believe that they alone suffer more than everyone else; therefore let experience be your teacher.'[41]

## Lay confraternities

In 1608 Sanzio Cicatelli described the large numbers of Neapolitan noblemen, divided into various religious brotherhoods, who 'without any kind of disgust look after the sick.' Born in Naples, Cicatelli could not help remarking that 'to tell the truth I do not remember ever having read or heard that in any other city of Christendom such a large number of noblemen go to serve in hospitals as in Naples.'[42] The statutes of one such noble congregation, the Oratorio del Santissimo Crocifisso, founded in 1553, identified in such charity the reason why 'Naples is extolled as the garden of Italy, not just for its pleasant hills, but also because [it is] a land ever rich in talented people and lively intellects, and cradle of saints and useful institutions.'[43] The obligation for confrères to perform acts of charity was not new by any means, but the Tridentine emphasis on the performing of good works as a means to salvation was formally written in to the statutes of the many confraternities founded or renewed after Trent. The 1562 statutes of the Santa Croce confraternity asserted that

> since visiting the sick is so important, the Lord himself having clearly indicated that by visiting the sick He himself is visited . . . all our brothers must visit the sick of the hospitals of this city; that is, for each hospital three brothers of our company . . . must visit the said poor sick, giving them that comfort and consolation that God inspires in them.

The emphasis was on spiritual assistance, ensuring that sufferers died without 'any hate or obstinacy.'[44] The confrères reserved *physical* aid for one another. It must be said, too, that looking after the sick pauper could become little more than a pretext, a means of obtaining salvation. What should we make of the actions of one Neapolitan confrère who promised, in 1646, to make the beds of ten sick people during the year while reciting prayers on behalf of the Jesuit general, Vincenzo Carafa?[45] The same can be asked of the many benefactors who, in their wills, stipulated the placing of plaques or busts in hospital corridors or churches and the saying of masses on their behalf. As a tangible sign of their presence, many important Neapolitan families had side-chapels in the church of the Annunziata Hospital.[46]

Confrères were reminded not to interfere in the running of hospitals. Nor were they to disturb the work of medical practitioners, but make themselves 'available to them, in all simplicity and humility, for the needs of those poor people', in the

words of the Santissima Annunziata confraternity of Lecce.[47] The confraternal contribution did not end with the Counter-Reformation. Well over two hundred years after Trent several confraternities still routinely served the sick on certain days of the week at the Incurables hospital, when 'they make the beds and serve the lunch that they themselves have prepared.'[48] The charitable activities of the city's confraternities continued to impress visitors well into the nineteenth century.[49]

As an extension of service in hospitals, confraternities occasionally contributed to the upkeep of a certain number of beds, presumably assuming the right to nominate who would occupy them. Early modern charity was not disinterested. When a member of the Oratorio del Santissimo Crocifisso stipulated the provision of twenty new beds for the Incurables Hospital in 1685, the congregation decided to contribute another eight, in order to fill an entire ward. It was not seen proper to have other beds alongside their own, easily recognised by the symbol of the Oratory displayed on each one.[50] The hospitals came to depend on such outside support. The charitable functions of confraternities were generally administered by *monti*, special funds or banks, which they set up for the purpose. A typical example is the confraternity of knights who set up the Monte dei Poveri Vergognosi in 1614 for the benefit of the 'shamefaced poor.' It supported twenty-nine beds at the Incurables, as well as feeding a certain number of the hospital's sick every Tuesday. It also assisted the poor in prison, supplied twenty poor girls with dowries each year and contributed to the dowries of poor girls of noble families wishing to enter a convent.[51]

Congregations were also set up with the specific intent of founding and running a hospital. This was especially the case among the large communities of *forastieri* present in the capital. As soon as numbers and economic fortunes permitted, they sought to establish their own confraternity, church and simple hospice caring for the sick and poor of their community. Religious devotion mixed with notions of national prestige. Due to the kingdom's status as a Spanish dominion, there was a large number of Spanish nobility, administrators and military personnel concentrated in Naples. This led to the creation of a brotherhood 'pro pauperibus Hispanae nationes.' With the support of the viceroy, Pedro de Toledo, they received papal approval in 1532. This permitted them to build a hospital dedicated to San Giacomo, complete with church, cemetery, apartments and offices. Land was purchased near the Castel Nuovo, in the area then known as 'little Genoa', inhabited by a community of Genoese merchants. Work on the hospital was initiated in 1547. This was no ordinary hospice, however. In 1583 and 1585 papal bulls exempted the church and hospital from local episcopal jurisdiction, putting them under the direct authority of the Holy See.[52] The hospital maintained its link with the military, taking in soldiers, but it expanded to take in the sick poor. During the middle decades of the eighteenth century it came to function as a teaching hospital, equipped with an anatomy theatre, museum, library and surgery. Practical anatomy, physiology, pathology, practical medicine and surgery were taught to twenty-four live-in students, plus various supernumary and day students, who served in the hospital whilst undergoing instruction.[53]

The wealthier and larger confraternities might even found their own hospitals. The nine-hundred–strong confraternity of Santa Trinità dei Pellegrini founded the hospital of the same name in 1579, which specialised in taking in vagabonds, for three nights at a time, and convalescents from the other hospitals. Outside the capital, analogous foundations were more modest, on a scale compatible with local populations and financial means. Gravina, with some nine thousand inhabitants, benefited from a twenty-two-bed hospital founded and run – not without serious problems – by the Santa Maria del Piede confraternity, the town's richest.[54] The same could be said of the Sacro Monte di Pietà Hospital in nearby Bari, founded in 1593. Here the governing body – a prior and two *mastri razionali* in charge of accounts – was consistently drawn from the ranks of the hospital's confrères. Except, that is, on those rare occasions when the confraternity was able to tempt the archbishop into serving as prior. The hospital's annual income varied widely, but averaged in the five hundred to six hundred-ducat range.[55]

Most of the kingdom's confraternities could not aspire to such works of charity and prestige. Instead they were dependent on the alms they collected in order to carry out their visits to hospitals and prisons. In practice, however, hospital visits by confrères may not have been as consistent as implied by the rousing words of the confraternity statutes. The Santa Croce confraternity statutes were mentioned above; but the subject of hospital visits never came up at any of the confraternity's meetings or featured in its registers over the centuries.[56] This is to say nothing of those confraternities which functioned sporadically, were underfunded or otherwise fell into decline. The impressions of English visitors notwithstanding, there was a lack of basic provision for the sick in hospitals of the time. Constant nursing care was virtually non-existent. The situation was that much worse in hospitals operating on a shoestring, in debt or governed by officials more concerned with their own careers. In 1601 the officials in charge of Gravina's Santa Maria del Piede hospital were denounced for mismanagement. Hospital patients complained that they did not buy the medicines the physician prescribed. Moreover, it was said of the officials that 'if they drink wine, they give water to the sick; if they eat chickens, to the paupers they give leaves.'[57] Just over a hundred years later an apostolic visitation severely criticised the confraternity responsible for not having spent 'even a penny' on the hospital, allowing it to become totally derelict.[58] Ecclesiastical visitations, which frequently provide descriptions of the conditions – physical and otherwise – of a diocese's hospitals, remind us that lists of charitable institutions in a given locality tell us only part of the story.

## The Ministers of the Sick

It was to provide continuing, reliable care – spiritual and physical – that the Abruzzese Camillo de Lellis set up his male nursing order, the Ministers of the Sick, in 1586 (figures 7, 8). Sanzio Cicatelli, already cited, sets the scene. The description is obviously rhetorical – it forms part of an early hagiography of de Lellis – but it alludes to features of hospital life that must have been widespread:

Who could ever recount the number of inconveniences from which the sick have been freed by the continuous presence or residence of our own [priests] in the hospitals? How many times before this, for lack of someone to help them or feed them, did the sick go entire days without tasting any kind of food whatsoever? How many seriously ill paupers, because their beds were not cleaned even once a week, rotted amidst vermin and filth? How many weak paupers, in getting out of bed for whatever need, died or seriously injured themselves falling down? How many, delirious from thirst, could not obtain a little water to rinse out or freshen their mouths?[59]

The Ministers of the Sick was to be a congregation of priests, along the lines of other 'clerks regular' like the Jesuits, Theatines and Oratorians. This arrangement, typical of the Counter-Reformation, gave individual members and houses a certain degree of freedom to adapt to differing pastoral situations. De Lellis' association with Philip Neri in Rome contributed to this decision. Its contribution was to be similar to that provided by the confraternities, but more systematic and better organised. According to its statutes, members of the order were to tend the sick according to physicians' wishes, informing physicians of any changes in the patients' conditions. They were to help the sick to eat, wash them, make their beds and help them to die a 'good death.' The statutes distinguished between priests and lay brothers, the former performing the more spiritual tasks, the latter primarily nursing duties, though there was a substantial degree of overlap. There were very few conditions put on what was referred to as 'complete service' in hospitals: but they were not to undertake portering, kitchen work, pharmacy or care of the insane. Sensing possible sources of conflict with hospital administrations, de Lellis stressed that they were to resist the temptation to become 'syndic or controller' of the hospitals in which they served.

Tentative beginnings were made at Milan's Ospedale Maggiore in 1594. Ten years later they were firmly established in Naples, under de Lellis' direct supervision. Twenty-four Camillians were serving at the Annunziata, fourteen at the Incurables and six at San Giacomo degli Spagnoli.[60] What, exactly, they did is not easy to say. We know little of their actual day-to-day routine. At the introductory hearing into de Lellis' canonisation, held in Naples, it was said that 'he conferred with physicians on the things necessary for the health of the sick, of which he had made a list.' This could include fairly specific nursing tasks. He would make the rounds of the sick, 'carrying a box with four or five jars of various kinds of water, according to the needs of the sick, to refresh them, wiping their tongues and rinsing their mouths.' In addition, he 'carried a chamber pot at his belt for the use of the sick, even bearing the necessary pots for them.'[61] Members of the order, like medical practitioners of the time, also visited the sick at home. They were recognisable because of the small red cross on their habits, for which they were soon known as 'Padri della crocella.' Once their founder acquired a reputation of saintliness, the priests would bring along a relic of his on their visits, if requested. The more important the sick person, the more important the relic. A well-connected sufferer like Vittoria di Ferrante was brought a reliquary in the shape de Lellis' head.[62] Given

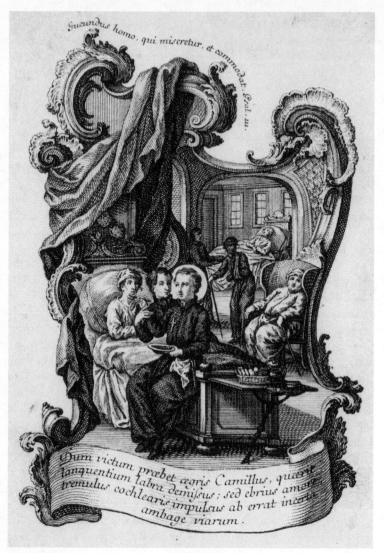

Figure 7 St Camillo de Lellis comforting patients in hospital, engraving by C. Klauber (eighteenth century)

the belief in the powers of relics to bring about a saint's miraculous intercession to heal disease, they form another aspect of the charity offered to the sick.

Just as it is difficult to ascertain the practical role of confraternal assistance and how it fit into the day-to-day management of a hospital, the same can be said of the contribution made by the Ministers of the Sick. The fact that they were allowed into institutions like the Annunziata on a full-time basis suggests a need and desire for what they offered. Despite the obvious need for people prepared to carry out the most menial, not to say disgusting, tasks, the relationship with

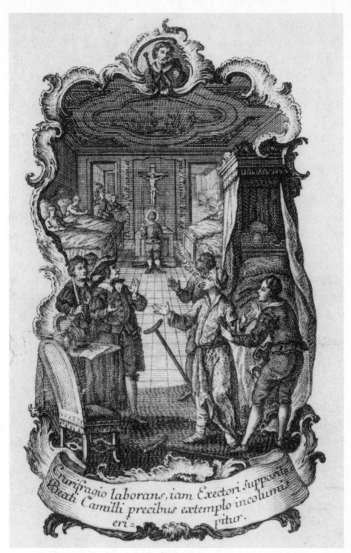

*Naufragio laborans, iam Exectori supposit: Beati Camilli precibus extemplo incolumis eri= pitur.*

Figure 8 St Camillo de Lellis performing a miracle with a man on crutches, engraving by C. Klauber (eighteenth century)

hospital administrators was not always easy. Tensions did occur, beginning with de Lellis' own early decision to found the house in Rome outside the auspices of the hospital of San Giacomo degli Incurabili in Rome. In Sicily – like Naples a Spanish dominion, though with a distinct administration – the Camillians were never permitted to enter into service at any of the island's hospitals. The authorities preferred to have them tend to the poor who died unassisted in their own homes.[63] And in Naples itself service to the Annunziata was withdrawn in 1639, only to be restored the following year. An otherwise rich source for details on

daily life and illness, the canonisation processes, are of little help in this regard. Any tensions arising in the performance of their duties are not referred to, even obliquely. The superior of the Annunziata, Rev. Scipione Carrozza, gives no particular details about de Lellis' workaday relations with the hospital. Indeed, he seems most impressed by the fact that innkeepers would take down profane images if they knew de Lellis was staying the night, replacing them with sacred ones, since de Lellis was known to change inns if there were no images of saints decorating the walls.[64] Even an assistant physician at the hospital, Giovanni Conca, sheds no light on the situation, making only generic references to de Lellis' 'ardent charity' in serving the hospital's sick.[65]

There is no doubting the difficult and sacrificial nature of their work. From the start the Camillians were given the most thankless tasks. When Spanish galleys were quarantined at Pozzuoli, outside Naples, in 1589 because of an epidemic of petecchial typhus on board, the viceroy turned to the Camillians to give succour to the sick and minister to the dying.[66] Their commitment was tested to the full during epidemics. During the plague of 1656 three Camillians entered into service at the San Gennaro pesthouse. The archbishop – from the relative safety of the mountain-top monastery of San Martino – sent others to the parishes of Santa Maria della Scala and Sant'Arcangelo agli Armeni to assist plague victims. Others alternated between day- and night-time duty in various places in the city. While the epidemic raged through the city some Camillians had to be withdrawn from active service to tend the increasing numbers of Camillians who were themselves becoming plague victims.

In all, forty-three Camillians died of plague in Naples, almost all as a result of tending plague victims throughout the city.[67] A typical victim was Fr Pietro Suardi, from Bergamo, who had been serving at the Annunziata for over thirty-five years, since just after his ordination. There was a handful of other victims serving in the nearby towns of Gaeta and Aversa, as well as in the towns associated with de Lellis' place of origin, Chieti and Bucchianico. The plague was a disaster of unprecedented proportions for Naples (to say nothing of the kingdom as whole). For the Camillians it resulted in the suspension of regular service at the city's hospitals. The provincial superior was amongst the victims, as were the prefects of each of the order's three Neapolitan houses. Complete service to the Annunziata was restored only in 1678, along with only weekly visits to the Incurables Hospital.

## The *monti*

Mention of the *monti* as a form of charity has already been made. The kingdom's first charitable bank, the Monte di Pietà, was founded in 1539, lending small sums of money at low rates of interest. It was located at the Annunziata until the latter founded its own bank, the Monte Ave Gratia Plena, in 1587. Six additional charitable banks were established over the next fifteen years: at the Incurables, San Giacomo, Sant'Eligio, Santo Spirito, the Monte dei Poveri and the Monte della Misericordia. These were the kingdom's largest banks throughout the early modern

period and many trade guilds and confraternities invested the funds of their own smaller *monti* in these banks. All of the kingdom's *monti* were dissolved by the Napoleonic government, though some were reestablished after 1815.[68]

Religious brotherhoods were often behind their foundation and running. The Incurables' *monte* was established in 1590 by the confrères of the Jesuit-run Immacolata congregation. Revenues were to be employed in helping the sick of the hospital, as well as the shamefaced poor.[69] The latter aim was typical of aristocratic confraternities. Poverty applied not only to those whose very survival was in question, but to those who lacked the means to live as their status in society required. In a 1631 deliberation the Pio Monte della Misericordia declared that whilst 'the poor of the people . . . by themselves without great repugnance can expose their necessity to the pious affections of others . . . the nobility, out of human reserve, most often remain in the wretchedness that, in accordance with adverse events, is often wont to occur in the human condition.'[70] The *monti* were a typically baroque mixture of charity and ostentation, piety and prestige. The Pio Monte della Misericordia was founded in 1602 by a small group of Neapolitan noblemen who had already been meeting regularly at the Incurables Hospital. It went on to become the city's wealthiest *monte*. Each of its seven governors had equal standing: changing position every six months during their term of office (which lasted three years and six months), which entailed rotating around a seven-sided inlaid table. Membership was only open to noblemen, through payment of thirty ducats. Noblewomen were admitted as benefactors through payment of twenty ducats. As early as 1607 it had enough funds to pay Caravaggio the enormous sum of four hundred ducats for his painting entitled Our Lady of Mercy, depicting the seven acts of mercy. In 1658 – barely two years after the calamitous plague of 1656 – it began work on its own palace and church and by the eighteenth century had an annual income of some sixty thousand ducats.

By this time the Pio Monte gave alms to specific cases of needy people, maintained a number of poor noble boys at the Jesuit noble seminary, distributed dowries and assisted the friars of two Capuchin monasteries. The alms were destined primarily to members of the titled nobility who had met with misfortune, death or disease: widows, women abandoned by their husbands, priests, Monte members, soldiers, doctors. Once the Pio Monte had decided to award an individual a monthly allowance, the recipient continued to receive it until death. Assistance was revoked only if their status changed. For men: if they came into new wealth, took in a concubine, took up paid manual labour, publicly begged or were found to have faked their poverty. For women: if they remarried, lived immodestly, left the city, became domestic servants or begged.[71] The Pio Monte was able to respond to conjunctural crises affecting numerous families, such as the failure of the Annunziata's bank in 1700. During the eighteenth century it supported forty-five beds at the Incurables Hospital, and provided lunch for the hospital's sick every Friday. The latter activity alone cost the Pio Monte two thousand ducats a year, more than the income of most town hospitals. In addition, the Pio Monte ran a hospice on the island of Ischia for the mineral baths, to which it organised two trips a year of some

two hundred people, including accompanying clergy. It provided 206 girls with dowries each year. And with the rise of Paris hospital-based medicine, the Monte funded the study of surgery in Paris of a local student for four or five years, following a legacy left by Luigi Tortora.[72] By this time, however, it would appear that the Pio Monte's original charitable impulse had been lost to routine and bureaucratisation. Rather than expand its sphere of operations to new kinds of needy, it tended to go on helping the same families (we see the same surnames reappearing) and groups (aged and ill doctors eventually account for a third of all allowances).[73]

Smaller-scale *monti* were a typical Counter-Reformation response to the threat of hardship, mingling piety with practical concerns. Thus the Spanish in Naples had their hospital of San Giacomo. A *monte* was also set up with the specific intent of helping Spanish residents who had fallen on hard times: poor girls, widows, the sick, prisoners and pilgrims. It even made funds available to pay for a voyage back to Spain.[74] *Monti* existed for any sort of group sharing similar interests, in addition to national communities: trade guilds, family lineages, a town's peasants. In fact, notions of poverty and poor relief were dominated by ideas about the group. It was considered the business of the group and helped to define it. The kingdom can be seen as a network of *monti*, which existed in even the smallest towns. Moreover, the dominance of the group in providing various forms of charity, from dowries to health care, helps explain the relative absence of state involvement in poor relief in the kingdom.

For the kingdom's guilds and artisan confraternities *monti* were the most common form of mutual assistance. Whilst many of these trade corporation-cum-religious brotherhoods had been in existence since the Middle Ages, many more had sprung up after Trent. Piety overlapped with trade protection, even attempts at wage control. In 1599 the archbishop was prompted to remark that, in Naples, 'the number of confraternities and congregations claiming to have charitable purposes has multiplied greatly.'[75] A guild's *monte* was administered by the guild itself, by appointed governors, either to assist guild members or to undertake a variety of welfare schemes. The *monte* set up by the apothecaries' and grocers' guild was to be administered by four masters resident in Naples, though its assistance extended beyond the capital.[76] The members of the guilds would contribute either a monthly quota or a percentage of the trade's total output. When a guild member fell sick a guild representative would visit him to ascertain his condition. A visit from a physician would be arranged if necessary. The physician might then issue a medical certificate stating the nature of the illness, which would determine the financial recompense due to the guild member. The amount was usually around one or two *carlini* a day for the first month (a figure approaching what a labourer might expect to earn); then half that rate for the second month. If the invalidity lasted a third month the governors of the *monte* would meet to decide on eventual further payment. In the case of a guild member who could no longer practise his trade because of disability, the governors were to use their discretion to decide on a monthly allowance, 'so that he does not go begging.'[77] Allowances were also issued when old age or imprisonment (as long as the cause was 'honourable') prohibited

a member from earning a living. And widows might receive a pension to permit them to live an 'honourable life', though the sum was a relatively low three or four *carlini* a week.

The greatest expense the guild *monti* faced was not the care of its own members, but their daughters: the funding of or contribution towards dowries for marriage or (less commonly) to enter a convent. Most guilds would dower from two to four members' daughters each year.[78] Dowries ranged from the twenty-four ducats the poorer guilds, like the carpenters', could afford, to those of eighty to one hundred ducats offered by the richer guilds, like the goldsmiths' and the tailors'.[79] The stress was on mutual assistance within the group. Dowries were an investment in the future: if no children resulted from the marriage – and thus no future guild members – the dowry would have to be paid back to the guild (just as any aristo-crat father would claim back the dowry if his daughter died without heirs). Poverty was often only introduced as a criterion in the awarding of dowries later on, as funds proved inadequate. Thus the *monte* of the apothecaries' and grocers' guild stated in 1602 that it would 'always prefer the neediest poor girls and the eldest, and this to avoid the disorders that have occurred in the past in [awarding] these marriage dowries.'[80] The *monti* also supported refuges and 'conservatories' for orphaned girls or women at risk related to guild members.

Much the same could be said of the *monti* set up by another type of social group-ing – family lineages. They reinforced a family's sense of identity and belonging, recognised in the meetings of governors which often took place in the family chapel, a fact which might be stipulated in the founder's will.[81] Their expansion during the sixteenth and seventeenth centuries was less a result of religious fervour and charity towards the poor, than an increasing tendency to exclude women from inheritance, providing them only with a dowry. To this we must add notions of honour that the old Neapolitan noble families possessed, resulting in the require-ment to provide ever larger dowries for the daughters. In addition, fallen branches of the clan affected the status and reputation of more well-off ones.

Attempts to protect and provide for 'vulnerable' women were a crucial aspect of early modern charity. The establishment of conservatories went hand in hand with the provision of dowries. The aim was to ward off the threat of prostitution, which contemporaries worried was the only recourse for women lacking male support or without a means to maintain themselves. In the case of family and guild *monti* the main criterion was membership of the group and the possible threat such helpless women might pose to the group's honour. The confraternities could afford to be more outward-looking. The Oratorio del Santissimo Crocifisso stipulated that can-didates for its dowries must be genuine: 'poor Neapolitan girls, honourable virgins [who] never have been in the service of others.' But their motives in providing dowries were similar. One girl, who proposed herself, seemed to have the neces-sary attributes, or at least knew what the aristocratic confrères were looking for. In 1646 Grazia Bolcana petitioned (in the third person) that she found herself 'in such wretchedness that she had no place to sleep, staying at the house of a woman in the Arinella [quarter] out of charity, where the said woman keeping her can no longer

support her.' 'Worrying that she would descend into vice', Bolcana concluded, 'and having found someone who wants her . . . she beseeches Your Most Illustrious Lordships to grant her a marriage dowry from the de Curtis *monte* that it would be an act of charity.'[82] Yet even the confraternities' notions about poverty were not absolute. They still referred to the inability to lead a life consistent with one's station. Charity existed to prevent this from happening. Husbands of the girls provided with dowries were of a similar status to the girls themselves; that is, their status prior to the accident or misfortunes which had left them poor. For the most part they were artisans (carpenters, tailors, weavers, shoemakers), domestic servants and shopkeepers (including the occasional apothecary).

Similar to the guild *monti* were the *monti* established and run by various groups within the capital's large public administration. The clerks and fiscals of the Court of the Vicaria (the central civil and criminal court) set up a *monte* for their own welfare and that of their families in 1604. The notaries of the court did likewise fourteen years later. Not that there was anything especially dangerous or threatening about working at the Vicaria; all groups had to look after their own interests. Even the officials employed at the Annunziata hospital set up their own *monte,* in 1663. In the latter case it might have been particularly prudent. It has been calculated that a childless man in Naples could not survive on less than eighteen ducats a month. The charitable institutions charged rents of ten ducats a month for the very basic, ground-floor rooms, known as *bassi,* they owned. The result was that even some of those employed by the Annunziata, such as the porters, earning twenty ducats a month, were often confronted with very real poverty.[83] Whether they could afford to pay into the *monti* schemes was another matter. They formed part of the estimated two-thirds of household heads who might have required the services of charitable institutions at one time or another.[84]

Throughout the kingdom towns also set up *monti* for the benefit of their own inhabitants. They varied a great deal from place to place. The most basic and specialised were the grain banks, *monti frumentari,* which made seed corn available for the next year's planting. They originated and spread rapidly as a result of the crisis in the countryside. Hunger forced peasants not only to eat their seed, but go into debt for the following year. The *monti frumentari* also sought to protect peasants from unscrupulous landlords who made loans which forced the peasants into lifelong debt. But during years of dearth their loans of grain were more likely to end up in the stomachs of famished peasants than be planted in the soil.

Many towns also set up more generalised *monti* for the poor. Changing attitudes towards poverty and the poor had an effect on the way these *monti* operated. In 1783 the governors of the nascent *monte dei poveri* of the town of Salice received instructions from Naples concerning the nature of the recipients. 'The earnings', the approval specified, 'are to go in aid no longer of pilgrims, who are for the most part lazy, nasty and useless to the State because of their indolence, but rather to just those citizens [who are] truly poor and who are declared to be such by the parish priest and administrators of the municipality.' In any case, the *monte* proposed

financial assistance of no more than one *carlino* per person at a time, with the exception of 'some wretched sick person or cripple' whose need was greater.[85]

The setting-up of *monti* was not the only sort of charitable initiative that towns could take. Feudal structures put great demands on the kingdom's towns, but they were able to show some vitality nevertheless. For instance, the mayor and elected officials of the village of Cava, bereft of 'any shop whatsoever', decided to run a small outlet selling foodstuffs at regulated prices.[86] In terms of medical provision, most towns would seek to bring in a community physician (*medico condotto*) and surgeon (*chirurgo condotto*), or at least the latter. The arrangements were usually for a fixed period, during which the *condotto* was to reside in the community and treat the poor gratis. Factors like the town's size and the amount its budget could permit would affect the nature of the contract, as we saw in chapter three.

The capital was a special case. In Naples the city government's six elected officials controlled the import of grain and were responsible for the city's food-provisioning measures. The latter less than welcome task fell to the elected official from the popular assembly. Naples was privileged in having a regulated and more or less guaranteed supply of grain, a fact which attracted thousands of people from the surrounding countryside and provinces each year, especially during times of dearth, as we have already seen in previous chapters. Giulio Cesare Capaccio's ironical tone in describing the influx hides a real fear of popular revolt:

> Calabrians, Apulians, Abruzzesi, and closer, people from Costa and Cava, have so filled the whole city with their presence that they make up almost a third of it. . . . Naples ennobles even those who come to live in it. . . . Such that, speaking of inhabitants of this kingdom, when some are here [in Naples] they seem to be reborn and their customs change and that village rusticity becomes civility. A freedom characteristic of Naples makes itself felt, and they want bread at the best possible price, the whitest and biggest loaves, and they forget about the barley and millet bread they used to eat.[87]

The difficulties inherent in the job of food provisioning were demonstrated by the treatment meted out to the *Eletto* Giovan Vincenzo Starace. In May 1585, during a wave of rioting over the price of grain, Starace was assaulted by the populace, put on trial and killed. Then his corpse was dragged through the streets, from the working-class district of the city (the Selleria), along the main thoroughfares to the viceroy's palace.[88]

## Poverty, public order and the state

The thousands of migrants arriving from the provinces each year in search of work or food each year made it a national issue. This was a problem faced by capitals of all the Italian states. Naples's large size made the problem particularly acute. Any increase in the kingdom's population was felt almost exclusively in the capital, or at least such was the conclusion reached by a 1726 report by the Collateral Council.[89] During the years immediately before and after the famine and epidemic of 1764, some twenty-five thousand to fifty thousand desperate migrants entered the city.

The result was begging. Even in normal years beggars and vagrants were said to form one-tenth of the city's population. As one description put it: 'crowds of wretched people and prostitutes, children without families, homeless, naked and sickly, infest the inhabitants with their laments, surviving on bark, corpses and badly made bread, sleeping in the streets piled one on top of another.'[90] They were known locally as *lazzari*, a term first used during this period and probably derived from the Spanish word *laceria*, meaning wretched and ragged (occasionally, leprous).

It was concern with beggars that occasioned the only concerted activities by the state with regard to poor relief. Not that the government's response ever formed part of a coherent policy or strategy. The Spanish viceroys never sought to institute a magistracy for the poor. In this they differed from other Italian states. Even Spanish Sicily had its Ufficio della Carità from 1555. On the plus side, this relative inaction meant that no serious attempts were made forcibly to enclose or segregate the poor. In any case, the reasons for this lie in part with the presence of separate organs of government, which dealt with problems as they arose, on an *ad hoc* basis. In serious cases, the viceroy intervened directly. What health care and charity existed for the kingdom's poor remained largely the province of the various groups and communities into which society was divided: confraternities, guilds, towns, families. As we have observed, Naples had a network of charitable institutions, like any other large city. But this activity remained uncentralised and piecemeal.

The only appreciable government initiative before the founding of the Albergo dei Poveri in 1751 consisted of turning the city's plague hospital into a hospice for the poor. This was done under instructions from the viceroy, Pedro Antonio de Cardona, in 1667, creating the 'Real Hospizio di SS. Pietro e Gennaro extra moenia.' It was not the first time that a viceroy had involved himself in the founding of a charitable institution. In 1616 the Duke of Osuna founded the conservatory of Santa Maria di Costantinopoli for girls, and in 1649 Iñigo-Velez de Guevara founded the conservatory of San Nicola a Nilo for children orphaned in the 1647 revolt. But the 1667 initiative was on a much larger scale, in line with initiatives taken elsewhere in Italy. As early as 1581 Genoa had converted its former pesthouse to take in beggars, used as such until the next plague epidemic, of 1648. The analogy between plague sufferers and beggars – both threats to social order and public health – is clear.[91] So on 14 February 1667 all of Naples' beggars were ordered to present themselves at the Hospice within eight days. Eight hundred would be distributed into its five divisions or *quartieri:* for young girls, women, boys, married and unmarried men. In December the viceroy announced that the city's ministers, noblemen, knights, citizens and guilds would be taxed to support the nascent hospice. So too would all of the kingdom's municipalities, once it had been discovered that one-tenth of its inmates were from outside Naples.[92]

In line with responses typical of Catholic Europe, the Hospice mixed the provision of charity with repressive measures. Its seven governors had numerous duties, which included touring the city to identify and punish beggars who had not presented themselves, helping boys into a trade, finding places for girls as servants in 'honourable houses' and ensuring that the alms that were collected were deposited

in public banks to make the best use of the money. But despite all these provisions the Hospice was a failure. Three years after opening, it was already in deficit. Most of the inmates had managed to distance themselves from it and an edict of 1671 was unsuccessful in obliging them to return. Not that it was the only one. In 1587 Pope Sixtus V had founded the Hospital for Poor Mendicants in Rome. Although it took in as many as 850 beggars in its first few years, by 1601 it was taking in fewer than 150, beset with financial difficulties.[93] The institutions in the Italian states fell far short of their original intentions to eliminate begging. This was due in part to inadequate funding and misplaced goals of being able to support themselves on the labour of their inmates. They were unable to keep inmates from coming and going, and economic realities soon forced them to restrict entry to certain categories.[94] In the longer term, the Neapolitan Hospice did manage to acquire something of a working routine, though on a much reduced scale and with a very different emphasis. It maintained two conservatories for women, in addition to taking in the shame-faced poor: 'people of lineage, [who have] become invalids.' The latter group, known as the 'poor of San Gennaro', numbered over two hundred and appeared as standard bearers in the funeral processions of the nobility.[95]

## Eighteenth-century developments and continuities

As early as the mid-sixteenth century, Padua had become renowned for its hospital training, the surgical education given physicians and the presence of physician-surgeons (*medici chirurghi*). The hospital of San Francesco there had an important role in instruction, providing practical demonstrations of the medical theory imparted at the university. In the early seventeenth century Neapolitan hospitals were being regarded as useful training grounds by at least one author. In his treatise for the aspiring barber-surgeon, Cintio d'Amato recommends that in order to acquire a knowledge of anatomy 'it will be exceedingly advantageous for them to seek engagement either in hospitals or in the infirmaries of monasteries or convents, or in other public places.' He gives the example of the viceroy, the Duke of Osuna, who called for an experienced surgeon after having been bled by an inexperienced one. At the recommendation of his physicians he was provided with a surgeon who had practised at the San Giacomo Hospital, who immediately found the correct vein.[96] Indeed, numerous physicians and surgeons served in Neapolitan hospitals as *pratici* – assistants training under a recognised practitioner. Marco Aurelio Severino, for example, had several assistants under his charge at the Incurables.[97] By the 1790s there were over one hundred 'young practitioners' at the Incurables Hospital.[98]

Yet the medicalisation of the Naples's hospitals was a very slow and uneven development. The Incurables Hospital was in no way exceptional in having far more ecclesiastics at the hospital than medical and nursing staff throughout the period. Like other Italian hospitals, it continued to spend far more on foodstuffs than on medical care.[99] None the less, by the mid-eighteenth century the Incurables had become to all intents and purposes a general hospital. In 1759 a total of 8,215 patients

were admitted. In keeping with the traditions of its foundation, twelve per cent (996) of these were described as syphilis sufferers. Another seventeen per cent (1,430) suffered from a range of skin diseases and sores. In previous centuries, however, it would probably not have admitted fever sufferers, a policy common to Italian hospitals for incurables. But in 1759 it treated more fever cases than any other single disease category: 2,271, or twenty-eight per cent of patients. The Incurables also treated large numbers of consumption sufferers. It also admitted a certain number of insane, the only hospital in the city to do so. This group, totalling 159, were exceptional in being from Naples alone. Overall, sixty per cent of patients came from the city and its surrounding province. But the fact that the Incurables was open to non-Neapolitans is shown by the thirty-three per cent who were natives of other provinces, though it is impossible to know how many were resident in Naples at the time. A small number – just under seven per cent – came from outside the kingdom. What is perhaps most striking about the records for 1759 is that even such a large hospital as the Incurables was admitting and treating mostly men – almost two-thirds, in fact.[100] Women were still cared for at home whenever possible.

At the same time, the Incurables began to institutionalise its teaching role. Its Medico-Surgical College was founded in 1764, the same year when the city was struck by famine and epidemic. The then director of the hospital also established the College of Young Practitioners. Its purpose was to assist poor students from the provinces and, through their services, provide better care of hospital patients. The students attended lectures at the hospital on a wide range of subjects and obtained practical training assisting the sick. These were the years when much of the city's medical teaching took place at the Incurables, under Domenico Cotugno, usurping the role of the hospital of San Giacomo, which had formed a previous generation of medics – including Cotugno himself (though his actual degree was from Salerno) and Domenico Cirillo. There were chairs in logic, metaphysics, physics, chemistry, physiology, practical medicine, efficacious medicine, practical surgery, efficacious surgery and anatomy. As of 1777 there was also a chair in obstetrics at the hospital.

Lest this conjure up images of a modern technologically advanced, research-based institution, it is worth remembering that the remedies used, at the Incurables as elsewhere, had changed relatively little over the centuries. In the middle of the eighteenth century the Hospital was treating ringworm with a special oil, the principal ingredient of which was 'a mountain toad.' It was left in olive oil for twenty-four hours and the oil was then filtered and rubbed on to the patient's shaved head.[101] I mention this not out of any sense of ridicule, but to put other developments into their proper context. Despite its being the centre of medical learning in the kingdom, these were difficult years for the Incurables. Galanti called it the city's worst, located 'in a pestilential place, where all the diseases accumulate and multiply.'[102] Not only was it spending far more than its income every year, but in 1788 it was forced to borrow heavily in order to replace all the roofs of the hospital, the monastery, the church and various other buildings. A major fire in 1795 had resulted in a deficit of over twenty-five thousand ducats two years later.[103]

The final two decades of the eighteenth century witnessed many calls for reform of the kingdom's hospitals, especially those of the capital. A perceptible decline in conditions coincided with increased expectations as to the role of hospitals. The dual functions of health care and poor relief were both regarded as necessary, but hospitals were accused of being woefully negligent of both. Cirillo did not regard the two functions as contradictory. Hospitals, however, required charity, love and kindness to succour the suffering; instead, they were run by 'an army of apathetics . . . the lowest of the earth', paid a pittance for their services. Everything was ruled by chance, ignorance and whim: foodstuffs (fit only for 'the most abject animals'), medicines ('leftovers of the most inert drugs'), sanitary conditions (which 'corrupt the air and greatly increase the strength of the diseases').[104] Expectations regarding the hospital's role in society had changed. The ceremonial activities of hospitals, both religious and civic, which had been such an important feature during earlier centuries, were no longer considered appropriate. The same could be said of the selfish involvement of local elites on governing bodies. 'It is not possible to watch humanity suffering in this way with disdainful indifference', concluded Cirillo, 'while we know which and how many riches are destined for the maintenance of our hospitals and charitable institutions. But everything is ruled by boastful ignorance, destructive idleness and all-consuming fraud.'[105] Galanti continued in much the same vein. Hospitals, he argued, were a necessary evil: 'Given that the political laws have created so many wretched people, hospitals must be tolerated so that they can redress the disorders of indigence. We must lodge, feed and treat all the needy reduced to the level bare survival.' As for the hospitals' more specifically medical functions, they were the last places one would expect to be cured. Here he went much further than Cirillo. Indeed, he put the blame on the physicians themselves: 'physicians who cannot diagnose a gentleman's disease in his own palace then treat all manner of diseases in hospitals.' Add to this the dire state of the institutions themselves. For Galanti the best treatment for disease would always be 'good air, good food and cleanliness', the three things that hospitals most ignored.[106]

And yet, the difficulty of reconciling the hospitals' dual functions remained. One solution, it was suggested, was to take the able-bodied poor out of hospitals and have them earn the cost of their support, employing them in the construction of much needed irrigation canals, for example.[107] The Florentine Luigi Targioni, resident in Naples from 1785, went further, calling for a separation of poor-relief and health-care functions. The hospitals' activities in taking in vagrants and beggars, providing them with room, board and clothing, was 'to turn an act of piety into a most serious vice.' Because the hospitals did not put their able-bodied inmates to work, they had become 'the chief shelters of idleness.' Little had been done to oversee public health in the kingdom, he argued. The hospitals had become the natural repository of enormous numbers of paupers seeking refuge 'under the false pretext of disease.' The physicians were all too easily taken in by this deceit. Targioni's solution was to reserve hospitals for the treatment of contagious and debilitating disease. Hospitals would offer 'medicaments and medical and surgical assistance' for less serious diseases, but treatment would be carried out at the patient's home as much as possible.[108]

The reforming climate under the French increased expectations still further. With Joseph Bonaparte as king, the pro-French Domenico Pignataro proposed confiscating a number of monastic buildings, along with their revenues, throughout the kingdom and turning them into hospitals.[109] Some tentative steps in this secularising direction had been taken from the middle of the previous century. In 1741, in a Concordat between Charles III and Pope Benedict XIV, the number of the kingdom's convents and monasteries was reduced and the entire ecclesiastical patrimony put under stricter juridical and fiscal control. The effects of this were mixed. Some streamlining of charitable institutions occurred through the creation of a mixed tribunal intended to supervise them. At the same time, the charitable functions of confraternities and guilds were limited and began to decline. The role of the state regarding hospitals was further increased in 1796, at the expense of the Church. But the reforms were piecemeal. More radical reforms were made in 1809 when a general council was set up to oversee the administration of 'all the interests of hospices, hospitals and other institutions involved in the assistance of the capital's poor, sick and foundlings.' Hospitals were no longer to be administered by their own governing bodies but by this council, composed of twelve men chosen by the Interior Minister. The capital's hospitals were to be 'rationalised', in the sense that each was to have different specialisations. A separate insane asylum was designated, just outside Naples at Torre del Greco, removing this long-standing function from the Incurables Hospital.[110] The effects of this legislation on the provinces was minimal, although some new hospitals were created in some small towns. In fact, by removing ecclesiastical sources of income, the situation may have deteriorated.

The only major development during the eighteenth century – and this was a long time coming – was the construction of the Albergo dei Poveri. Built as the 'Royal hospice for the poor of the whole kingdom' ('Regium totius regni pauperum hospitium'), words that can still be read on the building's crumbling façade, it was intended to provide housing, a Catholic upbringing and a trade for able-bodied vagabonds and orphans. Despite the Enlightenment rhetoric behind the initiative, the state's contribution was minimal. The income derived from the collection of some minor duties and fines were awarded to the Albergo, such as the fines collected from those caught poaching on royal lands. In addition, some thirty-four thousand ducats were put towards the building following the abolition of eleven Augustinian monasteries, in the wake of the 1741 Concordat. Given this, it is somewhat ironic that most of the funding came from traditional, religious sources, including some fifty thousand ducats from the city's wealthier religious orders.[111] And despite its centralising intentions, traditional forms of charity persisted. A lay association, based at the Albergo, was founded to go about the city collecting alms and organising work for the inmates. Its members included the elite of society: government ministers, courtiers, magistrates, aristocrats, merchants and ecclesiastics.[112] The Albergo increasingly attracted legacies that would previously have gone to more standard forms of charity, but testators still targeted their donations in traditional ways, restricting them to specific categories of beneficiaries. Money was thus left to the Albergo to establish dowry funds for orphan girls from the benefactor's

town of origin, for instance, or to support branches of the benefactor's noble clan unable to support themselves.

There is little that was coercive or authoritarian about the Albergo's activities during its first fifteen years. Rather it seems to have adapted to the non-conflictual structures of traditional private charity. However, the famine–epidemic of 1764 saw a massive increase in the number of inmates, leading to routine mass internments by century's end. Annual intake rose from under 100 to 1,500 during this period, large numbers of paupers being required to work the Albergo's woollen mill, producing clothing for the troops.[113] There was an accompanying shift in the Albergo's image and fortunes. At the outset, the Albergo and its inmates were to project a unified image. Consistent with the grand appearance of the building were attempts to make the inmates presentable and decorous. They were to be taught good manners, religious doctrine and a basic education. They had a special uniform which they were to wear when outside the building, consisting of jacket, hat with ribbon, cloth necktie, cotton stockings and leather shoes. But by the end of the century these standards had fallen into abeyance: the clothes became basic, the instruction drastically reduced, the work harder and the food more meagre.[114] And, of course, the building was still incomplete; only one-fifth of Ferdinando Fuga's grandiose plan was ever realised.

One interesting feature of the Albergo is the way the poor used it as temporary source of relief, admitting and discharging themselves as they chose. In the years 1751–58, according to the Albergo's own registers, fully one-fifth of inmates were voluntary arrivals, most coming from within the city.[115] It was part of a strategy on the part of the city's textile workers, manual labourers and domestics to cope with lean times, going themselves or sending one or more of their children. Most stayed only briefly, if repeatedly, seeking to leave as soon as possible. This chapter has focused on hospital care and poor relief from the top down, examining the supply; but it is important to remember that there was also a demand. That is to say, forms of poor relief were used by the sick and the poor as part of a strategy, a network, to obtain treatment and care. We have seen how the simple presence of a community physician in a given town did not ensure that the large majority of people – the community's peasants – would make use of his services. Remarks of an anecdotal nature suggest that people could admit themselves into hospital, obtain the treatment they sought and then discharge themselves when they were ready. One patient, due to have his gangrenous leg amputated, left hospital following a vision in which Bishop Lucci told him he could get up and walk out, completely cured.[116] Treatment – even in hospital – was ultimately in the hands of the sick themselves. This is still the case when a timely miraculous intercession could spare painful and crippling surgery. And let us not forget the wet nurses. Although they were paid a pittance for their services, it was not unheard of for women to leave their own infants in the *ruota*, only to present themselves as wet nurses at the foundlings home to nurse them, pocketing the small income for their services.[117]

Finally, with this same active spirit the remedies administered to patients could find their way into popular healing rituals. In 1697 an out-of-work farm labourer,

Donato de Quarto, denied having used witchcraft to treat an acquaintance suffering from the French disease. The treatment consisted of spreading sour grapes over the kidneys and genitals. It was one he had observed during his five-month stay in hospital in Lecce, where he says it was used for fever. In addition to his own application of the remedy, de Quarto added a twist: he had two masses said first and bought some ribbon blessed in the name of St Francis de Paola, which he also applied to the sick man.[118] The role of the sacred in illness and healing has run like a strand through the texture of this book. It is to this theme that we now turn.

NOTES

1  Edmund Warcupp, *Italy, in its original glory, ruine and revival* (London, 1660), pp. 264–5; in Edward Chaney, 'Giudizi inglesi su ospedali italiani, 1545–1789' in G. Politi, M. Rosa and F. della Peruta (eds), *Timore e carità: i poveri nell'Italia moderna* (Cremona, 1982), p. 96.

2  J. Malham (ed.), *The Harleian Miscellany* (London, 1808–11), vol. 12, pp. 118–19; in Chaney, 'Giudizi inglesi', p. 95.

3  Gilbert Burnet, *Some letters containing an account of what seemed most remarkeble in Switzerland, Italy, etc.* (Rotterdam, 1686), p. 193; in Chaney, 'Giudizi inglesi', p. 95.

4  Enrico Bacco, *Descrittione del Regno di Napoli* (Naples, 1671). In English as *Naples: an early guide,* trans. E. Gardiner (New York, 1991), p. 55.

5  Cornelio Musso in a sermon of 7 March 1570; in Romeo De Maio, 'L'Ospedale dell'Annunziata: "il megliore e più segnalato di tutta Italia"' in De Maio, *Riforme e miti nella Chiesa del Cinquecento* (Naples, 1973), p. 246.

6  Brian Pullan, '"Support and redeem": charity and poor relief in Italian cities from the fourteenth to the seventeenth century'; *Continuity and Change,* iii (1988), especially pp. 197–9.

7  Teresa Filangieri Ravaschieri Fieschi, *Storia della carità napoletana* (Naples, 1875), pp. 45–6, 109–11.

8  According to its 1488 statutes. Giuliana Vitale, 'Ricerche sulla vita religiosa e caritativa a Napoli tra medioevo ed età moderna', *Archivio storico per le province napoletane,* lxxxv-lxxxvi (1968–69), p. 219.

9  Giulio Cesare Infantino, *Lecce sacra . . . ove si tratta delle vere origini e fondationi di tutte le chiese, monasterij, cappelle, spedali et altri luoghi sacri* (Lecce, 1634). I cite from the Lecce, 1859 edn, p. 51; Patricia Skinner, *Health and medicine in early medieval southern Italy* (Leiden, 1997), p. 103.

10  Maria Gabriella Rienzo, 'Nobili e attività caritativa a Napoli nell'età moderna. L'esempio dell'Oratorio del SS. Crocifisso dei Cavalieri in S. Paolo Maggiore' in G. Galasso and C. Russo (eds), *Per la storia sociale e religiosa del Mezzogiorno d'Italia* (Naples, 1982), vol. 2, p. 254.

11  Vitale, 'Vita religiosa', pp. 226–7.

12  Alessandro Pastore, 'Gli ospedali in Italia fra Cinque e Seicento: evoluzione, caratteri, problemi' in M. L. Betri and E. Bressan (eds), *Gli ospedali in area padana fra Settecento e Novecento* (Milan, 1992), p. 78.

13  By the early 1550s, as a result of moves towards a definition of Catholic dogma at the Council of Trent, the Valdesian movement had become suspect and its followers were expelled from the Bianchi in 1552–53. Giovanni Romeo, *Aspettando il boia: condannati a morte, confortatori e inquisitori nella Napoli della Controriforma* (Florence, 1993), p. 110.

14 *Capitoli e statuti riformati dela Confraternita e Compagnia de Bianchi* (Naples, 1551); in Vitale, 'Vita religiosa', p. 221.

15 Ernesto Pontieri, 'Le origini della riforma cattolico-tridentina a Napoli' in idem, *Divagazioni storiche e storiografiche* (Naples, 1965), pp. 329–33.

16 'Capitoli et ordinationi da osservarsi per li ecc.ti et mag.ci S.ri governatori et maestri del venerabile hospitale dell'Incurabili' in appendix to Vitale, 'Vita religiosa', p. 264.

17 The sponsoring of beds first appears in 1565, according to legacies listed in S. Ravacini, *Sulla universalità della S. Casa degl'Incurabili in Napoli: memorie e documenti storici* (Naples, 1899), pp. 269–72.

18 *Ibid.*, p. 305.

19 Piero Ventura, 'Le ambiguità di un privilegio: la cittadinanza napoletana tra Cinque e Seicento', *Quaderni storici*, xxx (1995), p. 403.

20 Jon Arrizabalaga, John Henderson and Roger French, *The great pox: the French disease in Renaissance Europe* (New Haven, 1997), p. 224.

21 Vitale, 'Vita religiosa', p. 261 n. 88.

22 According to Galanti there were sixty-eight clerics (including priest, chaplains, confessors and 'assistants to the dying'), plus five nuns, to the forty-five physicians and surgeons, and twenty cleaning and nursing staff (of whom just six were 'assigned to the washing of the sick'). Giuseppe Maria Galanti, *Nuova descrizione storica e geografica delle Sicilie* (Naples, 1786–90), vol. 3, p. 142.

23 Sandra Cavallo, *Charity and power in early modern Italy: benefactors and their motives in Turin, 1541–1789* (Cambridge, 1995), p. 153.

24 Vitale, 'Vita religiosa', pp. 229–31.

25 *Epistolae Mixtae, ex variis Europae locis ab anno 1537 ad 1556 scriptae* (Madrid, 1901), vol. v, p. 402, in De Maio, 'L'Ospedale', pp. 245, 252.

26 Francesco Imperato, *Discorsi intorno all'origine, reggimento e stato della Gran Casa della SS. Annunziata di Napoli* (Naples, 1629), p. 50.

27 This was just one of the Annunziata's jurisdictional and fiscal privileges. Ventura, 'Ambiguità', p. 402.

28 Imperato, *Discorsi*, p. 41.

29 Brian Pullan, 'Poveri, mendicanti e vagabondi (secoli XIV-XVII)' in C. Vivanti and R. Romano (eds), *Storia di'Italia. Annali 1: Dal feudalesimo al capitalismo* (Turin, 1978), p. 1025.

30 Giuseppe Battista D'Addosio, *Origine, vicende storiche e progressi della S. Casa dell'Annunziata di Napoli* (Naples, 1883), p. 527; in Ruggero Romano, *Napoli: dal vice-regno al regno* (Turin, 1976), p. 59.

31 Galanti, *Nuova descrizione*, vol. 3, p. 153. For other cities, see Valerie Fildes, *Wet nursing: a history from antiquity to the present* (Oxford, 1988), p. 156; Joan Sherwood, *Poverty in eighteenth-century Spain: the women and children of the Inclusa* (Toronto, 1988), ch. 6.

32 Giovanni Maria Galanti, 'Giornale di un viaggio eseguito di real ordine per la visita della Calabria meridionale dal dì 20 aprile fino al 15 giugno 1792' in Gabriele De Rosa, 'L'emarginazione sociale in Calabria nel XVIII secolo: il problema degli esposti', *Ricerche di storia sociale e religiosa*, xiii (1978), pp. 12–13.

33 De Rosa, 'L'emarginazione sociale', pp. 26–7.

34 John Chetwood Eustace, *A tour through Italy* (London, 1813–19); in Desmond Seward (ed.), *Naples: a travellers' companion* (London, 1984), p. 280.

35 De Maio, 'L'Ospedale', pp. 249–50.

36 Archivio della Casa Santa dell'Annunziata, *Appuntamenti,* viii; in Ventura, 'Ambiguità', p. 414 n. 76.

37 Giovanni Muto, 'The form and content of poor relief in early modern Naples' in A. Calabria and J. Marino (eds), *Good government in Spanish Naples* (New York, 1990), pp. 222–3.

38 Archivio della Casa Santa dell'Annunziata, *Appuntamenti;* in Ventura, 'Ambiguità', p. 400.

39 Cavallo, *Charity and power,* p. 85.

40 Muto, 'Form and content', p. 231.

41 A.S.N., *Capellano Maggiore: statuti e coporazioni,* b. 1196/64; in Muto, 'Form and content', p. 223.

42 He concluded that 'with the same charity and piety, the foremost noblewomen serve sick women in the hospital of the Incurables.' 'Vita di P. Camillo de Lellis Fondatore della Religione de Chierici Ministri dell'Infermi descritta brevemente dal P. Sanzio Cicatelli Sacerdote della stessa Religione', 1608, MS, Archivio Generale dell'Ordine dei Ministri degli Infermi, Rome, ed. R. Corghi and G. Martignoni, *Un uomo venuto per servire: Camillo de Lellis nell'antica cronaca di un testimone oculare* (Milan, 1984), p. 83.

43 Regola del Venerabile Oratorio del SS. Crocifisso dei Cavalieri (1796; Naples, 1930); in Rienzo, 'Attività caritativa', pp. 254–5.

44 A.S.D.N., *Santa Visite,* vii, fol. 609v.; in Appendix to Silvana Musella, 'Dimensione sociale e prassi associativa di una confraternita napoletana nell'età della Controriforma' in G. Galasso and C. Russo (eds), *Per la storia sociale e religiosa del Mezzogiorno d'Italia* (Naples, 1980), vol. 1, pp. 341–438.

45 A.R.S.I., *Prov. Neap.,* 74, fol. 404; in Louis Châtellier, *The Europe of the devout: the Catholic Reformation and the formation of a new society,* trans. J. Birrell (Cambridge, 1989), p. 133.

46 Maria Antonietta Visceglia, *Il bisogno di eternità: i comportamenti aristocratici a Napoli in età moderna* (Naples, 1988), p. 129.

47 'Regole comuni della Santissima Annonciatione della Beatissima Vergine nel Collegio di GIESU nella magnifica città di Lecce', 1582, in appendix to Pasquale Lopez, 'Le confraternite laicali in Italia e la riforma cattolica', *Rivista di studi salernitani,* ii (1969), p. 222.

48 *Ibid.,* p. 142.

49 Eustace, *Tour through Italy;* in Seward, *Naples,* p. 281.

50 Archivio Oratorio SS. Crocifisso Cavalieri, Naples, *Libro di conclusioni,* b. 63, fol. 14v.; in Rienzo, 'Attività caritativa', p. 262. Founding beds may also have been a form of investment, attracting interest, as in Turin. Pastore, 'Ospedali in Italia', p. 74; Cavallo, *Charity and power,* pp. 141–3.

51 Galanti, *Nuova descrizione,* vol. 3, p. 187.

52 Maria Gabriella Rienzo, 'Inventario sommario dell'Archivio della Confraternita del S.mo Sacramento dei nobili spagnoli di S. Giacomo in Napoli' in AA.VV. (various), (eds), *Le chiavi della memoria: miscellanea in occasione del I centenario della Scuola Vaticana di paleografia diplomatica e archivistica* (Vatican City, 1984), pp. 461–4.

53 Galanti, *Nuova descrizione,* vol. 3, p. 151. All the hospital buildings, with the exception of the church, were demolished in 1819, to make way for the projected Palazzo dei Ministeri, now the Naples city hall (Palazzo del Municipio).

54 Marisa d'Agostino and Fedele Raguso, *Confraternite: statuti, attività socio-assistenziali. Gravina secc. XV-XVIII* (Gravina, 1990), pp. 23–7, 60–3.

55 Archivio Sacro Monte di Pietà, Bari, *Platea,* 'Libro degli introiti e degli esiti, 1619–1726' in Vito Antonio Melchiorre, *Il Sacro Monte di Pietà e Ospedale Civile di Bari* (Bari, 1992), pp. 83–100.

56 The requirement to visit hospital disappears from the Santa Croce's statutes of 1779. Musella, 'Dimensione sociale', p. 375.

57 A.D.G., *Fondo Vescovile: Epistole,* I D 6, f.; in D'Agostino and Raguso, *Confraternite,* p. 60 n. 21.

58 A.D.G., *Fondo Vescovile,* 'Visita apostolica del cardinale Orsini (1714)'; in D'Agostino and Raguso, *Confraternite,* p. 60 n. 20.

59 Cicatelli, 'Vita', p. 83.

60 Piero Sannazzaro, *Storia dell'Ordine Camilliano (1550–1699)* (Turin, 1986), p. 67.

61 A.S.V., *Riti,* 2631, fols 41v.-42r.

62 *Ibid.,* fol. 129v.

63 Sannazzaro, *Ordine Camilliano,* p. 61.

64 A.S.V., *Riti,* 2631, fol. 66r.

65 *Ibid.,* fol. 299r.

66 Cicatelli, 'Vita', pp. 79–81.

67 Sannazzaro, *Ordine Camilliano,* p. 179. Jean Delumeau gives the number of victims as 96, out of 100 members in Naples; in Delumeau, *La peur en Occident (XIVe-XVIIIe siècles): une cité assiégée* (Paris, 1978), p. 128.

68 Tommaso Astarita, *The continuity of feudal power: the Caracciolo di Brienza in Spanish Naples* (Cambridge, 1992), p. 183.

69 A.R.S.I., *Prov. Neap.,* 177, fols 98–105, 247–8.

70 Archivio Pio Monte della Misericordia, *Conclusioni,* book C; in Silvana Musella, 'Il Pio Monte della Misericordia e l'assistenza ai "poveri vergognosi" (1665-1724)' in G. Galasso and C. Russo (eds), *Per la storia sociale e religiosa del Mezzogiorno d'Italia* (Naples, 1982), vol. 2, p. 301.

71 Musella, 'Pio Monte della Misericordia', pp. 314–18, 324–5.

72 Galanti, *Nuova descrizione,* vol. 3, pp. 188–9.

73 Musella, 'Pio Monte della Misericordia', pp. 326–8.

74 Rienzo, 'Inventario', pp. 464–5.

75 A.S.V., *Relationes ad limina,* Archbishop Alfonso Gesualdo, Naples 1599; in Rosario Villari, *The revolt of Naples,* trans. J. Newell (Cambridge, 1993), p. 219, n. 57.

76 Ventura, 'Ambiguità', p. 397.

77 As the statutes of the salt-dealers' guild put it. A.S.N., *Capellano Maggiore: statuti e coporazioni,* b. 1182/58; in Muto, 'Form and content', p. 217.

78 During the seventeenth century the total number of dowries made available by Neapolitan confraternities and guilds amounted to 665, according to one contemporary estimate. Gardiner, *Naples: an early guide,* p. 39.

79 Muto, 'Form and content', p. 218.

80 Archivio di Stato di Napoli, *Capellano Maggiore: statuti e coporazioni,* b. 1196, no. 7; in Gérard Delille, 'Un esempio di assistenza privata: i Monti di maritaggio nel Regno di Napoli (secoli XVI-XVIII)' in G. Politi, M. Rosa, and F. della Peruta (eds), *Timore e carità: i poveri nell'Italia moderna* (Cremona, 1982), p. 280.

81 Visceglia, *Bisogno di eternità,* p. 136.

82 Archivio Oratorio SS. Crocifisso Cavalieri, *Maritaggi,* b. 24, folder 199, file 2; in Rienzo, 'Attività caritativa', p. 269.

83 Giuseppe Moricola, *L'industria della carità: l'Albergo dei Poveri nell'economia e nella società napoletana tra '700 e '800* (Naples, 1994), p. 16.

84 Pullan, 'Poveri', pp. 995–6.

85 The kingdom has more than one town named Salice and it is unclear which is being described. A.S.N., *Reali dispacci*, ser. I, 8, fol. 7; in De Rosa, 'L'emarginazione sociale', p. 9.

86 A.S.N., *Provvisioni del Collaterale*, 4, fol. 208; in Giovanni Muto, 'Il Regno di Napoli sotto la dominazione spagnola' in G. Cherubini (ed.), *Storia della società italiana: La Controriforma e il Seicento* (Milan, 1989), p. 314.

87 Giulio Cesare Capaccio, *Il forastiero* (Naples, 1634), p. 690; in Aurelio Musi, 'Pauperismo e pensiero giuridico a Napoli nella prima metà del secolo XVII' in Politi, *et al.*, *Timore e carità*, p. 263.

88 Villari, *Revolt of Naples*, pp. 23–5. One of those sentenced to execution for his part in the revolt was Giovan Leonardo Pisano, apothecary, captain of the Selleria district and brother of Giovan Antonio Pisano, former protophysician of the kingdom and professor of medicine. Pisano fled from the city, never to return. In 1586 the viceroy had his house razed to the ground and erected a monument on the site, complete with niches containing the heads and hands of the executed citizens.

89 Pasquale Villani, 'Note sullo sviluppo economico e sociale del Regno di Napoli nel Settecento', *Rassegna economica*, i (1972), p. 34.

90 A.S.N., *Ministero dell'Interno: Atti del Consiglio Provinciale*, inventory I, 183; in Moricola, *Industria della carità*, p. 14.

91 Alessandro Pastore, 'Strutture assistenziali fra Chiesa e Stati nell'Italia della Controriforma' in G. Chittolini and G. Miccoli (eds), *Storia d'Italia. Annali 9: La Chiesa e il potere politico dal Medioevo all'età contemporanea* (Turin, 1986), pp. 445–6.

92 G. Pandolfi, *La povertà arricchita o vero l'Hospitio de' poveri mendicanti fondato dall'eccellentissimo signor Don Pietro Antonio Raymondo Folch de Cardona* (Naples, 1671), p. 16; in Muto, 'Form and content', p. 234.

93 Pastore, 'Strutture assistenziali', p. 445.

94 Pullan, '"Support and redeem"', p. 197; Nicholas Terpstra, 'Apprenticeship in social welfare: from confraternal chairty to municipal poor relief in early modern Italy', *Sixteenth Century Journal*, xxv (1994), pp. 101–20; Daniela Lombardi, *Povertà maschile, povertà femminile: l'Ospedale dei Mendicanti nella Firenze dei Medici* (Bologna, 1988), ch. 4.

95 Galanti, *Nuova descrizione*, iii, p. 147.

96 Cintio d'Amato, *Nuova et utilissima prattica di tutto quello ch'al diligente barbiero s'appartiene* (Naples, 1671), pp. 11–12.

97 The *pratici* were not necessarily humble servants or faithful followers of their master. Severino's 'interventionist' approach to patients was deemed by two of his assistants to cause too much pain in the name of success. The resulting rivalry had Severino temporarily expelled from the Hospital and accused before the Inquisition. See the discussion in José Elia, 'Il medico a rovescio: per la biografia di Marco Aurelio Severino (1580–1656)', *Rivista storica calabrese*, iv (1983), pp. 137–74.

98 A.S.N., *Ministero delle Finanze*, 2nd inventory, b. 2376, 2377; in Vittorio Donato Catapano, *Medicina a Napoli nella prima metà dell'Ottocento* (Naples, 1990), pp. 17–18. Many of the young practitioners were active participants in the French-inspired Neapolitan Republic of 1799, treating injured French soldiers, fighting their opponents, and even planting a tree of liberty in the hospital courtyard. When Bourbon order was restored the College was abolished. Vincenzo Cuoco, *Saggio storico sulla rivoluzione napoletana del 1799*, ed. N. Cortese (Florence, 1926), pp. 327–9.

99 Pastore, 'Ospedali in Italia', pp. 80–1.

100 Ravicini, *Universalità*, pp. 354–5.
101 'Capaccio. Ad usum mei Nicolai Angeli Meola, oppidi Grecorum', MS, c. 1750, fol. 135; in Cleto Corrain, 'Il prontuario manoscritto di un protomedico irpino del secolo XVIII', *Acta medicae historiae patavina*, v (1958–59), p. 49.
102 Galanti, *Nuova descrizione*, vol. 3, p. 141.
103 A.S.N., *Oper pie: varie*, 8; in Catapano, *Medicina*, p. 94.
104 Domenico Cirillo, *La prigione e l'ospedale. Discorsi accademici* (Naples, 1799 edn), pp. 198–200.
105 *Ibid.*, p. 203.
106 Galanti, *Nuova descrizione*, vol. 3, pp. 140–1.
107 Domenico Grimaldi, *Piano per impiegare utilmente i forzati e col loro travaglio assicurare ed accrescere le raccolte del grane nella Puglia e nelle altre provincie del Regno* (Naples, 1781).
108 Luigi Targioni, *Saggi fisici, politici ed economici* (Naples, 1786), pp. 363, 388–9 in Antonio Borrelli, 'Medicina e società a Napoli nel secondo Settecento', *Archivio storico per le province napoletane*, cxxii (1994), pp. 155–60.
109 Domenico Pignataro, *Memoria sullo stato attuale della medicina nelle provincie di questo Regno di Napoli* (Naples, 1806), pp. 16–19.
110 Catapano, *Medicina*, pp. 98–100.
111 A.S.N., *Gran Corte dei Conti*, 3659, 5 March 1789, fols 1–6; in Moricola, *Industria della carità*, pp. 74–5.
112 Laura Guidi and Lucia Valenzi, 'Malattia, povertà, devianza femminile, follia nelle istituzioni napoletane di pubblica beneficenza' in Angelo Massafra (ed.), *Il Mezzogiorno preunitario: economia, società, istituzioni* (Bari, 1988), p. 1173.
113 Moricola, *Industria della carità*, pp. 38, 48.
114 *Ibid.*, pp. 57–8.
115 Archivio dell'Albergo dei Poveri, Naples, *Giornale di famiglia: matricole uomini*, discussed in Moricola, *Industria della carità*, pp. 37–47.
116 A.S.V., *Riti*, 279, fol. 465v.
117 Guidi and Valenzi, 'Malattia', p. 1175 n. 12.
118 A.D.O., *Magia*, I, 'Nicola Gargaro denuncia Donato de Quarto' in David Gentilcore, *From bishop to witch: the system of the sacred in early modern Terra d'Otranto* (Manchester, 1992), pp. 134–5.

# THE CHURCH, THE DEVIL AND LIVING SAINTS

During their rural mission in the diocese of Potenza in 1687, the Jesuit mission-
ers commented on the widespread use of 'superstitions.' According to the
definition of the time this meant any of a wide range of popular rituals to heal,
cause injury, predict the future or bind someone in love, the efficacy of which – the
Church believed – was due to an expressed or tacit pact with the devil. In this case,
the missioners reported that the principal practitioner was a nun whom the local
populace believed to be a living saint:

> Above all, the people were freed from a great error, that of reputing and esteeming to
> be a saint a woman of a town not far away, to whom they had recourse for all their
> necessities, and from whom they obtained remedies, all consisting in superstitious
> things. All these things were gathered together, and having made a great bundle out
> of them, they were consigned to the flames in front of the people, and God favoured
> this in such a prodigious way that the people, terrified, did not stop weeping and
> promised God never again to have recourse to the mentioned witch. And we shall try
> to notify her Superior of the superstitions, so she receives the punishment she
> deserves.[1]

Why was this nun such a threat to the Church, personified here by the Jesuit
missionaries evangelising in the 'deep south'? Why did it campaign so virulently
against the use of 'superstitions', even when they brought relief from illness? In this
chapter I shall examine the opposition of the Counter-Reformation Church
authorities to local attempts to tap the power of the sacred, particularly in response
to disease, at a time when these authorities were seeking to define and regulate the
access to such power, by laity and clergy alike. These include figures like the
cunning man or woman, exorcists and 'living saints.' The latter are a special case,
in that they embodied the sacred in themselves, while the cunning folk and exor-
cists simply employ the tools and techniques at their disposal in their healing rituals.
Because of the power of these living saints – recognised locally as wonder-working
and holy, but not canonised by the Church – and the ever-present threat that the
devil might be using them and deceiving them for his own ends, the Church felt
that it could never let up its vigilance. In addition to the Church's response I shall
also discuss the interpretation of the medical community and how it perceived the

diabolical menace, especially with regard to disease causation. But the control exercised by the Counter-Reformation Church over sacred healing will form the underlying theme. The increasingly numerous forays of the Church into the period's medical pluralism – attempting to regulate it, while at the same time encouraging its growth and proliferation – constitutes one of the paradoxes which characterise the Baroque. Its regulatory efforts were sometimes parallel to those of the medical authorities, like the protophysician, sometimes in direct contact. Their aims and outlooks were at times complementary, at times competitive, as we shall see here and in the next chapter.

## A tale of two Congregations

One fundamental aspect of medical pluralism in the kingdom of Naples, as in the rest of the Catholic world, was the recourse to the healing powers of saints, through their miraculous intercession or the touch of their relics. Intercession could be the result of prayer, pilgrimage or a vow made to the saint. Many diseases had their own 'patrons', to whom the sick could turn when in need: St Roch for plague (throughout Catholic Europe), St Donatus for epilepsy and St Paul for tarantism (in southern Italy), to name but three.[2] The unceasing demand for sources of healing also explains the thriving trade in relics, which the Church sought to regulate. Church synods forbade people from circulating or making use of new or previously unknown relics, in an attempt to stem the commerce in false relics. They also sought to prevent relics from being taken out of churches and loaned to devoted patients. Even exorcists, who frequently used the saintly relics as part of the ritual means of forcing the devil out of the possessed person's body, had to obtain permission for their use.

Devotion to saints thrived, and new canonisations kept up the supply, despite the more rigorous and standardised procedure of saint-making adopted by the Church in the years following the Council of Trent. The middle decades of the sixteenth century had seen something of a 'crisis of canonisations' within the Church, due in no small part to the Protestant Reformation.[3] Confidence was restored with the establishment of the Congregation of Sacred Rites and Ceremonies in 1588, responsible for canonisations. The revival could be said to have culminated on 12 March 1622 with the canonisation of four 'servants of God' in one triumphant ceremony: Teresa of Avila, Philip Neri, Ignatius of Loyola and Francis Xavier. The official making of saints was thus controlled from Rome. However, the initial impetus came from the local level, wherever a cult sprang up around a holy man or woman. For the faithful, the 'living saint' meant a source of sacred power, the function of which was to provide healing, as we shall see further in the next chapter. But the Church was looking primarily for saints of the edifying variety. As a result, of these many local cults, some would be recognised and approved by the central authorities, others would be suppressed, and still others would be put in abeyance, neither rejected nor approved, awaiting further developments. Thus, depending on ecclesiastical reaction, the living saints would end up as either canonised saints,

saints-in-waiting or failed saints. The Church regarded devotion to living saints as a something of a battleground: where the eager faithful saw visions, ecstasies and healing wonders, the Church saw the possibility of diabolical trickery to lead men and women to damnation. While word of new miracles circulated rapidly amongst the faithful, the Church declared that nothing should be made public as miraculous until it had first been investigated and approved by the local bishop, for fear that fakery or the devil lay behind it. The result was that a large number of living saints were to be examined by that other entity of the Catholic Reformation designed to define and enforce access to the sacred, the Congregation of the Holy Office of the Inquisition, founded in 1542. In Naples this meant the archbishop's tribunal, with the involvement of a representative of the Holy Office. Several Neapolitan cases have been studied, although they represent only the tip of the iceberg of the phenomenon.[4] New cases are continually coming to light, such as the two late seventeenth-century cults which sprang up around two young boys. The younger of the two, Francesco Belli, was only five and was known as the *santolillo,* or 'little saint.'[5] For this reason a quantitative approach to the phenomenon would be premature. Virtually nothing is known about the presence of living saints outside the capital, so I shall concentrate on two previously unstudied provincial cases.

Whereas popular religion, in practice, did not stress the differences between divine and diabolical, grouping them together under the power of the sacred, the Church, of course, did. This included the ecclesiastical concept of disease and calamity. On the one hand, they could be caused by the wrath of God as punishment for unrepentant sinners. On the other hand, and more menacing still, were the activities of the devil. He could bring about any sort of malady and misfortune, either of his own accord, or through the influence of spells cast by those in his service. And let us not forget, that even the most humble and devout cunning woman, healing the sick of her village, was considered by the Church to be in league with the devil. The Church stressed that only its trained exorcists could ascertain whether an ailment was caused by sorcery, and if this was the diagnosis, only they had the power to treat it. Of course, the sufferers themselves and their families were generally prepared to use whatever remedy was thought to be efficacious, in a pragmatic search for a cure. But theologians saw the devil everywhere, even in the healing rituals of wise women. Such was the devil's insidious astuteness that under their apparently pious prayers and 'signings', could lie the threat of eternal damnation. Because it realised that popular healing was so often employed in good faith or ignorance, the Counter-Reformation Church focused its campaign against it around the enforcement of orthodox teaching on matters such as sorcery, demoniacal possession and divine intercession. The activity of parish priests, confessors, preachers, episcopal and inquisitorial tribunals was crucial in this campaign, though its impact was a question of centuries rather than decades.

The emphasis placed on the power of exorcists to 'liberate' the possessed from diabolically caused diseases resulted in the mushrooming of extra-canonical exorcists to meet the increased demand. The latter were simply laymen or clerics who practised exorcisms without episcopal training or approval. Sometimes the fame of

an extra-canonical exorcist was such that he developed a reputation and a clientele, in much the same way as the living saints we shall examine below. Diocesan synods frequently decreed that no one should perform exorcisms without episcopal licence. If caught, they would be tried by the episcopal courts or the Inquisition. But the typical exorcism was both extremely complicated and vague, not unlike the learned magic of the period. In terms of the ritual performed, therefore, it was often difficult to distinguish official from unofficial exorcists. It would also seem that there existed a 'low' domestic form of exorcism used against diabolically caused maladies, and a 'high' public form, used for demoniacal possession.[6] This situation was exacerbated by the fact that until the Roman Ritual of 1614 there was no standard exorcism format or rite. Even after that date unapproved manuscript exorcisms continued to circulate widely. To explore how the devil was believed to operate in early modern Catholic society, let us turn at last to our two living saints, Maria Manca and Suor Giglia di Fino.

Manca was born in 1571 in the town of Squinzano, near Lecce. Married at the age of nineteen to a local patrician, she was widowed four years later, and made a vow to God to remain chaste and never remarry. However, a local tradesman – a repairer of windmills – fell blindly in love with her. When Maria told him of her vow to God, the tradesman, Lupo Crisostomo, realised he would have to employ other means to win her love. He thus turned to a local cunning man for a love philtre, which consisted of some powder sprinkled on a mushroom, Maria's favourite food. Brought to her that evening for supper, she ate the mushrooms and soon felt the burning passions of love. Her hagiographer refers to its 'burning in her guts.'[7] She immediately went out to find Crisostomo, arriving at his house late that night. When he answered the door she told him that her mill needed repairing, to which he replied that it was her brain that needed repairing. The whole town was soon gossiping about the affair and Maria's relatives decided that she would have to marry him in order to save her honour. The love philtre allows the hagiographer to account for Maria's breaking of her vow and subsequent remarriage, unusual events in a candidate for canonisation. But more importantly, it explains the terrible torments that were soon to afflict Maria, after the death of her first child. Demons had been introduced into her body through Crisostomo's spell and started to cause havoc. They began by beating her and causing her terrible visions at night, including a 'black Ethiopian' and 'most shameless embraces and a hundred and a thousand dirty and foul acts.'[8] Visions like these were regarded as real manifestations of the demonic presence.

The physical manifestations began after the death of her second child, immediately after birth. Comparing her to Job, Maria's hagiographer describes her torments:

> By reason of the fever having left almost by accident her most worn-out body, which resembled a corpse, having almost nothing more to consume, she soon saw herself covered with wounds, abscesses, gangrene and with the most dreadful pains, which tormented her with all their power all the time, without ever letting up. She offered

her most gentle limbs to the knife, flame and every other similar and most painful remedy with a most exemplary and incomparable constancy, but the surgeon worked in vain, because he was incapable of finding a remedy and cure for the grievous diseases of Hell. The wounds grew more cruel in such a way that her most delicate flesh rotted, so as to generate nauseous worms, and these ulcers emanated such a pestiferous stench that whoever came to visit her, fled at once from her presence and held her in abomination, like a plague victim.[9]

Seeing her suffering, Crisostomo asked forgiveness and took her to the Greek Rite church in Lecce, whose priests were believed to be expert exorcists. They concluded that she was possessed but could not liberate her of the demons. The same negative result was obtained by Catholic priests who performed exorcisms repeatedly over the next nine months. Crisostomo even went back to the cunning man who had cast the original spell, but he said he was unable to undo it. From this point on, Crisostomo was miserable and melancholic, developed pleurisy and died.

After the medical practitioners and exorcists, Maria offered her ailments up to God, allowing the hagiographer to exercise his descriptive skills once again:

> Her disease having become harsher and she herself having become a dungheap of putrefaction, a centre of filth and a sink of rot, overwhelmed by unbearable pains, eaten alive by worms, held in abomination, abandoned and shunned by everyone, in imitation of Agatha, she held up her wounds to the Celestial Doctor and, scorning human industry, placed all her hope in him.[10]

Meanwhile, her habit of going to a tumbledown chapel outside the town and praying to an image of the Virgin and child there eventually paid off. One day a young woman appeared to her and gave her a carnation, telling her to take it to a certain church in the nearby town of Galatone. The rumour of her divine favour spread and the clergy arrived at once to perform an exorcism, taking advantage of what seemed to be a propitious moment. A demon announced he would depart her body the following day on the way to Galatone. Maria was thus finally liberated, vomiting the charm: 'a round bone the size of one of the larger *tarì* coins, perforated in the middle with a piece of string and a few hairs at the tip.'[11]

It is interesting that on several occasions during the narration of these events Maria's hagiographer, Mauro Paticchio, intervenes with lengthy asides on the means employed by demons to bring about illness. Here, Paticchio puts to use his theological training with the Dominicans in Lecce, citing Scripture, church councils, demonologists and theologians in suppport of his statements. The reason that the physicians' cures were ineffective was due to the diabolical, as opposed to natural, origin of Maria's ailments. Spells like the one employed by Crisostomo (*maleficio venefico* or *amatorio*) frequently led to possession and disease, for which Paticchio cites the authority of demonologists like Del Rio, Sprenger and Torreblanca.[12] He also criticises the 'mad presumption' of 'the Englishman Doctor Mead', who suggested in his *Medica Sacra* that the possessed men and women of the Bible were in fact suffering from incurable natural disease or insanity.[13] The

treatise in question by Richard Mead was published in 1749, a time of great change in medical thinking. Paticchio's hagiography was published twenty years later, and it is clear that he is seeking to affirm the traditional viewpoint of the Church on the subject of possession and disease causation against those of an increasingly secular science. Yet as Paticchio must have been only too aware, during the lifetime of Maria Manca (1571–1668) – the period that concerns us here – the worlds of learned medicine and the Church had been in harmony concerning the belief in diabolical disease causation.

## The devil and disease

The traditional ecclesiastical view of the manner in which the devil brought about disease is summarised in Francesco Maria Guazzo's 1608 work, the *Compendium maleficarum*.[14] After citing Galen and Avicenna, he quotes the work of the Spanish physician Franciscus Valesius to describe how the devil brings about disease.[15] Melancholy sickness is brought about by disturbing the bile and dispersing a black humour throughout the brain and the internal cells of the body; he then increases the black bile by inducing other irritations and preventing the purging of the humour.

> He brings epilepsy, paralysis and such maladies by a stoppage of the heavier physical fluids, obstructing and blocking the ventricule of the brain and the nerve-roots. He causes blindness or deafness, bringing a noxious secretion in the eyes or ears. Often again he suggests ideas to the imagination which induce love or hatred or other mental disturbances. For the purpose of causing bodily infirmities he distils a spiritous substance from the blood itself, purifies it of all base matter, and uses it as the aptest, most efficacious and swiftest weapon against human life: I say that from the most potent poisons he extracts a quintessence with which he infects the very spirit of life.[16]

Citing the physician Andrea Cesalpino, Guazzo notes that the 'human skill' of physicians is all but helpless against diseases caused in this way. This is because the devil's poison 'is too subtle and tenacious, too swift and sure in killing, and reaches to the very marrow of the bones.'[17]

Many of the authorities cited by Guazzo in support of his arguments were used by another writer on medicine and magic, Pietro Piperno. Piperno, the diligent protophysician for the papal enclave of Benevento, published his *De magicis affectibus* (*On magical afflictions*) in 1634, along with a treatise on the walnut tree of Benevento, the supposed site of witches' sabbaths.[18] The work which concerns us here, the first one, is divided into six sections: magical maladies, superstitious remedies, medical treatment, inexistent magical maladies, religious therapy and case studies. According to Piperno a malady can be considered 'magical' (i.e., diabolical) if the symptoms are 'beyond the common order of nature without manifest cause, as they do not correspond to the essence of the disease, for which wise men and medics themselves expert in practice are at a loss in getting to know the affliction.'[19] He goes on to list the seven signs which indicate the 'transnatural' nature of a disease:

(i) normally effective remedies show no signs of efficacy; (ii) symptoms are extreme and out of proportion, 'since the devil flees from mediocrity'; (iii) sacred and consecrated things are insulted; (iv) while ranting and then resting the diseased speak in the third person; (v) they speak various languages, not corresponding to their 'regions, practices or occupations'; (vi) they prophesy and forecast the future without feeling; and (vii) through simple and pious prayer they are healed briefly of lypothemia, syncope, heart palpitation, tremor, epilepsy, and so on.[20]

He suggests that melancholic people are most susceptible to magical maladies, due to their less efficient external senses and more fervent imaginations. This results in a certain 'spiritual somnolence', of which the devil takes advantage. The list of maladies which can be brought about in this way is endless (more precisely, forty pages). They include not only those diseases which might be seen as more predictably diabolical, such as neurosis, psychosis, delirium, epilepsy, insomnia, sciatica and extreme feelings of love or hate; but what to us are more everyday ailments, like headache, stomachache and sneezing.[21]

The solutions he proposes to these 'magical maladies' are in line with Counter-Reformation orthodoxy. The healing rituals of a cunning woman would prove fruitless. And as for seeking out the man or woman who cast the spell in order to have it undone – the most common practice, he notes – this would only expose the patient to new and more insidious magic. Here he is supporting the opposition of the Church to popular healing rituals, referred to above.

The Church had its own remedies, working in tandem with learned medicine. The devil could be defeated by taking the inverse route to the one used to bring about the disease. The two-step treatment consisted of first recognising the maleficent nature of the disease, and then proceeding to find and destroy the charm, or exorcise the demon, which was causing it. The *curatio medica* of bleedings, cauterisations, fumigations, change of air and diet, baths, poultices and purgations was used in concert with the *curatio divina* of blessings and exorcisms. Because the supernatural had been used to bring about physical disease, exorcisms had to be given a helping hand by medical remedies. The most symbolically effective was no doubt the *purgatio*. Following the tradition of Hippocrates, vomiting was considered a purifying and liberating force against disease. This 'evacuatory purge made a clean sweep of the humoral quagmire, the seat of fermentation for witchcraft',[22] expelling any charms that might be lurking in the body (as in Maria Manca's small bit of bone with a string through it). Indeed, such was the importance of this purgative therapy in the minds of the medical practitioners that it continued to be used on cases of suspected insanity until the end of the eighteenth century, by which time the whole concept of possession and exorcism had been called into question by the same profession.[23]

The use of both natural and supernatural remedies to treat preternatural illnesses suggests a harmony between physicians and churchmen in the centuries after Trent. But was this the case? In fact, there was ample room for disagreement. In chapter one we encountered Battista Codronchi, who doubted the reality of disease causing spells until undergoing a sort of conversion experience following the sickness of his infant daughter. Because of their university training in natural philosophy,

physicians tended to look first to natural explanations of phenomena. And for this reason clerics often suspected them of irreligious tendencies, as we shall see in the next chapter regarding miraculous cures. It is easy to overgeneralise: physicians like Codronchi and, of course, Piperno, seem happy to put their trust in and even use ecclesiastical remedies. But how typical were they? At least one exorcist writer was convinced that they were the exception. Candido Brugnoli, friar and vicar of the Inquisition in Bergamo, was convinced that physicians were as much part of the problem as the solution. In his 1668 *Alexicacon* he criticised physicians for looking only at the indispositions of the body in attempting to recognise and treat every physical malady. They went out of their way to exclude preternatural causes of disease. Physicians who denied that there was any truth in witchcraft and in the ability of demons to cause disease, ruling out the role of God in testing sinners, remained 'locked behind the gates of nature.' They were guilty of atheism.[24] Physicians should not be so proud as to imagine they could deny the exorcist's role. Instead of trying to use natural remedies against diabolical disease, they should trust in the work of experienced exorcists and their spiritual remedies. Only the latter possessed 'the keys of divine science' to make judgements on such matters, where 'medical science' was not enough.[25]

If Brugnoli showed a professional jealousy with regard to physicians, he was also critical of those exorcists who made too much use of corporeal remedies. The use of medicines should be left to qualified physicians, he argued. Nor could the devil be made to stand in for nature (just as nature could not replace the devil).[26] In fact, one of his aims was to separate and distinguish the functions of physician and exorcist. But he was fighting an uphill battle; one of the central features of medical pluralism during this period consists of attempts by the authorities, medical and ecclesiastic, to separate healers and forms of healing that kept intertwining. Shortly after warning exorcists away from corporeal remedies against demons, Brugnoli himself lists various unguents that can be used against them, including one 'composed and tried by the author.'[27]

To express the debate in chronological – as well as Neapolitan – terms, theories about the nature of spells had shifted from the natural magic of Giovan Battista Della Porta, Giordano Bruno and Tommaso Campanella, to the demonological magic of Bishop Leonardo Vairo and Piperno. Not even the Neapolitan Enlightenment put an end to a belief in fascination: it simply secularised and 'rationalised' it, calling it *iettatura*. In the last two decades of the eighteenth century this theory that certain individuals had the power to harm others through even involuntary eye contact spread from the educated elites of the city throughout the kingdom. The approach was a mixture of the deadly serious and the facetious.[28] This is evident in the study by the professor of jurisprudence Nicola Valletta, who came to believe in it after his infant daughter's death – not unlike Codronchi's 'conversion' two hundred years earlier. The physician and medical author Gian Leonardo Marugi went so far as to explore *iettatura* in scientific terms, employing recent discoveries in the field of electricity.[29] During the nineteenth century the phenomenon was destined to be reduced to the status of folkloric curiosity in the eyes of foreign tourists travelling

to the 'backward south.' In any case, the link with Renaissance natural magic was more apparent than real. Marugi, it has been argued, was in fact a typical exponent of the scientific enlightenment. He was convinced that all forces – even evil ones – could be rationally explained. For this reason, the *iettatura* debate is best appreciated in the wider European scientific context of the time, which includes figures like the Viennese physician Franz-Anton Mesmer.[30]

This same enlightenment spirit also had an impact on clerical attitudes towards the devil and the exorcism ritual. The bishop of Trani, Giuseppe Davanzati, was highly critical of the powers generally ascribed to the devil. In a study written in 1739 he asserted that only God could overturn natural laws, as these had been expressed by Galileo and Newton. The demonological treatises that had conditioned Catholic thinking for so long, he reasoned, were nothing but 'fictitious narratives.'[31] Exorcists, and especially the unsuspecting laity who made use of their services, became prime targets for satire. The Neapolitan political theorist Pietro Giannone delighted in telling of one exorcist, 'in a village near Naples', who decided to alter the rite, so tired was he of having to minister to the hordes of 'possessed' women who came to him for exorcisms. The new rite consisted of a simple stick, with which he beat the unfortunate possessed, promising to double the dose if they should return. As Giannone concludes, the devil never again put in an appearance in either that village or the others nearby.[32] The exorcist – if he was ever anything more than a figment of Giannone's imagination – was, like Davanzati, an indication of new trends within the Church. And yet, one has the impression that the traditionalist Paticchio was probably more representative of the provincial cleric when it came to intepreting and responding to the actions of the devil.

It is striking that the exorcistic treatment was the reverse of the 'superstitious' rituals used to bring about the disease. Divine mirrored diabolical. Such a conception was typical of the period. The demonological, in fact, lacked a language of its own; it was merely the antithesis of the divine.[33] Thus the descriptions of the ecstasies of the mystics and the experiences of the witches have much in common: the rapturous flights to paradise resemble the witches' flights to the sabbath; the languor following ecstatic visions of Jesus compares to the exhaustion of witches after being visited by the devil; the mystical marriage to Christ is analogous to the pact with the devil. One living saint was even known as 'the witch of God', transported by angels instead of demons, to worship God rather than the devil.[34] So close were the two categories, that the woman held to be a living saint and the woman suspected of being a witch could be victims of the same thing. Women were believed to be especially prone to the devil's deceits, whether in the form of diabolical pacts or simulated sanctity. Their inferior powers of reason, childish curiosity and insatiable lust meant that they were more easily seduced by the devil than men. Paradoxically, the credulity and simplicity that gave them an advantage over men in attaining mystical union with God, also made them more apt to be victims of the devil's snares.[35]

The Church tried to stress and enforce the differences between divine and diabolical visions, as it did the opposition between God and Satan. But in popular culture the devil was but a trickster, easily duped by those sly enough to do so. The

pact with the devil was not completely different from a vow made to a saint, and they both could be used to seek protection from malady and misfortune. The divine and the diabolical together formed the sacred and were not yet the opposing forces of good and evil, moral and immoral. Following the Council of Trent the Church did its best to diabolise popular notions of the devil. A soul not on constant guard against the devil's presence could easily be deceived and eternally damned by him. This was as much the threat of Protestant heresy as anything else, and the living saint was particularly dangerous in this regard, because she would lead other people astray along with her.

Paticchio's account of the life of Maria Manca is careful to stress her orthodoxy, as well as her practice of the saintly virtues to a heroic degree. In addition to her obvious piety, her charity, humility, patience, obedience and modesty had resulted in her receiving the gifts of healing and prophecy. The Church taught that these gifts were the result of divine favour, its outcome. In other words, the saintliness led to the power to heal. For most of the laity and much of the clergy, however, it was the other way around: the ability to heal was of itself an indication of sanctity, its cause. The living saint was thus torn two ways. Paticchio goes to great length to show that despite Manca's reputation as a saint, she insisted she was not and remained humble through-out. But the temptation to exploit her powers for an increased role in local society must have been great. The people of her town, as well as from other towns further away, all came to see her, 'very important and notable personages, to obtain graces, favours and advice.' When she walked past, people would shout 'There's the saint, there's the saint!'[36] In true orthodox fashion, Maria attributed her healing favours to the Virgin working through her touch (the touch of her 'embalmed hand' which had held the divine carnation).[37] She treats the difficult pregnancy of the marchioness of Campi by placing her hand on the woman's uterus and addressing the Virgin with the words, '*Madonna mia,* I touch her, you heal her.'[38] Whereas pregnant women were regarded as being particularly vulnerable to witches, the living saints are frequently seen in this role of aiding difficult pregnancies. And of course, Paticchio takes advantage of the account to demonstrate the well-bred nature of her clientele: not just 'dull-witted men and empty-headed women' (*uomini balordi e feminuccie*) who are easily swayed by claims of sanctity. The belief in her holiness was universal, as demonstrated by the general hunt for relics, such as pieces of her clothes, not only whilst she was alive but after her death. Thus – in a *topos* common to saints' *Lives* – if 'she had not been protected and surrounded by guards assigned for the purpose, since Maria was held by all in great regard and opinion of sanctity, they would have torn her clothes from her body, and divided them in many pieces out of devotion.'[39]

## Life strategies and ecclesiastical responses

In Maria Manca we have the careful construction of sanctity, following accepted Tridentine models of what qualities and activities constituted holiness. The hagiography itself was compiled by Paticchio from the writings of her spiritual director and other 'reliable' contemporaries.[40] The order to write everything

down regarding one's spiritual life was a common practice in convents, for example, allowing for a measure of control over the nuns or even to legitimate future calls for canonisation. It permitted the hagiographers to record those events which would add to the candidate's reputation, and eliminate those which would detract from it, especially suggestions of beliefs or practices which might be considered heretical. Print became the ideal means of promoting a cult because it fixed the image of the candidate for canonisation according to accepted ecclesiastical models. It also served to spread the fame of living saints beyond the local area, complementing the traditional modes of diffusion: preaching, travel and within single Orders.[41]

Yet the women themselves, rather than being 'heterodoxes', were usually seeking a more prominent role in society, employing a religiosity which responded to the affirmation of their own individuality and search for forms of charismatic power within small groups. This put them in a potentially dangerous position. Such is the conclusion of a study about the Sicilian nun and living saint Suor Maria Crocifissa (1645–99). She, at least, had a whole 'apparatus' surrounding her – consisting of convent, well-placed family and spiritual directors – which put a complex system of supervision and control into operation, guiding her into safer territory.[42] Less fortunate was the attempt of another seventeenth-century nun, Suor Benedetta Carlini (1590–1661). Her ecstasies, prophecies and healing certainly brought her recognition; but without powerful patrons to protect her, she was examined on several occasions by the Church authorities, suspected of simulated sanctity. Any chances she had of persuading her judges of the authentic nature of her achievements were put to an end by testimony describing lesbian acts with other nuns.

The visions and healing activities of Benedetta and women like her were increasingly suspect because they remained outside the sacramental structure of the Church. Furthermore, in the words of Judith Brown, who has brought us Benedetta's story, the Church 'sought to weaken all competing conduits for grace and to limit the propagation of heresy by well meaning but ignorant visionaries whose flawed interpretations of their experiences could inadvertently lead them and their followers into doctrinal errors.'[43] Yet even Benedetta had the relative security of the convent walls and the recognised status that being a nun gave. More fragile still was the condition of the tertiary or Third Order nun, from whose ranks most of the living saints were drawn. Our second living saint, Suor Giglia di Fino of Altamura, was just such a tertiary. Whilst Maria Manca was careful enough to remain humble about the nature of her achievements – which anyway remained within acceptable bounds – and so receive no opposition from the local Church authorities,[44] Giglia's career was to end in disgrace before a representative of the Holy Office.

Known in the kingdom as *bizzoche,* in 1714 there were well over eight hundred tertiary nuns in Naples. They were loosely linked to various Orders: 297 were Jesuit tertiaries, 191 Dominican, 144 Franciscan, 98 Carmelite and so on.[45] The tertiary nun was a woman who had taken a simple or private vow of chastity, wore a habit, observed some sort of religious rule, and lived either in the community of other

tertiaries or on her own. A typical tertiary was a single or married pious woman who lived at home (for this reason they are sometimes referred to as 'house nuns' or *monache di casa*), wearing a habit she had made for herself. Why would women join a Third Order as opposed to entering a nunnery? Primarily, given the low social status of most tertiaries, it was because they simply could not afford the dowry payment required to enter a convent. In addition, many may have felt that a cloistered life was too restrictive and the combined life of a tertiary was the ideal compromise.[46] The decision to become a tertiary nun allowed one to partake of both the secular and sacred life. It was an important part of a woman's life strategy, particularly if she had no other well-defined role in the community or institutional protection. But because they straddled the sacred and secular worlds they were regarded with suspicion by the Counter-Reformation Church, which kept a watchful eye over their activities. As for those women who sought to follow established models of sanctity through their role as tertiary, it suggests an awareness of self and individuality, whilst at the same time a greater capacity to adhere and conform to these pre-set models.[47] But seeking to imitate the models of canonised women like Catherine of Siena and Teresa of Avila was a dangerous business, with the Church on the lookout for sources of heresy or scandal. In the stricter climate of the Counter-Reformation institutional protection was required for the visionary and healer, a protection which the Third Orders did not provide. Sainthood outside cloistered convents was rendered all but impossible.

While the living saints at the courts of the Italian cities in the first half of the sixteenth century have come down to us through hagiographies, the stories of those mystics, visionaries and miracle-workers esteemed as living saints after Trent are generally told by the surviving records of the Inquisition.[48] Even those living saints who were later canonised, like St Teresa of Avila, had first to pass the test of the Holy Office. Most, of course, never made the grade. All channels to the sacred – and the sources of healing it provided – were now being increasingly regulated and controlled by the Church in order to combat heresy and incorrect belief, as we have seen with regard to cunning folk, relics and exorcisms. But the living saints posed a special threat. First of all, they were predominantly women. The influence they had over their followers meant a disruption of the accepted patterns of relations between the sexes. This, at a time when the Church was seeking to enclose all nunneries and limit the public activities of nuns. Secondly, living saints subverted the established ecclesiastical hierarchy by posing as direct channels to divine inspiration and revelation.[49]

The trend of increasing ecclesiastical control over paths to sanctity was common to all the Inquisitions, Roman, Spanish and Portuguese. Despite being part of the Spanish Dominions, Naples had successfully opposed the introduction of the Spanish Inquisition, as already mentioned. This opposition had much to do with the desire of local elites to preserve their own spheres of influence. These elites could expect to have connections with representatives of the Roman Inquisition, familial and otherwise, offering them some scope of protection. The Spanish version would have deprived them of this. For this reason developments within the

kingdom of Naples also influenced the course of local inquisitorial activities. The investigation of Suor Giglia follows in the tradition of the controversial case involving Suor Orsola Benincasa (1547–1618), a Neapolitan tertiary nun. However, it lacks some of the dogmatic urgency that accompanied the former investigation, which occurred only a few years after the closure of the Council of Trent in 1563. Suor Orsola was born into a family of noble origin and from a young age she demonstrated great piety accompanied by frequent ecstasies and revelations. She set up a hermitage in 1576, where her fasts, ecstasies, acts of healing and elementary preaching brought her great fame amongst Neapolitans of all classes. By this point, she had already been examined by the archbishop, and the agents of the Inquisition continued to keep an eye on her. In 1582, without the archbishop's permission, she arranged an audience with the pope, Gregory XIII, to tell him of the dire warnings she had received from God. She went into ecstasy three times during the audience and was unable to deliver her message. The pope, thinking her experiences might be evil spirits, set up a committee of nine judges to examine her, headed by Philip Neri (and also including one of the chief inquisitors, Cardinal Santoro, and the General of the Jesuits, Claudio Acquaviva). Rigorous interrogations, exorcisms and purgations continued for the following nine months. This included being completely stripped and shaved to see 'if she had on her, in any place, anything prohibited and pertaining to witchcraft that might be causing the ecstasy.'[50] Rumours even circulated in Naples that she had been burnt at the stake. The committee concluded that her spirit was 'good' and her soul pure and simple.[51] She was allowed to return to Naples but forbidden to preach or prophesy. Her new role was to be private rather than public. In the years that followed pressure was put upon her community to come under some sort of Church control, and the enclosed convent she founded in 1617 was placed under Theatine supervision. When the plague of 1656 seemed to verify her prophesies, devotion to her spread to official circles, and she was proclaimed venerable (the first stage to canonisation) in 1793.

Even while alive Suor Orsola had become something of an archetype for the *bizzoca* in the kingdom of Naples. Most women, of course, were only able to imitate her model on a much smaller scale, in part due to their humbler origins. Orsola, however, was somewhat exceptional in having had her achievements recognised as divinely inspired. Most of the women who imitated her model and that of other living saints were not so lucky.

Suor Giglia di Fino's story is typical.[52] Giglia (1601– ?) was a local tertiary nun, reputed to be a saint because of her visions, ecstasies, prophecies and healing power. Her fame brought her case to the attention of a local delegate of the Holy Office, the Dominican friar Vincenzo di Ferrandina. Aware that such feats could have any of three origins – divine, diabolical or simulation – he began an investigation in 1628. Testimony comes largely from those men who had formed a group around her, calling themselves her 'spiritual children.' In the same way that some living saints had become counsellors and advisers to the princes and courts of Europe, although on a smaller scale, Suor Giglia was asked for advice by her spiritual children based on the revelations she was said to receive from God. They 'associated

with her because the said Suor Giglia was reputed to be a saint, and they became attached to the spiritual life, penitential exercises and advice of Suor Giglia as spiritual mother, who had told them that God had revealed to her that she would adopt them as her spiritual children.'[53] One of her 'spiritual children' was Rev. Roberto Campanile, cantor at the church of San Nicola. He asked for prayers and advice on God's intention regarding his decision to retire to the Dominican monastery in Naples and will his possessions to his brother now, rather than when he died. Her response was to sprinkle holy water in the direction of the door through which she said two devils were fast approaching, and tell him that he was a terrible sinner and ought to perform acts of penitence. She left him with a meditation which she said had been written by her guardian angel.[54]

It was her guardian angel who was ultimately responsible for some of her healing. He had brought her a piece of the Cross, housed in an ornate reliquary, and she used it to heal the sick by having them drink the water in which the relic had been placed momentarily. One man who was at death's door had drunk the water, vomited 'matter of different colours', and was healed. Suor Giglia's physician noted succinctly that 'by making a sign of the cross [along] with a Salve Regina' with the oil from the lamp which burned before her crucifix 'she healed every infirmity.'[55] A boy was healed in the following more roundabout way:

> having approached Hell, she touched him and, saying an Our Father and Hail Mary
> to St Dominic so that he would pray Our Lady of the Rosary for the health of the
> boy, she held her hand on his stomach, after which the boy vomited certain matter of
> different colours, asked his mother for food and got better.

On another occasion she sent an ailing priest the relic. His condition improved for eight days, then worsened again and he died. Suor Giglia explained that he had died because he did not want to believe that he had been 'liberated' by virtue of her prayers.[56] Liberation from disease is analogous to liberation from evil spirits – a concept we shall explore further in chapter seven. But even more interesting is the suspicion in which Suor Giglia is beginning to be held, at least by some. If her guardian angel was in fact the devil in disguise then the relic would be fake as well, and the healing attained through diabolical rather than divine favour.

Her guardian angel was also at the centre of her numerous ecstasies. Whilst she was in rapture, enjoying the beatific vision, her body stayed on the ground, her guardian angel directing her, speaking for her and performing other normal actions, like embroidery work.[57] One of Suor Giglia's spiritual children was convinced of the divinity of the spirit speaking through her because it spoke articulate praises of the Virgin, the dignity of the priest, the Blessed Sacrament and Christ's Passion.[58] Her levitations also aroused considerable public interest and curiosity. During them many people would come and watch from behind a closed door. The atmosphere was one of tension and suspense as onlookers took turns peering underneath the bottom of the door to catch a glimpse of the 'saint' in levitation five or six palms off the floor with a crucifix in one hand. On one occasion a cape fell to the ground on the inside of the door, blocking the view, and

causing great fear when people tried to move it and it resisted, all of which was followed by a loud thump on the door. A woman named Isabella who lived nearby recounted that 'she too wanted to watch from under the door, [but] while Suor Giglia was raised up in the air she [Giglia] put her hand inside her sleeve and threw a book impetuously at her where she was watching, and the said Isabella, terrified, never wanted to go again.'[59] Giglia accounted for this by saying that her guardian angel did not want her watched when she was closed in her room.[60] In order to prevent her levitations from becoming too much of a public spectacle – especially when doubts about their divine origin were beginning to arise – her confessor had a bar put across the bottom of the door.

In many ways Suor Giglia's experiences imitated those of the female mystics who had gone before her. Indeed, she claimed that St Teresa, recently canonised, as we have seen, appeared in all her visions alongside Christ. During one of her ecstasies Suor Giglia had undergone the mystical marriage with Christ in the company of saints and angels (similar to that of St Catherine), although the ring was visible only to her. Other 'wondrous deeds' (*opere maravigliose*) included being taken up into paradise during the feasts of Christmas and Easter, and celebrating Palm Sunday with the blessed, during which she was given blessed palms for herself and her spiritual children. On the feast of Corpus Christi, unable to go to mass to take communion, Jesus gave her communion with his own hands.[61] On another occasion an angel of paradise brought her a jar of 'celestial liquor.' It was the special food of paradise and she drank it 'for the nourishment of her soul', but its intense warmth and sweetness caused her to be sick. Finally, like St Philip Neri, she claimed that the gift of grace had caused her heart to dilate and break her ribs apart (going even further than Neri, whose ribs had only been raised up). Campanile – who was especially devoted to Neri – was told to feel Suor Giglia's ribs by the guardian angel. He did this, and was amazed to be able to put four fingertips into the space.[62]

It was probably this self-confidence and boasting which were Suor Giglia's undoing. Her attempts at constructing her public role as saint began to miscarry. It was one thing to justify her status by referring to her saintly childhood, early manifestations of holiness and daily acts of self-mortification (the most standard of saintly models);[63] quite another to claim that she was more favoured than St Philip Neri. Suspicion about the divine nature of her achievements was aroused when several of her prophecies went wrong. On one occasion she told Dr Cornacchia to cheer up since his pregnant wife was going to give birth to a baby girl; but, instead, she became ill and died within a few days.[64] She was suspected of spending the alms she had supposedly collected for the poor. She was accused of giving such harsh penances to followers that they were brought close to death. Furthermore, a priest from Naples had told Campanile about the blood of a holy man there which had been put inside an ampoule and which occasionally boiled inside it, as well as performing numerous miracles. The model is that of the famous Neapolitan reliquary containing the blood of St Januarius. Campanile resolved to try this with Giglia's blood. So, with the help of her physician Cornacchia, a pretext was found to have

her bled, and the blood was put into an ampoule. However, the ampoule was then taken by another of Giglia's spiritual children, Rev. Serio Moro, her favourite. First a word about Moro. Several witnesses say that Suor Giglia was seen in his house one night, Moro naked to the waist, causing much scandal. Serio is also the only one who still frequented Suor Giglia at the time of the trial, despite the charges against her. Be that as it may, Serio dropped the ampoule, spilling the contents, an event which Campanile blamed on the devil. When asked why by the inquisitor, Campanile replied that he and Cornacchia had planned to take it, along with Giglia, to the shrine of Monte Sant'Angelo, to give the alleged guardian angel the chance to prove himself before the priests there. The rector of the Jesuit College in Bari had also shown interest in the ampoule. But the trip would have resulted in the clear discovery of the deception, if deception it was.[65]

Suor Giglia's case was weakened further still when her guardian angel told her spiritual children that she had gone to church and had been exorcised by her confessor and another priest, both of whom were now firmly convinced of the guardian angel's divine nature. Campanile decided to ask Giglia's confessor to ascertain the truthfulness of the account, and he responded by saying that the story was a complete lie and advised Campanile not to have anything more to do with her, for the good of his own soul. In fact, Giglia had not even told her confessor and spiritual director about her guardian angel for fear of arousing his suspicion. As Campanile told the inquisitor, he now came to the conclusion

> that the intention of the devil was none other than to have the said Suor Giglia credited as a saint in order to prepare some great evil. And I believe that the Lord allowed me to know this because I prayed to him many times that he not let me fall into some evil and I recommended myself to St Philip, who is my particular devotion.[66]

At this point another of her spiritual children, Rev. Giovanni Chiuro, was even courageous enough to confront Giglia's guardian angel with this. On the eve of All Saints (just a coincidence?), Chiuro was reasoning with her on how she was being deceived by the devil and how this had occurred to many other holy and devout people, when she mentioned paradise and seemed to be leaving herself (*astraersi*) to make way for her spirit. He insisted: 'Stop! stop! Stay with me and listen to what I say.' But in vain, so he addressed the spirit now in her: 'Evil beast, infernal demon! By lying you have kept this poor creature and we others for a long time, pretending to be a good angel. But now the deceit and the lies you told have been discovered. . . . Infernal beast, what are you doing inside the body of this creature?' In confusion, the spirit seemed to bow his head and look towards the ground, and then said in a low voice, 'God sent me here.' 'How could you have spoken about the greatness of Mary and call her Our Lady?', Chiuro demanded. To which the spirit responded that since he was an angel she was Our Lady for him as well. Then the spirit began to impersonate Suor Giglia, taking her rosary and small reliquary from the head of her bed and kissing it. Chiuro asked where the relic came from, and Suor Giglia – having now returned inside herself – said it was a splinter of the true Cross.[67]

The inquisitor would seem to have been convinced of the deceit. But the fault was recognised as the devil's and not Suor Giglia's. She was regarded as a *povera illusa*, a poor dupe, the devil having taken advantage of her simple piety to further his own ends. When confronted with the deceits and told to pray for God's guidance, she replied, in tearful resignation:

> What I have done, I have done and do for this Christ [pointing to the crucifix], who has done and suffered so much for me, and this I understand, if this Christ then in remuneration of my works wants to give me a demon who becomes master of my soul, as master let him do what he wants.[68]

Even Suor Giglia's spiritual director – about and to whom she had lied, and whose instructions she had not respected – believed that she was 'a good Christian, but for the extravagant things which he saw in her life suspected that she was duped by the devil.'[69] The inquisitor was also concerned with Giglia's current reputation in the town, for it was important that no one be led astray by the delusion. The three clerics Campanile, Chiuro and Loizzo reply that she is commonly regarded as pious but possessed and deceived by the devil. Only Cornacchia, her physician, left the court with some doubt, suggesting that her healing and prophecy were still in demand:

> For much time the said Suor Giglia was commonly held to be a saint. But when it was discovered that she did not confer with her spiritual director about her things, or with us, we then considered her a liar, and her usual confessor did not want nor wants to confess her. The people are divided into those who consider her good, and those [who consider her] possessed.[70]

Once women like Suor Giglia began to lose their respectability because of an impending inquisitorial investigation, they were quickly abandoned by many of their followers and soon found themselves all but isolated. After they had recognised the error of their ways, they were generally sent to a convent where they would spend the rest of their days. This not only demonstrated that they had returned to the fold of the Church, but also kept them under strict supervision and prevented them from having contacts with any followers that might be left. This is not to say that people in the community ceased to believe in their healing powers. On the contrary. When Benedetta Carlini finally died after thirty-five years of solitary confinement, crowds of people gathered to collect relics from her unburied corpse.[71]

It is not simply a question of the Church reform of 'popular' culture. First of all, the power and influence of these living saints could rise to such heights precisely because all levels of society participated. The difference being that the more highly placed her clientele, the more protection the living saint would have, and the more likely that she would have the guidance of those in tune with the accepted limits of holiness. This is what saved Maria Manca. She worked within the confines of what were considered acceptable expressions of piety. Her holiness was of the edifying rather than wonder-working variety, and her piety channelled

into the construction of a new church. Suor Giglia, on the other hand, was not aware of the limits and the risks of what she was doing. Her model of sanctity was becoming increasingly outmoded as far as the Church was concerned, even if it still satisfied local demands for sources of sacred power for healing, revelation and other wonders. The deeds of living saints would be defined as divinely or diabolically inspired, according to the outcome of the inquisitorial investigation. The women would then be labelled and their actions interpreted accordingly. A 'good' living saint was the antithesis of the witch; a 'bad' living saint, the witch's counterpart.

Despite the risks inherent in being a living saint, or in seeking her cures or forming part of her cult, the cultural type survived throughout the early modern period.[72] This is testimony to both the role of saints in medical pluralism and the unceasing quest for manifestations of the sacred. The Church's ongoing struggle to regulate such phenomena – without discouraging their development – demonstrates the ecclesiastical interpretation of sacred healing after the Council of Trent. The boundary between orthodoxy and unorthodoxy, divine and diabolical, holy and sinful, was a very fine one indeed, and one the Church reserved for itself the capability of distinguishing. Those in error, whether wise women, lay exorcists or living saints, risked not only their souls but, like an evil contagion, those of the entire community.

What changes over the period covered by this book is the participation of the local elites in such cults. During the seventeenth century physicians, for instance, are frequently found amongst the disciples of living saints. By the next century, however, the Church's view of orthodoxy was firmly implanted at these levels. Moreover, the spirit of Enlightenment rationalism that swept through Naples had the effect of limiting the array of occurrences that could be accepted as supernatural. Tarantism was one such casualty, the virtual cult that had developed around the devil another. The response of the Church authorities was ambiguous, sometimes rejecting rationalistic conclusions (as in its continuing acceptance of tarantism), sometimes embracing them. The ecclesiastical elites were now more hostile than ever to purported visionaries and mystics in their midst. In 1736 the kingdom's chaplain major and founder of the Academy of Sciences, Celestino Galiani, was quick to brand one such woman, Suor Maria Celeste Crostarosa, an impostor. He accused her of 'faking visions and heavenly appearances.'[73] Reason was increasingly the yardstick by which both living saints and miracle cures were measured.

NOTES

1 'Breve Notitia delle Missioni fatte nelle Diocesi, e Città di Campagna, Satriano, e Potenza da' Padri della Compagnia di Giesù', A.R.S.I., *Prov. Neap.,* 76 I, fol. 174v.
2 François Lebrun, *Se soigner autrefois: médecins, saints et sorciers aux XVIIe et XVIIIe siècles* (Paris, 1983), pp. 113–18; David Gentilcore, *From bishop to witch: the system of the sacred in early modern Terra d'Otranto* (Manchester, 1992), pp. 136–7, 151–2, 170, 184–5.

3 Peter Burke, 'How to be a Counter-Reformation saint' in Burke, *The historical anthropology of early modern Italy: essays on perception and communication* (Cambridge, 1987), p. 49.

4 Jean-Michel Sallmann, *Naples et ses saints à l'âge baroque (1540–1750)* (Paris, 1994), pp. 177–232.

5 Appropriate to his tender age, Belli acquired a reputation for healing childbirth and nursing difficulties, making the sign of the cross on the sufferer. Pierroberto Scaramella, *I santolilli: culti dell'infanzia e santità infantile a Napoli alla fine del XVII secolo* (Rome, 1997), pp. 26–7.

6 Giovanni Romeo, *Inquisitori, esorcisti e streghe nell'Italia della Controriforma* (Florence, 1990), p. 151.

7 Mauro Paticchio, *Brieve ristretto della vita di Maria Manca della Terra di Squinzano* (Naples, 1769; reprinted Galatina, 1971), p. 36.

8 *Ibid.*, p. 42.

9 *Ibid.*

10 *Ibid., p. 74.* St Agatha was a Sicilian virgin and martyr whose breasts were cut off and then miraculously healed after a vision of St Peter. Maria Manca was also a devotee of St Teresa of Avila.

11 *Ibid.*, p. 92.

12 *Ibid.*, p. 33. The Belgian Jesuit Martín Del Rio was author of *Disquisitionum magicarum libri sex* (Louvain, 1600); the German Dominicans Jakob Sprenger and Heinrich Institoris (or von Krämer) compiled the *Malleus maleficarum* (1486); and the Spaniard Francisco de Torreblanca y Villalpando wrote the *Epitomes delictorum, in quibus aperta, vel occulta invocatio daemonis intervenit* (Seville, 1618).

13 Paticchio, *Brieve ristretto,* p. 41. Richard Mead (1673–1754) was physician to George II for a time, and such was his fame in Italy that the king of Naples wrote to him asking for his works and inviting him to the palace. In his *Medica Sacra, a Commentary on the Diseases mentioned in Scripture* (London, 1749), he discusses leprosy, palsy and possession, identifying Job's ailment as elephantiasis, Saul's as melancholia, and so on.

14 Francesco Maria Guazzo (or Guaccio), *Compendium maleficarum in tres libro distinctum ex pluribus autoribus* (Milan, 1608); English trans. E. A. Ashwin (London, 1929).

15 Franciscus Valesius, *De occultis naturae miraculis,* bk II, ch. 1.

16 Guazzo, *Compendium,* bk II, ch. 8 (Ashwin trans., p. 106).

17 Andrea Cesalpino, *De daemonum investigatione* (Florence, 1580), ch. 16.

18 It quickly went into a second edition, from which I cite: Pietro Piperno, *De magicis affectibus lib. vi* (Naples, 1635). See also Michele Miele, 'Malattie magiche di origine diabolica e loro terapia secondo il medico beneventano Pietro Piperno (+ 1642)', *Campania sacra,* iv (1973), pp. 166–223.

19 Piperno, *De magicis affectibus,* p. 57.

20 *Ibid.*, p. 59.

21 *Ibid.*, pp. 169–207.

22 Piero Camporesi, *The incorruptible flesh: bodily mutation and mortification in religion and folklore,* trans. T. Croft-Murray (Cambridge, 1988), pp. 161–2.

23 Michael MacDonald, 'Religion, social change and psychological healing in England, 1600–1800' in W. J. Sheils (ed.), *The Church and healing* (Oxford, 1982), p. 123.

24 Candido Brugnoli, *Alexicacon, hoc est opus de maleficiis et morbis maleficis* (Venice, 1668), vol. 1, pp. 158–9.

25 *Ibid.*, p. 232.

26 *Ibid.*, pp. 2–3.

27  *Ibid.*, vol. 2, p. 101.

28  See the contrasting discussions of Ernesto De Martino, *Sud e magia* (Milan, 1959), pp. 100–34 and Giuseppe Galasso, *L'altra Europa: per un'antropologia storica del Mezzogiorno d'Italia* (Milan, 1982), pp. 253–83.

29  Nicola Valletta, *Cicalata sul fascino, volgarmente detto jettatura* (Naples, 1787); Gian Leonardo Marugi, *Capricci sulla jettatura* (Naples, 1788). The latter was also author of a detailed study of diseases associated with flatulence (*Le malattie flatuose: opera medico-fisica scritta con metodo matematico,* Naples, 1786–87) and a treatise on the sciences, including medicine (*Stato attuale delle scienze,* Naples, 1792).

30  Vincenzo Ferrone, *I profeti dell'illuminismo: le metamorfosi della ragione nel tardo Settecento italiano* (Rome and Bari, 1989), pp. 123–30.

31  Giuseppe Davanzati, *Dissertazione sui vampiri* (Naples, 1774), p. 117; in Ferrone, *Profeti dell'illuminismo,* p. 32.

32  Pietro Giannone, *L'ape ingegnosa ovvero raccolta di varie osservazioni sopra le opere di natura e dell'arte,* Biblioteca Reale, Turin, *Varia,* 304, fol. 73v.; in Ferrone, *Profeti dell'illuminismo,* p. 372 n. 30.

33  Michel de Certeau, 'Discourse disturbed: the sorcerer's speech', in idem *The writing of history,* trans. T. Conley (New York, 1988), p. 265.

34  She was the Dominican tertiary Caterina da Racconigi. Gabriella Zarri, 'Le sante vive. Per una tipologia della santità femminile nel primo Cinquecento', *Annali dell'Istituto storico italo-germanico in Trento,* vi (1980), p. 428.

35  Judith Brown, *Immodest acts: the life of a lesbian nun in Renaissance Italy* (Oxford, 1986), p. 52.

36  Paticchio, *Brieve ristretto,* p. 54.

37  *Ibid.*, p. 125.

38  *Ibid.*, p. 145.

39  *Ibid.*, p. 164.

40  *Ibid.*, p. 11.

41  Zarri, 'Sante vive', p. 379.

42  Sara Cabibbo and Marilena Modica, *La santa dei Tomasi: storia di Suor Maria Crocifissa (1645–1699)* (Turin, 1989), pp. 146–7.

43  Brown, *Immodest acts.* p. 51.

44  If the memory of Maria Manca is still alive today in Squinzano it is because she is offered as a model of devotion, and the veneration itself is channelled to the image of Our Lady of the Carnation in the church she built in the town. A more modern-day example of this is the healer and seer Marietta D'Agostino of Orta Nova, near Foggia. As observed by the ethnologist Annabella Rossi in 1968, she performed healing activities in a shrine she had set up in her two-room house, attributing her powers to Our Lady of Altomare, to whom the shrine was dedicated. Hundreds of people came every day for cures and predictions and their contributions enabled her to build a small church in the vicinity. It was consecrated by the bishop, despite earlier trouble with the clergy over her alleged visions of and conversations with the Virgin. Annabella Rossi, *Le feste dei poveri* (Palermo, 1986 edn), pp. 61–5.

45  A.S.D.N., *Vicario delle monache,* 503; in Giuliano Boccadamo, 'Le bizzoche a Napoli tra '600 e '700', *Campania sacra,* xxii (1991), p. 393.

46  Zarri, 'Sante vive', p. 409.

47  Gábor Klaniczay, 'Legends as life strategies for aspirant saints in the late Middle Ages' in idem *The uses of supernatural power,* trans. S. Singerman (Cambridge, 1990), p. 96.

48 Such was the case in places like Mantua, Ferrara, Milan and Florence in the first half of the sixteenth century, as discussed by Zarri, 'Living saints', pp. 418–20. After the Council of Trent the activities of such 'court saints' became much more circumscribed and they were subjected to inquisitorial scrutiny. For example, the case of a prioress from Lisbon, Sr Maria de la Visitación, whose visionary powers and stigmata resulted in her becoming one of the most influential women in Europe during the 1580s – consulted by secular rulers and Church officials – before she was discovered to be a fraud. E. Allison Peers, *Studies of the Spanish mystics* (London, 1951), vol. 1, pp. 30–1.

49 This was to be the principal case against the many Spanish *beatas* tried by the Spanish Inquisition, some of whom were linked to the earlier Alumbrado heresy. Mary Elizabeth Perry, 'Beatas and the Inquisition in early modern Seville' in S. Haliczer (ed.), *Inquisition and society in early modern Europe* (London, 1987), pp. 147–68.

50 Francesco Maria Maggio, *Vita della Venerabil Madre Orsola Benincasa napoletana* (Rome, 1655), p. 253.

51 At this point in his hagiography Maggio criticised Gregory XIII for not recognising the need for reform and acts of penance which Orsola had repeatedly called for, the result being the succession of calamities that had followed her death and showed no signs of abating. Maggio, *Vita,* pp. 305–8. This criticism no doubt had a lot to do with his book being placed on the Index. S. Menchi, 'Orsola Benincasa', *Dizionario biografico degli italiani* (Rome, 1966), vol. 8, pp. 527–30. One calamity which Maggio did not include in his list occurred the year after the book's publication, the 1656 plague, as mentioned in chapter one.

52 'Informatio supra Giglia Fino', 1628, A.D.G., *Fondo vescovile,* Atti del S. Ufficio: materie varie, IV.D9.c1.

53 Deposition of Giovanni Gironamo Cornacchia, 'Informatio supra Giglia Fino', fol. 15v.

54 Deposition of Rev. Roberto Campanile, *ibid.,* fols 2r-3r.

55 Cornacchia, *ibid.,* fol. 19v. The crucifix was itself imbued with sacred power, for it had 'talked and conferred with her' (fol. 15r.).

56 Deposition of Rev. Giovanni Chiuro, *ibid.,* fols 24v-25r.

57 Campanile, *ibid.,* fol. 4v.

58 Chiuro, *ibid.,* fol. 22r.

59 *Ibid.,* fols 20v-21r.

60 Deposition of Rev. Agostino Loizzo, *ibid.,* fol. 35.

61 The inquisitor made a point of asking how Jesus gave her communion, and the answer was like a priest, giving her the host. Campanile, *ibid.,* fols 6v-7r.

62 Campanile, *ibid.,* fols 7v-8r.

63 Loizzo, *ibid.,* fol. 36v.

64 Campanile, *ibid.,* fol. 12v.

65 Campanile, *ibid.,* fols 8v-9v.

66 Campanile, *ibid.,* fol. 5v.

67 Chiuro, *ibid.,* fols 23r-24r.

68 Loizzo, *ibid.,* fols 38v-39r.

69 Cornacchia, *ibid.,* fol. 14r.

70 Cornacchia, *ibid.,* fol. 19r.

71 Brown, *Immodest acts,* p. 137.

72 William Christian, *Apparitions in Late Medieval and Renaissance Spain* (Princeton, 1981), p. 185.

73 Letter from Galiani to Tanucci, 16/iv/1736, A.S.N., *Cappellano Maggiore: relazioni,* I, fols 357–60 in Gabriele De Rosa, *Vescovi, popolo e magia nel Sud* (Naples, 1983), p. 41 n. 60.

# CHAPTER SEVEN

# ILLNESS NARRATIVES, MIRACLE CURES AND THE MEDICAL COMMUNITY

The actual words of healers and the sick have been quoted from time to time in the course of this book as a way into the daily lived experience of illness. This chapter will privilege those words. Recent work in the history of medicine has stressed the importance of the 'view from below' – the sick person's view – as a way of overcoming an overly Whiggish approach to the subject, which has tended to isolate it from mainstream historiography. As Roy Porter has noted, 'health is the backbone of social history, and affliction the *fons et origo* of all history of medicine.'[1] How did ordinary early modern Europeans regard health and sickness? How did they explain their illnesses?[2] How did they manage their encounters with the whole range of healers that existed in a time of medical pluralism? The posing of such questions is necessarily influenced by the work of sociologists and anthropologists, medical and otherwise. They have increasingly focused on accounts of chronic illness to analyse how people interpret and cope with illness in their lives, especially as the sufferers themselves express it.[3] Great attention is paid to how sufferers construct and tell illness stories and the functions such narratives serve. What historians can do along these lines is clearly limited by the sources available to them, records created with very different ends in mind than anthropologically inspired analysis. None the less a wide range of sources is available. In addition to studying diaries and other personal documents offering first-hand accounts, historians have looked at doctors' own case books.[4] They have studied accusations of magic and sorcery to discover what these could reveal about attitudes to illness caused by such forces and about popular forms of healing.[5] In the ongoing search for relevant sources, the canonisation processes have been largely overlooked. While scholars of the medieval period have used miracle accounts to study disease, early modernists have been more reluctant to take up the challenge.[6] This is somewhat surprising, given that historians of earlier periods must largely rely on the miracle registers of saints' shrines and saints' *Lives,* where the mediation of churchmen in recording the event is most evident.

There is no simple way of counting the number of saints from the kingdom of Naples. Some 'servants of God' who lived during the early modern period were only canonised in this century, others spent some or most of their lives outside the kingdom and still others, identified with it, came from elsewhere. Then there are

the various stages of ecclesiastical recognition: venerables, blesseds and saints. And this is to say nothing of those whom the Church rejected outright, like the 'living saints' examined in chapter six. In any case the number was substantial. For example, Jean-Michel Sallmann has identified causes for 105 servants of God during the period 1540 to 1750.[7] In 1588 the Congregation of Rites and Ceremonies was founded within the Catholic Church as a standing committee of cardinals to examine the causes of candidates for canonisation. It adopted a rigorous judicial procedure, of which the examination of witnesses was an important part. The witnesses called to give evidence at these hearings responded to and commented on a series of questions and declarations regarding the holiness, Christian virtues, miracles, prophecies, quality of death, and so on, of the candidate for canonisation.[8] In fact, it is the narratives of miracles performed by such holy people, both whilst alive and after death, that form the larger part of the processes and that would go on to constitute episodes in the published hagiographies and miracle collections so numerous during the period.[9] The narratives frequently permit the historian to reconstruct entire courses of treatment leading up to the miraculous intercession. They also contain a vivid description of aspects of everyday medical attitudes and practice, to which those of the miraculously cured sick people, the *miracolati*, can be compared.

To judge by these narratives, the principal function of saints was to perform miracle cures.[10] The witnesses, in their own words, describe these miracles, which represented a source of hope in cases of imminent death, where medicine could provide no relief or cure. As in the Middle Ages, miracles formed part of the expectations of mankind in early modern Catholic Europe. They were part of accepted, everyday experience. They provided a source of healing at a time when resistance to disease was low and pre-modern medicine was of little efficacy. Indeed, in this medically pluralistic society the intervention of physicians was but one source of relief, and not necessarily the most common. As outlined in the preceding chapters, the period's network of healers consisted not only of regular medical practitioners, but cunning folk, exorcists and saints, to say nothing of widespread domestic medicine.

The early modern body was a battleground for differing interpretations of disease: natural, divine and diabolical. Miracle cures exemplify this ambivalence. They represent a useful focus for study because with them 'the body finds itself at a limit: between health and disease, life and death, nature and the supernatural, the real and the imaginary.'[11] Rather than deal with miracles *per se,* however, the focus of this chapter will be on what miracles – and stories about them – can tell us about the healing process in general. In the first section, I shall consider how the miraculously cured sick people represented illness and the healing process. What can the miracle stories tell us about the links between medicine and religion in Catholic Europe during the early modern period? To answer this we must return to religious and medical concepts of disease. The second and third sections will therefore focus on how two different professions – physicians and ecclesiastics – competed over self-definitions, skills and roles, as evinced in the miracle cure.

## The illness narratives

Let us begin by looking at one miracle narrative in detail. In 1747, Giuseppe Orecchio of Naples, a fifty-year-old widowed shoemaker, recounted how he had been miraculously cured of the French disease. The occurrence has come down to us because he testified before the hearing being held in the city's Dominican monastery to investigate the cause of the saintly Dominican tertiary nun Maria Rosa Giannini, who had died six years earlier. He recounted that in February 1746,

> a swelling or tumour began to form and become visible in the area of my testicles, [speaking] with reverence, which spread backwards as it grew, so that after about fifteen days it reached the size of a large lemon, and it divided into three . . . each as big as above, and they caused me bitter pains worse and worse as they grew, and they kept me from sleeping and resting, or urinating freely, or having bodily evacuations, which I could not have without great pain.

Orecchio called a surgeon. The surgeon resolved to cut open the tumours, the only way to save him, even though it was a dangerous operation and the result uncertain. Each incision was a palm in length and two fingers in depth, and out of them came 'bloody and putrid watery matter, about eight pounds in weight', according to Orecchio. As a result of the cuts, his urine 'no longer went out through its natural canal' but through each of the incisions. Though 'continually medicated with wadding and other things the surgeon deemed opportune', the sores got continually worse and Orecchio began suffering from 'continuous fever.' When the wounds had failed to close by the following July, Orecchio went to the baths at Ischia. However, after taking six baths Orecchio's bladder developed a second opening, so he promptly returned home to Naples. The surgeon informed him that there was nothing more they could do to save his life. As a result, Orecchio related, 'there was weeping in my house, with the realisation that I could die within a few days.'

At this point, mid-July, two of his daughters went to church to make confession and 'dedicate their holy communion to my health', according to Orecchio. On their way there, they were stopped by two young women, who charitably asked Orecchio's daughters why they were weeping. When they told the women of their dying father, the two women persuaded them to follow them into the church of San Domenico, where they could recommend their father to the intercession of Sr Maria Rosa Giannini, who was buried in the church. This they did. That same morning they brought their father back a paper image of Giannini. Orecchio remembered the nun's saintly reputation, and hearing of his daughters' chance meeting, he prayed to her. Meanwhile his daughters had begun a novena, timed to end on the feast of St Dominic (4 August). That night, for the first time in many months, Orecchio slept well, without pain.

> I felt much better and I had the idea to have a quick look at the cut tumours, to which I had applied the image of the said Servant of God from the time my daughters had brought it to me, and I had continuously kept it in those parts; so I got down from

my bed, and . . . I got dressed into my clothes, which I had not been able to do in the past, and with anxiety I saw that the said tumours had already ceased and settled down with the other parts to their natural place, as if they had never been there, and the wounds [were] closed with natural skin, that you could hardly tell they had been there, having no other scar than that of a flea bite.

Orecchio was convinced the cure was a miracle. He became assured of this when, with some anxiety, he urinated. To his relief, 'it came out through the natural channel, as before the cut.' He praised God and Giannini's intercession. And, Orecchio concluded, when the surgeon saw him healthy for the first time, he too was convinced that the cure was miraculous, 'since humanly I should have been dead.'[12]

We can compare Orecchio's account of events to that related by the surgeon who treated him, the thirty-five-year-old Gennaro Sarno. It differs in several respects. Sarno deposes that he had first begun to treat Orecchio as far back as 1740, and identified Orecchio's malady as the French disease, a fact which Orecchio, perhaps out of shame, had neglected to mention. Nor did Orecchio mention that he had spent a month at the Incurables Hospital. This was at Sarno's behest, who was aware of the seriousness of Orecchio's condition and his poverty. Orecchio had gone there for the removal of a chancre, though he was forced to return home due to unspecified family reasons before the treatment was complete. This resulted in what Sarno referred to as a 'serpent herpes' and led to the tumours which Sarno incised, but which had failed to heal. Around this time Orecchio's wife had died of a related form of consumption (*etticia gallica*). Orecchio then resolved to go to the baths of the Sacred Mount of Mercy at Ischia, though Sarno advised against it. When Orecchio returned home after the sixth bath, in worse health than ever, he sent for Sarno in repentance and desperation. Sarno concluded that the case was hopeless and advised him 'to go to some hospital to end his days there more comfortably, since in his house he had no comfort or means of protecting his health.' In September of the same year one of Orecchio's daughters told Sarno of her father's miraculous recovery. As Sarno told the hearing, at first he did not believe the news. But, when he saw Orecchio alive and well, and later examined him, he became convinced that the cure was indeed miraculous.[13]

Typically, illness narratives start by identifying the genesis of illness, making use of a particular explanatory model to give it meaning. The story's beginning is anchored in a particular time and place. This was the case with Antonia Jurlaro's account of her daughter's illness episode, with which I began this book. No doubt it was also true of Orecchio's experience. However – presumably because Orecchio was ashamed of his French disease – he did not tell the ecclesiastical investigation how and when his illness first began. The next stage in narratives moves from genesis to the period when the physical symptoms become a major disruption in the person's life. It is interesting that Orecchio's narrative began not with the beginning of his disease (in 1740), but when it took on a much more frightening appearance and reached a life-threatening stage with the tumours (1746). This situation

was exacerbated by his wife's death. At this point in narratives, the relief from pain and the search for a cure come to the fore. Various events pertinent to the illness and its treatment are related, such as Orecchio's desperate trip to the baths at Ischia – against the surgeon's wishes. But Orecchio's account only became really loquacious when he entered the second phase of his story. This began with his daughters' chance encounter and visit to Giannini's tomb. This shift into 'sacred time' is something that we shall return to below.

Narratives like this one are important for the historian, since telling stories about particular experiences is the primary human mechanism for bestowing meaning upon them.[14] They reveal not so much actual happenings as the underlying meanings attributed to the events.[15] Disease is seen to occur not only in the body, but in time, in place, in history and within the context of lived experience and the social world.[16] In a world shattered by illness, the construction of narrative allows the sick person to 'reconstitute' the world. Being a *miracolato* assured ample opportunity to tell and retell the story, as new sources of cure were added to the pre-existing explanatory model of illness. The relating of miraculously cured illnesses to ecclesiastical hearings investigating the holiness of servants of God was an extension of this function. The narratives given as testimony share many of the characteristics of similar stories told to relations, friends and neighbours. Yet the hearings were directed and conditioned by the ecclesiastical authorities. As a source, therefore, the canonisation processes do have their limitations, and it is worth bearing them in mind as we proceed.

First of all, the structure of the hearing consists of a series of numbered articles compiled by the cause's postulator, to which the witnesses responded in turn. The comments of witnesses were thus structured, and often restricted, by the formulation of the article itself. But there was always a question of the sort – 'describe any further miracles that you know about' – which gave the witnesses relatively free rein, allowing for greater variety in the narratives and bestowing a more direct oral quality upon them. Even here, however, we are not dealing with the episode exactly as recounted by the witness, but as taken down by court clerks. Often this involved translating dialect testimony into Tuscan Italian and the paring-away of any tangential remarks, with a resulting loss of spontaneity. The involvement of a postulator in shaping the cause meant that witnesses were not representative samples of medical practitioners, or of the community as a whole. Only privileged witnesses – those with something positive to contribute to the cause – were singled out by the postulator to testify before the Congregation or at a local hearing. The role of the postulator is one to which we shall return in section three.

Events were not necessarily recounted as they occurred, or even as they were perceived to have occurred. Witnesses were often speaking about events and impressions of many years prior to the hearing. Memories could undergo the deleterious effects of the passage of time, as witnesses themselves occasionally noted.[17] There was also a conscious reshaping of testimony on the part of witnesses, conditioned by the servant of God's local fame and a desire to present him or her favourably. But of greater relevance to this study is the similar process of

*self*-representation by witnesses before the Congregation. For example, in order to give more weight to the miracle cure, witnesses almost always described it as having taken place as a result of the sick person's invocation of the saint only after all other remedies had been exhausted and the physicians had given up hope. This made the miracle more acceptable to both the medical community and the Church authorities. But in fact, saints were generally invoked from the very start of the illness, alongside other forms of treatment, in a form of double recourse. The entire illness episode was thus reinterpreted in the light of the miraculous outcome. Yet this is not so much a limitation as a characteristic that can be turned to our advantage. Although the narratives were structured by the way the hearing was conducted, they provide us with an indication of how such stories were told and the importance they had in relating illness experiences within the community.

What can they tell us about how illness was perceived? The language used to represent illness is remarkably similar to that used to describe possession of the body by demons. The popular healing rituals of the period made use of exorcising formulas to conjure disease out of the body.[18] But the possession–illness link is clearly evident in the miracle narratives, too, uniting learned and popular traditions. Disease is represented as an active force, which enters and advances through the body. It 'assails', 'assaults', 'oppresses', 'comes upon', 'strikes', 'crushes', 'burdens' the body. A war between sickness and health ensues, the body becoming the field of battle. The disease 'grows', 'spreads' or 'winds its way' (*serpere)* through the body, 'clinging' to it, becoming 'rooted.' During this corporeal encounter the sick person is somehow dispossessed. The doctors, after having tried their remedies on the body, abandon it. The sick person reacts to the loss of his or her body by seeking a miracle. The miracle is the 'moment of struggle when, despite the laws of nature, the defeat of the disease is decided.'[19] The disease 'withdraws', the body is 'liberated', 'cleansed.' The sick person has been singled out, the body reunited with the self and its functionality restored. The miracle cure is at once unique and part of a timeless corpus of similar cures. But for the physician recounting the same event, the miracle is often presented as something of an anti-climax, which does not involve him directly. After all, the sick person's life has not only been saved by the miracle; it has been marked, singled out. The physician's life is affected to a much lesser degree, if at all (except, of course, in those cases where the physician is also the *miracolato).*

In the canonisation processes there is remarkably little difference between the terms used by sick people and those of their doctors, though they did often differ on what constituted a miracle cure. At least as far as 'natural' illnesses were concerned, there was a substantial convergence between lay and professional medical outlooks and attitudes, though lay knowledge was practical know-how based on experience, without the medical-theoretical underpinnings spelt out.[20] In the case of one miracle cure, both the nun cured of a paralysis, Sr Maria Rispoli, and the helpless convent physician, Giovanni de Turris, were agreed on why the cure could only have been miraculous:

Nor could I have recovered otherwise [Rispoli recounted], given that the medicaments were of no help to me, as was seen by my four months' experience [with them]. I recovered instantaneously, having stopped taking medicaments several days before; nor was any crisis brought about in me, either by sweating or other evacuation, by which the humour causing my illness could have been dissipated and digested.[21]

De Turris likewise said that the cure was a miracle because it had taken place without the necessary fever or other 'movement of the body' (*scioglimento di corpo*) to act as a purge.[22]

The evacuation of evil humours was one of the pillars of Galenic medicine. A cure brought about in its absence helped to define that cure as miraculous. But, as far as many non-medical witnesses were concerned, saints could also use their miraculous intercession to bring about the vital purge. The miracle is depicted as a crisis. The sick person's condition gets dramatically worse, the bad humours spread throughout the body, until the miracle intervenes to expel them from the various orifices.[23] In any case, popular and learned traditions shared the concept of 'flow' within the body. A blockage in one part of the body could manifest itself elsewhere. This is particularly evident in women's perceptions of their bodies. Thus a woman who had just given birth linked her swollen leg, so painful she could not move it, to her difficult labour. She refused to be examined by a surgeon, consenting to be treated only by the midwife who had delivered the baby.[24] In 1623, the domestic servant Rosata Tomasi recounted how several years earlier her mistress had been suffering from sharp pains in her belly/womb (*ventre* [25]) and was losing an abundant quantity of blood. The ailing woman fetched the Jesuit Bernardino Realino (1530–1616), held locally to be a saint. Whilst he was kneeling at her bedside, reciting a litany to the Virgin Mary, she took his biretta, which he had removed to say the prayer. She placed it – like a relic – over her womb, where she had the pains. Tomasi concluded her account thus: 'and as soon as she touched her *ventre* with that biretta, a large piece of putrid and congealed blood came out of her body, and all her pains ceased.'[26] This discharge was a dangerous though necessary element of the cure. This is true whether or not the expulsion was a mola, a fact which is never specified. A bodily growth was not identified as pregnancy until the quickening occurred. In fact, the belly/womb ambiguity indicates the way in which this space was hidden and mysterious. The womb was not yet a part of some medicalised reproductive apparatus.[27] What is interesting in this context is the woman's control over her own body. No medical practitioner figures in the story.

Physicians and sick people also shared the need to describe and identify the disease. Objectifying the illness and its symptoms brought a certain sense of control over it, as well as exerting a powerful influence over behaviour.[28] The narrative process was a crucial element in this. Talking about illness and comparing previous experience was basic to an understanding of the malady and seeking a cure. If professional care was sought then the medical practitioner depended on the sick person's often harried and urgent description of the illness in order to formulate a diagnosis. This was facilitated by the existence of vividly descriptive and figurative

popular and regional terms for illnesses, used, or at least understood, in all levels of society. When using such illness terms in their narratives, witnesses sometimes preceded them with an expression like 'as popularly called' (*volgarmento detto*). Such was the term *le coccia,* literally swellings or pustules, to refer to smallpox (*vaiuolo* in Tuscan Italian); *i porri* (literally, leeks) to refer to warts, as opposed to the learned term *verruche*; *mal di punta* (in the sense of stitches or sharp pains) for pleurisy; and *mal mazzucco,* literally hammer sickness, to refer to a kind of frenzy.

Let us take cases of fever. To analyse them it may be useful to bear in mind what Byron Good has called 'semantic networks.' These consist of the 'words, situations, symptoms and feelings which are associated with an illness and give it meaning for the sufferer.'[29] Fevers were considered diseases in their own right, not symptoms of something else. They were the most prevalent form of illness in the narratives, both in their sheer numbers and in their variety. If very dangerous, fevers were at least familiar. Sick people and physicians alike sought to identify as early as possible the variety of fever in question. The canonisation processes reveal shared ideas about causation as well as terminology. Both popular and learned traditions saw fright or fear as possible causes of fever. This was possible because sudden and strongly felt emotions were thought to block the flow of fluids in the body.[30] In a conception very different from our own, fevers 'occupied' the body; they could then be described as 'leaving' it. As for the numerous expressions used to indicate fever, they can be broken down into types (pestiferous, aerial, lymphatic, frenetic, hectic, rabic), into degrees (malignant, acute, ardent) or into rhythm (slow, continuous, intermittent, quotidian, tertian, double tertian, quartan). Adjectives used to describe the fever vary from the common 'great' to 'fermentative.'

Statements about pain also suggest how the sick body was perceived by early modern Europeans. Because pain could not be understood objectively, it had to be described. The language used was therefore metaphorical.[31] During pain the body became an object, the sick person outside it, looking down on it. The reality of pain, as a natural part of both sickness and medical treatment, explains the number of miracles which intervene to save the sick from dangerous physic and surgery or alleviate pain during the course of an operation. Pain itself was frequently linked to the emotions. This helps explain why a nun could 'find herself oppressed by evil thoughts and other pains.'[32] Pain was even perceived to lead to madness. One illness episode exhibits these various features. In 1729 Benedetto Jurleo recounted how he had been suffering from sciatica and had exhausted various remedies, and how on 18 November the pain had increased so sharply that he thought he would 'die mad' (*morire arrabbiato*). But following a vision of the saintly Carmelite nun Rosa Maria Serio (1674–1726), during which she told him he was cured, Jurleo said he 'immediately felt [as if] a one-*cantaro* weight had fallen from my aching thigh, and in an instant I was relieved and healthy, and the next morning I walked through town, as if I had never suffered any malady at all.'[33] The moment of release from pain can be described as vividly as the pain itself and the moment when it first began. Jurleo's sense of relief is at once poignant and palpable.

[184]

The *miracolati* often refer to specific dates or phases in the illnesses. In addition to naming – identifying – the illness, it was important to locate crucial moments in its course. The narratives did not seek the dispassionate representation of the illness experience, but to elicit a particular understanding of the events. Witnesses privileged certain times in their narratives: the exact moment when they discovered their illness, times of medical intervention, sudden changes in conditions. These are times of extreme uncertainty, when a person's life is suddenly and patently in the balance. Entry into the marked time of illness is thus carefully recorded by sick people, distinguished from the rest of their lives.[34] When she testified in 1725, the articulate nun Maria Rispoli remembered the exact date when she had had her apoplectic fit, even though it was nine years earlier (4 February 1716). We may have doubts about the general use of numerical dates in society at this time, but at the very least she was able to calculate them for the benefit of her deposition. She remembered, too, the day when she began invoking the intercession of the saintly Jesuit preacher Francesco de Geronimo, shortly after his death in nearby Naples (11 May 1716). She remembered when her pains got much worse, now affecting both sides of her body (4 June), followed by the application of relics, which took these new pains away but left the original paralysis intact. She remembered the night when she had a vision of de Geronimo (14 June), for the following day she awoke without pain and was able to walk.[35] The onset of her illness was in fact reinterpreted and given new meaning in the light of her devotion to the saint and the subsequent miracle.

For those suffering from chronic or fatal illness the devotion to and invocation of a saint offered an opening-up of the 'bounded time' of illness. Illness is wholly 'present time.' Sick people have difficulty remembering when they were well or will be well again. Devotion to a saint opens a way out of this present time and space by allowing the devotee to express confidence in the future actions of the saint.[36] Religious devotions and vows to saints structure and give meaning to time outside that of the illness, and faith in a cure offers a future beyond illness. For those who testified, belief in the imminent possibility of a miracle was crucial. For this reason relics were always applied to the body and saints invoked 'with keen faith', 'with great trust and hope.' Indeed, the act of invocation itself often brought an immediate sense of relief and 'a certain internal consolation', as one witness put it.[37] For this reason miracle accounts put great emphasis on how the sick person first found out about the particular saint and when and in what circumstances that saint was first invoked. The transmission of such knowledge was fundamental for cultural models of illness. Invocation brought the illness into a new, symbolic phase. This is evident with the onset of 'sacred time' in the Orecchio narrative described at the beginning of this section. Illness was not something restricted to specific sites in the body. It was located in imagination and experience, in history and in social relations.

The wording of the invocations made to the saints indicates the link they provided to times and spaces outside the bounded ones of illness. They express a desire for the recovery of a functional body, guaranteeing reinsertion into society or community. A paralysed nun prayed to have her ability to walk restored, so that she

could at least 'go to confession and communion *in the places where she used to.*'[38] As this request suggests, devotees do not always ask the saints to 'cure' them. The early modern idea of the functional body was different from ours. The complete recovery of health, in the modern sense, is not necessarily the sick person's main desire or expectation. There is a gap between 'health' as defined by modern biomedicine and what people of other societies, past and present, are prepared to put up with, while considering themselves free from sickness. Even Paolo Zacchia (see below) admitted that miracle cures could consist of having one illness transmuted into another or shifted to another part of the body: the supernatural equivalent of the Galenic procedure of conducting disorders from vital to less important regions of the body. He gives the example of a patient of his suffering from a tumour, ulcers and painful haemorrhoids, much to her great personal shame, who, after invoking the intercession Cardinal Bellarmine, awoke to find herself suffering from articular pains and nothing else.[39]

Other miracles permitted sick people to confess their sins before they died. Dying the 'good death' was of great importance throughout the early modern period. Any illness was to serve as a warning of what would ultimately befall everyone. When illness forced people to bed, with the threat of death hovering over them, it gave them the chance to put their things in order. In 1743 serious illness gave Angela Intano both the motivation and the opportunity to confess to having stolen a host from church eight years earlier, secretly removing it from her mouth after taking communion. She had been asked to do so by an acquaintance and was worried that the host might have been used in magic. 'Later, when I was bedridden with blood fluxes', she told the ecclesiastical tribunal of Gravina, 'and having confessed to my father confessor, he made me feel a remorse of conscience for having performed such an action.' Her appearance before the court was the result.[40] Although pious writers had shifted the emphasis away from the *memento mori* of previous centuries, and on to lifelong preparation for and meditation on death, the faithful continued to regard the time immediately preceding death as crucial.[41] In 1765 the apothecary Onofrio Stiffa recounted the following incident, which outlines the elements constituting a 'good death':

> The late Pietro Alosca, Neapolitan, was struck down by an illness which caused him to cough up blood through the mouth, and he bled in such great quantity when I was fetched . . . that I was unable to look at him, [and] I thought then that he was about to suffocate. Forced to make a decision, I suggested, as was my wont, that he recommend himself to the said servant of God [Ludovico Sabbatini], by touching the said relics to himself and praying to him for the grace of his soul and body, depending on [Sabbatini's] will. And immediately I saw the vomit of blood cease, and the said Pietro was moved into a position in which he could make confession, take communion and put all his things in order. And within five or six days he died peacefully, the servant of God having, I believe, granted the grace of his soul, considering it expedient, perhaps, that he should die.[42]

## Miracle cures and the medical community

Educated physicians recognised that only the Church had the authority to decide whether something was miraculous. Legal medicine had much to say about presumed supernatural activities of all kinds, from possession through to the miracles and ecstasies of saints. The Roman protophysician and pioneer of forensic medicine Paolo Zacchia dealt with the subject at length in his wide-ranging treatise *Quæstiones medico-legales,* parts of which were first published in 1623. In the questions devoted to miracles, of special interest to us here, Zacchia remarked that the unlearned were quick to call cures miraculous. The number of ex votos covering the walls of saints' shrines was testimony to this. Moreover, physicians heard of 'miraculous cures of sick people daily, or rather by the hour, even by the minute.'[43] Due to the number of apparent miracles, Zacchia advised caution in defining something miraculous. Apparent miracles could be brought about by 'evil men' and demons, to say nothing of the deliberate staging of fake miracles. The final decision was therefore to be left up to the Church.[44]

Zacchia devoted question eight (book iv, title 1) to discussing 'the miraculous healing of the sick.' Cures *could* be miraculous, but there had to be no doubt, in particular instances, that the cure had not come about naturally or 'through art.' Thus the illness had to be impossible, or at least very difficult, to cure. Zacchia gives the example of blindness. Its symptoms had to be very severe, as in the case of 'burning and malignant fever.' And the illness could not be in its final phase at the time the miracle occurred, since the illness could have declined naturally shortly afterwards.[45] As for the miracle cure itself, it had to take place suddenly and instantaneously. It had to be in every way perfect and absolute. In no way must a miracle cure resemble a natural one, so that where a crisis or evacuation took place – 'namely by vomit, haemorrhage, diarrhoea, sweating, urination' – the cure had to be categorised as natural, not miraculous.[46]

When it came to the category of so-called 'magical' or diabolical diseases, physicians were willing to recognise their impotence. Because the demons behind such illnesses were of spiritual and metaphysical substance, nothing natural, corporeal or physical could work against them.[47] In cases like this physicians advised the sick person to visit a priest or exorcist for supernatural – that is, sacramental – remedies, in keeping with the Church's teaching. Yet early modern medicine was also prepared to draw the line when it came to naturally caused afflictions. Miracles form part of this grey area. Physicians had no difficulty in accepting the theoretical possibility of miracle cures. The guidelines may have been strict, but miracles were seen to occur. Zacchia himself, examining the depositions of witnesses – which included at least three doctors – certified as miraculous the case of an Aretine woman who had been saved from certain death whilst giving birth in 1625.[48] By its very nature, the miracle cure meant that the physicians were recognised to have done all that was humanly possible. The miracle only took place once the patient was 'given over' (*spedito*) by the doctors, who could thus distance themselves from the miraculous event. In this way there was no question of the saints competing

with doctors. In fact, they complemented their powers. In theory, at least, the medical community was thus not diminished.

Yet the physician who recounted a miracle cure before the Congregation of Rites found himself in a rather ambivalent position. On the one hand, he was giving glory to God and the candidate in question. On the other hand, he was admitting to the limitations of his art. There was a way out, however. With regard to plague, for instance, physicians could allow for primary (divine) causes, whilst concentrating their own efforts on secondary (natural) ones. A similar theological distinction allowed them to preserve their professional dignity in this context, by adopting the categories of 'miracle' and 'grace.' Through these the physician could reclaim a voice lost in the wake of the miracle cure and, at the same time, distance himself from the unlearned. It allowed the physician to be at least cautious, if not sceptical, in his interpretation of the event. Many witnesses, especially the uneducated, made no distinction between miracle and grace. One midwife replied that 'as a poor woman, I do not know what difference there is between miracle and grace; I call and say a grace and miracle what is obtained when we recommend ourselves to the saints.'[49] Physicians were expected to know the difference. A twenty-nine-year-old doctor from Cosenza, with a degree from the University of Naples, confidently explained the difference in this way:

> Because I am a medical practitioner, I have studied philosophy and therefore, under the name of the natural event, I include all that which happens and the way in which it happens in all its circumstances *secundum vires causarum naturalium* [according to the force of natural causes]. [This is] in contrast to the miracle which, whether in substance, manner, time or place, exceeds the powers and properties of secondary causes and recognises God directly who operates through his omnipotence. I also know that amongst the common people the recovery of a sick person from a disease in very great danger of death is held to be a miracle; but, according to my thinking, this recovery of health obtained by means of the intercession of some servant of God, whether dead or alive, is not a miracle but a simple grace.[50]

In actual usage the distinction physicians made could be vague. It was sometimes simply a question of degree, a decreasing scale of the wonder the cure provoked. 'Pure miracle', 'miracle', 'special' or 'singular grace', and 'grace' – to say nothing of the fudge 'miraculous grace' – is the range of terms used (somewhat uncritically) by just one physician.[51]

How typical of the profession as a whole were testifying physicians? On the one hand, it could be argued that because of their education (with its classical stress on the natural) and training physicians tended to be more sceptical than laymen when it came to miracle cures. As a group, physicians were often suspected of impiety and materialism. However, in this period of religious orthodoxy – which extended to control over the teaching of medicine at Naples University – such sentiments were rarely manifested openly.[52] It is difficult to ascertain to what extent the few physicians tried before representatives of the Holy Office in Naples for 'irreligion' represent more generalised trends. One example is the 1584 denunciation of Giuseppe

Perrotta, future lecturer in anatomy and surgery at Naples University, 'for irreligion and possession of prohibited books.' Perrotta told the court that his accusers were really motivated out of envy for his earnings. He was eventually sentenced only to payment of a surety and obliged to treat the sick of the monastery of Santa Maria la Nova gratis and visit the shrine of Piedigrotta three times. A century later, one physician, Gioacchino Senatore, was caught up in the series of inquisitorial trials against the Neapolitan 'atheists', though the group consisted primarily of lawyers and clerics.[53] Nor can we expect illumination from the canonisation processes. Scepticism regarding miracle cures is too much to ask of a procedure designed to celebrate them. Those who testified before the Congregation of Rites were orthodox Catholics: unreliable witnesses would have been screened out of the process by the cause's postulator. On the other hand, we should not assume that all practising physicians shared the ardent devotion to saints shown by some of their number who testified.[54] There was a middle ground which allowed for both proper devotion and practical caution. If they wished to distance themselves or express scepticism, the most participating physicians could do was refer to a cure as a grace rather than a miracle. This served to limit the importance and the exceptional nature of the event. One physician, upon being confronted with his suddenly cured angina patient, recounted that 'both [the patient] and her daughter, when telling me about the occurrence, called it *miraculous;* and I, believing their account [and seeing] what was left of the malady, became truly convinced that it had to be attributed to a *grace* obtained through the servant of God's intercession.'[55]

I have come across only one episode which hints at scepticism; and, in keeping with the nature of the source, these sceptics are proved wrong in the end. A nun of Fasano, Rosa Maria Serio, was reputed to be a 'living saint': popularly venerated as a saint while still alive because of her visions and wonder-working. It was believed Serio could predict the outcome of serious illness.[56] This may have served as a source of tension with the area's physicians. Zacchia noted that medicine had a natural prophesying function in predicting the course of a patient's illness, yet it could not promise unerring predictions of future events. Mistakes would be made.[57] Servants of God, on the other hand, had supernatural aid. When the parish priest of a town near the convent was taken seriously ill with a catarrhal flux, his brother, a physician, was informed. The latter went to see Sr Serio, who handed him a note on which was written: 'Your brother's disease is fatal, and only God can help him.' When he went to see his brother the priest, he found him up on his feet, apparently healthy. With a mixture of scepticism and relief he showed the note to those present, 'and they all made fun of the prophecy made to them . . . and everyone said that it was the servant of God's vanity, and laughed and ridiculed her.' Certainly, an account with this sort of ending would not have made it into the canonisation process. In fact, unnoticed by the doctor, the priest's disease got worse 'internally', and he died three days later, 'so that everyone was bewildered, and confessed that the said Sr Rosa Maria was truly a servant of God.'[58]

Both the medical witnesses we have just heard were avid collectors of relics and were confident that the relics had brought about cures. Giannini's physician believed

so fervently in the holy woman's powers of healing while she was alive that he referred to her as 'a living relic.'[59] It should come as no surprise that members of the medical community participated in the widespread 'hunt for relics' that testifies so vividly to a belief in the healing powers of saints. In a symbolic way, relics extended their own limited powers. Moreover, physicians and surgeons were favoured by their proximity to the diseases of 'living saints' – always convenient sources of relics. Thus the physician at Sr Serio's convent, when he saw her cloth bandages soaked with blood during one of his calls, had them surreptitiously wrapped up and took them away. With pride he told the 1729 hearing how the relics had been used by an exorcist to liberate a possessed woman. The same relics were also used by the physician to provide 'supernatural help' – the physician's words – during a potentially fatal childbirth.[60] It is noteworthy, however, that he was the only physician, in all the processes I have read, to have witnessed at first hand the miracle cure he later corroborated. Many had relics, and gave them to their moribund patients to help bring about a saint's intercession; but even they were almost never present when the narrated miracle actually took place. In fact, it often seems that it is the physicians who are the most put out by the occurrence of a miracle cure. Invariably the doctor's patient confronts him with a *fait accompli,* at which the doctor can only wonder. This reflects the fact that the social dynamics of healing – including both natural and supernatural remedial sources – were driven largely by the sick person. In the first section we saw how Giuseppe Orecchio went to the baths at Ischia of his own accord. In 1621 a certain Giulia Pagano began her deposition by describing the great pain and blindness she had suffered in her left eye the year before. The doctors told her that it was a cataract, and that if it had not got better by the 14th of the month, 'the eye was most assuredly lost.' While the doctors carried out their own treatment of syrups, sudatories and other remedies, she asked for a relic of Father Camillo de Lellis from a visiting member of his Order, the Ministers of the Sick.[61] She put her faith in the intercession of de Lellis, so the actions of the doctors became inconsequential. As she remarked: 'the doctors continually told me that the said eye was lost, and they made their remedies to do what they could *as far as they were concerned.'* But it was the relic that eventually brought about a cure.[62]

In the reinterpretation of illness episodes in the light of miracle cures the physicians often figured as helpless bystanders. Initiative was taken away from them and put in the hands of the sick person, who turned to the saints. The Neapolitan physician Giovanni Comes, who counted the kingdom's protophysician amongst his acquaintances, recounted how he had treated a woman with sciatica for many years, with only moderate improvement in her condition. But she had taken supplementary measures:

> and returning to her house to examine the said infirm woman as usual, I found her healthy, and so I asked her how she had received this health, given that the infirmity was long, troublesome and almost incurable, and she replied that it was not for use of the remedies, but by a sign of the cross made on her by Father Camillo, who had come to her house that morning and made the sign of the cross on the said afflicted part.[63]

It is striking that other sorts of practitioners seem less put out by such eventualities. Indeed, they seem to welcome them without hesitation. Surgeons, barbers, apothecaries and midwives were often actors, not mere bystanders, in the miraculous events they proudly related. They often represented themselves as playing a prominent role setting the stage for the miracle. They were also more frequently present when the miracles actually occurred. Finally, they were more inclined to ascribe a cure to a miracle, as opposed to a grace, especially if they lacked a formal education. One example will suffice. An apothecary recounted being present at a whole series of miracles, brought about through the relics he owned and his encouragement of the dying people to venerate them. In 1765 Onofrio Stiffa told the hearing investigating the cause of the Piarist Sabbatini of an episode involving a woman dying from rabic cough, continuous hectic fever and chest pains. The remedies prescribed by doctors had been of no use:

> I said to her frankly that she was as good as dead, since there was no further remedy or refuge, and I added that only one other medicament remained to be taken, if she wanted, that would not be nauseating for her, and she replied that she would take it if I gave it to her. I added that the medicament was this: that I wanted to bring her a relic of the servant of God Father Ludovico Sabbatini that I kept at home . . . a bit of his shirt soaked in his blood and a bit of his hose and habit . . . and that since I had had these relics I had received a great many massive miracles from them . . . and that if she promised me to have the same faith in them that I and the other people had, I would bring her the said relics, otherwise I would not.

Not only was Stiffa's own devotion in keeping with post-Tridentine orthodoxy, but he encouraged it in the sick people who made use of his relics. In presenting the above sick woman with the relic, he had her first kiss it, then recite three Glorias in honour of the Trinity: a special devotion of Sabbatini's, he says, so that he would 'first grant her the grace of her soul and then that of her body.'[64] This reminds us of the close relationship between the health of the body and the salvation of the soul in Christianity.[65]

Midwives were also more 'ready to believe' than physicians. As discussed in chapter three, the sacred frequently found a way into their techniques. The practice of placing amulets on the expectant mother during delivery was accompanied by the placing of saints' relics or images. While physicians might encourage patients to invoke the saints or lend them a relic when they felt they could do no more, midwives also made use of such devotions themselves. In difficult births, according to the testimony of midwives, recourse to saints was automatic: when 'the baby was coming out with his feet first', 'was twisted in the womb' or 'was coming out double, that is bent at the back with head and feet first.'[66] But such were the dangers inherent in giving birth that midwives in Chieti told a local hearing that they routinely said seven Paternosters and seven Ave Marias and invoked Camillo de Lellis – who came from the area – before each birth. As one woman told the Congregation: 'I am so convinced that Father Camillo is a saint that, as midwife in this town, there is no labour during which I do not invoke him, and I have seen many graces because of this.'[67]

## Saints and ecclesiastical views of disease

The Church taught its own interpretations of disease: it could be God-sent, as a gift, test or warning. It was to be borne with patience or regarded as an opportunity for repentance and conversion. At the same time, the Church regarded it as a state of bodily suffering which every good Christian should seek to alleviate. God and the saints provided recognised sources of healing, as did the medical community. This ambiguity was a source of some competition between natural and supernatural healing. Nowhere is this contradiction viewed more clearly than in the convents of the period. On the one hand, the medical arts were present in the physicians and surgeons who served these institutions, treating the nuns – who thus found themselves in a privileged position with respect to the majority of the population. On the other hand, nuns were the first to put these aside and trust in the 'celestial healer', following the period's models of holiness and devotion. Entire religious communities would routinely suspend medical visits and forego medicines while undergoing spiritual exercises conducted by Jesuit missionaries.[68] Individual nuns looked for signs that their diseases might have supernatural causes, a sign of divine favour. It formed part of the same cultural model advocating a strenuous regime of fasting, penance and bodily mortification.[69] This approach was especially evident in the case of those nuns and monks who fashioned themselves as, and were reputed to be, living saints. By the same token, it is striking how rarely the ecclesiastical concept of disease causation crops up in the narratives of lay men and women. While a remarkable (for us) amount of pain and illness was accepted as natural, it is as if much of the laity had no time for the niceties of pious forbearance, when sickness meant an inability to perform vital social and economic functions.

The living saints discussed in chapter six best exemplify the ambivalence of the physician's role, because they lived face-to-face with other more secular healers. Medical practitioners, as part of the educated elite, frequently numbered themselves amongst the closest followers or 'disciples' of living saints, in the same way that in an earlier time they had formed circles around religious reformers.[70] In the years after Trent, when the latter was no longer a safe option, being close to living saints was not only an expression of devotion, but a role that conferred status on the devotee. Paradoxically, however, the living saints provided the physicians with competition when it came to healing. They were able to impart the sacred through their touch. When the Dominican friar Serafino Balbi was crippled with gout in his left leg, he went directly to the living saint Maria Rosa Giannini for relief from his suffering. Though there was a physician present, who also testified at the hearing, he did not intervene, nor was he asked to. Giannini looked at Balbi's leg and reminded him to say the Rosary several times each day. Then, according to Balbi, 'she took her Rosary, made the sign of the cross three times on my foot with it, each time saying: through the merits of the Most Holy Virgin of the Rosary may the gout go away.'[71] Even dead saints possessed this healing touch, their living presence conveyed symbolically through visions. Francesco de Geronimo appeared in this way before a paralysed nun. She recounted: 'it seemed to me that this servant

of God extended his right hand over the left side of my body, touching me from the left side of my head to the underside of my left foot, and he disappeared.'[72]

Whilst healing the sick who came in never-ending droves to see them, living saints themselves suffered diseases with heroic humility. Such was the prevailing model of holiness, that those most gifted at performing miracle cures were also expected passively to endure their own illnesses. They regarded their illnesses as God-sent and told their physicians that they were powerless against them. In addition to natural illnesses, God also sent the stigmata, every bit as real and as painful. Here the natural and the symbolic met. The surgeon of the Neapolitan nun and mystic Maria Villani (1584–1670) told a 1680 hearing that 'such was the love that this servant of His bore towards God that she was worthy of being pierced by a spear . . . above her right breast, in such a way that the spear penetrated through to wound the heart.' He knew about the outer wound, 'which no medicine could treat'; but only on her death, when her body was examined, did he see that there was a deep, open wound in her heart as well, three fingers in length.[73] A further example is the nun Giannini. She put up with her numerous diseases 'with indescribable resignation, never complaining, in fact, showing not a little pleasure, with the greatest peace and readiness of heart.'[74] Servants of God like Giannini gloried in their maladies, which were always long-lasting, repugnant and torturous. This attitude was shared by the witnesses called to testify at hearings for their canonisation, who described the diseases in the most vivid detail. Thus, in addition to her headaches, vomiting and 'an umbilical hernia as big as a cucumber', Giannini suffered from articular tumours, nephritic pains, four abdominal scirrhuses, a prolapse of the uterus and, most terrible of all, two tumours or cysts, 'each as big as a baker's basket, so that when the servant of God had to go out she put them inside two bags, which were hung from and attached to her neck with strings.'[75] Giannini refused any medical treatment for the follicles, saying that 'they were gifts from her spouse and for this reason she wanted to bear them until her burial.' The reference to the mystic marriage with Christ and the presumed divine origin of the disease was something Giannini had in common with many other female saints, after whom she modelled herself. One witness, head apothecary at a nearby monastery, brought medicines for some of her other ills, and noted 'the patience she had in taking certain medicaments not suited in the least to certain of her ailments, which did not have a natural origin as the doctor believed, but a supernatural one, as she explained to her spiritual director.'[76]

If the medical elites recognised their limitations when in the presence of the sacred they was justly rewarded. The Church's support of organised medicine is mirrored in the way it emphatically privileged those miracle cures narrated in the first person by a physician (i.e. as *miracolato*) or, more often, corroborated by one. As far as the Church authorities were concerned, it was crucial that the miracles be verified as closely and strictly as possible. They were to have all the characteristics of historical facts, complete with precise dates, places, names, occupations and any other relevant details.[77] Who better than learned physicians could give the stamp of authenticity to healing miracles? 'Professional hands that incise, tear out, treat,

examine, attest, [were] the necessary route by which the Church [could] publicly take a stand.'[78] The role of physicians and surgeons extended even to the examination of the corpses of servants of God upon their exhumation, often hundreds of years after their deaths. This status as expert witnesses was entirely consistent with Roman-canon law, where medico-legal work was well regarded and occasionally restricted to a privileged elite of practitioners.[79] The Congregation of Rites functioned as a tribunal, under the supervision of the Church's high court, the Rota. Indeed, Zacchia was one of the Rota's regular medical consultants.

The verification requirement and the propaganda factor of the processes helps to explain two important features of the records with regard to healing and healers in early modern society. First, the complete absence of non-professional healers, such as wise women or itinerant pedlars, as witnesses in the processes. Whilst the medical profession sought to regulate the activities of mountebanks and charlatans, the Counter-Reformation Church – in the form of the inquisitorial and the episcopal courts – was waging war against what it referred to as 'superstitious' healing. Wise women may make the occasional appearance in the illness narratives, but their role was an entirely negative one. They provided the living saint with the opportunity of sniffing out their charms or countering their diabolical remedies – which always made the patient worse – with his or her divine ones. The verification of miracle cures provided by physicians also accounts for the relatively low representation of the popular classes amongst the *miracolati*. In addition to being considered less reliable witnesses, they often chose not to rely upon the services of physicians – physicians who could have then corroborated their accounts.

The Church's caution and control went hand-in-glove with a widespread encouragement of devotion to the saints, as paradoxical as this may seem. Enforcing orthodoxy was all about channelling devotion along recognised lines, not limiting the number of saints. This was consistent with the widespread need for, and occurrence of, miracles among the population as a whole. It also suited the Religious Orders, who could thereby encourage devotion to the saints and candidates for canonisation of their own Order, thereby increasing their own prestige. A popular, though unofficial cult was the *sine qua non* of the canonisation process. The Orders collected and published miracle accounts to further the causes of their own candidates or encourage devotion to members of their Orders already canonised.

What explains the predominance of healing miracles in the processes? On the one hand, they corresponded to everyday needs, fears and expectations. On the other hand, such miracles tended to be privileged by the Congregation of Rites and the Religious Orders. This was because miracle cures could be verified in a way that other miraculous interventions – as in the case of accidents – could not. Moreover, healing miracles could be edifying and instructive at the same time. They taught a trust in divine will and forbearance in the presence of suffering. Miracles which spared people from violent deaths – as a result of a duel, say, or judicial torture – were not so edifying, and so are underrepresented in the canonisation

processes.[80] Finally, miracle cures were most in keeping with the Biblical model. This was recognised and encouraged, even though the types of maladies cured did not reflect the diseases typically healed in the New Testament.[81] Thus, instead of healing the possessed, the paralysed, the blind, deaf and dumb, Counter-Reformation miracles tended to intervene in cases of a wide variety of fevers and pains, only to a lesser degree healing the crippled. It should be noted that where there was less clerical mediation, the miracle typology was more varied, following medieval models. Such is the case with the miracles recorded in shrine miracle registers and the ex votos hung on shrine walls. For this reason, the published miracle collections penned by members of various Religious Orders, because of their overt propaganda uses, are more in keeping with the Counter-Reformation emphasis on verifiable (according to the criteria of the time) healing miracles determined by the Congregation of Rites for the canonisation processes.[82] If the laity continued to want saints who could perform miracles, rather than the purely edifying models proposed by the Church, then the authorities were determined that the miracles should at least be of an 'acceptable' sort.

The editorial control exercised by the monks compiling the published miracle collections influenced, and was influenced by, that of the clerics in charge of postulating the causes of particular candidates for canonisation before the Congregation of Rites. The task of the postulator – usually a member of the servant of God's own Order – was to collect favourable evidence, screening witnesses and their testimony before the hearing began. For the historian, it is where the centre (Rome) and periphery (local devotion) meet. The postulator looking for miracle accounts came face-to-face with the lay men and women for whom miracles represented an existential need, a means of maintaining the symbolic order of the world. Who better, then, to mediate between them and a servant of God than that servant of God's own postulator? If the pressure exerted on priests and exorcists to heal was great, because of their sacramental powers,[83] it was that much greater on the postulator and his agents. They were often seen as representatives of a servant of God on earth. One such helpless victim was Fra Angelo da Baccarizzo, responsible for collecting alms for the cause of the Calabrian Capuchin Angelo d'Acri (1669–1739). The incident concerns a four-year-old boy who lay dead after a fall from a ladder. When Baccarizzo refused to go into a village chapel where the boy lay, and pray to the servant of God to save him, the boy's grandmother screamed at Baccarizzo, 'blaspheming against all dead monks.' Then the boy's uncle came out in a rage and grabbed Baccarizzo by the collar and forced him into the chapel, leading him up to the altar, on which the boy had been placed. Shaking, Baccarizzo knelt down. He took an image of Angelo d'Acri from inside his habit, placed it on the boy's chest, and – 'to comply with the importunity of others', as he discreetly put it – began to recite the litany of Our Lady. In the middle of this the boy revived, 'vomited bile and food' and then got up. Those present 'began rejoicing, saying miracle, miracle of Father Angelo, [and] they took the boy and went out of the chapel.' Baccarizzo, having served his purpose, was left alone inside, 'where I remained without finishing the litany.'[84]

## Miracles: popular, medical, ecclesiastical

Thus while the Church authorities and the medical community argued over, but mostly complied in, the construction of miracles, the bulk of the population continued to seek and interpret them in terms that most met their own needs. Miracles provided a universal possibility of cure. They complemented and extended. Images and relics made real the saint's presence to even the poorest in society. And where obtaining corporeal or other relics was difficult, the oil, holy water or flowers from the saint's tomb would do.[85] Its use combined domestic remedial forms, where oil was a regular ingredient to be rubbed on afflicted bodily parts, with the power of the sacred. In this way, miracles symbolically extended the powers of nature. Likewise, consistent with the Galenic tradition, miracles could also help occasion the vital purge of fluids necessary for cure when the physicians were unable to. This flew in the face of medical teaching, however, which taught that true miracles must not imitate nature in any way.

Each illness episode generated the telling of stories about it. These narratives served to transmit vital information within the community and eased the sufferer's anxiety. They were shaped and constructed by the need to provide meaning. The telling of stories allowed people to symbolise the source of suffering, attach meaning to experience, reconstitute a world shattered by illness. This symbolic ordering took place each time the story was retold, including the occasion when it was recounted before the Congregation of Rites. The miracle narratives reveal much about notions concerning the body and sickness. For sick people the body was objectified and distanced. It became a battlefield. Disease, like demonic possession, occupied and took over the body; a cure meant that the body was liberated. There was flow throughout the body which, if blocked in one part, could result in disease in another part. In the canonisation processes, the physicians gave up on the object of their attention, after having tried their remedies. But for the sick person this was not an insurmountable problem, since the dynamics of healing were largely controlled by him or her. It was the sick person's own responsibility. The sick frequently turned to the help of the saints, either accompanying the treatment of physicians or when the physicians had given up on the patient.

The narratives contain a wide variety of descriptive disease terms. These helped to label and objectify the affliction, allowing both patient and practitioner to come to terms with it. This labelling process is particularly evident in the case of fever, the most frequently mentioned illness in the records. Another characteristic of the illness episode as recounted was the tendency to stress certain moments and aspects of the experience. The narratives privileged the discovery of the illness, sudden worsening in conditions, treatment strategies and interventions, all leading up to the rhetorical climax of the miraculous intercession. Although localised in the objectified body, illness was understood and related in terms of a person's life, history and social relations. The miracle itself returned the body to functionality, restoring its place in the community. This was not necessarily a complete cure in the modern sense, a fact which suggests a difference between pre-modern and

current definitions of health. Early modern expectations regarding sickness and health, like those regarding medical treatment, were remarkably different from our own.

Physicians seemed to have shared most of these notions. Yet their role in testifying before the hearing was inherently ambiguous. Whilst seeking to give glory to God and the saints through their testimony, physicians sought to distance themselves from the unlearned and protect the prestige and dignity of their profession. They were facilitated in this by the theological distinction between miracle and grace. They could thus adopt a critical stance, if not outright scepticism. Physicians often figure as mere bystanders to the miracle cure, confronted with a *fait accompli*. However, other members of the medical community – barbers, apothecaries and, especially, midwives – often presented themselves as actors in the event, bringing about the sick person's cure through relics they owned and being present at the event itself. This is not to say that physicians were less devoted to the cult of saints than the rest of the population. Indeed, they often formed part of the circles that developed around 'living saints.' Miracles were a welcome possibility for all; but the criteria adopted for defining a cure miraculous were that much stricter for university-educated physicians. These became even stricter towards the middle of the eighteenth century. By this time the limits of reason were becoming 'those that reason itself imposed, by censorship or self-censorship, in the face of the theological province of the invisible.'[86]

The entire canonisation procedure depended on this strict approach to corroborate healing miracles. For all those involved, from postulators to cardinals of the Congregation of Rites, this gave them a higher propaganda value. The involvement of physicians was crucial, as far as the Church was concerned. They lent an air of objective verification to the proceedings, as witnesses to events or as participants in the exhumations of saintly bodies. Healing miracles were verifiable in a way that other sorts of miracles were not. They were also edifying and instructive. While involving the medical community in this way, the Church also taught that disease could be God-sent. It was a gift or a warning: something Christians should seek to alleviate by accepted means – this did not, however, include wise women or itinerant charlatans – or bear with saintly patience. This inherent ambivalence in interpreting disease came to a head when living saints turned down the treatments offered by their attending physicians as useless. When diseases were sent by God no natural cure could help. This was particularly evident in the case of wounds linked to the stigmata which were, of course, incurable.

The wide range of cures provided by the miraculous intercession of saints and the stories told about them can tell us much about the important role of miracles in the everyday lives of early modern Neapolitans and, by extension, of Catholic Europeans in general. Reading backwards from the miraculous event, these narratives can also reveal otherwise hidden perceptions of the body and disease. They contribute to our knowledge of how sick people and their curers reacted to illness, how they explained and described it, and how they dealt with it. As the narratives suggest, miracles represent the point where natural, supernatural and symbolic

come together, indeed collide. Illness is contested: it can be categorised in different ways, affecting the efficacy of available forms of treatment. Professions, too, come into contact. Churchmen and physicians manage to collaborate and find common ground in the miraculous healing of illness, despite an ongoing tension and ambiguity. Indeed, these two forces become more pronounced as one proceeds through the eighteenth century. Certain practitioners (and not a few ecclesiastics), influenced by broader enlightenment trends, were less willing to participate as equal players in the time-honoured medical pluralism. They were less likely to share in, or be sympathetic towards, the aetiological categories I have called 'ecclesiastical' and 'popular.' More and more, the medical consensus which I have stylised as three overlapping rings was giving way, in their minds, to two separate cultures: the high and low, learned and folk, so dear to nineteenth-century folklorists like Giuseppe Pitrè.[87]

## NOTES

1 Roy Porter, 'The patient's view: doing medical history from below', *Theory and Society,* xiv (1985), p. 192.

2 Robert Jütte, 'The social construction of illness in the early modern period' in J. Lachmund and G. Stallberg (eds), *The social construction of illness: illness and medical knowledge past and present* (Stuttgart, 1992), pp. 29–30.

3 Linda Garro, 'Chronic illness and the construction of narratives' in M. J. Del Vecchio-Good, P. Brodwin, B. Good and A. Kleinman (eds), *Pain as human experience: an anthropological perspective* (Berkeley, 1992), pp. 100–37; Byron Good, *Medicine, rationality and experience: an anthropological perspective* (Cambridge, 1994), ch. 5.

4 Roy Porter and Dorothy Porter, *In sickness and in health: the British experience, 1650–1850* (London, 1988); Barbara Duden, *The woman beneath the skin: a doctor's patients in eighteenth-century Germany,* trans. T. Dunlap (Cambridge, MA, 1991).

5 David Gentilcore, *From bishop to witch: the system of the sacred in early modern Terra d'Otranto* (Manchester, 1992), ch. 5.

6 P.-A. Sigal, *L'Homme at le miracle dans la France médiévale (XIe-XIIe siècle)* (Paris, 1985), esp. ch. 5; Ronald Finucane, *Miracles and pilgrims: popular beliefs in medieval England* (London, 1977), esp. ch. 4; John Wortley, 'Three not-so-miraculous miracles' in S. Campbell, P. Hall and D. Lausner (eds), *Health, disease and healing in medieval culture* (London, 1992), pp. 159–68; and Patricia Skinner, *Health and medicine in early medieval southern Italy* (Leiden, 1997), pp. 92–8. One exception has been Jacques Gélis, 'Miracle et médecine aux siècles classiques: le corps médical et le retour temporaire à la vie des mort-nés', *Historical Reflections/Réflexions Historiques,* ix (1982), pp. 85–101.

7 Jean-Michel Sallmann, *Naples et ses saints à l'âge baroque (1540–1750)* (Paris, 1994), pp. 124–5. See also Yves Beaudoin, 'Elenco di processi di beatificazione e canonizzazione conservati nel fondo dei Riti (S.C. per le Cause dei Santi) dell'Archivio Segreto Vaticano' (A.S.V. 1982, Index 1147) and Giulio Sodano, 'Santi, beati e venerabili ai tempi di Maria Francesca delle Cinque Piaghe', *Campania Sacra,* xxii (1991), pp. 441–60.

8  For a discussion of the procedure, see Simon Ditchfield, 'How not to be a Counter-Reformation saint: the attempted canonization of Pope Gregory X, 1622–45', *Papers of the British School at Rome*, lx (1992), esp. pp. 380–3 and G. Dalla Torre, 'Santità ed economia processuale: l'esperienza giuridica da Urbano VIII a Benedetto XIV' in G. Zarri (ed.), *Finzione e santità tra medioevo ed età moderna* (Turin, 1991), pp. 231–63.

9  Giulio Sodano, 'Miracoli e Ordini religiosi nel Mezzogiorno d'Italia (XVI-XVIII secolo)', *Archivio storico per le province napoletane*, cv (1987), pp. 293–414.

10  For an analysis of the role of saints and miracles in local culture, see Pierre Delooz, 'Towards a sociological study of canonised sainthood in the Catholic Church' in S. Wilson (ed.), *Saints and their cults* (Cambridge, 1983), pp. 189–216; Jean-Michel Sallmann, 'Image et fonction du saint dans la région de Naples à la fin du XVIIIe siècle', *Mélanges de l'Ecole Française de Rome*, xci.ii (1979), pp. 827–74; Gentilcore, *Bishop to witch*, pp. 162–208.

11  O. Redon and J. Gélis, 'Pour une étude du corps dans les récits de miracles' in S. Boesch Gajano and L. Sebastiani (eds), *Culto dei santi, istituzioni e classi sociali in età preindustriale* (Rome, 1984), p. 565.

12  A.S.V., *Riti*, 1861, fols 576v-581r.

13  *Ibid.*, fols 598r-602r.

14  H. Brody, *Stories of sickness* (New Haven, 1987), p. 5.

15  A. Kleinman, *The illness narratives: suffering, healing and the human condition* (New York, 1988), pp. 49–52.

16  Good, *Medicine, rationality and experience*, p. 133.

17  A.S.V., *Riti*, 2615, fol. 76v.

18  Dino De' Antoni, 'Processi per stregoneria e magia a Chioggia nel XVI secolo', *Ricerche di storia sociale e religiosa*, iv (1973), esp. pp. 190–208; Gentilcore, *Bishop to witch*, pp. 131–7.

19  Redon and Gélis, 'Etude du corps', p. 570.

20  Porter and Porter, *Sickness*, p. 274. Cf. John Henry, 'Doctors and healers: popular culture and the medical profession' in S. Pumfrey, P. Rossi and M. Slawinski (eds), *Science, culture and popular belief in Renaissance Europe* (Manchester, 1991), pp. 191–221.

21  A.S.V., *Riti*, 2024, fol. 2406r.

22  *Ibid.*, fols 2456r.-v.

23  Redon and Gélis, 'Etude du corps', 570.

24  A.S.V., *Riti*, 2023, fols 2031v.-2032v.

25  The Italian word *ventre* exemplifies the difficulties inherent in translating body and illness terms into another language – to say nothing of another time. *Ventre* can mean, variously, stomach/belly, bowels, womb/uterus. In any case, early modern medicine often described the functions of the stomach and the womb in the same terms. Duden, *Woman beneath the skin*, pp. 165–6.

26  A.S.V., *Riti*, 1514, fol. 1680.

27  Duden, *Woman beneath the skin*, p. 28.

28  A. Kleinman, *Patients and healers in the context of culture: an exploration of the borderland between anthropology, medicine and psychiatry* (Berkeley, 1980), pp. 76–7; Jean-Pierre Peter, 'Les mots et les objets de la maladie. Remarques sur les épidemies et la médecine dans la société française de la fin du XVIIIe siècle', *Revue historique*, no. 499 (1971), pp. 22–3.

29  Byron Good, 'The heart of what's the matter. The semantics of illness in Iran', *Culture, Medicine and Psychiatry*, i (1977), p. 39.

30 The Bolognese physician Ippolito Albertini (1662–1738) wrote in an undated consulta-
   tion, regarding a woman suffering from malignant fever, that fear 'directly touches and
   disturbs the spirits and the nerve structure, which govern movement in all our fluids.'
   In Saul Jarcho (trans. and ed.), *Clinical consultations and letters by Ippolito Francesco Albertini,
   Francesco Torti and other physicians* (Boston, 1989), no. 131, p. 214. See also David
   Gentilcore, 'The fear of disease and the disease of fear' in W. Naphy and P. Roberts
   (eds), *Fear in early modern society* (Manchester, 1997), pp. 184–208.

31 Duden, *Woman beneath the skin,* pp. 88–9.

32 A.S.V., *Riti,* 378, fol. 24v. Women were regarded as particularly susceptible to 'hysteri-
   cal' pains, or convulsions, which originated in 'the uterus and nervous structures',
   according to a consultation written in 1704 by Albertini; in Jarcho, *Clinical consultations,*
   no. 61, p. 77. Nuns, especially those of 'melancholic temperament', were particularly
   vulnerable.

33 A.S.V., *Riti,* 708, fol. 3892v. The Neapolitan *cantaro* was equal to eighty kilograms.

34 Robert Orsi, 'The cult of saints and the reimagination of the space and time of sick-
   ness in twentieth-century American Catholicism', *Literature and Medicine,* viii (1989),
   pp. 66–7.

35 A.S.V., *Riti,* 2024, fols 2401r.-2403r.

36 Orsi, 'Cult of saints', p. 69.

37 A.S.V., *Riti,* 2615, fol. 105r.

38 A.S.V., *Riti,* 2024, fols 2402v. (italics mine).

39 Paolo Zacchia, *Quæstiones medico-legales. In quibus eæ materiæ medicæ, quæ ad legales facul-
   tates videntur pertinere, proponuntur, pertractantur, resolvuntur* (Amsterdam, 1651 edn), bk iv,
   title 1, question 8, pp. 224–5.

40 'Acta Inquisitionis S. Officii contra Diaconum Miachaelem Gramegna ut intus',
   A.D.G., *Fondo Vescovile,* iv.D9.c.c22, fol. 11v.

41 Philippe Ariès, *The hour of our death,* trans. H. Weaver (London, 1981), pp. 300–5,
   310–12; Daniel Roche, "La Mémoire de la Mort': recherche sur la place des arts de
   mourir dans la Librairie et la lecture en France aux XVIIe et XVIIIe siècles', *Annales
   E.S.C.,* xxxi (1976), pp. 76–119.

42 A.S.V., *Riti,* 1931, fols 647r.-v. Sabbatini (1650–1724) was a Neapolitan Piarist.

43 Zacchia, *Quæstiones,* bk iv, title 1, question 8, p. 223.

44 *Ibid.,* question 1, p. 198.

45 *Ibid.,* question 8, pp. 223–4.

46 *Ibid.,* question 8, p. 225.

47 *Ibid.,* question 8, p. 226.

48 Ditchfield, 'How not to be a Counter-Reformation saint', pp. 397–8.

49 A.S.V., *Riti,* 2473, fol. 164.

50 A.S.V., *Riti,* 234, fol. 684v.

51 A.S.V., *Riti,* 2470, fols. 322r-327r.

52 Giorgio Cosmacini, *Storia della medicina e della sanità in Italia* (Rome and Bari 1987),
   pp. 182–5.

53 Luigi Amabile, *Il Santo Officio dell'Inquisizione* (Città di Castello, 1892), vol. 2, in appen-
   dix, document 8A, pp. 28–50; Luciano Osbat, *L'Inquisizione a Napoli: il processo agli
   ateisti, 1688–97* (Rome, 1974).

54 This is the somewhat hasty conclusion reached by Gabriele De Rosa in his *Storie di santi*
   (Rome and Bari 1990), p. 42.

55 A.S.V., *Riti,* 1861, fols 184v-185r. (italics mine).

56 A.S.V., *Riti,* 705, fol. 1033v.

57 Zacchia, *Quæstiones,* bk iv, title 1, question 5, pp. 205–6.

58 A.S.V., *Riti,* 703, fol. 671.

59 A.S.V., *Riti,* 1861, fol. 348v.

60 A.S.V., *Riti,* 705, fols 1048v-1049r.

61 Despite the fact that De Lellis spent a lifetime working in the hospitals of Rome and Naples, the miracles narrated by witnesses do not differ in typology from those of other canonisation processes.

62 A.S.V., *Riti,* 2631, fols 71v.-72v. (italics mine).

63 *Ibid.,* fols 138v.-139r.

64 A.S.V., *Riti,* 1931, fols 644v.-645r.

65 F. Laplantine, *Antropologia della malattia* (Florence, 1988), p. 206; in French as *Anthropologie de la maladie* (Paris, 1986).

66 A.S.V., *Riti,* 2628, fols 36r., 273r.-v.

67 *Ibid.,* fols 62v, 272v.

68 David Gentilcore, '"Adapt yourselves to the people's capabilities": missionary strategies, methods and impact in the kingdom of Naples, 1600–1800', *Journal of Ecclesiastical History,* xlv (1994), p. 286.

69 A world that Piero Camporesi evokes in *The incorruptible flesh: bodily mutation and mortifaction in religion and folklore,* trans. T. Croft-Murray (Cambridge, 1988), especially pt I.

70 J. Martin, *Venice's hidden enemies: Italian heretics in a Renaissance city* (Berkeley, 1993), pp. 150–2.

71 A.S.V., *Riti,* 1861, fols 265r-v.

72 A.S.V., *Riti,* 2024, fol. 2403r.

73 A.S.V., *Riti,* 1882, fols 209r.-v.

74 A.S.V., *Riti,* 1861, fol. 15.

75 Deposition of her physician Giuseppe Scoppa, *ibid.,* fols 132r.-v.

76 *Ibid.,* fol. 433r.

77 J. de Viguerie, 'Le miracle dans la France du XVIIe siècle', *XVIIe Siècle,* xxxv (1983), p. 316.

78 Sara Cabibbo and Marilena Modica, *La santa dei Tomasi: storia di Suor Maria Crocifissa (1645–1699),* (Turin, 1989), p. 65.

79 Catherine Crawford, 'Legalizing medicine: the early modern legal systems and the growth of medico-legal knowledge' in M. Clark and C. Crawford (eds), *Legal medicine in history* (Cambridge, 1994), p. 93.

80 Though they are commonly represented in the ex votos spontaneously left at shrines thoughout Italy. For Naples, see Giuseppe Imbucci, 'Il timor di Dio: le tavolette votive di Madonna dell'Arco tra '500 e '900', *Ricerche di storia sociale e religiosa,* xlii (1992), pp. 129–30.

81 Howard Kee, *Medicine, miracle and magic in New Testament times* (Cambridge, 1986), pp. 70–9.

82 This was particularly true of those collections compiled by members of Tridentine Orders like the Jesuits and the Theatines. Sodano, 'Miracoli e Ordini religiosi', pp. 397–8.

83 Luciano Allegra, 'Il parroco: un mediatore fra alta e bassa cultura', *Storia d'Italia. Annali 4: Intellettuali e potere* (Turin, 1984), p. 907.

84 A.S.V., *Riti,* 234, fols 884v-885r.

85 See the discussion in Gentilcore, *Bishop to witch*, pp. 187–93.

86 Elena Brambilla, 'La medicina nel Settecento: dal monopolio dogmatico alla professione scientifica' in F. della Peruta (ed.), *Storia d'Italia: Annali*, vii, *Malattia e medicina* (Turin, 1984), p. 91. The restricted realm of the miraculous was not limited to physicians. It was also reflected in treatises like Ludovico Antonio Muratori's *Della forza della fantasia umana*, first published in 1740, and Prospero Lambertini's *De servorum Dei beatificatione et beatorum canonizatione*, published 1734–38. Lambertini had served as Promoter of the Faith, in charge of cannonisations, from 1708 to 1727 and was elected pope in 1740 as Benedict XIV.

87 Pitrè was himself a practising physician, with an approach to popular culture that was at once sympathetic and positivistic. I have in mind his monumental *Medicina popolare siciliana* (Turin, 1896; new edn Florence, 1949).

# CONCLUSION

The preceding chapters have explored the interaction of three spheres of healing during the early modern period: medical, ecclesiastical and popular. Each interpreted disease and the body in a different way, with a correspondingly different way of reacting to it and treating it. However, these three cultures were not distinct in any absolute sense. Their boundaries – if they had any at all – were permeable. The spheres overlapped with, and contributed to, one another. Most importantly, they competed with one another. This was competition, first, in the sense that the sick chose for themselves the form of healing they believed best suited to their affliction. It was competitive in a second sense in that the two therapeutic forms that came equipped with their own power structures – university medicine and ecclesiastical rituals – sought to influence and shape the nature of the entire medical network. In unison, for the most part, they distinguished, variously, between licit and illicit; licensed and unlicensed; orthodox and unorthodox; natural, divine and diabolical.

The interface between medicine and religion has been the most studied, particularly within the history of ideas tradition.[1] By and large, the approach has yet to find its way into more general history of medicine surveys as anything more than an add-on extra. This book was intended as a step towards remedying this situation, exploring the manifestations of the medicine–religion overlap as it relates to a Catholic state during the period following the Council of Trent (1563). The Counter-Reformation desire for order and orthodoxy conditioned much of what happens on stage. Attention has also been paid to medical practice, as well as the behaviour of the sick. We have seen how the third sphere of popular therapeutics overlapped with the preceding two. The 'popular' – for lack of a better term – is not somehow beyond the pale of the historian. Nor do I consider popular responses to disease and forms of healing to be simply out-of-date derivatives of elite medicine. The sources seem to tell us otherwise. Conversely, it would be inaccurate to suggest they had an autonomous existence. People did not belong or limit themselves uniquely to a single sphere – churchmen to the ecclesiastical, physicians to the medical and peasants and the urban poor to the popular. After all, in early modern Italy popes depended on their own private physicians and surgeons; physicians could find themselves the victims of sorcery or the beneficiaries of miracles;

and the poor could make use of the services of community practitioners free of charge. In other words, people moved from one sphere to another according to circumstance and need.

All this suggests that there is a history of medical pluralism in the kingdom of Naples. If, in order to understand the interconnectedness, I have tended to stress the functional nature of the relationship, it is time to explore some of the shifts that occurred during the period. Furthermore, we must consider how the Italian model of medical pluralism presented in this book compares to the range of 'healers and healing' elsewhere in early modern Europe. First of all, let me say that there is no clear-cut periodisation. What there is is as pluralistic as the subject matter. The medical material is structured by the Royal Protomedicato and contains data from as early as the 1530s and extends into the kingdom's Napoleonic period (1806–15). As far as the ecclesiastical material is concerned, the focus is provided by the Counter-Reformation and the institutions it generated, relevant to this study: the Holy Office of the Inquisition, founded in 1542, and the Congregation of Rites and Ceremonies, founded in 1588. Local bishops were entrusted with acting on behalf of these two tribunals, and they were at their busiest from the late sixteenth century to the mid-seventeenth century. Finally, our knowledge of popular forms of healing depends on the records generated by these medical and ecclesiastical bodies. This means, as far as the historian is concerned, that it must take on something of their chronology, just as its cultural contours were shaped by them.

Recent regional studies on the social history of medicine have stressed one thing: that the sick of early modern Europe were not indifferent to health but went to great lengths to preserve it or regain it. They generally diagnosed their own illnesses, along with the help of family and friends. They also treated themselves. Where they were treated by practitioners this treatment was usually carried out in the home. All this depended on the communication of vital information about illness, achieved through the everyday recounting of illness episodes. The telling of stories allowed people to symbolise the source of suffering, attach meaning to experience, reconstitute a world shattered by illness. Disease was seen to occupy the body, while a cure meant that the body was liberated. Flow throughout the body was also crucial; if it was blocked in one part, disease could result in another. The wide variety of descriptive disease terms used served to label and objectify the illness. Stories of illness also indicate that time was not uniform. They stressed certain moments of the experience, from the discovery of illness, its various stages, through to the cure. The latter was not necessarily seen in modern biomedical terms, but in the sense of functionality: being able to resume one's previous life.

Illness narratives privileged the search for a cure. This search was not as straightforward as it usually is for us today. It depended, first, on determining the nature of the disease, its causation. The medical pluralism of early modern Europe meant not only a range of healers, but a range of aetiological categories. These could directly correspond. When sick people ascribed their illnesses to magical spells, the most obvious recourse was to the wise women held responsible, in the hope that they could be persuaded to break the spells. However, in Catholic

Europe, the sick could also turn to another category of healer to counter the spells: the exorcist. The Counter-Reformation Church instructed that only its trained, licensed exorcists were capable of dealing with such spells, because they depended on the intervention of the devil in order to work. The sick rarely turned to physicians for such magically-caused illnesses, for their remedies were not deemed effective against them.

Determining causation responded to the universal questions of why me? why now? I do not wish to suggest that diseases were generally put down to spells. Indeed, the most typical causation was generally some mixture of natural and supernatural factors. The emphasis varied from person to person, and changed over time. Natural, material explanations for events increasingly predominated over religious ones, especially during the course of the eighteenth century. I have mentioned the link between magic and disease to illustrate my point that to talk of medical pluralism is not synonymous with the medical market-place. Supply and demand alone did not determine the medical landscape. Economic factors were certainly an important element in decisions made by the sick regarding the choice of healer. However, they do not seem to have been the most important. People went to great lengths and were prepared to make great sacrifices to attract the services of the form of healer or particular practitioner they hoped would bring about a cure. Going to the local wise woman was not the easy option; her services could cost as much as those of a learned physician, not to mention the emotional blackmail that frequently accompanied the relationship. The same can be said of going to a saint's shrine. The ex votos that devotees left as tangible signs of their miraculous cures were often quite costly, to say nothing of the time and effort required to visit the shrine.

Not that miracles were available to all early modern Europeans. For many, officially at least, the biblical 'age of miracles' was past, relegated to the level of idolatry and 'papist superstition.' For the Protestant churches the role of saints in healing diseases was thus severely curtailed, where it was not eliminated. This was not absolute: if Catholic Italy had its 'living saints', occupying the overlap between popular and official religion, Protestant England had its Valentine Greatrakes.[2] The role of the divine was still recognised, both in causing illness and in treating it. The divine increasingly meant God alone and direct recourse to him through prayer and fasting. The devil, too, could cause illness; in this case, however, there were often no exorcism rituals to turn to, the 'priesthood of all believers' having sought to put an end to all such monkish ceremonials. In Catholic regions of Europe both the ceremonials and the saints survived and prospered. Well into the eighteenth century both were still central to life, as the Counter-Reformation climate persisted. The Enlightenment introduced reason as a means of accounting for apparent miraculous events, certainly for the educated elites. Then again, the Church from the foundation of the Congregation of Rites had adopted a strict stance with regard to miracles. Reason added another critical element, but it did not eliminate the *possibility* of miracle cures, not even for most learned physicians.

If we continue to look at things from the view of the sick, another element determined their choice of healer: accessibility. This meant not only such things as

availability and geographical proximity, but similarities in terms of mentality and status. With the exception of the elites, the majority of people were more comfortable in the hands of a barber-surgeon than a physician. What have been called 'ordinary practitioners'[3] were not only numerically strong, they also shared the attitudes of most of the sick. While the sick might turn to a physician for 'protection', guidance and advice, they turned to the barber or unlicensed practitioner for more practical, basic and direct treatment. While the relationship with physicians was vertical, that of inferior–superior, the relationship with other practitioners was more horizontal.[4] The elites, however, were more particular in their choices. This seems to have been especially the case where corporatism dominated society, as in Italy and France, for instance.

Corporatism affected the interplay of practitioners, further restricting the role of the market-place, in theory if not in practice. It meant that there were recognised bodies which defined and regulated the various branches of the medical arts. This usually meant colleges of physicians, often associated with university medical faculties, alongside various trade guilds for the barber-surgeons and apothecaries. The various Italian Protomedicati all overlapped, and sometimes competed with the various trade corporations and other organs of the state. Although the state apparatus grew in size during the early modern period, this did not mean that it replaced or even weakened other centres of power. Local elite groups and traditional institutions maintained their importance in European states. Indeed, corporatist institutions were closely allied to the state. However, regardless of the system in force, governance and regulation were complex, cumbersome and inefficient, plagued by layers of competing interests. Negotiation and compromise played a greater part than principle or precedent. The Enlightenment introduced notions of improvement, reform, expedience and the common good into public health matters.[5] Real changes, however, often had to await the nineteenth century.

Neapolitan protophysicians were regularly consulted in the wake of outbreaks of disease, but this was the extent of their public health role. Throughout the period, despite medical advances and Enlightenment reforms, the kingdom's public health remained inadequate, piecemeal and *ad hoc*. This is especially evident with regard to plague where the kingdom's response contrasted with the advanced measures of other Italian states, like the Venetian Republic and Tuscan Grand Duchy. Likewise, the Neapolitan provision of community physicians and surgeons for the poor was fragmentary and seems to have declined by the end of the eighteenth century, just when similar provision was being proposed elsewhere, such as in revolutionary France. The Neapolitan Protomedicato never acquired the greater powers of its Castilian cousin, or even the functions of the other, college-based Italian Protomedicati. Its supervisory function played second fiddle to the annual collection of licence fees from practitioners throughout the kingdom. This was just as true in 1610, when the fee-collecting was first farmed out, as it was in 1810, despite the various reforms of the Bourbon and Napoleonic rulers. The Protomedicato never evolved into a system of medical police then being advocated

in German-speaking areas, nor did it foreshadow the rise of a united medical profession. In fact, it strove to keep the various branches apart.

The focus of traditional medical histories on the medical 'regulars' – the tripartite hierarchy of physicians, surgeons and apothecaries – tended to overplay the role of the regulars in the healing network, at the expense of 'irregular' healers – that is, everyone else. It also implied a kind of harmony or at least working arrangement within this group. Recent medical historiography has refined this picture. The regulars still have centre stage, but other healers are granted more than a role on the fringes of society. And we have come to see that there was as much differentiation within the ranks of the regulars as differences between them and everyone else. This was the case in countries where medical regulation was relatively weak, as in England, just as in countries where it was stricter, as in Italy, Spain or France. City physicians with rich, aristocratic patrons looked down on rural physicians eking out a living as town or monastic employees; university-educated surgeons ridiculed unlearned barbers, and so on.

The moral order of society, whether or not this was seen in specifically corporate terms, was threatened by the 'disorder' that ensued when practitioners overstepped their occupational limits. For instance, when barber-surgeons, limited to external treatments, administered internal remedies, the realm of physicians; or when apothecaries, limited to the preparation of medicines, prescribed them. Whether the patient benefited or not was not the question. Such disputes characterised the latter half of the sixteenth century and the entire seventeenth century, throughout Europe. Where it dominated, corporatism gave the elites a means of pursuing offenders and resisting calls by surgeons and apothecaries to practise physic. The Neapolitan Protomedicato certainly had this function, but what impact did it have? In one sense, I would like to suggest, it was only a difference of degree. Everywhere in Europe practitioners of all ranks responded to the demands of the sick – upon whom they depended for their living – even if this meant exceeding their occupational limits on occasion. This was true whether medical regulation was weak or strong, fragmented or centralised. Itinerant practitioners, too, were a common feature of the European medical landscape. This was the case whether the official attitude to medical practice tended towards the *caveat emptor* variety or one of more or less rigorous inspection and licensing. For the latter did not seek to eliminate charlatanry, merely to supervise it in some way, pocketing the income generated by the licence fees charlatans had to pay.

However, there were substantial differences, too. England saw the greatest unpunished mixing of occupations, leading eventually to the rise of the 'general practitioner.' Such a development was unthinkable where the corporatist ethos was entrenched. Even here, however, the tripartite divisions were increasingly called into question during the course of the eighteenth century. This was due in part to the diminishing status of the university medical faculties and their associated colleges, tied up with the relative stagnation of physic and the rise of surgery and hospital instruction and training. In Italy, hospitals had long served as places where practitioners could acquire experience, surgery was part of the university

curriculum and some surgeons had university doctorates and were on a par with physicians. However, the second half of the eighteenth century saw many changes in the instruction, knowledge and practice of the medical regulars. In Naples, this occurred in the wake of developments elsewhere, especially in Paris, but the time-lag was not great. Medical instruction was transferred to the city's main hospital, a college uniting physicians and surgeons was founded, a chair in obstetrics established. These were all effects of the Enlightenment in Naples. At the same time, hospitals were almost non-existent outside the capital, the old college of physicians continued in operation and virtually all midwives remained without instruction.

There is no arguing that the content of university medicine had changed considerably. At the beginning of the period physic underwent the Galenic revival, witnessed chemical and mechanical interpretations, withstood the dispute between ancients and moderns, and saw a renewed stress on nature, the environment and hygiene factors. Enlightenment medicine had become increasingly observational and empiricist. These changes, significant as they were, had surprisingly little impact on medical treatment and provision. By the 1800s there existed what could be called a medical science, based on the clinical method: hospital-based research into disease, making use of large numbers of patients suffering from the same illness. Despite increasing observation and empiricism, there was still no single dominant theory of physic. Even in Paris, home of the clinical method, therapy and cure lagged far behind advances in the knowledge of sickness. Medicine was still promising more than it delivered.[6] It has been suggested that in Edinburgh the appearance of hospitals had the effect of separating the patient from household and family. It was more difficult for amateur consultations to be obtained. The effect, when combined with new medical theories, was to reduce the input of the patient in determining diagnosis and treatment.[7] The same may have occurred in Naples, where the Incurables was well on its way to becoming a general hospital by the middle of the eighteenth century. And yet, the sick continued to admit and discharge themselves as they saw fit. Most treatment still took place in the home, especially as we move outside the capital.

In much of Europe expectations had moved on, the criticisms become more vociferous, while medical practice, whether in terms of hospitals or midwives, remained little changed. Thus Neapolitan midwives continued to be chosen by community sanction and trained by other midwives. Neither courses or examinations played much of a role. Nor did midwives face competition from learned men-midwives or accoucheurs, as in England and France. In this regard at least Naples would seem to resemble Spain.[8] By the time of the statistical survey of 1811 educated Neapolitans veered between being resigned to this situation and being scandalised by it. The medical landscape as a whole was remarkably unchanged. Naples lacked the openness of the English system or the *laissez-faire* experiments of revolutionary France. Like their contemporaries in Germany, the physicians could rant on about the 'superstition' of the ignorant and local intransigence, but they themselves remained locked into patronage and clientage networks, continuing to

define themselves in terms of local allegiances.[9] The kingdom – indeed the Italian peninsula as a whole – still had high practitioner-to-population ratios when compared to the rest of Europe. These were almost evenly divided between the four occupations making up the medical arts: physicians, surgeons, apothecaries and midwives. No argument is being made for the quality of medical service; simply that provision was high. A community of 1,000 people might expect to have a practitioner of each type. If anything, Naples developed a glut of underemployed provincial physicians, as the rise in the number of doctorates granted by the kingdom's two universities in the last few decades of the eighteenth century outstripped population increases. The more usual situation in Europe was to have the barber-surgeon outnumbering all the rest. He would often have been the only practitioner to be found outside the towns. None the less, rural Europe was no medical wasteland. Despite high numbers of practitioners in state capitals, it appears to have been in the smaller towns that medical densities were highest.[10]

It has been my argument throughout this book that the constituent elements of medical pluralism remained in place during the early modern period. What changed was their individual contours and their relationship to one another. Thus charlatanry may be as old as medicine itself, but it has a history. The Orvietan's medical secret, one of medicine's earliest brand names, was grafted on to a much older world of the quasi-sacred snake-charmer. It emerged just when the theriac of learned medicine was being revived and just as Italian troupes of actors were beginning to take the *commedia dell'arte* to European audiences. Even the corporatism of the Italian states was not enough to prevent the commercialisation of medicine by charlatans, over a century before similar developments took place in England.[11] The Protomedicati and medical colleges did not seek to eliminate charlatanry, merely to contain it within what they deemed proper limits. Charlatans could be tolerated as long as the prestige and repute of physic was not damaged.

If there was a 'golden age' of medical pluralism as presented in this book, it was the 150-year period following the Council of Trent, when many of the values and attitudes were shared throughout society. By the eighteenth century this consensus was breaking down. This was most evident amongst the kingdom's educated elites and numerically small bourgeoisie. Religious explanations for disease were no longer as convincing, and religious forms of cure – especially miracles – not anticipated or at least accepted as they had once been. Likewise, the efficacy of maleficent magic had been recognised by all levels of society at the beginning of our period, though to different degrees. If physicians discussed spells, it was to admit to the powerlessness of natural remedies to affect them. Even at their most sceptical, physicians had considered them part of that grey area shared with the miraculous: an acceptance of the possibility tempered with a suspicious approach to individual cases. This was a scepticism destined to increase over the period. The natural magic of Della Porta eventually gave way to a semi-serious discussion of the phenomenon of *iettatura,* akin to Franz-Anton Mesmer's 'animal magnetism.' By the later eighteenth century even some churchmen were expressing doubts as to the role of the devil in causing disease, as well as the usefulness of the Church's

exorcistic rituals. In the south-eastern corner of the kingdom, Apulian tarantism was found to be a 'fraud' by Neapolitan intellectuals, and relegated to the realm of peasant belief. And in the south-western corner of the kingdom, the terrible Calabrian earthquake of 1783 resulted in a heated dispute between figures of the Neapolitan Enlightenment, who favoured a rational, naturalistic explanation, and much of the clergy, who favoured a religious one.[12] What had previously been a complementary relationship – for instance, between the supporters of primary and secondary causes when it came to interpreting plague, and religious and secular responses when it came to combating it – was now transformed into a struggle between the two opposing forces of reason and tradition.

## NOTES

1 For example, Ole Grell and Andrew Cunningham (eds), *Religio Medici: medicine and religion in seventeenth-century England* (Aldershot, 1996).

2 Eamon Duffy, 'Valentine Greatrakes, the Irish stroker: miracle, science and orthodoxy in Restoration England', *Studies in Church History,* xxvii (1981), pp. 251–73.

3 Toby Gelfand, 'A "monarchical profession" in the old regime: surgeons, ordinary practitioners and medical professionalization in eighteenth-century France' in G. L. Geison (ed.), *Professions and the French State, 1700–1900* (Philadelphia, 1984), pp. 85–101.

4 Gianna Pomata, *La promessa di guarigione: malati e curatori in antico regime, Bologna XVI-XVIII secolo* (Rome and Bari, 1994), pp. 256–8.

5 Mary Lindemann, *Health and healing in eighteenth-century Germany* (Baltimore, 1996), p. 371.

6 Laurence Brockliss and Colin Jones, *The medical world of early modern France* (Oxford, 1997), p. 832.

7 Helen Dingwall, *Physicians, surgeons and apothecaries: medicine in seventeenth-century Edinburgh* (Edinburgh, 1995), p. 240.

8 Adrian Wilson, *The making of man-midwifery: childbirth in England, 1660–1770* (London, 1995); Hilary Marland (ed.), *The art of midwifery: early modern midwives in Europe* (London, 1993).

9 Lindemann, *Health and healing,* pp. 372–3.

10 Jean-Pierre Goubert, 'The extent of medical practice in France around 1780', *Journal of Social History,* x (1977), pp. 410–27.

11 Harold Cook, *The decline of the old medical regime in Stuart London* (Ithaca, NY, 1986), p. 259.

12 Vincenzo Ferrone, *I profeti dell'illuminismo: le metamorfosi della ragione nel tardo Settecento italiano* (Rome and Bari, 1989), pp. 33–4.

# SELECT BIBLIOGRAPHY

## Primary sources

### Manuscript

(Abbreviations used in the notes are in parentheses)

Avezzano dei Marsi
Archivio Diocesano dei Marsi, Avezzano (A.D.M.), *Cause criminali*

Bologna
Archivio di Stato (A.S.B.), *Fondo Studio*

Gravina di Puglia
Archivio Diocesano (A.D.G.), *Fondo vescovile*

Naples
Archivio Storico Diocesano (A.S.D.N.) *Sant'Ufficio; Visite Pastorali*
Archivio di Stato (A.S.N.) *Dipendenze della Sommaria: Arrendamento del Protomedicato (Sommaria: Protomedicato)*, series I and II; *Arrendamenti: serie registri*, no. 250

Oria
Archivio Diocesano (A.D.O.), *Fondo magia e stregoneria*

Rome
Archivium Romanum Societatis Iesu (A.R.S.I), *Provincia Neapolitana (Prov. Neap.)*
Archivio Segreto Vaticano (A.S.V.), *Congregazione dei Riti (Riti)*
Archivio di Stato (A.S.R.), *Fondo Università*

Siena
Archivio di Stato (A.S.S.), *Fondo Studio*

*Printed sources*

Altimarum, B., *Pragmaticae, edicta, decreta, regiaque sanctiones Regni Neapolitani* (Naples, 1682–95).

Bacco, E., *Descrittione del Regno di Napoli* (Naples, 1671); *Naples: an early guide*, trans. and ed. by E. Gardiner (New York, 1991).

Brugnoli, C., *Alexicacon, hoc est opus de maleficiis et morbis maleficis*, 2 vols (Venice, 1668).

Bulifon, A., *Giornali di Napoli dal MDXLVII al MDCCVI*, ed. N. Cortese (Naples, 1932),

Calvanico, R., *Fonti per la storia della medicina e della chirurgia per il regno di Napoli nel periodo angioino (1273–1410)* (Naples, 1962).

Caravita, F., 'Relazione' in G. de Blasiis (ed.), 'L'università di Napoli nel 1714', *Archivio storico per le province napoletane*, i (1876), 141–66.

Cicatelli, S., 'Vita di P. Camillo de Lellis Fondatore della Religione de Chierici Ministri dell'Infermi descritta brevemente dal P. Sanzio Cicatelli Sacerdote della stessa Religione', 1608, MS, Archivio Generale dell'Ordine dei Ministri degli Infermi, Rome; ed. R. Corghi and G. Martignoni, *Un uomo venuto per servire: Camillo de Lellis nell'antica cronaca di un testimone oculare* (Milan, 1984).

Cirillo, D., *La prigione e l'ospedale: discorsi accademici* (Naples, 1799 edn).

Codronchi, B., *De morbis veneficis et veneficiis* (Venice, 1595).

Confuorto, D., *Giornali di Napoli dal MDCLXXIX al MDCIC*, ed. N. Nicolini, 2 vols (Naples, 1930).

D'Afflitto, E., *Memorie degli scrittori del Regno di Napoli*, 2 vols (Naples, 1789–94).

D'Amato, C., *Nuova et utilissima prattica di tutto quello ch'al diligente barbiero s'appartiene* (Naples, 1671).

Demarco, D., ed. *La 'Statistica' del Regno di Napoli nel 1811*, 3 vols (Rome, 1988).

De Renzi, S., *Napoli nell'anno 1656, ovvero documenti della pestlenza che desolò Napoli nell'anno 1656, preceduti dalla storia di quella tremenda sventura* (Naples, 1867).

——, *Napoli nell'anno 1764, ossia documenti della carestia e della epidemia che desolarono Napoli nel 1764, preceduti dalla storia di quelle sventure* (Naples, 1868).

——, *Osservazioni sulla topografia medica nel Regno di Napoli (Domini al di qua del Faro)*, 3 vols. (Naples, 1828–30; 4th edn, Naples, 1845).

——, *Storia della medicina italiana*, 5 vols (Naples, 1845–48).

——, *Storia documentata della Scuola Medica di Salerno* (Naples, 1857).

Firpo, L., ed. *Regimen sanitatis Salerni* (Turin, 1972).

Fra Donato D'Eremita, *Antidotario . . . nel quale si discorre in torno all'osservanza che deve tenere lo spetiale nell'elegere, preparare, componere, e conservare i medicamenti semplici e composti, diviso in libri tre* (Naples, 1639).

Galanti, G. M., *Calabria 1792: diarii, relazioni e lettere di un visitatore generale*, ed. A. Placanica (Salerno, 1992).

——, *Nuova descrizione storica e geografica delle Sicilie*, 4 vols (Naples, 1786–90).

Garzoni, T., *La piazza universale di tutte le professioni del mondo* (Venice, 1616 edn).

Giannone, P., *Istoria civile del Regno di Napoli* (Naples, 1723).

Giustiniani, L., *Nuova collezione delle prammatiche del Regno di Napoli*, 12 vols (Naples, 1803–05).

Guazzo (or Guaccio), F. M., *Compendium maleficarum in tres libro distinctum ex pluribus autoribus* (Milan, 1608); Eng. trans. E.A. Ashwin (London, 1929).

Howard, J., *An account of the principal lazarettos in Europe* (London, 1791).

Imperato, F., *Discorsi intorno all'origine, reggimento e stato della Gran Casa della SS. Annunziata di Napoli* (Naples, 1629).

Infantino, G. C., *Lecce sacra . . . ove si tratta delle vere origini e fondationi di tutte le chiese, monasterij, cappelle, spedali et altri luoghi sacri* (Lecce, 1634).

Ingrassia, G. F., *Constitutiones, capitula, iurisdictiones, ac pandectae regii protomedicatus officii* (Palermo, 1657).

——, *Methodus dandi relationes pro mutilatis, torquendis aut a tortura excusandis*, ed. G. Curcio, (Catania, 1938).

Lancellotti, S., *L'Orvietano per gli hoggidiani* (Paris, 1641).

Magdaleno, R., ed. *Titulos y privilegios de Nápoles, siglos XVI-XVIII*, vol. I: *Onomastico* (Valladolid, 1980, Catalogue 28 of the Archivo General de Simancas).

Malfi, T., *Il barbiere . . . libri tre, ne' quali si ragiona dell'eccellenza dell'arte e de' suoi precetti* (Naples, 1626).

Marino, R. (ed.), *Medicina e magia: segreti e rimedi in due manoscritti salernitani del '700* (Rome, 1991).

Mercurio, S., *De gli errori popolari d'Italia* (Verona, 1645 edn).

Montorio, S., *Zodiaco di Maria, ovvero le dodici provincie del Regno di Napoli, come tanti segni, illustrate da questo sole per mezo delle sue prodigiosissime immagini, che in essi quasi tante stelle risplendono* (Naples, 1715).

Moryson, F., *Fynes Moryson's itinerary*, ed. C. Hughes, (London, 1903).

Muñoz, M., *Recopilación de las leyes, pragmáticas reales, decretos y acuerdos del Real Proto-medicato hecha por encargo y dirección del mismo Real Tribunal* (Valencia, 1751; reprint Valencia, 1991).

Muratori, L. A., *Della forza della fantasia umana* (Venice, 1753 edn).

Occhilupi, C., 'Veri motti, buoni consigli, e giusti avvertimenti lasciati da savi, letterati e plebei, e villani huomini', 1774, Biblioteca Provinciale, Lecce, MS 76; published in L. Lazari Congedo, 'Una raccolta settecentesca di proverbi salentini', in M. Paone (ed.), *Studi di storia pugliese in onore di Giuseppe Chiarelli*, v (Galatina, 1980), 5–65.

Origlia, G. G., *Istoria dello Studio di Napoli*, 2 vols (Naples, 1753–54).

Paolucci, S., *Missioni de Padri della Compagnia di Giesù nel Regno di Napoli* (Naples, 1651).

Parrino, D. A., *Teatro eroico e politico de' governi de' vicere del regno di Napoli dal tempo del re ferdinando il Cattolico fino al presente*, 3 vols (Naples, 1692–94).

Paticchio, M., *Brieve ristretto della vita di Maria Manca della Terra di Squinzano, fondatrice della chiesa della Santissima Annunziata di detta Terra. Opera del Sacerdote Mauro Paticchio della medesima* (Naples, 1769; reprinted Galatina, 1971).

Pettiti, P. (ed.), *Repertorio amministrativo ossia collezione di leggi, decreti, reali prescritti, ministeriali, regolamenti ed istruzioni sull'amministrazione civile del regno delle due Sicilie*, 2 vols (Chieti, 1838–49).

Pignataro, C., *Petitorium in quo continetur ea, quae quilibet pharmacopoeus in sua officina, in hac urbe Neapolis & Regno, in visitationibus faciendi habere & ostendere debat* (Naples, 1684).

Pignataro, D., *Memoria sullo stato attuale della medicina nelle provincie di questo Regno di Napoli* (Naples, 1806).

Piperno, P., *De magicis affectibus lib. vi. Medicè, stratagemmaticè, divinè, cum remediis electis. Exorcismus, phisicis, ac curiosis. Et de nuce Beneventana maga* (Naples, 1635).

Possevino, A., *Cause et rimedii della peste, et d'altre infermità* (Florence, 1571).

Ravacini, S., *Sulla universalità della S. Casa degl'Incurabili in Napoli: memorie e documenti storici* (Naples, 1899).

Riollet, T., *Remarques curieuses sur la Thériaque, avec un excellent traité sur l'Orviétan* (Bordeaux, 1665).

Santorelli, A., *Il protomedico napolitano, ovvero dell'autorità di esso. Dialogo raccolto da un discepolo . . . e data in luce dal signor Fabio Cava* (Naples, 1652).

Zacchia, P., *Quæstiones medico-legales. In quibus eæ materiæ medicæ, quæ ad legales facultates videntur pertinere, proponuntur, pertractantur, resolvuntur* (Amsterdam, 1651 edn).

Zerenghi, F., *Breve compendio di cirurgia . . . dove facile e breve si dimostra che cosa sia cirurgia* (Naples, 1603).

## Secondary sources

Acton, H., *The Bourbons of Naples, 1734–1825* (London, 1956).

Aliberti, G., 'Economia e società da Carlo III ai Napoleonidi (1734–1806)', in *Storia di Napoli,* vol. 8 (Naples, 1971), 75–164.

Amabile, L., *Il Santo Officio dell'Inquisizione: narrazione con molti documenti inediti,* 2 vols (Città di Castello, 1892).

Arrizabalaga, J., J. Henderson and R. French, *The great pox: the French disease in Renaissance Europe* (New Haven, 1997).

Astarita, T., *The continuity of feudal power: the Caracciolo di Brienza in Spanish Naples* (Cambridge, 1992).

Avallone, R., 'Le *Disputationes* della Scuola medica salernitana nel Seicento' in *Salerno e il Principato Citra nell'età moderna (secoli XVI-XIX)* (Naples, 1985), 929–54.

Aymard, M., 'Epidémies et médecines en Sicile à l'époque moderne', *Annales Cisalpines d'Histoire Sociale,* iv (1973), 9–37.

Badaloni, N., 'Fermenti di vita intellettuale a Napoli dal 1500 alla metà del '600', in *Storia di Napoli,* vol. 5: 2 (Naples, 1972), 641–89.

Beier, L. M., *Sufferers and healers: the experience of illness in seventeenth-century England* (London, 1987).

Belloni Speciale, G., 'La ricerca botanica dei Lincei a Napoli: corrispondenti e luoghi' in F. Lomonaco and M. Torrini (eds), *Galileo a Napoli* (Naples, 1987), 59–79.

Benedicenti, A., *Malati, medici, farmacisti: storia dei rimedi attraverso i secoli e delle teorie che ne spiegano l'azione sull'organismo,* 2 vols (Milan, 1951 edn).

Bentley, J., *Politics and culture in renaissance Naples* (Princeton, 1987).

Bevilacqua, P., *Breve storia dell'Italia meridionale dall'Ottocento a oggi* (Rome, 1993).

Boccadamo, G., 'Le bizzoche a Napoli tra '600 e '700', *Campania sacra,* xxii (1991), 351–94.

Borrelli, A., 'Medicina e società a Napoli nel secondo Settecento', *Archivio storico per le province napoletane,* cxxii (1994), 123–77.

Botti, G., '"Febbri putride e maligne" nell' "anno della fame": l'epidemia napoletana del 1764' in P. Frascani (ed.), *Sanità e società: Abruzzi, Campania, Puglia, Basilicata, Calabria, secoli XVII-XX* (Udine, 1990), 75–100.

——, 'L'organizzazione sanitaria nel Decennio' in A. Lepre (ed.), *Studi sul Regno di Napoli nel Decennio Francese (1806–1815),* (Naples, 1985), 81–98.

Brambilla, E., 'La medicina nel Settecento: dal monopolio dogmatico alla professione scientifica' in F. della Peruta (ed.), *Storia d'Italia: Annali,* vii, *Malattia e medicina* (Turin, 1984), 5–147.

——, 'Il "sistema letterario" di Milano: professioni nobili e professioni borghesi dall'età spagnola alle riforme teresiane' in A. De Maddalena, E. Rotelli and G. Barbarisi (eds), *Economia, istituzioni, cultura in Lombardia nell'età di Maria Teresa,* vol. III, *Istituzioni e società* (Bologna, 1982), 79–160.

Brockliss, L. and C. Jones, *The medical world of early modern France* (Oxford, 1997).

Brown, J., *Immodest acts: the life of a lesbian nun in Renaissance Italy* (Oxford, 1986).

Burke, P., *The historical anthropology of early modern Italy: essays on perception and communication* (Cambridge, 1987).

Cabibbo, S. and M. Modica, *La santa dei Tomasi: storia di Suor Maria Crocifissa (1645–1699)* (Turin, 1989).

Calabria, A., *The cost of empire: the finances of the Kingdom of Naples in the time of Spanish rule* (Cambridge, 1991).

Calabria, A., and J. Marino (eds), *Good government in Spanish Naples* (New York, 1990).

Caldora, U., *Calabria Napoleonica (1806–1815)* (Naples, 1960).

Calvi, G., 'L'oro, il fuoco, le forche: la peste napoletana del 1656', *Archivio storico italiano*, cxxxix (1981), 405–58.

Camporesi, P., *Bread of dreams: food and fantasy in early modern Europe*, trans. D. Gentilcore (Cambridge, 1989).

—— (ed.) *Il libro dei vagabondi* (Turin, 1973).

——, *La miniera del mondo: artieri, inventori, impostori* (Milan, 1990).

Castaldo Manfredonia, L., *Gli arrendamenti: fonti documentarie conservate presso l'Archivio di Stato di Napoli* (Naples, 1986).

Catapano, V. D., *Matti agli "Incurabili" di Napoli* (Naples, 1995).

——, *Medicina a Napoli nella prima metà dell'Ottocento* (Naples, 1990).

Cavallo, S., *Charity and power in early modern Italy: benefactors and their motives in Turin, 1541–1789* (Cambridge, 1995).

Chaney, E. P., 'Giudizi inglesi su ospedali italiani, 1545–1789' in G. Politi, M. Rosa and F. della Peruta (eds), *Timore e carità: i poveri nell'Italia moderna* (Cremona, 1982), 77–102.

Châtellier, L., *The Europe of the devout: the Catholic Reformation and the formation of a new society*, trans. J. Birrell (Cambridge, 1989).

Chiosi, E., '"Humanitates" e scienze. La Reale Accademia napoletana di Ferdinando IV: storia di un progetto', *Studi storici*, ii (1989), 435–56.

Ciammitti, L., 'Una santa di meno: storia di Angela Mellini, cucitrice di Bologna (1667–17—)', *Quaderni storici*, xiv (1979), 37–71.

Cipolla, C. M., *Miasmas and disease: public health and the environment in the pre-industrial age* (New Haven, 1992).

——, *Public health and the medical profession in the Renaissance* (Cambridge, 1976).

——, 'The professions: the long view', *Journal of European Economic History*, ii (1973), 37–52.

Colletta, M. G., 'Il Collegio dei Dottori dal 1722 al 1744 attraverso le carte dell'Archivio di stato di Napoli', *Archivio storico per le province napoletane*, xcvii (1979), 217–41.

Coniglio, G., 'Annona e calmieri a Napoli durante la dominazione spagnuola', *Archivio storico per le province napoletane*, lxv (1940), 105–94.

——, *I Borboni di Napoli* (Milan, 1992).

——, *Il viceregno di Napoli nel sec. XVII* (Rome, 1955).

Cook, H. J., *The decline of the old medical regime in Stuart London* (Ithaca, NY, 1986).

——, 'Institutional structures and personal belief in the London College of Physicians', in O. P. Grell and A. Cunningham (eds), *Religio Medici: medicine and religion in seventeenth-century England* (Aldershot, 1996), 91–114.

Corrain, C., 'Il prontuario manoscritto di un protomedico irpino del secolo XVIII', *Acta medicae historiae patavina*, v (1958–59), 40–87.

Corsini, A., *Medici ciarlatani e ciarlatani medici* (Bologna, 1922).

Cortese, N., 'Il governo spagnuolo e lo Studio di Napoli' in idem, *Cultura e politica a Napoli dal Cinque al Settecento* (Naples, 1965), 31–119.

Cosmacini, G., *Storia della medicina e della sanità in Italia, dalla peste europea all guerra mondiale: 1348–1918* (Rome and Bari, 1987).

Croce, B., *Storia del Regno di Napoli,* ed. G. Galasso, (Milan, 1992 edn).

——, *I teatri di Napoli* (Naples, 1891; Milan, 1992).

Csordas, T., *The sacred self: a cultural phenomenology of charismatic healing* (Berkeley, 1994).

d'Agostino, M., and F. Raguso, *Confraternite: statuti, attività socio-assistenziali. Gravina secc. XV-XVIII* (Gravina, 1990).

D'Ancona, A., *Viaggiatori e avventurieri* (Florence, 1974).

Del Bagno, I., *Legum doctores: la formazione del ceto giuridico a Napoli tra Cinque e Seicento* (Naples, 1993).

Delille, G., 'Un esempio di assistenza privata: i Monti di maritaggio nel Regno di Napoli (secoli XVI-XVIII)' in G. Politi, M. Rosa and F. della Peruta (eds), *Timore e carità: i poveri nell'Italia moderna* (Cremona, 1982), 275–82.

——, *Famiglia e proprietà nel Regno di Napoli, XV-XIX secolo* (Turin, 1988).

Del Panta, L. *et al.*, *La popolazione italiana dal Medioevo a oggi* (Rome and Bari, 1996).

De Maio, R., 'L'Ospedale dell'Annunziata: "il megliore e più segnalato di tutta Italia"' in De Maio, *Riforme e miti nella Chiesa del Cinquecento* (Naples, 1973)

De Martino, E., *Sud e magia* (Milan, 1959).

——, *La terra del rimorso: contributo a una storia religiosa del Sud* (Milan, 1961).

De Rosa, G., 'L'emarginazione sociale in Calabria nel XVIII secolo: il problema degli esposti', *Ricerche di storia sociale e religiosa,* xiii (1978), 5–29.

——, *Storie di santi* (Rome and Bari, 1990).

De Rosa, L., 'The "Protomedicato" in southern Italy, XVI-XIX centuries', *Annales Cisalpines d'Histoire Sociale,* iv (1973), 103–17.

De Seta, C., *Storia della città di Napoli dalle origini al Settecento* (Rome and Bari, 1973).

Digiorgio Viti, M. P., 'Peste, terremoti e culto dei santi tra XVII e XIX secolo nella provincia di Matera', *Ricerche di storia sociale e religiosa,* xxxv (1989), 129–40.

Dingwall, H., *Physicians, surgeons and apothecaries: medicine in seventeenth-century Edinburgh* (Edinburgh, 1995).

di Nola, A., *Gli aspetti magico-religiosi di una cultura subalterna italiana* (Turin, 1976).

Dubost, J.-F., *La France italienne, XVIe-XVIIe siècle* (Paris, 1997).

Duden, B., *The woman beneath the skin: a doctor's patients in eighteenth-century Germany,* trans. T. Dunlap (Cambridge, MA, 1991).

Eamon, W., *Science and the secrets of nature: books of secrets in medieval and early modern culture* (Princeton, 1994).

Elia, J., 'Il medico a rovescio: per la biografia di Marco Aurelio Severino (1580–1656)', *Rivista storica calabrese,* iv (1983), 137–74.

Ferrone, V., *I profeti dell'illuminismo: le metamorfosi della ragione nel tardo Settecento italiano* (Rome and Bari, 1989).

Filangieri, A., *Territorio e popolazione nell'Italia meridionale: evoluzione storica* (Milan, 1980).

Filangieri Ravaschieri Fieschi, T., *Storia della carità napoletana* (Naples, 1875).

Fildes, V., *Wet nursing: a history from antiquity to the present* (Oxford, 1988).

Filippini, N. M., 'The Church, the State and childbirth: the midwife in Italy during the eighteenth century' in H. Marland (ed.), *The art of midwifery: early modern midwives in Europe* (London, 1993), 152–75.

Findlen, P., *Possessing nature: museums, collecting and scientific culture in early modern Italy* (Berkeley, 1994).

Fisch, M., 'The Academy of the Investigators' in E. A. Underwood (ed.), *Science and medicine in history: essays on the evolution of scientific thought and medical practice in honour of Charles Singer,* 2 vols. (Oxford, 1953), I, 521–63.

Forti Messina, A., 'I medici condotti nell'ottocento preunitario: il caso della provincia di Napoli' in G. Politi, M. Rosa and F. Della Peruta (eds), *Timore e carità: i poveri nell'Italia moderna* (Cremona, 1982), 445–70.

Galasso, G., *L'altra Europa: per un'antropologia storica del Mezzogiorno d'Italia* (Milan, 1982).

——, *Napoli spagnola dopo Masaniello: politica, cultura, società* (Florence, 1982).

Garofalo, F., *Quattro secoli di vita del Protomedicato e del Collegio dei Medici di Roma (Regesto dei documenti dal 1471 al 1870)* (Rome, 1950).

Garro, L., 'Chronic illness and the construction of narratives' in M. J. Del Vecchio-Good, P. Brodwin, B. Good and A. Kleinman (eds), *Pain as human experience: an anthropological perspective* (Berkeley, 1992), 100–37.

Gelfand, T., 'A "monarchical profession" in the old regime: surgeons, ordinary practitioners and medical professionalization in eighteenth-century France' in G.L. Geison (ed.), *Professions and the French State, 1700–1900* (Philadelphia, 1984), 149–80.

Gélis, J., 'Miracle et médecine aux siècles classiques: le corps médical et le retour temporaire à la vie des mort-nés', *Historical Reflections/ Réflexions Historiques,* ix (1982), 85–101.

Gentilcore, D., '"Adapt yourselves to the people's capabilities": missionary strategies, methods and impact in the Kingdom of Naples, 1600–1800', *Journal of Ecclesiastical History,* xlv (1994), 269–96.

——, '"All that pertains to medicine": *protomedici* and *protomedicati* in early modern Italy', *Medical History,* xxxviii (1994), 121–42.

——, '"Charlatans, mountebanks and other similar people": the regulation and role of itinerant practitioners in early modern Italy', *Social History,* xx (1995), 297–314.

——, 'The fear of disease and the disease of fear' in W. Naphy and P. Roberts (eds), *Fear in early modern society* (Manchester, 1997), 184–208.

——, *From bishop to witch: the system of the sacred in early modern Terra d'Otranto* (Manchester, 1992).

——, 'Ritualised illness and musical therapy: views of tarantism in the kingdom of Naples' in P. Horden (ed.), *Music and medicine: the history of music therapy since Antiquity* (forthcoming).

Giardino, A.E. and M. Rak, *Per grazia ricevuta: le tavolette dipinte ex voto per la Madonna dell'Arco* (Pompei, 1983).

Ginzburg, C. and M. Ferrari, 'The dovecote has opened its eyes', trans. E. Branch, in E. Muir and G. Ruggiero (eds), *Microhistory and the Lost Peoples of Europe* (Baltimore, 1991), 11–19.

Good, B., *Medicine, rationality and experience: an anthropological perspective* (Cambridge, 1994).

Goubert, J.-P., 'The extent of medical practice in France around 1780', *Journal of Social History,* x (1977), 410–27.

Granjel, L., *Historia general de la medicina española,* 4 vols (Salamanca, 1980).

Green, M., 'Women's medical practice and health care in medieval Europe', *Signs,* xiv (1989), 434–73.

Guidi, L., 'Levatrici ed ostetrici a Napoli: storia di un conflitto tra XVIII e XIX secolo' in P. Frascani (ed.), *Sanità e società: Abruzzi, Campania, Puglia, Basilicata, Calabria, secoli XVII-XX* (Udine, 1990), 103–30.

Guidi, L., and L. Valenzi, 'Malattia, povertà, devianza femminile, follia nelle istituzioni napoletane di pubblica beneficenza' in A. Massafra (ed.), *Il Mezzogiorno preunitario: economia, società, istituzioni* (Bari, 1988), 1171–91.

Gunn, P., *Naples: a palimpsest* (London, 1961).

Henry, J., 'Doctors and healers: popular culture and the medical profession' in S. Pumfrey, P. Rossi and M. Slawinski (eds), *Science, culture and popular belief in Renaissance Europe* (Manchester, 1991), 191–221.

Iacovelli, G., *Gli acquedotti di Cotugno: medici pugliesi a Napoli tra illuminismo e restaurazione* (Galatina, 1988).

Iborra, P., *Historia del Protomedicato en España (1477–1822)* (Valladolid, 1987).

Intorcia, G., *Civitas beneventana: genesi ed evoluzione delle istituzioni cittadine nei secoli XIII-XVI* (Benevento, 1981).

Jenner, M., 'Quackery and enthusiasm, or why drinking water cured the plague' in O. P. Grell and A. Cunningham (eds), *Religio Medici: medicine and religion in seventeenth-century England* (Aldershot, 1996), 313–39.

Jütte, R., 'The social construction of illness in the early modern period' in J. Lachmund and G. Stallberg (eds), *The social construction of illness: illness and medical knowledge past and present* (Stuttgart, 1992), 23–38.

Kagan, R., 'Le università in Italia, 1500–1700', *Società e storia*, xxviii (1985), 275–317.

Klaniczay, G., *The uses of supernatural power,* trans. S. Singerman (Cambridge, 1990).

Kleinman, A., *The illness narratives: suffering, healing and the human condition* (New York, 1988).

Koenigsberger, H. G., *The government of Sicily under Philip II of Spain* (London, 1951).

Kristeller, P. O., 'The School of Salerno: its development and its contribution to the history of learning', *Bulletin of the History of Medicine,* xvii (1945), 138–94.

Lanning, J., *The Royal Protomedicato: the regulation of the medical profession in the Spanish empire,* ed. J. Tepaske (Durham, NC, 1985).

Laplantine, F., *Anthropologie de la maladie* (Paris, 1986).

Lebrun, F., *Se soigner autrefois: médecins, saints et sorciers aux XVIIe et XVIIIe siècles* (Paris, 1983).

Leone, N., *La vita quotidiana a Napoli ai tempi di Masaniello* (Milan, 1994).

Le Paulmier, C.-S., *L'Orviétan: histoire d'une famille de charlatans du Pont Neuf aux XVIIe et XVIIIe siècles* (Paris, 1893).

Levi, G., *Inheriting power: the story of an exorcist,* trans. L. Cochrane (Chicago, 1988).

Lindemann, M., *Health and healing in eighteenth-century Germany* (Baltimore, 1996).

Lingo, A., 'Empirics and charlatans in early modern France: the genesis of the classification of the "other" in medical practice', *Journal of Social History,* xix (1986), 583–603.

Lopez, P., 'Le confraternite laicali in Italia e la riforma cattolica', *Rivista di studi salernitani,* ii (1969), 153–238.

——, *Napoli e la peste, 1464–1530: politica, istituzioni, problemi sanitari* (Naples, 1989).

López Piñero, J. M., 'The medical profession in sixteenth-century Spain' in A. Russell (ed.), *The town and state physician in Europe from the Middle Ages to the Enlightenment* (Wolfenbüttel, 1981), 85–98.

López Terrada, M. L. and Alvar Martínez Vidal (eds), 'El Tribunal del Real Protomedicato en la monarquía hispánica', special number of *Dynamis,* xvi (1996).

Malamani, A., 'L'organizzazione sanitaria nella Lombardia austriaca' in A. De Maddalnea, E. Rotelli and G. Barbarisi (eds), *Economia, istituzioni, cultura in Lombardia nell'età di Maria Teresa, vol 3: Istituzioni e società* (Bologna, 1982), 991–1010.

Manconi, F., *Castigo de Dios: la grande peste barocca nella Sardegna di Filippo IV* (Rome, 1994).

Marin, B., 'La topographie médicale de Naples de Filippo Baldini, médecin hygiéniste au

service de la couronne', *Mélanges de l'Ecole Française de Rome: Italie et Méditerranée,* ci (1989), 695–732.

Martin, A. L., *Plague? Jesuit accounts of epidemic disease in the 16th century* (Kirksville, 1996).

Matthews, L., 'Licensed mountebanks in Britain', *Journal of the History of Medicine and Allied Sciences,* xix (1964), 30–45.

Melchiorre, V. A., *Il Sacro Monte di Pietà e Ospedale Civile di Bari* (Bari, 1992).

Miele, M., 'Malattie magiche di origine diabolica e loro terapia secondo il medico ben-eventano Pietro Piperno (+ 1642)', *Campania sacra,* iv (1973), 166–223.

Mongelli, N., 'Diffusione di un medicamento popolare nel Regno di Napoli: la teriaca di Andromaco', *Lares,* xlii (1976), 307–44.

Moricola, G., *L'industria della carità: l'Albergo dei Poveri nell'economia e nella società napoletana tra '700 e '800* (Naples, 1994).

Musella, S., 'Dimensione sociale e prassi associativa di una confraternita napoletana nell'età della Controriforma' in G. Galasso and C. Russo (eds), *Per la storia sociale e religiosa del Mezzogiorno d'Italia* (Naples, 1980), vol. 1, 341–438.

——, 'Il Pio Monte della Misericordia e l'assistenza ai "poveri vergognosi" (1665–1724)' in G. Galasso and C. Russo (eds), *Per la storia sociale e religiosa del Mezzogiorno d'Italia* (Naples, 1982), vol. 2, 291–347.

Musi, A., 'Medici e istituzioni a Napoli nell'età moderna' in P. Frascani (ed.), *Sanità e società: Abruzzi, Campania, Puglia, Basilicata, Calabria, secoli XVII-XX* (Udine, 1990), 19–71.

——, 'Medicina e sapere medico a Salerno in età moderna' in *Salerno e la sua Scuola Medica* (Salerno, 1994), 29–36.

——, 'Pauperismo e pensiero giuridico a Napoli nella prima metà del secolo XVII' in G. Politi, M. Rosa and F. della Peruta (eds), *Timore e carità: i poveri nell'Italia moderna* (Cremona, 1982), 259–74.

——, 'La professione medica nel Mezzogiorno moderno' in M. L. Betri and A. Pastore (eds), *Avvocati, medici, ingegneri: alle origini delle professioni moderne* (Bologna, 1997), 83–92.

Muto, G., 'The form and content of poor relief in early modern Naples' in A. Calabria and J. Marino (eds), *Good government in Spanish Naples* (New York, 1990), 205–36.

——, 'Il Regno di Napoli sotto la dominazione spagnola' in G. Cherubini (ed.), *Storia della società italiana: la Controriforma e il Seicento* (Milan, 1989), 225–316.

Nathan, T. and I. Stengers, *Médecins et sorciers: manifeste pour une psychopathologie scientifique* (Paris, 1995).

Nicolini, F., *Saggio d'un repertorio biobibliografico di scrittori nati o vissuti nell'antico Regno di Napoli* (Naples, 1966).

Nicolson, M., 'Giovanni Battista Morgagni and eighteenth-century physical examination' in C. Lawrence (ed.), *Medical theory, surgical practice: studies in the history of surgery* (London, 1992), 101–34.

Nutton, V., 'Continuity or rediscovery? The city physician in classical antiquity and medieval Italy' in A. Russell (ed.), *The town and state physician in Europe from the Middle Ages to the Enlightenment* (Wolfenbüttel, 1981), 9–46.

——, 'Humanist surgery', in A. Wear, R. French and I. M. Lonie (eds), *The medical renaissance of the sixteenth century* (Cambridge, 1985), 75–99.

Olmi, G., 'Farmacopea antica e medicina moderna: la disputa sulla teriaca nel Cinquecento bolognese', *Physis,* xix (1977), 197–246.

Orsi, R., 'The cult of saints and the reimagination of the space and time of sickness in twentieth-century American Catholicism', *Literature and Medicine,* viii (1989), 63–77.

Osbat, L., *L'Inquisizione a Napoli: il processo agli ateisti, 1688–97* (Rome, 1974).

——, 'L'Inquisizione a Napoli: problemi archivistici e problemi storiografici' in A. Del Col and G. Paolin (eds), *L'Inquisizione romana in Italia nell'età moderna: archivi, problemi di metodo e nuove ricerche* (Rome, 1991), 263–93.

Palmer, R., 'Pharmacy in the Republic of Venice in the sixteenth century', in A. Wear, R. French and I. M. Lonie (eds), *The medical renaissance of the sixteenth century* (Cambridge, 1985), 100–17.

——, 'Physicians and the state in post-medieval Italy' in A. Russell (ed.), *The town and state physician in Europe from the Middle Ages to the Enlightenment* (Wolfenbüttel, 1981), 47–61.

Pancino, C., *Il bambino e l'acqua sporca: storia dell'assistenza al parto dalle mammane alle ostetriche (secoli XVI-XIX)* (Milan, 1984).

Panseri, G., 'La nascita della polizia medica: l'organizzazione sanitaria nei vari Stati italiani' in G. Micheli (ed.), *Storia d'Italia. Annali 3: Scienza e tecnica nella cultura e nella società dal Rinascimento a oggi* (Turin, 1980), 157–96.

Papa, E., 'Carestia ed epidemia nel regno di Napoli durante il 1763–64 nella corrispondenza tra la Nunziatura e la Segreteria di Stato', *Rivista di storia della chiesa in Italia,* xxviii (1974), 191–208.

Park, K., 'Medicine and society in medieval Europe' in A. Wear (ed.), *Medicine in society: historical essays* (Cambridge, 1992), 59–90.

Pastore, A., 'Gli ospedali in Italia fra Cinque e Seicento: evoluzione, caratteri, problemi' in M. L. Betri and E. Bressan (eds), *Gli ospedali in area padana fra Settecento e Novecento* (Milan, 1992), 71–87.

——, 'Strutture assistenziali fra Chiesa e Stati nell'Italia della Controriforma' in G. Chittolini and G. Miccoli (eds), *Storia d'Italia. Annali 9: La Chiesa e il potere politico dal Medioevo all'età contemporanea* (Turin, 1986), 433–65.

Pelling, M., 'Medical practice in early modern England: trade or profession?' in W. Prest (ed.), *The professions in early modern England* (London, 1987), 90–128.

Pelling, M. and C. Webster, 'Medical practitioners' in C. Webster (ed.), *Health, medicine and mortality in the sixteenth century* (Cambridge, 1979), 165–235.

Perry, M. E., 'Beatas and the Inquisition in early modern Seville' in S. Haliczer (ed.), *Inquisition and society in early modern Europe* (London, 1987), 147–68.

Pesciatini, D., 'Maestri, medici, cerusici nelle comunità rurali pisane nel XVII secolo' in *Scienze, credenze occulte, livelli di cultura* (Florence, 1982) 121–45.

Petraccone, C., *Napoli dal Cinquecento all'Ottocento: problemi di storia demografica e sociale* (Naples, 1974).

Pitrè, G., *Medici, chirurgi, barbieri e speziali antichi in Sicilia, secoli XIII-XVIII* (Rome, 1942).

——, *Medicina popolare siciliana* (Turin, 1896; new edn Florence, 1949).

Pomata, G., *La promessa di guarigione: malati e curatori in antico regime, Bologna XVI-XVIII secolo* (Rome and Bari, 1994).

Pontieri, E., *Divagazioni storiche e storiografiche* (Naples, 1965).

Porter, R., *Health for sale: quackery in England, 1660–1850* (Manchester, 1989).

——, 'The patient's view: doing medical history from below', *Theory and Society,* xiv (1985), 175–98.

Porter, R. and D. Porter, *In sickness and in health: the British experience, 1650–1850* (London, 1988).

Prosperi, A., *Tribunali della coscienza: inquisitori, confessori, missionari* (Turin, 1996).

Pullan, B., 'Poveri, mendicanti e vagabondi (secoli XIV-XVII)' in C. Vivanti and R.

Romano (eds), *Storia d'Italia. Annali 1: Dal feudalesimo al capitalismo* (Turin, 1978), 981–1047.

——, '"Support and redeem": charity and poor relief in Italian cities from the fourteenth to the seventeenth century', *Continuity and Change*, iii (1988), 177–208.

Ramsey, M., *Professional and popular medicine in France, 1770–1830* (Cambridge, 1988).

Redon, O. and J. Gélis, 'Pour une étude du corps dans les récits de miracles' in S. Boesch Gajano and L. Sebastiani (eds), *Culto dei santi, istituzioni e classi sociali in età preindustriale* (Rome, 1984), 565–72.

Rienzo, M. G., 'Inventario sommario dell'Archivio della Confraternita del S.mo Sacramento dei nobili spagnoli di S. Giacomo in Napoli' in *Le chiavi della memoria: miscellanea in occasione del I centenario della Scuola Vaticana di paleografia diplomatica e archivistica* (Vatican City, 1984), 461–90.

——, 'Nobili e attività caritativa a Napoli nell'età moderna. L'esempio dell'Oratorio del SS. Crocifisso dei Cavalieri in S. Paolo Maggiore' in G. Galasso and C. Russo (eds), *Per la storia sociale e religiosa del Mezzogiorno d'Italia* (Naples, 1982), vol. 2, 251–89.

Romano, R., *Napoli: dal viceregno al regno* (Turin, 1976).

Romeo, G., *Aspettando il boia: condannati a morte, confortatori e inquisitori nella Napoli della Controriforma* (Florence, 1993).

——, *Inquisitori, esorcisti e streghe nell'Italia della Controriforma* (Florence, 1990).

Rosa, M., 'Pauperismo e riforme nel Settecento italiano: linee di ricerca' in P. Brown, O. Capitani, F. Cardini and M. Rosa, *Povertà e carità dalla Roma tardo-antica al '700 italiano* (Abano Terme, 1983), 93–125.

Rosen, G., *A history of public health* (Baltimore, 1993 edn.).

Rubel, A. J., and C. Sargent (eds), 'Parallel medical systems: papers from a workshop on the "healing process"', special number of *The Social Sciences and Medicine*, xiiiB (1979).

Russo, A., *L'arte degli speziali in Napoli* (Naples, 1966).

Ryder, A., *The kingdom of Naples under Alfonso the Magnanimous: the making of a modern state* (Oxford, 1976).

Sallmann, J.-M., *Chercheurs de trésors et jeteuses de sorts: la quête du surnaturel à Naples au XIVe siècle* (Paris, 1986).

——, *Naples et ses saints à l'âge baroque (1540–1750)* (Paris, 1994).

Sannazzaro, P., *Storia dell'Ordine Camilliano (1550–1699)* (Turin, 1986).

Scaramella, P., *Le Madonne del Purgatorio: iconografia e religione in Campania tra rinascimento e controriforma* (Genoa, 1991).

——, *I santolilli: culti dell'infanzia e santità infantile a Napoli alla fine del XVI secolo* (Rome, 1997).

Seppilli, T. (ed.), *Le tradizioni popolari in Italia: medicine e magia* (Milan, 1989).

Sessa, M. (ed.), *Il patrimonio del povero: istituzioni sanitarie, assistenziali ed educative in Campania dal XIII al XX secolo* (Naples, 1997).

Sherwood, J., *Poverty in eighteenth-century Spain: the women and children of the Inclusa* (Toronto, 1988).

Sinni, A., 'Vita scolastica dell'almo Collegio salernitano', *Archivio storico della provincia di Salerno*, ii (1922), 38–74.

Sodano, G., 'Miracoli e Ordini religiosi nel Mezzogiorno d'Italia (XVI-XVIII secolo)', *Archivio storico per le province napoletane*, cv (1987), 293–414.

——, 'Santi, beati e venerabili ai tempi di Maria Francesca delle Cinque Piaghe', *Campania sacra*, xxii (1991), 441–60.

Thorndike, L., *A history of magic and experimental science*, 8 vols (New York, 1923–58).

Torrini, M., 'L'Accademia degli Investiganti: Napoli, 1663–1670', *Quaderni storici*, xlviii (1981), 845–83.

Turchini, A. *Morso, morbo, morte: la tarantola fra cultura medica e terapia popolare* (Milan, 1987).

Valente, A., *Gioacchino Murat e l'Italia meridionale* (Turin, 1965).

Ventura, P., 'Le ambiguità di un privilegio: la cittadinanza napoletana tra Cinque e Seicento', *Quaderni storici*, xxx (1995), 385–416.

Venturi, F., *Italy and the Enlightenment: studies in a cosmopolitan century*, trans. S. Corsi (London, 1972).

Villari, R., *The revolt of Naples,* trans. J. Newell (Cambridge, 1993).

Visceglia, M. A., *Il bisogno di eternità: i comportamenti aristocratici a Napoli in età moderna* (Naples, 1988).

Vismara Chiappa, P., *Miracoli settecenteschi in Lombardia tra istituzione ecclesiastica e religione popolare* (Milan, 1988).

Vitale, G., 'Ricerche sulla vita religiosa e caritativa a Napoli tra medioevo ed età moderna', *Archivio storico per le province napoletane*, lxxxv–lxxxvi (1968–69), 207–91.

Volpe, F., 'Il clero della diocesi di Capaccio dopo la peste del 1656', *Ricerche di storia sociale e religiosa*, ii (1973), 9–43.

Watson, G., *Theriac and mithridatium: a study in therapeutics* (London, 1966),

Wear, A., 'Making sense of health and environment in early modern England' in Wear (ed.), *Medicine in society: historical essays* (Cambridge, 1992), 119–48.

Zarri, G., 'Le sante vive. Per una tipologia della santità femminile nel primo Cinquecento', *Annali dell'Istituto storico italo-germanico in Trento*, vi (1980), 371–445.

# INDEX

Note: 'n.' after a page number refers to a note on that page.

# DATE DUE

| APR 0 2 2005 | | | |
|---|---|---|---|
| | | | |
| | | | |
| | | | |
| | | | |
| | | | |
| | | | |
| | | | |
| | | | |
| | | | |
| | | | |
| | | | |
| | | | |
| | | | |
| | | | |
| | | | |
| | | | |
| | | | |